American Realism

Twentieth-Century Drawings and Watercolors

From the
Glenn C. Janss
Collection

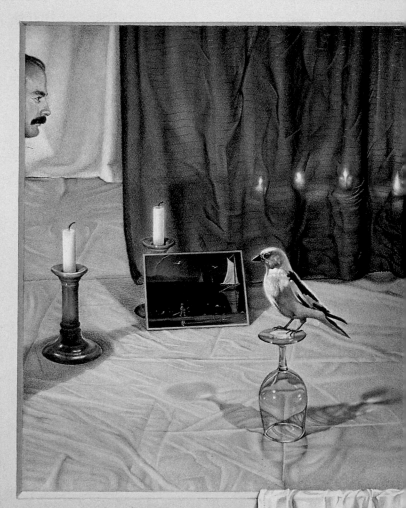

Text by Alvin Martin

Foreword by Henry T. Hopkins

Introduction by Glenn C. Janss

San Francisco Museum of Modern Art

in association with

Harry N. Abrams, Inc., Publishers, New York

American Realism

Twentieth-Century Drawings and Watercolors

From the Glenn C. Janss Collection

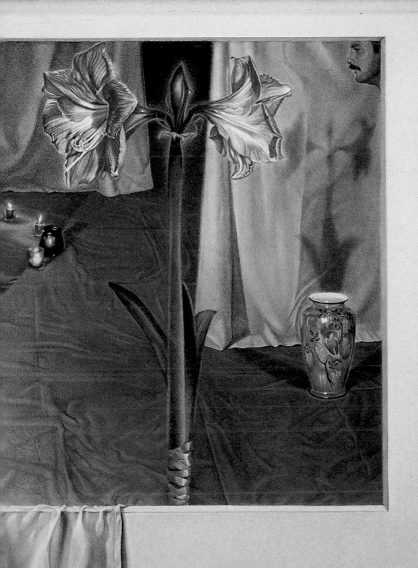

This book was published on the occasion of
the exhibition *American Realism: Twenti-
eth-Century Drawings and Watercolors*, or-
ganized by the San Francisco Museum of
Modern Art.

SCHEDULE OF THE EXHIBITION

San Francisco Museum of Modern Art
7 November 1985–12 January 1986

De Cordova and Dana Museum and Park,
Lincoln, Massachusetts
13 February–6 April 1986

Archer M. Huntington Art Gallery,
University of Texas, Austin
31 July–21 September 1986

Mary and Leigh Block Gallery, North-
western University, Evanston, Illinois
23 October–14 December 1986

Williams College Museum of Art,
Williamstown, Massachusetts
15 January–8 March 1987

Akron Art Museum
9 April–31 May 1987

Madison Art Center, Wisconsin
26 July–20 September 1987

Project Director: Margaret L. Kaplan
Editor: Teresa Egan
Designer: Darilyn Lowe

Front cover: Elena Borstein. *Red Gate.* 1983
Back cover: Philip Pearlstein. *Two Models on Spanish Rug.* 1982
Title page: Juan Gonzalez. *Double-Portrait of Jimmy in New York
City.* 1984. Watercolor on paper, 23 × 33¾" (sight) (58.4 × 85.7)

Library of Congress Cataloging in Publication Data

Martin, Alvin.
 American realism.

 Catalog of an exhibition.
 Bibliography: p. 228
 Includes index.
 1. Art, American—Exhibitions. 2. Realism in art—United
States—Exhibitions. 3. Art, Modern—20th century—United
States—Exhibitions. 4. Janss, Glenn C.—Art collections—Exhibi-
tions. 5. Art—Private collections—Idaho—Exhibitions. I. San Fran-
cisco Museum of Modern Art. II. Title.
N6512.5.R4M37 1985 741.973′074′019461 85–13481
ISBN 0–8109–1839–0 (Abrams)
ISBN 0–918471–04–4 (San Francisco Museum of Modern Art: pbk.)

Copyright © 1986 by the San Francisco Museum of Modern Art,
401 Van Ness Avenue, San Francisco, California 94102-4582

The San Francisco Museum of Modern Art is supported in part by
the Institute of Museum Services, the National Endowment for the
Arts, the San Francisco Hotel Tax Fund, and the San Francisco
Foundation.

Published in 1986 by Harry N. Abrams, Incorporated, New York.
All rights reserved. No part of the contents of this book may be
reproduced without the written permission of the publishers

Printed and bound in Japan

Contents

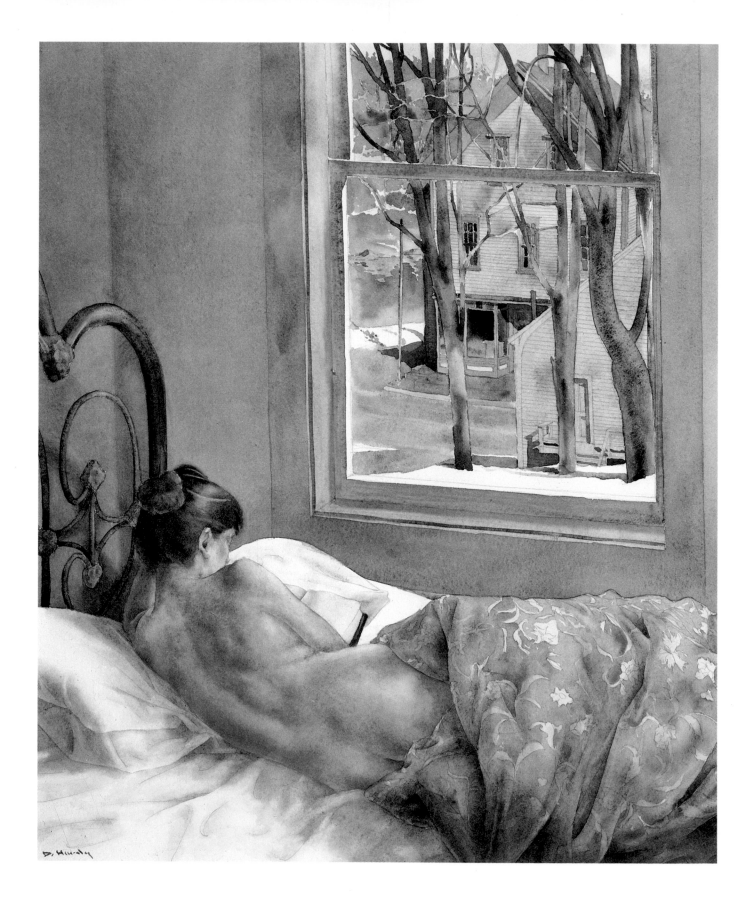

Acknowledgments

We wish to thank not only Glenn and William Janss for their generosity toward the organization of the exhibition and the catalogue for *American Realism: Twentieth-Century Drawings and Watercolors*, but also Alvin Martin, Associate Professor, Department of Art History, Southern Methodist University, Dallas, who was asked by Mrs. Janss to help with the selection of works in the exhibition and to write the essay for the book that accompanies it.

Of the Museum staff, we would like to thank Donna Graves, Curatorial Assistant, for coordinating all aspects of the exhibition, including organizing the tour and writing many of the artists' biographies; Katherine Church Holland, former Research/Collections and Registration Director, who wrote the rest of the artists' biographies; Lydia Tanji, Curatorial Secretary, who assisted with the compilation of the information for the exhibition and the catalogue; Junko Iwabuchi, Curatorial Intern, who assisted with the artists' biographies; Anne Munroe, Exhibitions and Publications Coordinator, who guided the publication through its various stages of production; Tina Garfinkel, Associate Registrar/Exhibitions, for organizing the transportation and circulation of the works in the exhibition; and Julius Wasserstein, Gallery Superintendent, and his crew for their handling and installation of the works in the exhibition.

We would also like to thank the staff of the following galleries for their cheerful assistance in compiling information on the artists in the exhibition and their work:

In Boston

The Alpha Gallery
Harcus Gallery
Barbara Krakow Gallery
Thomas Segal Gallery

opposite: 2. DeWitt Hardy. *Nude Reading, New Market, New Hampshire.* 1983. Watercolor on paper, 25⁵⁄₁₆ × 21³⁄₁₆" (sight) (64.3 × 53.8)

In Chicago

Dart Gallery
Fairweather Hardin Gallery
Frumkin & Struve
Rhona Hoffman Gallery
Roger Ramsay Gallery
Betsy Rosenfield Gallery

In Dallas

Adams-Middleton Gallery

In Los Angeles

James Corcoran Gallery
Janus Gallery
Koplin Gallery

In New York

ACA Galleries
Brooke Alexander, Inc.
Susan Caldwell Gallery
Andrew Crispo Gallery
Davis and Langdale, Inc.

Tibor de Nagy Gallery
Sid Deutsch Art Gallery
Martin Diamond Fine Arts
Terry Dintenfass Gallery
Fischbach Gallery
Forum Gallery
Xavier Fourcade, Inc.
Allan Frumkin Gallery
Graham Gallery
O. K. Harris Gallery
Hirschl & Adler Galleries
Hirschl & Adler Modern
Nancy Hoffman Gallery
Kennedy Galleries
Kornblee Gallery
Kraushaar Galleries
David McKee, Inc.
Kathryn Markel Fine Arts
Marlborough Gallery
Louis K. Meisel Gallery
Robert Miller Gallery
Alexander F. Milliken, Inc.
Odyssia Gallery
Pace Gallery of New York

Luise Ross Gallery
Salander-O'Reilly Galleries
Robert Schoelkopf Gallery
Allan Stone Gallery
Tatistcheff & Co., Inc.
Jack Tilton Gallery
Richard York Gallery
Zabriskie Gallery

In San Francisco

John Berggruen Gallery
Braunstein Gallery
Charles Campbell Gallery
Joseph Chowning Gallery
Fuller-Goldeen Gallery
Ivory/Kimpton Gallery
Quay Gallery
William Sawyer Gallery
Jeremy Stone Gallery

In Washington, D.C.

Fendrick Gallery

Foreword

The Glenn Janss collection of American realist drawings and watercolors, now numbering more than three hundred works, is possibly the most comprehensive gathering of this material in private hands. Ranging from a turn-of-the-century Edward Hopper drawing to a recent Edward Ruscha, the collection presents a wide variety of subject matter, techniques, and philosophical attitudes.

Although comprehensiveness is in itself a virtue, the primary virtue of this grouping is its particular complexity, which reflects the passionate and single-minded vision of its collector, who looked for the special and sometimes unique qualities of an individual drawing or watercolor within the accepted body of work by a given artist. The result is a rich crazy quilt of images, including portraits, landscapes, still lifes, and interiors of large and small scale. The works of the most renowned artists mix easily with works by artists of lesser reputation.

A collection of this magnitude and sensibility does not emerge overnight. Nor does a collector, full of zeal tempered by intellect, emerge fully formed on the scene. Glenn Janss became involved with the art world in the early 1960s at the old Los Angeles County Museum of Art in Exposition Park, when museum Director Richard F. Brown asked her to form a new, stronger docent council that would provide art education for schoolchildren as well as adults. Her intelligence, charming manner, and organizational abilities were already apparent through previous volunteer work for the museum. Overseeing sixty volunteer docent trainees each year for several years, as well as attending for three years the training classes in art history that were provided for the docents, led her to a new awareness of the life-enhancing value of art.

After this experience, she returned to graduate school to study art history at the University of California, Los Angeles, and opened a shop called Art Imports, where she tested her "eye" in selecting antique art objects for a small but enlightened clientele. The shop was not wildly successful, but her collecting habit had been firmly established.

3. Carolyn Brady. *Peaches for Casa Rovai.* 1982. Watercolor on paper,
42¼ × 60½″ (sight) (107.3 × 153.7)

opposite: 4. Wayne Thiebaud. *Shoe Rows.* 1975. Pastel on paper,
22³⁄₁₆ × 17³⁄₁₆″ (56.4 × 43.7)

In the late 1960s she moved with her family to Sun Valley, Idaho, where she founded the successful Sun Valley Center for the Arts and Humanities, which provides creative opportunities in painting, photography, and ceramics and offers lectures and cultural events for its Idaho audience.

Her second marriage, to William Janss—an avid collector of the first generation of American Abstract Expressionists and, more recently, of the early twentieth-century modernists and Precisionists—allowed her to continue to expand her vision.

However, rather than participate in the formation of her husband's collection, she decided to branch out on her own and to acquire drawings and watercolors created by living American realist artists. This was an area that suited her solid, if somewhat conservative, tastes and that was not being trampled over by "me too" collectors.

The discipline of drawing fascinates her, in that each work is unique and often takes longer to create than a large-scale painting. Since drawings have not proved to be widely popular with American collectors, they have the advantage of being economically feasible. Nonetheless, a collection of over three hundred of anything in this day and age represents a significant investment, not only of money but also of time and energy.

Glenn Janss's search for works to be included in the collection has been extensive, painstaking, and national in scope: She has visited a full range of galleries and artists' studios throughout the United States. Her search was a disciplined one as she attempted to establish new, broader guidelines for the realm of realism by looking beyond the few galleries whose artists epitomize the style. Her interest in art history led her to establish a significant library of the primary literature in the field and brought her in contact with the leading writers, critics, and museum curators involved in the movement, as well as with the artists themselves, which has added considerable pleasure to the project. In several instances the artists have been commissioned to do specific works relating to the Idaho environment.

It is with great pleasure that we at the San Francisco Museum of Modern Art present the Glenn Janss collection of American realist drawings and watercolors to our audience and then to a number of sister institutions throughout the United States.

Henry T. Hopkins,
Director,
San Francisco Museum of Modern Art

Introduction: A COLLECTOR'S PERSPECTIVE

Collecting is an art. It requires the nurturing of many of the same creative talents that must be developed by the artist. The collector also confronts the *tabula rasa* of the artist—an untouched, smooth tablet. The artist faces his prepared *tabula* with concern, uncomfortable with its emptiness and with what he alone is responsible for. Collectors face their empty walls with a similar concern—that what is placed there will be meaningful. The collector and the artist ask many of the same questions and seek the same answers.

The artist must ultimately confront the tablet and make some intuitive or conscious choices. As he develops and matures, he will care less and less about what the world thinks of his art and will create for himself with confidence; so it is with the collector.

Collecting involves three basic resources: commitment, aesthetic judgment, and knowledge. These are not suggested in order of priority; rather, one follows quite naturally from the other. None of these resources ordinarily is—or needs to be—fully, or even partially, developed in order to begin to collect. Whether collecting is considered to be a hobby or a profession, the true novice begins with interest only and with little aesthetic judgment or knowledge.

Once the first choices have been made, the collector has already fulfilled the requirements of the first resource: His interest has become a commitment. From this small beginning, a process, of which the collector is hardly aware, has been initiated—a process of personal development that will parallel the development of his collection. His visual perception and aesthetic responses are challenged by each choice that he makes. He learns that it is of no consequence at all that what might have been meaningful for him earlier holds no meaning for him now. He becomes confident in his second resource: aesthetic judgment.

The development of aesthetic judgment can be hastened by studying art history and the images in historical and contemporary art books, by visiting museums and galleries, by subscribing to art magazines, and by travel. There are

many avenues, but the important requisites are to continue to expand perception and visual response, to look and evaluate and assess for ourselves.

The third resource follows quite naturally. Our interest has been kindled, our first choices have been made, our aesthetic judgment has been challenged, and now we naturally want to accrue the background knowledge that will help us to perceive, evaluate, and respond more surely, more confidently, and that will support our choices. We begin to study our specific area of interest and to seek out the artists, the galleries, and the informed art professionals who can best help us pursue our particular commitment.

The pursuit and development of these three resources does not guarantee the achievement of a significant personal collection. Such a collection must be open-ended; it must develop as the collector develops, and to be unique, the collection must reflect the personality of its owner. Only then will the collection become more than the sum of its parts, and only then will it add something new to the art world: a new perception, a new approach, and possibly a new educational view.

Now the collector exposes himself—just as the artist does. His intuition, sensitivity, and aesthetic evaluations are open for judgment and criticism. But without these dangers there will never be that very special personal adventure or that very special personal collection.

I have been asked to write about my personal collecting experiences but am reticent to do so lest these be taken as models. There is no definitive way to collect, but perhaps my experiences can underscore the idea of collecting as a personal challenge and commitment. It is my hope that I can, through this exhibition and catalogue, educate and encourage new collectors to find a rewarding personal pursuit.

This collection of twentieth-century American realist drawings and watercolors is reflective of my own psyche. Always rationally and intellectually oriented, I attended Wellesley College as a philosophy major. The study of Plato's ideas first awakened in me questions about the nature of the world's truths and realities. Further study of other philosophers and their searches for the real truths about the "real" world intrigued me. My particular responses to art evolved from this background. The realist's search for real truths is usually just as ardent as the philosopher's, and he is just as deeply concerned with establishing his own ideas about reality.

On a meager budget I began to buy art in my early twenties. Even then I selected representational art because I was interested in how an artist dealt with subject matter. In graduate school I studied art history and selected a disputable topic for a thesis: "Realism in Trecento Painting." I continued to purchase works of art in the 1950s and 1960s, unaware that I had any specific focus or was purchasing the work of any "school" or movement. I bought purely for enjoyment, following my belief that artists are concerned with enabling us to see more than our personal perceptions normally reveal about the real world—and with expanding our perceptions through the sharing of their individual visions. And these were the concerns that the realists proved to have.

As an art term, *realism* is very difficult to define, because we all have perceptions of our world. The realist presents his subject matter as realistically as possible, using any of a vast range of approaches, often taking artistic license to make his work seem more "real" than real. At times he will manipulate his composition, adjust his colors, alter a perspective, or create arbitrary light sources. He does this in order to accomplish his intent to reveal more than one would ordinarily see. He is giving additional content to his subject matter. Content—not idealization of subject matter or pure subject matter—is what continues to intrigue me as I see it revealed through the individual realist's vision. I also share with the realists their interest in medieval and Renaissance techniques, and I admire their dedication to anatomical studies, their painstakingly detailed drawings and watercolors, and their use of earlier mediums such as tempera and gold leaf. It is sometimes said that the realists are not concerned with ideas, that they are adding nothing new to the mainstream of modern art. But the realists *are* dealing with ideas. They *are* dealing, as did the Abstract Expressionists, with the problem of the picture plane and the fact that a work can be a *picture* of something. They are not tricking the viewer with illusionism; they are revealing, within the parameters of a picture plane, the reality of their subject.

It is also said that the realists are objective, cool, distant, detached, and unemotional. The realist observes and analyzes, and to do so he must first approach his subject mat-

ter objectively. But he is *not* detached or emotionally uninvolved. Subjectivity must enter into the conscious choice of how to deal with the subject matter, how to achieve the desired content, and this implies deep involvement. The realists' approach is through careful observation and delineation. Their work involves more than pure subject matter; it expresses content and meaning and the irrepressible imprint of the artists' personality and intent.

I realized that there was a focus to my collection when the term *realism* reentered the contemporary art vocabulary with new meaning in the 1960s. To art historians and critics, realism had been an academic tradition, sometimes in, and sometimes out, of favor. In the 1970s the art world was deluged with new labels: Magic Realism, Painterly Realism, Photo Realism, New Realism, Superrealism, and Sharp-Focus Realism. Although realism *per se* had always been included in art history surveys, its supposed polarity to the inevitable twentieth-century advance toward abstraction made its significance more emphatic, and the art world focused on it with new interest. In the 1970s it became clear to me that all facets of realism deserved my attention too, and I moved quickly to add contemporary realists to the collection. I felt confident that such a resurgence of realism should not go undocumented and that my collection could be significant in introducing an important tradition of American art to a wide public.

No art collection can be created without the influence of past history and present associates. My collection is no exception. I am proud and grateful that I have had the guidance and support so generously afforded me by the many art professionals with whom I have had the good fortune to be associated: artists, professors, authors, dealers, and gallery and museum directors.

To these persons and institutions I owe my gratitude: My lifelong friend, Henry Hopkins, Director of the San Francisco Museum of Modern Art, to whom I owe a lifetime of art experiences. Our lives have been happily intertwined with the art world for over thirty years. His advice and encouragement have been limitless and invaluable in the formation of this collection, exhibition, and catalogue.

The staff of the San Francisco Museum of Modern Art, who labored ceaselessly to provide the museum services necessary to produce an exhibition and catalogue of this size.

Two authors who, through their timely publications, unknowingly guided and influenced me in my collecting: John Arthur, for his *Realist Drawings and Watercolors* and other works in the realist area, and Frank Goodyear, for his exhibition and catalogue, *Contemporary American Realism since 1960.*

Nancy Hoffman of Nancy Hoffman Gallery, for her guidance in my first selections of contemporary realist works, her support of my desire to develop a collection of realist works on paper, and her continuing patience and advice as I persevered to further my knowledge and understanding.

Jane and Bob Schoelkopf of the Robert Schoelkopf Gallery, Lawrence DiCarlo of the Fischbach Gallery, Allan Frumkin of the Allan Frumkin Gallery, and Caroline and Brooke Alexander of Brooke Alexander, Inc., for their enthusiasm for this project and their unceasing efforts to locate the best works of the realists.

Hirschl & Adler Galleries for their concern in locating for me the finest of historical works. Most of the historical works in this exhibition were found through the dedication of M. P. Naud and Stuart Feld. And Don McKinney, who continued this guidance in contemporary realist selections from Hirschl & Adler Modern.

The galleries who so loyally support the realists and whose artists are represented in this exhibition by a number of works: John Berggruen Gallery, Charles Campbell Gallery, James Corcoran Gallery, Tibor de Nagy Gallery, Sid Deutsch Art Gallery, Terry Dintenfass Gallery, Forum Gallery, Frumkin & Struve, Fuller-Goldeen Gallery, Graham Gallery, O. K. Harris Gallery, Kornblee Gallery, Barbara Krakow Gallery, Kennedy Galleries, Louis K. Meisel Gallery, Alexander F. Milliken, Inc., Marlborough Gallery, Robert Miller Gallery, Thomas Segal Gallery, Allan Stone Gallery, and Tatistcheff & Co., Inc.

All the other galleries who have participated in this exhibition are recognized separately.

Andrew Kent, friend and professional photographer, who is responsible for much of the photography for this catalogue and for whose professionalism and dedication to perfection I have a profound respect.

Gail Severn and her staff at Images Gallery, Ketchum, Idaho, for their professional framing services.

Dr. Alvin Martin, for agreeing to take on the nearly impossible task of unraveling the historical development of realism and then giving the breadth of contemporary realist approaches a sense of order and meaning.

The editors of Harry N. Abrams, Inc., for wanting to publish this catalogue and for being so patient, gracious, sensitive, and responsive in their cooperation.

My loving husband, Bill, who initially inspired me to collect and who supported me through years of research for American realist works and whose patience and encouragement were the true sources that nurtured this collection.

Without the help of so many, American realism and our contemporary realists would not have this special opportunity to be appreciated by a wide public.

Glenn C. Janss

Facing Reality: TWENTIETH-CENTURY AMERICAN REALIST AND REALISTIC DRAWINGS IN PERSPECTIVE

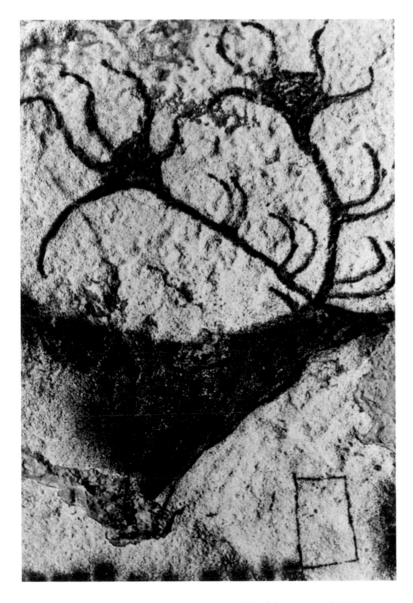

Figure 1. *Head of Red-deer.* Cave painting. Magdalenian, c. 15,000 B.C. Lascaux, France

All art is the expression of an urge on the part of its creator to comprehend and reveal the nature of reality. As reality is extremely elusive and can only be explained in terms of human perceptions, it has been represented in a variety of ways by different individuals and cultures in different regions and periods of time. Reality may or may not be immutable, but perceptions of its nature change constantly, and understanding of it can be expressed only in aspects, never as a whole.

In this regard one of the most interesting pictures in the history of art was done more than fifteen thousand years ago and is preserved on the walls of the cave of Lascaux in southwestern France (fig. 1). It is a depiction of a deer expressively rendered with considerable zoological understanding. Indeed, the animal has been identified as the ancestor of a type of red deer that still lives in parts of Germany. Adjacent to the deer is a representation of a four-sided figure that is approximately a rectangle. Why or by whom these images were created is unknown. What may be said, however, is that the painter was aware of both realism and abstraction. To the artist who painted it, the deer accurately symbolized the appearance of an important cohabitant of his or her world. It may be presumed that the rectangle, a shape that very seldom occurs spontaneously in nature, represents another reality—a conception of the human mind.

Both figures engaged reality and had their effects upon it. The rectangle—apparently a purely abstract form, whatever symbolic meaning it may have had—became the figure that in many ways shaped the world.

The Old Stone Age hunter-gatherers who decorated Lascaux inhabited a world of organic forms. They lived in shelters provided by or adapted from nature—caves, geologically formed enclosures, or shelters constructed from gathered materials such as stones, boughs, and animal skins. The geometric conception—the rectangle—set in motion a sequence of applications of that form, which created notions

of organization and analysis, the precursors of civilization. The simple rectangle was the harbinger of language and mathematics. It was the source of such practical innovations as the plans and elevations of architectural constructions and the laying out of fields. It determined the drawing of territorial boundaries, such as those of certain western American states. The rectangle was the conceptual ancestor of the brick, the box, and even television and computer screens. Appropriately, the rectangle also became the most common shape of the supports for pictures and, in our own century, has been a source for their content.

The image of the deer is also an archetype. The desire—and the need—to comprehend reality is fulfilled by making images, one of the most profound means of grasping knowledge. Just what these Stone Age Picassos or Mondrians had in mind when they created these images can only be the subject of speculation. It may be assumed, however, that the figures were not simply decorations, but that they also had ritual or religious significance. The deer probably represented the symbolic capture of the animal through the magic of capturing its appearance. Most likely, the picture was also a monument expressing the hope that this important source of food and clothing would endure and that the herd would prosper and return. Animal representations may also have had totemic value to the artist and his clan, perhaps marking a tribal rallying point and a symbol of identity between themselves and a majestic creature of nature.

It may seem odd to begin a discussion of twentieth-century American drawings with a description of two figures on the wall of a Stone Age cave, but the juxtaposition of the rectangle and the deer and the motivation for their creation provide an important lesson in understanding the art of all ages and styles. The creation of symbolic images to induce a sense of spiritual, emotional, or intellectual identity between the thing depicted and the viewer underlies all representational art. The simple harmony, the conceptual purity, and the practical applicability of such abstract conceptions as the rectangle have not only informed nonrepresentational imagery in art, design, architecture, and decoration but also have provided the means of clarifying ideas that have given form and structure to mathematics and philosophy.

The rectangle and the deer are the expressions of two extremes on a spectrum of choices available to all artists at all times. At one extreme, indicated by the deer, is what is commonly called realism. This denotes an outward-looking interest in the observable appearance of objects and phenomena in the external, or nominal, world. The other extreme indicates a fascination with the constructs of the internal realm of the mind and with the creation of forms referred to as abstract or nonrepresentational. These extremes on the spectrum of choice parallel the two primary avenues along which all creativity proceeds and by which the knowledge is gained that creates the constant changes in human understanding of reality itself—discovery and invention.

Discovery involves the creative interpretation of pre-existing forms, facts, and phenomena present in external reality. Invention denotes the creation of new forms and concepts based primarily on internal mental conceptions and insights. Discovery in the purest sense is the realm of the explorer, the natural scientist, and the physician. Pure invention is the territory of the metaphysician, the mathematician, and the theoretical philosopher. Both processes may, and usually do, operate simultaneously in individuals, and the results profoundly influence culture as a whole. The boundaries between them are unclear and overlapping, and neither is inherently superior to the other. Discovery leads to invention, and invention, to discovery.

Each artist, like everyone else, is a unique individual, so creative responses to personal perceptions vary enormously. Because of this, one may speak of an artist's individual style. Individual styles develop through a complex of preferences that are determined by the personal creative will of the artist, but a style will also reflect the shared knowledge of the society in which an artist lives. At all times the artist may apply creativity to any point on the scale of choices between imitative realism and pure abstract form. However, if the artist's work does not conform to a more general understanding at the time it is created, it is likely to be misunderstood or ignored. This cultural consensus determines period and regional style. Style in this sense, like the perception of reality, changes as consensus develops, breaks down, and redevelops with the passing of time and the application of knowledge.

The average person, sharing in the heritage of Western civilization from the vantage point of the late twentieth century, may believe that art is and has been normally con-

cerned with realism. This is not the case. The vast majority of the works of art that have been made throughout human history are representations that are located between the extremes of realism and nonrepresentation, and they reflect the consensus of beliefs and values of the period and the region in which they were created. During most of the last one hundred and fifty years, informed artistic opinion has been guided by the consensus called modernism. This progressive theory, which militated against realism in the twentieth century, moved the focus of stylistic consideration and artistic activity to the extreme abstract end of the scale. More recently, the modernist consensus has disintegrated. Extreme realism is one of the many styles that have emerged in the last two decades, which seems to indicate that a new stylistic consensus may be in the making.

These shifts have happened many times in the history of art. The present era, the so-called post-modernist period in art, is devoid of a guiding set of theoretical beliefs and is therefore quite fascinating. As in the Lascaux image, extreme realism and extreme abstraction are both present simultaneously. Neither dominates, and the spectrum of artistic choices is fully visible in the many current styles.

What follows is an exploration of the history of the realist end of the spectrum as it exists now and as it has existed in the past. Throughout history, realism, though a continuous current in art, has been an aesthetic focal point only occasionally and then usually during periods of fundamental cultural change.

Realism is more an attitude of mind than a style. Realists are discoverers, and they express and reveal their personal perceptions of the visible world in a way that is at once both specific and universal. No two people perceive the same thing in the same way, therefore realistic expressions are as varied as the individuals who make them. Their subjects, however, are recognizable and provide a common point of departure for both the artist and the audience. If the artist is successful, the viewer will see, as never before, some part of the shared experience of reality.

Drawing

Drawing is the expression of the will to leave a trace or to delineate a shape on a surface. The difference between drawing and other related two-dimensional artistic statements, such as painting or printmaking, is frequently subtle but is usually evident in the intent of the artist. Drawing tends to be a direct means of exploring visual ideas. The physical processes employed are usually less elaborate than those of other media, therefore drawings provide the viewer with more immediate and intimate access to the relationship between the drawn image and the artist's eye, hand, and mind. Images take on as many forms as there are individuals who make them. Drawings are an artist's handwriting and signature.

In general, artists draw for one purpose—or a combination of four. Perhaps the overriding purpose is the sheer pleasure derived from watching and feeling the movement of an instrument held in one's hand as it delineates on a flat surface a pattern created in one's eye and mind. It is the nature of this pattern and the intent of its creator, however, that differentiate drawing from doodling or scribbling. Intent, then, determines the other purposes. Drawings may be made to describe things observed or conceived of, to symbolize feelings and concepts, or to visualize and depict the nature of an idea.

Drawing is the "mother of invention" in the visual arts. It is an act that involves participation at every level of the creative process, from the training of the artist's hand and eye to the capturing and execution of an image or an idea, to the planning and design of every form of plastic expression. Whether done for itself, or as a preliminary plan, or as a final design for something else—be it sculpture, painting, architecture, or industrial design—drawing facilitates realization. In order to construct a building or design an airplane, plans must be made, and they usually take the form of drawings. In the development of a painting or a sculpture, drawing is generally employed at some stage in the procedure.

Drawing is a fundamental medium of expression, as is evident both in individual works and in the history of cultural development. It has often been stated that man's art began with his discovery of tools. From the ability to shape stones, bones, and sticks into functional implements came the skills to create three-dimensional forms that, when ultimately combined with spiritual awareness and symbolic intent, led to sculpture. Painting is thought to have come somewhat later in humanity's cultural evolution. Our distant ancestors devel-

oped the urge to decorate themselves and their environment with colors made first from blood or earthy pigments such as clay and mud, then later from more sophisticated ground pigments or vegetable dyes. From these beginnings, more elaborate symbolic and decorative ideas and techniques evolved.

I believe that drawing in its most elemental sense preceded both sculpture and decoration of the body. I believe it developed from some sensitive hominid's fascination with the imprint left by his body when he walked, squatted, or lay on soft or sandy soil. When it occurred to this australopithecine genius that from an imprint his intelligence and imagination could recreate the creature who made it, deduce whether the being had been standing or moving, and if moving, in what direction and how fast, he had come to a profound discovery. When he first purposefully made a handprint on the earth and then traced a line with his finger, he had invented drawing. This led to imbuing marks with meaning, which eventually resulted in the creation of both symbols and representations.

From this conceptual point of departure, the techniques of drawing gradually expanded. A stick or a bone or a sharp stone could be used instead of a finger to draw a plan on the ground or to decorate harder surfaces. Once this mark-making stage was reached, little additional inspiration was required for our primitive cousins to dip their fingers or their sticks into mud, clay, or blood and draw upon themselves or the surfaces of their habitats.

Most of the tools of drawing as well as those of the other visual arts were invented long ago and are, in one form or another, still in use. Marks made with fingers and hands—the most basic of tools—appear on the walls of Ice Age caves. Artists still use their fingers to manipulate transitions of tone in either wet or dry media. Chuck Close, for example, used his own fingerprints and an ink pad to produce *Gwynne*, 1981 (plate 118).

The tools of drawing generally fall into three categories according to the medium or technique for which they are to be used, namely, incision, dry media, and wet media.

Incision is the most ancient of the three. It involves the use of an implement—or a finger—to scratch into a surface that is softer than itself. Some of the earliest extant prehistoric drawings were made by using stone or bone incising tools to engrave images into the walls of caves. Wood and quills were used to make a variety of points and spatulas for incising designs or written language onto clay vessels or tablets. Similar tools are used by ceramic artists today.

When metals came into general use, incising tools were adapted for engraving their surfaces. The stylus and the burin were originally devised by metalsmiths to decorate arms, armor, jewelry, and utilitarian household objects. The tools were adapted to printmaking in the fifteenth century and remain in use by intaglio artists and craftsmen today. The ancient technique of incising also has application in the conventional sense of drawing. Many artists enrich the texture of their images by using a knife, stylus, or even an eraser to scratch through surface areas made with other media.

The dry media are many, and they also have primitive beginnings. At a very early stage of our cultural development, dust, chalk, or powders were probably rubbed into skins, bark, and other substances for symbolic or decorative purposes. In the dry-media techniques, the material and the tools are often one and the same. Our most distant ancestors discovered the efficacy of lumps of natural chalks, dried clay, coal, ocher, and charcoal for marking and delineating. As more sophistication was gained, the manufacture of dry media and the techniques of applying them became more refined. Chalks and charcoal were shaped in various forms for specialized uses. As ground pigments were developed, the range of drawing media expanded. A by-product of the discovery in antiquity of encaustic—paint made by mixing pigment with hot wax—was the wax crayon. Powdered pigments bound by various glues or oils and pressed into sticks resulted in colored drawing materials such as pastels and conté crayons.

Pastel is simply a fine powder pigment held together by a mild, nonwaxy binding agent such as animal-skin glue or resin. Oil pastels and oil sticks are made by using oil as part of the formula so that the stick will hold its form and the pigment will adhere to the surface to be drawn upon. Carbon, lampblack, or other pigments are mixed with oil or wax to make conté, or lithographic, crayon. All of these were inventions of the eighteenth century and remain in wide use today.

Metal is another form of dry medium. That metal could be used to draw on certain coarse grounds was probably dis-

covered in the Middle Ages. Metalpoint, like all dry media, depends on the abrasion of the drawing surface, which allows tiny fragments of the drawing material to stick to it. Almost any metal can be used, provided the supporting ground is suitably coarse. A nail, for example, can be used to draw on glass-paper or emory board. Usually, however, soft metals such as gold, silver, copper, and lead are employed in metalpoint drawings. They are generally used in the form of wire segments, sharpened and placed in a holder, which produces an instrument rather like a modern drafting pencil. In the nineteenth century extruded cylinders of lead—later, lead and graphite alloys—were encased in wooden dowels, thus creating the common pencil as we know it. This type of metal point is probably the most popular form of drafting instrument.

The wet media are, essentially, paint and ink. Paint consists of ground pigment suspended in a liquid base. Again, its ancestry can be traced to the primitive use of mud and clay for decorative and symbolic ends. The simplest yet least durable form of paint is a mixture of pigment and water. Like whitewash or watercolor, this can be smeared or brushed onto a surface. When the water evaporates, a thin layer of powdery pigment remains. This can be easily brushed away. If, however, as our primitive ancestors discovered, the mixture is placed on a porous surface, such as the damp limestone wall of a cave, capillary attraction will absorb the pigment into the stone, forming a more durable bond. This produced a primitive form of pseudofresco.

True fresco is mostly used for wall decoration. In this technique a coating of mud, clay, or plaster is spread over the wall itself. While the coating is still damp, the outlines of the design to be created are drawn or incised on the surface and then paint is applied. The paint is absorbed into the damp ground and dries with it. Though probably invented earlier, by 4000 B.C., wall frescoes on mud ground were certainly being made by the Egyptians.

In the Minoan and other pre-Attic Mediterranean civilizations, frescoes were created by drawing and painting on wet lime plaster, which was more durable than mud or clay. This method came to be called *buon fresco* during the Renaissance. Other variations on the fresco technique are the Pompeiian secco method and fresco secco.

The Pompeiians covered masonry with mortar, sand, and marble dust, then covered this with a layer of tinted plaster. Designs were drawn or incised, then paint was applied, which was worked into the surface with a hot iron. Fresco secco is a process of painting on set plaster. The plaster is soaked with slaked lime and the pigments are diluted in lime water to ensure their fusion to the wall. This method, developed in the thirteenth century, was the technique used by Giotto. Finally, secco is the procedure of painting onto either moist or dry plaster with true paints such as casein or tempera.

True paint is composed of pigment, an adhesive agent, and a dilutant liquid. When dry, the adhesive binds the pigment to any appropriate surface. Blood or honey was used as a binding agent in the most primitive true paints. Later, such substances as animal glues, vegetable gums, resins, wax, milk, egg, oils, and lacquers were combined with colored pigments to produce different kinds of paint.

Paints are usually identified by either their binders or their dilutants. The earliest paints were those diluted with water, and, generically, they are called watercolors. The most common of these still used for drawing are watercolor, casein, tempera, and gouache. Watercolor is made by combining pigment with either mild glues or vegetable gum. Casein is bound by extracts of milk. The adhesive for tempera is either egg yolk or whole egg. For gouache, color is combined with an opaque white pigment, and gum arabic is the binder.

The most popular artists' paints are those bound with oil and diluted with turpentine. Oil paints were developed in the fifteenth century and have been used continuously ever since. Though normally considered a painting rather than a drawing medium, these durable, versatile, and flexible paints may be used for either purpose.

In recent years scientific discoveries in the field of petrochemicals have provided new binding media such as acrylics, vinyls, copolymers, and alkyds. These tend to be quick-drying and permanent, and like oils, they may be used on many kinds of supports for either drawing or painting.

Ink was probably invented simultaneously in China and in Egypt about 2500 B.C. These early inks were made of carbon with gum or glue binders and were similar to modern India inks and tusche. Other inks are made by various processes and combinations based on the chemical effects of acids, water, and oxidation on metal pigments.

The tools used to apply the wet media are as ancient as the media themselves. Modern paintbrushes have their origins in the feathers and tufted animal tails used in prehistory. Modern palette knives and scrapers derive their lineage from similar tools made of bone and wood ten millennia or more ago. The prototypes of today's drawing pens are quills, reeds, and bamboo shoots—indeed these tools are still employed by many contemporary artists. Even the evolution of such modern devices as airbrushes and spray guns can be traced back through atomizers and bellows pipes to the reed or bone blowpipes used to decorate Paleolithic caves.

The evolution of the tools, materials, and techniques of art relies heavily on tradition. As in style itself, technical innovation comes from roots deeply embedded in human collective experience.

Supports

Equally as important as the media and the tools used to make a work of art is the material that supports its form. There can be no line in the sand without the sand. Whether the support is a stone to be carved or a piece of paper to be drawn upon, the artist must be sensitive to its special properties and employ a compatible technique.

Drawing supports, like those of painting, are many, but essentially they fall into two categories: those that are rigid and those that are flexible. All drawing and painting supports are virtually interchangeable. Incisions and chalk or painted designs executed in planning a wall painting are compositional drawings on a rigid support, as are planning marks on a stone to be sculpted or designs for easel paintings made on panels of wood.

Flexible supports may be made of canvas or other cloth, and though usually considered to be supports for painting, they are equally suited for drawing in either wet or dry media. Cloth is considered to be flexible even when it is stretched on a wooden frame.

Drawings made to sketch in the underlying composition of a painting or to outline the forms of a sculpture disappear unless the final product remains unfinished. Most often we think of drawing as a disposition of lines on a thin, flexible support, usually paper. Since the Renaissance, this has been, essentially, the correct perception of what a drawing is. However, other thin, flat, flexible supports were used for drawing long before the invention of paper, and they are still in use. Animal skins were no doubt drawn and painted upon in prehistory. During the Middle Ages, this use evolved into the making of vellum and parchment as supports for illuminated manuscripts. Completely new materials are just beginning to be exploited for drawing purposes. The contemporary Photo Realist artist Don Eddy has used sheets of clear Mylar for his drawings to facilitate their conversion to photolithographs.

Though the materials mentioned above are all suitable, by far the most common support for drawings during the last five hundred years has been paper. The Egyptians hammered the fibrous roots of the papyrus plant into thin sheets, which were used as pages or scrolls. The papyrus sheet continued to be used for writing and drawing in Mediterranean civilizations and in Europe until the Middle Ages. Plants, particularly rice, also supplied the fibrous materials for paper in ancient China and Japan. Various Oceanian peoples have long used the bark of the paper mulberry and other plants as raw material for the manufacture of tapa cloth. Modern newsprint is made from wood pulp.

Paper, as we commonly know it, is made from the fiber of cloth, from wood pulp, or from a combination of the two. The fibers are boiled, shredded, and pounded into a liquid pulp, which is combined with any one of a number of binding materials. A smooth, thin layer of the mixture is poured over a wire screen. The water drains off, and the pulp dries and fuses into a sheet of paper. There are many recipes for paper, and there are a variety of ways in which different strengths, thicknesses, and textures may be achieved. The most durable and light-resistant papers are those with the highest cloth-fiber content. The least expensive and those most subject to disintegration and discoloration, such as newsprint, are made almost entirely of wood pulp.

Cloth-fiber papers came into use in Europe in the thirteenth century. Following the invention of the printing press in the fifteenth century, the demand for paper increased and paper-making technology developed rapidly. The availability and relatively low cost of paper liberated drawing from its subordinate role as a preliminary stage in the development of some other product. Drawings thus became the foundation of the visual arts. The use of paper also greatly reinforced the development of Renaissance realism and idealism in art.

Sheets of paper could be used to practice one's skills, to refine one's eye and touch, or to experiment with images and ideas. Paper also allowed convenient storage of these images for future reference.

It is possible to speak of drawing as an art form in itself. However, the profound linkage of drawing to all other forms of visual expression gives it its special place in the history of art. Both in individual artists and in cultural history, drawing leads the way to style.

Representation: Egypt and Greece

The notion of using background spatial illusionism in depicting the world was slow to develop in man's art. The convention of separating figure from ground by a contour is the oldest and simplest form of differentiating a subject from its support. This also seems to be one of the most profound impulses in visual logic, as it gives emphatic significance to the subject represented. It is certainly evident in the deer and the rectangle at Lascaux, and this means of depiction survived as the main, indeed almost only, means of differentiation in two-dimensional compositional convention for the first thirty thousand years of art history.

Another organizational device implied in the cave paintings and conventionalized by ensuing cultures was the concept of a baseline. In the main chamber of Lascaux, the animals are placed as if running along a line formed by the geological striations of the cave wall. This convention continued to be used throughout the Neolithic period, and along with geometry, it became fundamental to the art of early civilizations, particularly that of Egypt.

Egyptian civilization endured longer than that of any other in the ancient world. The Egyptians developed a rich written language, well-organized political structures, and sophisticated and magnificent forms of art and architecture that have influenced culture for the past six thousand years. Their art was essentially conservative. Most of their aesthetic conventions were established very early in their cultural history and were elaborated throughout the more than forty centuries of the dynasties and kingdoms. Geometry governed their ideals of proportion and pictorial organization, yet representational imagery was the source of both their depictions and their written language. By about 2500 B.C., the Egyptians be-

came more interested in the phenomenological world, and they began to attempt more realistic renditions, not only of figures but also of the space in which the figures are depicted. Figure/ground relationships became more complex with the introduction of overlapping forms that refer not only to the close interaction of the subjects depicted but also to the spatial relationship existing between them, as in *Feeding the Oryxes* (fig. 2). Interest in depicting geometrically composed

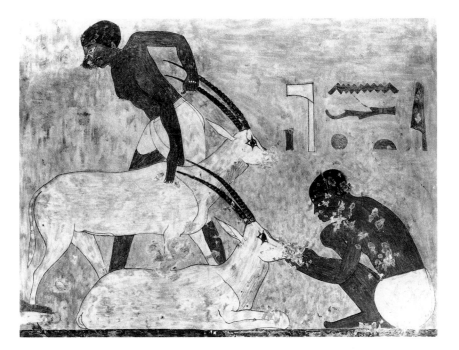

Figure 2. *Feeding the Oryxes.* c. 1920 B.C. Tomb of Khnum-hotep, Beni Hasan

images and an increased desire to portray subjects with empirically observed naturalism reached their apogee in Egypt in the fourteenth century B.C.

During the late second and the first millennia B.C., the trend toward the relatively realistic treatment of objects and creatures in spatial contexts evolved in Egypt as well as in a number of emerging Mediterranean civilizations. In none, however, was this development more important to the evolution of Western art history or the study of realism than in Greece. Naturalism began to emerge in ancient Greece

about 800 B.C. and was fully developed by about 400 B.C. Greek pictorial art, like the art of most Late Stone Age cultures and that of the ancient world, started with abstraction and became increasingly involved with analytic representations of the nominal world. The earliest known artifacts show no representational images, and the decorations on such things as pottery consist of abstract geometric patterns. Greek figurative style emerged in sequential but confluent phases, and it becomes increasingly realistic.

The Geometric style of the eighth century B.C. is similar to that of the Egyptians. In vase paintings, figures are schematic, geometric, and they are organized along baselines as silhouettes against a simple ground. In the seventh century the Orientalizing style appears. It represents the Greeks' adaptations of the styles of the Mediterranean civilizations with whom they had established active trade. This style is characterized by curvilinear, animated, and realistic representations in complex figure/ground relationships. The Archaic period, from approximately the late seventh century to the early fifth century B.C., was a time of synthesis. Both artifacts and literary evidence suggest that this period was the high point of vase painting—drawing with incised line and paintbrush. Figure and ground were differentiated by flat, silhouetted shapes of a single color. The Archaic Greeks elaborated the concept of overlapping and added foreshortening and linear projection—precursors of perspective—to the repertoire of two-dimensional spatial illusion. In sculpture, the Archaic Greeks freed their figurative forms from the shape of the stone block, something rarely seen before either in prehistory or in the ancient world.

The Classical phase of Greek painting and sculpture occurred between the early fifth century and the late fourth century B.C. The contributions of this period, regarded as the high point of Greek art, were simultaneously both realistic and abstract. The Classical artists gained fluency in the technical expression of musculature. They also learned more sophisticated ways of creating convincing illusions of unified perceptual space in painting and in drawing. They maintained the old conventions of composition such as baseline and overlapping, to which they added an understanding of perceptual scale—a realization that things of similar actual size appear smaller as they assume relatively greater distance from the viewer.

The art of Classical Greece was characterized by an admiration for the beauties of nature, particularly the beauty of the human form. This admiration was not expressed by simply copying nature but rather by improving upon it—by conceptualizing an ideal of beauty. This idealization was based not only on the selection and combination of aspects of the most admirable examples of human and other natural forms but also on a respect for the abstract elements of logic, harmony, and order inherent in Euclidean and Pythagorean laws of geometry, symmetry, and proportion.

If the Classical Greeks' representational arts tended to be very near the realistic end of the scale, their architecture and their mathematics depended very much on pure abstraction. The simultaneous interaction of these extremes of realism and abstraction held them in harmonious balance. It is probably just this balance that has given Classicism its long-lived influence in Western culture.

The art of the Hellenistic period—which began in the late fourth century B.C.—was co-opted by the Etruscans, and later, along with works of Archaic and Classical art, it was avidly collected and copied by the Romans. Indeed, most of what we know of this period—and much of what is preserved of Greek Classical art—comes to us via Rome. What may be said generally of Hellenistic art is that it showed a tendency to be more concerned with verisimilitude in representation and less concerned with balance and order than the art of the Classical period.

We know from literary sources that Greek artists were interested in the verisimilitude of their representations and in the formal means by which they were executed. Socrates maintained that simple geometric shapes and forms were more perfect and more honest than realistically rendered subjects because they represent only what they are. There is no attempt to trick the beholder into believing he sees something that is not there. Certainly the echoes of Socrates' ideas on the purity of geometric form have reverberated loudly in the philosophy of art criticism in our own century. In 1968 the Museum of Modern Art in New York produced an exhibit called *Art of the Real*. This showed not representations of things and people but Platonically simple objects of Minimalist art. Essentially, its organizer, E. C. Goossen, was reinterpreting Socrates in asserting the beauty of the concrete reality and purity of such abstract forms.

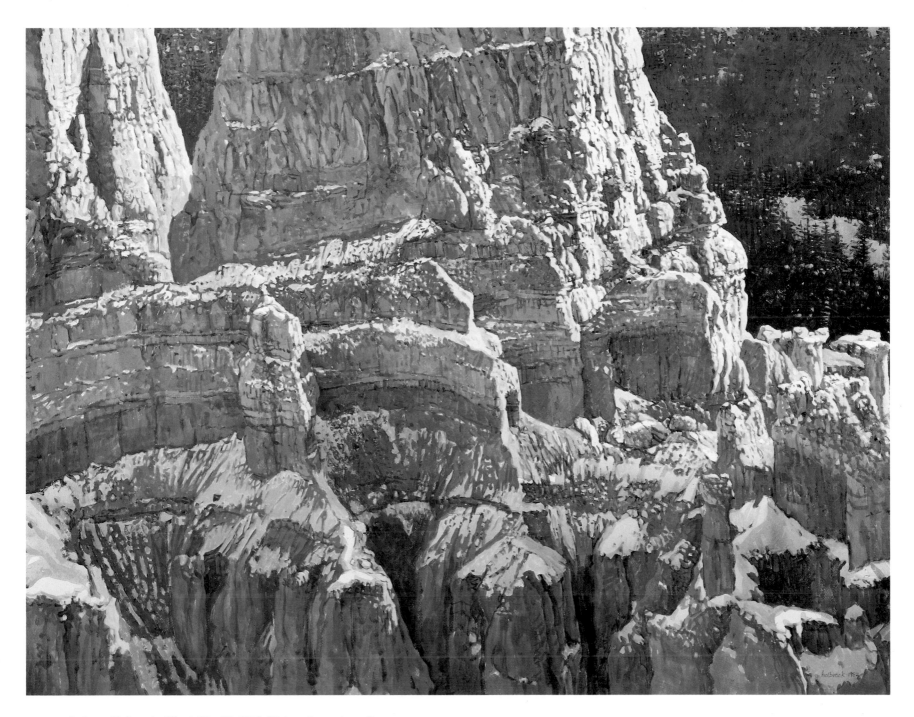

5. Peter Holbrook. *Silent City III*. 1983. Watercolor and acrylic on paper,
29½ × 38⅜″ (sight) (74.9 × 97.5)

6. Catherine Murphy. *Nature Preserve*. 1983.
Graphite on paper, 11 × 13⅝″ (27.9 × 34.6)

7. Daniel Dallman. *Landscape with Dogwoods*.
1980. Graphite on paper, 15¾ × 22½″ (sight)
(40.0 × 57.2)

8. James Valerio. *California Landscape.* 1984. Graphite on paper,
29⅝ × 41½″ (75.3 × 105.4)

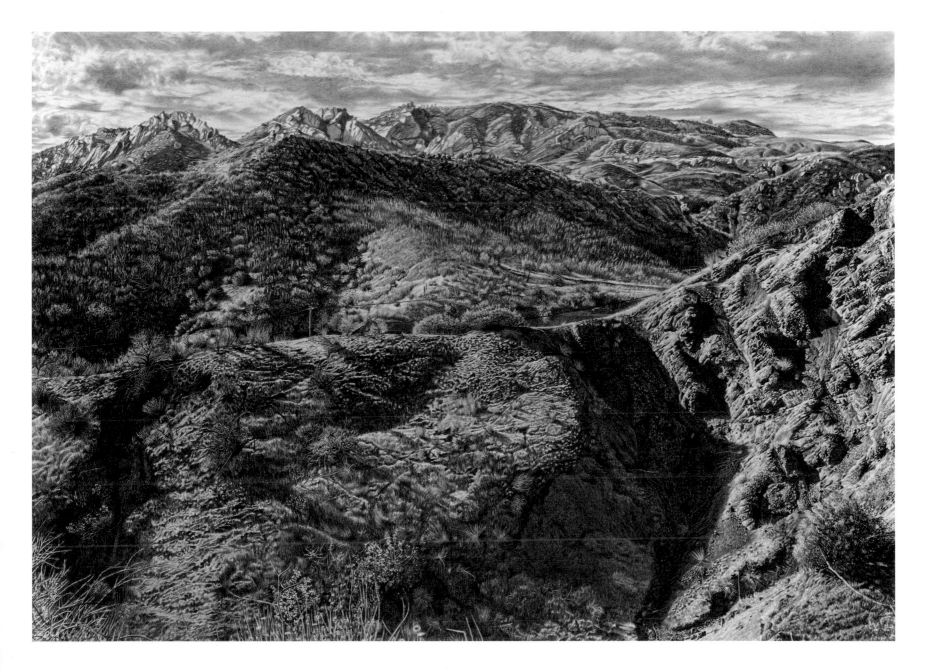

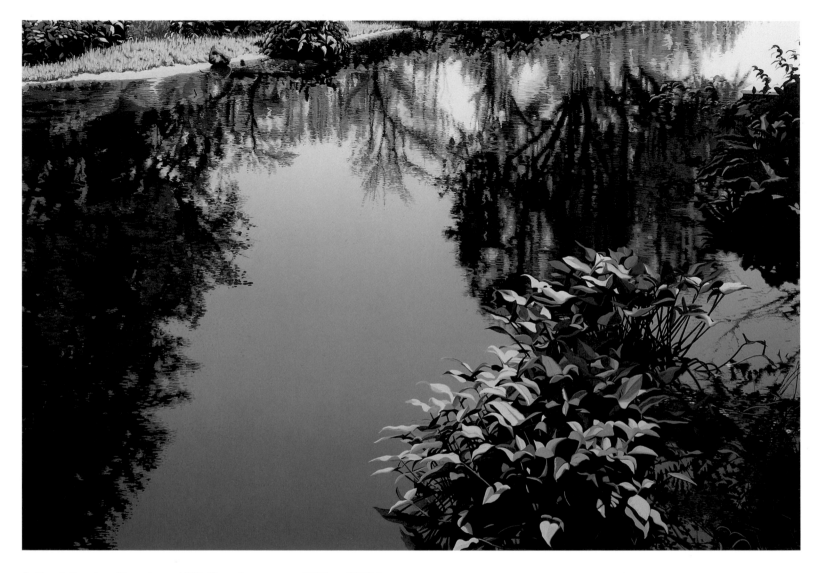

9. Sarah Supplee. *Shawsheen.* 1982. Gouache on paper, 22¹⁵⁄₁₆ × 33¹¹⁄₁₆″
(sight) (58.3 × 85.6)

10. Nell Blaine. *Cloud Opening*. 1981. Watercolor and pastel on paper, 17⅛ × 23⅛″ (sight) (43.5 × 58.7)

below: 11. Susan Shatter. *Channel to the Sea*. 1982. Watercolor on paper, 40¾ × 77½″ (103.4 × 196.9)

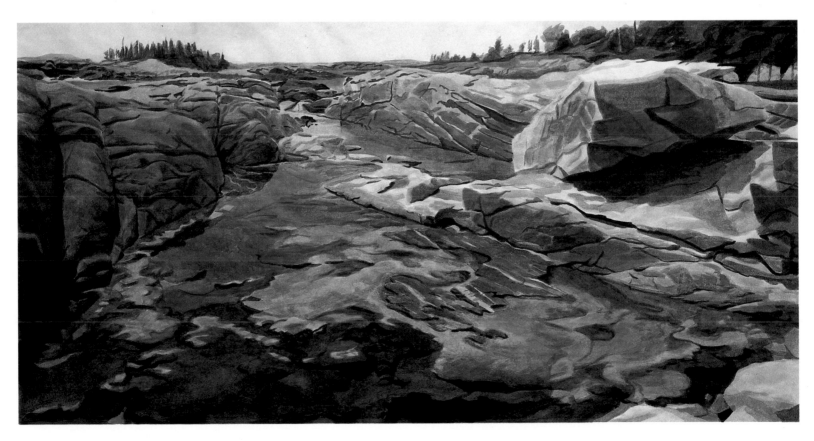

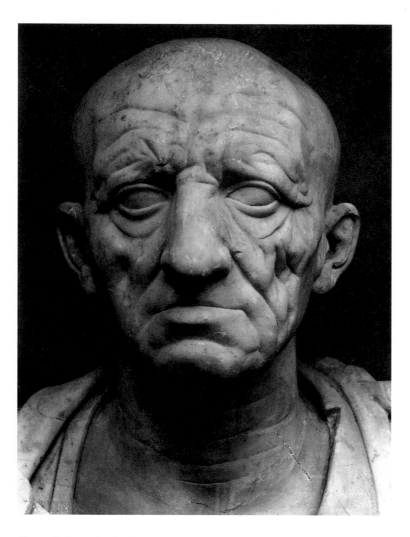

Figure 3. *Portrait of a Roman.* c. 80 B.C. Marble, life-size. Palazzo Torlonia, Rome

Roman Realism

The Romans further elaborated on the achievements of Greek art. Stylistically, however, with the exception of their portraiture, particularly in sculpture, they added little to the concepts of the Greeks. In sculpture the Romans pushed mimetic faithfulness to objective reality to the extreme. In *Portrait of a Roman* (fig. 3), the artist makes an almost topological recording of the subject, unedited and unidealized. Unlike the psycho-dramatic expressions of Hellenistic faces, the character and dignity of the sitter are conveyed by

the sheer mass of factual information painstakingly rendered by the sculptor. This matter-of-fact reportage of the physiognomy of the sitter is not much different—except in technique and in the social class of the sitter—from the body-cast sculptural creations by such contemporary Superrealist artists as Duane Hanson.

From examples of their painting and drawing, it is evident that the Romans continued to develop the Greeks' discoveries of the means of creating illusions of three-dimensional space. They were masters of foreshortening, and they devised sophisticated schemes of atmospheric and linear perspective. Atmospheric perspective is a means by which spatial illusions are created by treating foreground elements with relatively more clarity of delineation and more intensity of tonal contrast and color than those of the middle distance and background. This is made to coincide with relative diminution of scale. One reads the implied space as if those things that are relatively large and clearly defined are perceived to be nearer the observer than those that appear smaller and less distinct in the composition.

Linear perspective is based on the geometric rules of orthogonal projection and is most clearly observed in representations of architectural settings. This form of perspective takes into account the optical perception that horizontal parallel edges of the sides of regular geometric solids such as cubes, when seen in three-dimensional space, will appear to converge in such a way that the most distant visible vertical edge is smaller than the nearest. The Romans discovered the basic rules of this application of solid geometry, which was seized upon during the Renaissance and greatly elaborated upon since, becoming a fundamental tool of realism.

In their art, the Greeks and the Romans synthesized those elements of pictorial organization, decoration, representation, and narration that are implied in Egyptian art and that had been applied on an ad hoc basis at different times and locations as part of the human collective unconscious for the previous thirty thousand years. To these they added an ability to express their observations of the natural world with a theretofore unknown descriptive accuracy. They were able as never before in human history to observe empirically and to describe the phenomena of the natural world and at the same time to extend these observations into universal abstractions through mathematical and philosophical reason-

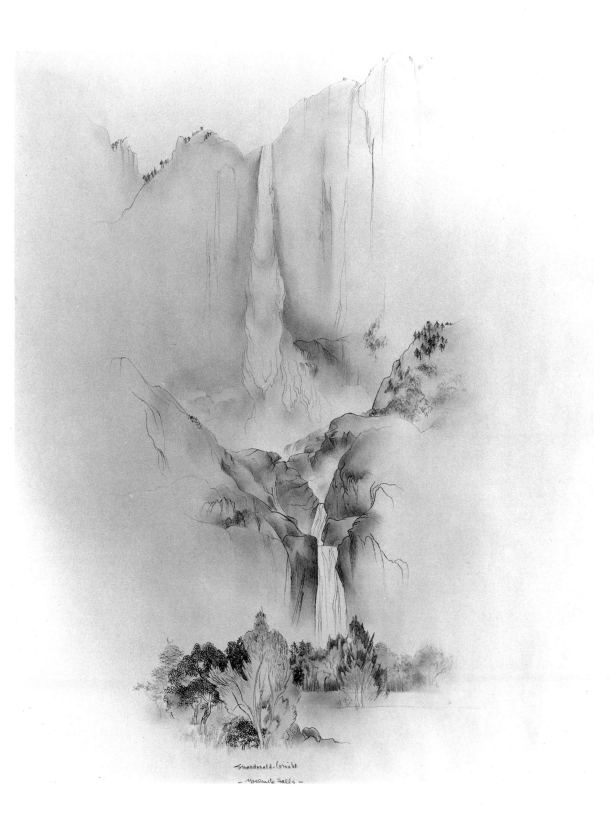

Gmacdonald-Gright

– Yosemite Falls –

12. Stanton Macdonald-Wright.
Yosemite Falls. 1937. Graphite
on paper, 27¹¹⁄₁₆ × 22³⁄₁₆″
(sight) (70.3 × 56.4)

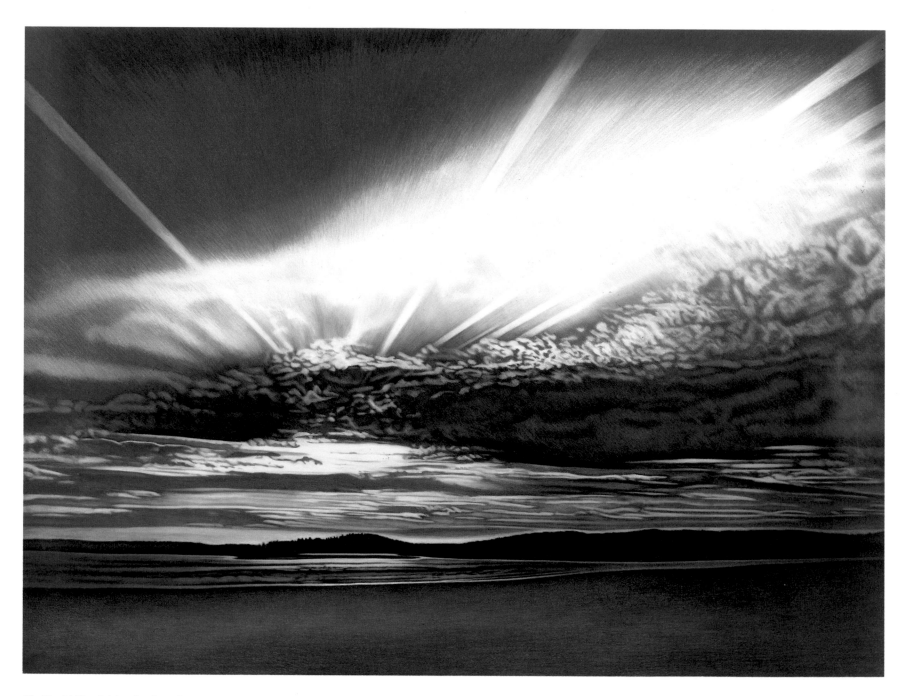

13. David Hendricks. *Popham Beach Sunset*. 1984. Colored pencil on
paper, 53⅛ × 72″ (134.9 × 182.9)

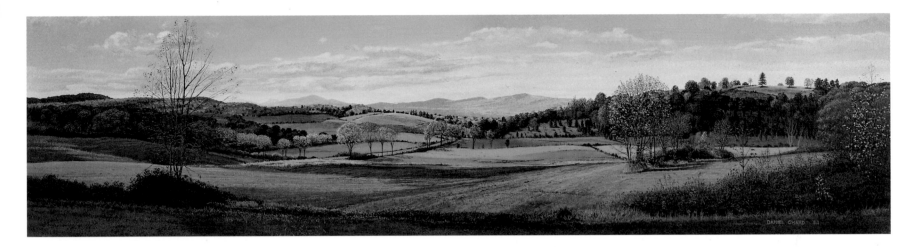

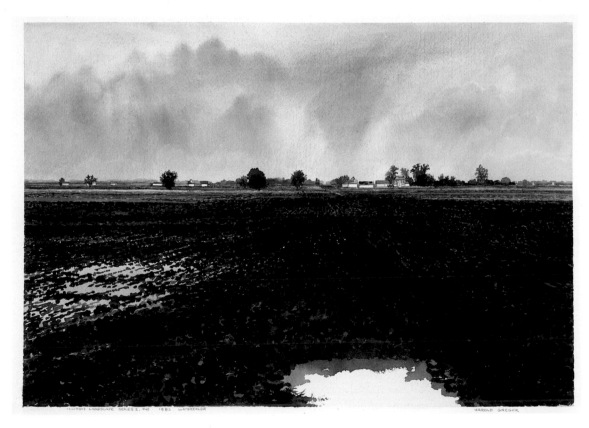

14. Daniel Chard. *Champlain Valley*. 1983.
Acrylic on paper, 5¼ × 20½″ (sight)
(13.3 × 52.1)

left: 15. Harold Gregor. *Illinois Landscape
Series II No. 41*. 1982. Watercolor on paper,
20⅝ × 28¾″ (sight) (52.4 × 73.0)

ing. This led to systems of placing elements within perceptual spatial context, which formed the basis for illusionistic realism as we know it.

Classical Greek and Roman representational art focused mostly on the realistic end of the scale of visual choices, but it should be recalled that the opposite end was also admired. During the first century A.D., a sophisticated Roman was capable of appreciating a realistic contemporary portrait sculpture, an illusionistic wall painting, or any number of antique examples from all periods of Greek art. In terms of its realism, Classical art began with the inquiring eyes of the artists of the late Archaic period and ended with the matter-of-fact empiricism of Roman portraiture.

The Medieval Period of Abstraction

For approximately a thousand years following the Christianization of the Roman Empire by Constantine in A.D. 323, realism ceased to be the focus of artistic interest. Cultural conditions changed, and the realistic imagery of the Classical era gradually became less and less important in a changing world.

Christianity—unlike the religions of Greece and Rome, with their anthropomorphic gods—is most abstract. It requires enormous, mystic leaps of faith to comprehend its single omniscient, omnipotent, and omnipresent God, whose only human corporeality is embodied in his sacrificed son. Not only did it demand that people divest themselves of their belief in the more comprehensible multiple gods of the past, but it brought with it the Judaic proscription against image worship. Thus the process of conversion entailed a good deal of iconoclasm. At the same time, communication and symbolism were required to unify, under Christ, extremely heterogeneous, polyglot, and largely illiterate populations. Clearly, Classical naturalism, with its overtones of idolatry and paganism, could not be countenanced. Thus, an art was required that was both representational and symbolic without violating dogma.

Early Christian and medieval art forms emerged to fit these needs. In the two-dimensional media—drawing, painting, mosaic, weaving, and embroidery—representations are symbolic and heraldic rather than naturalistic. Narratives are clear and didactic and take place generally in simple figure/ ground organizations with relatively little regard to three-dimensional illusionism.

Sculptural images have similar characteristics. They tend to be austere. Low relief is preferred, and freestanding forms are most often close to the block, frontal, and placed in an architectural setting.

By the twelfth century, the Church had established itself as the unifying spiritual authority, and its temporal power had reached its peak. In northern France a new style of religious architecture emerged. It seemed aptly suited to symbolize the Catholic Church Triumphant. In the next four hundred years this style, the Gothic, spread throughout Europe and, through the Crusaders, to the Middle East.

Gothic Realism and the Renaissance

The Gothic mind brought into being the first broad-based and international stylistic consensus in architecture, sculpture, drawing, and painting since Classical antiquity. Indeed, it is during this period that a conscious and conscientious interest in Classical art, science, and literature reemerged, setting the stage for the Renaissance. It is also during this epoch that an interest in empirical observation and description of forms and space reemerged in European art, once again moving the focus of attention in the representational arts toward the realistic end of the aesthetic spectrum. By the early thirteenth century, one sees in sculpture, throughout Europe, more open forms and a well-understood and articulated anatomical naturalism. Painting followed suit in the fourteenth century, when increased attention was paid to tonal modeling and there were tentative attempts at spatial illusionism.

In Italy, international Gothic elegance in both painting and sculpture was increasingly modified by the growing interest in and understanding of ancient Classical examples. In the visual arts, the notions of analysis and empiricism implied by humanist ideas caused artists to examine their world with a searching intensity more acute even than that of their Classical predecessors.

In the fourteenth and early fifteenth centuries, humanist influence in northern France and the Netherlands impelled the Northern Gothic international style in painting and drawing along a realistic, but somewhat different, path from that of Italy. Lacking readily available examples from

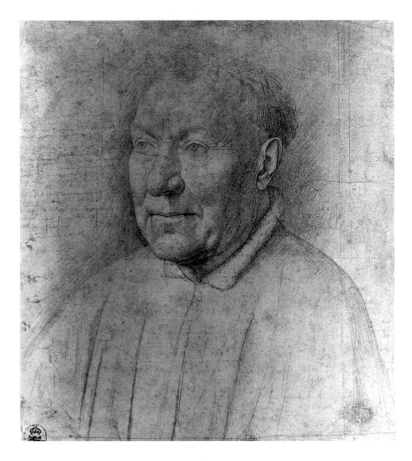

Figure 4. Jan van Eyck. *Cardinal Niccolò Albergati.* c. 1431. Silverpoint, 8⅜ × 7⅛". Kupferstichkabinett, Staatliche Kunstsammlungen, Dresden

grate figures, landscape, and architecture—both interior and exterior—into a comprehensive and rational illusionistic whole.

A further technical innovation of the Northern Late Gothic or Early Renaissance was oil painting. This medium allowed a translucent luster and smooth finish that further served these artists' love of detail.

By the mid-1400s, in both religious and secular subjects, the realistic impulse in Northern painting and drawing reached its high point. Jan van Eyck, for example, in his drawing *Cardinal Niccolò Albergati* (fig. 4), attains a degree of unvarnished factual verisimilitude not seen in Western art since Roman antiquity.

Whether one looks on Van Eyck and his contemporaries as the last artists of the Gothic era or the first of the Northern Renaissance is largely unimportant. By dint of penetrating observation and painstaking skill in both draftsmanship and painting, they reestablished the methods and the standards with which to take the measure of, to describe, and to interpret the apparent reality of their own mid-fifteenth-century world.

At about the same time in Florence, one of the most remarkable circles of artists and thinkers ever to be found in one small place at one time had reached similar ends through different means. By the 1440s, Filippo Brunelleschi and Leon Battista Alberti had, through their studies of antique texts and their observations of natural phenomena, not only developed but also published a theory of perspective based on principles of geometry and optics. This theory of "vanishing-point perspective" provided the means by which rational, systematic illusions of space in a unified field of vision could produce the appearance of a window on the world. They and their artist associates, Piero della Francesca, Paolo Uccello, Masaccio, Donatello, Fra Angelico, Fra Filippo Lippi, and others, experimented with perspective theory in relation to realism—idealized through their comprehension of Classicism—to lay the groundwork for a new stylistic consensus.

By the end of the fifteenth century, the pioneering work of the early Florentine Renaissance masters had matured, and it influenced the whole of Italy. In the art of the High Renaissance, roughly the years 1490–1526, we see the culmination of the pioneering efforts of the Early Renaissance Florentines. That art produced the essential theory and

Classical antiquity and being racially and linguistically further removed from the roots of Classicism than their Italian counterparts, northern artists turned their inquiring eyes directly to nature for understanding.

In Italy, large-scale wall paintings were often commissioned, but in northern Europe in the fifteenth century, the most widely patronized works were illustrated books and manuscripts or relatively intimate panels serving as altarpieces or retables. Working on this small scale and in great detail gave the Burgundian and Netherlandish artists a meticulously trained hand and eye. When these were employed in the analysis of the facts and phenomena of the world, the result was an intuitive but extremely accurate ability to inte-

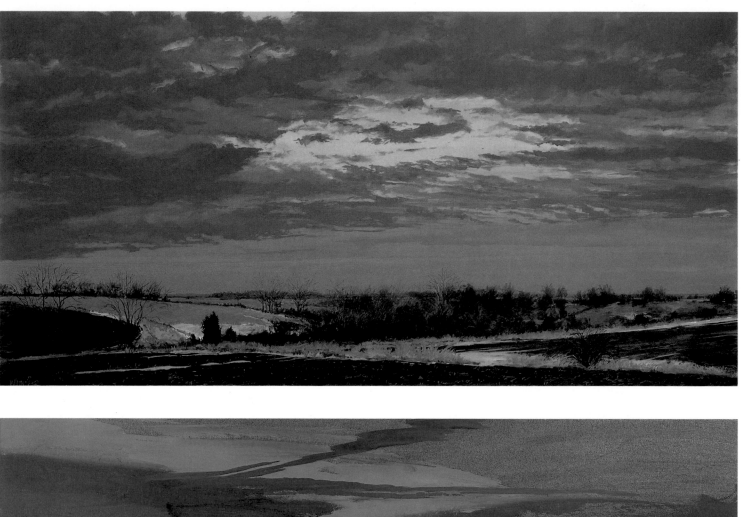

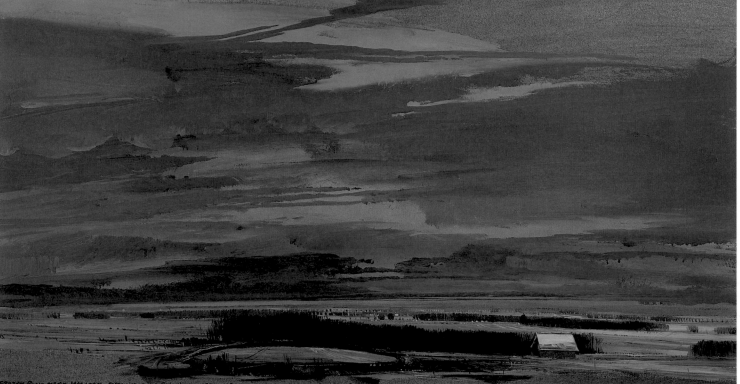

FROZEN POND NEAR WALTON - EVENING OF THE FEBRUARY 1981 - 4° MELTING SNOW. SOUNDS OF A CABIN SON & WOOD CUTTING TO THE SOUTHWEST - HOT COCO FROM A THERMOS. N. JACOBSHAGEN

opposite above: 16. James Winn.
Dusk, Late November. 1982. Acrylic
on paper, 14 9/16 × 27 5/16″
(sight) (37.0 × 69.4)

opposite below: 17. Keith Jacobsha-
gen. *Frozen Pond near Walton.* 1983.
Oil on paper, 9 7/8 × 17 7/8″ (sight)
(25.0 × 45.4)

right: 18. Barbara Cushing.
Bridgewater Sunset, November 9th.
1983. Oil on paper,
26 1/4 × 37 3/16″ (sight)
(66.6 × 94.5)

below right: 19. John Button. *La Ca-
margue Afternoon.* 1970. Gouache
on paper, 9 × 12 1/8″ (22.9 × 30.8)

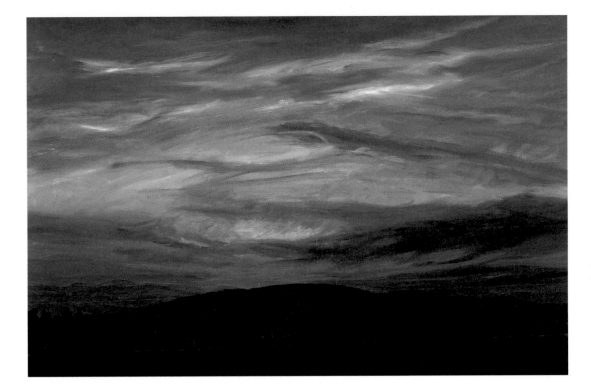

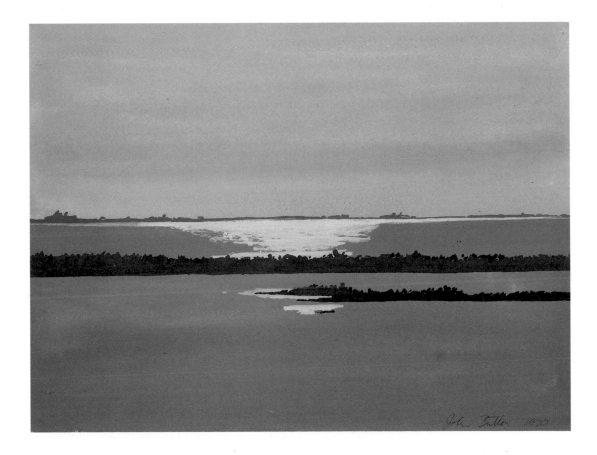

set the standards of an aesthetic and intellectual consensus that was to dominate Western art for the next four hundred years and that, to a degree, continues to have influence today.

In the High Renaissance realism was carefully balanced by theoretical and Classical ideals. The achievements of its greatest masters, Leonardo da Vinci, Albrecht Dürer, Michelangelo, Raphael, Titian, and Giorgione, essentially established the course and set the standards for artistic endeavor from the early fifteenth to the mid-nineteenth century.

Inherent in the Renaissance ideal was the notion that each past achievement must be excelled. How did one improve on the "divine" Michelangelo? The artists of the period from the 1530s to the 1590s resolved that the most important sources of development were to be found in theory and in style. They chose to emphasize notions of beauty and indi-

vidual expression at the expense of realism to create what they called the *bella maniera*, or beautiful style, which has given them the name Mannerists. This style moved the course of later Renaissance art somewhat in the direction of abstraction. Elegant figural distortions, attenuations, and exaggerated gestures were combined with unnatural colors and implausible perspectives to produce a style of refinement and sensuality.

Toward the end of the sixteenth century there was an artistic shift away from the sensuous and arcane excesses of Mannerism toward a more realistic and didactic art. This anti-Mannerist realistic period in Italy served as the springboard to a new international stylistic variant fundamentally but very differently based again on Renaissance principles. This style, which has come to be called the Baroque, dominated the seventeenth century.

The most notable figures in the origination of this style

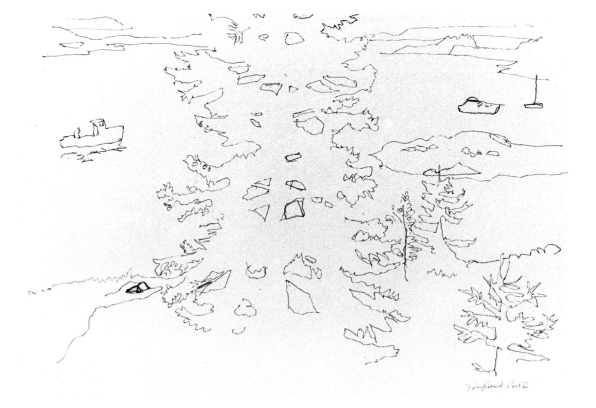

20. Fairfield Porter. *Bay through the Trees.* 1965. Ink on paper, 9½ × 13 11/16" (sight) (24.1 × 34.8)

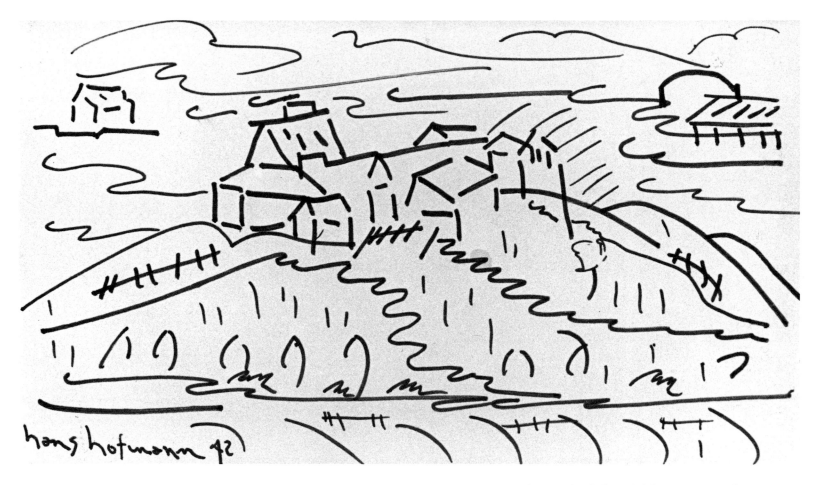

21. Hans Hofmann. Untitled. 1942. Ink on paper, 4 × 7″ (10.2 × 17.8)

are Annibale Carracci and Michelangelo da Caravaggio. Both started from a realist premise in both subject matter and execution. Hitherto, representations of genre scenes—ordinary, unidealized people engaged in the commonplace acts of normal existence—had been primarily the province of the Netherlandish painters. These artists and their subject matter had been deemed unworthy by Italian artists of the High Renaissance because they "merely" represented mundane events and circumstances and employed no ideation or idealization.

Caravaggio's tempestuous nature and short life served to preclude his stylistic influence from taking deep root in his own lifetime. One of the most original artists of all time, he strove to combine the realism of an acutely perceptive nature

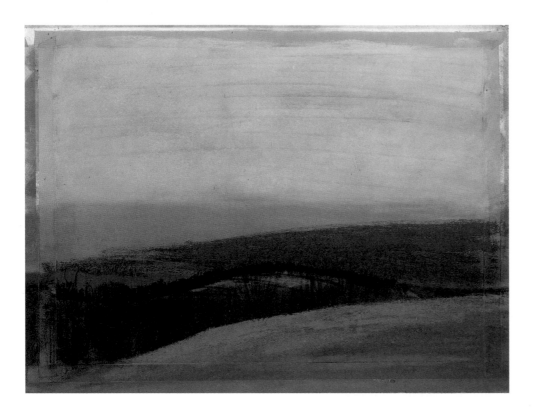

22. Sylvia Plimack Mangold. *Untitled.* 1983. Pastel on paper, 22⅜ × 30″ (56.8 × 76.2)

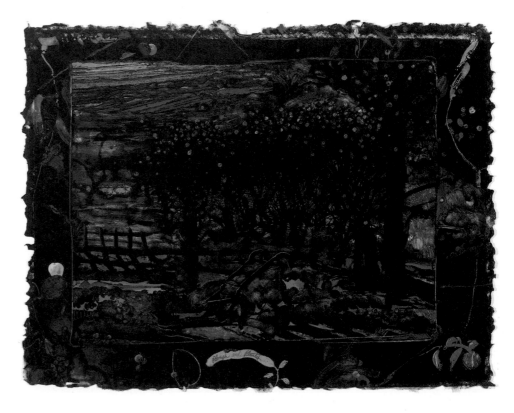

23. James McGarrell. *Plough and Plenty.* 1982. Gouache on paper, 23¹⁵⁄₁₆ × 31⅝″ (60.8 × 80.3)

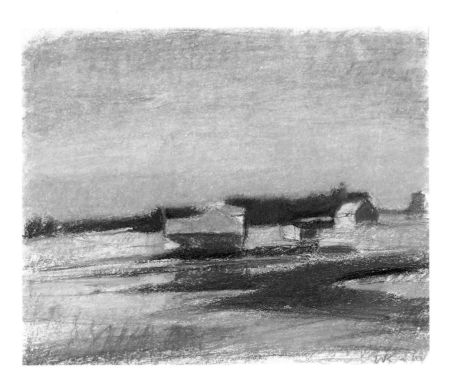

24. Wolf Kahn. *Deer Isle, North West Harbor*. 1967.
Pastel on paper, 13½ × 16⁵⁄₁₆″ (sight)
(34.3 × 41.4)

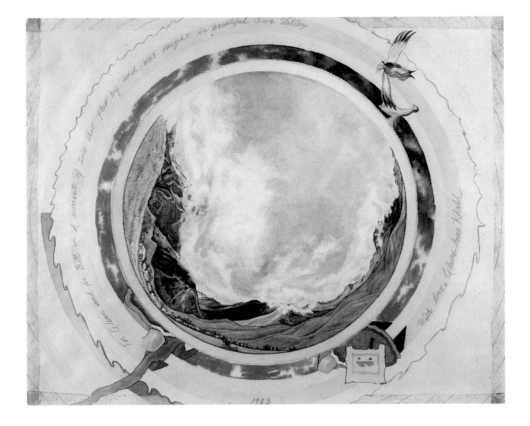

25. Claire Khalil. *View of Sun Valley*. 1983. Water-
color on paper, 9 × 11″ (22.9 × 27.9)

with a unifying and dramatic scheme of space, light, and movement. In his religious works Caravaggio attempted to create populist images that would bring biblical episodes to life for the common viewer, using a cast of characters with whom the public could easily and immediately identify. Ironically, the very audience his art was intended for rejected it. The general public thought his work too mundane and unseemly. He was, however, deeply admired by a small group of knowledgeable collectors and artists. Among these were a number of foreigners, and it is through them that Caravaggio's direct influence was transmitted, not so much in Italy as in the Netherlands, France, and Spain.

In Spain, Sánchez Cotán, Francisco de Zurbarán, and Diego Velázquez all adopted a naturalistic style based on closely observed specific forms interacting with high tonal contrasts to create the illusion of enveloping space. In France the realist strain of Baroque art is most strongly seen in the art of Georges de La Tour and the brothers Le Nain. Louis Le Nain's genre paintings of humble yet dignified people and de La Tour's Caravaggesque low-life scenes are in marked contrast to the cool Classicism of their contemporaries Nicolas Poussin and Claude Lorrain or to the grandeur of such monumentally Baroque structures as the Palace of Versailles. In Holland more than any other nation the seeds of Caravaggio's naturalism found fertile ground. The Dutch nation prospered through the growth of a dynamic and industrious middle class. It was from this body of self-made merchants, traders, farmers, tradesmen, and mariners that the republic's art patronage came. The Netherlandish tradition of realistic painting that reached back through Pieter Aertsen to Hugo van der Goes and Van Eyck, along with the practical taste of the new patrons, stimulated the flourishing schools of Dutch naturalism in the seventeenth century. Utrecht was the earliest center of Caravaggism in Holland. It was imported via Italy by Hendrik Terbrugghen, who had seen the work of Caravaggio in Rome. Haarlem's leading artist, Frans Hals, combined objective observation with dashing brushwork to capture a movemented instant, a conception drawn upon two hundred years later by the Impressionists.

Rembrandt of Leyden and Amsterdam, the universal genius of drawing, painting, and printmaking, combined realism with dramatic tonal contrasts to create images of unsurpassed psychological depth. Few artists in history have

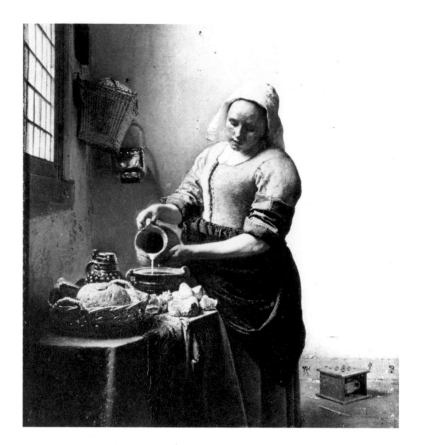

Figure 5. Jan Vermeer. *Kitchen Maid.* c. 1658. Oil on canvas, 17⅞″ × 16⅛″. Rijksmuseum, Amsterdam

made drawings in which so much is conveyed with such economy of means.

Landscapists viewed their world with meteorological interest in the changing effects of weather and light, and the view of nature was no longer just a backdrop for other subjects; it became an art form itself. Dutch artists observed the sweep of nature, but they also turned attentive eyes to the small and outwardly mundane accouterments of domestic life. The still life, also a subject that had previously been a part of the trappings of more elaborate themes, became important in itself. But it is the so-called little masters of genre painting who allow the most comprehensive insights into the period. Of these, the most significant to modern eyes is Jan Vermeer (fig. 5), who had a clarity of vision and a compositional intelligence equaled by very few artists in history. He

opposite: 26. Blanche Lazzell. *Provincetown Houses.* 1922. Charcoal on paper, 15⅞ × 14⅜″ (sight) (40.3 × 36.5)

27. Claire Khalil. *Sun Valley and the Janss Collection with Dove*. 1984.
Watercolor on paper, 41⅛ × 27¼″ (104.5 × 69.2)

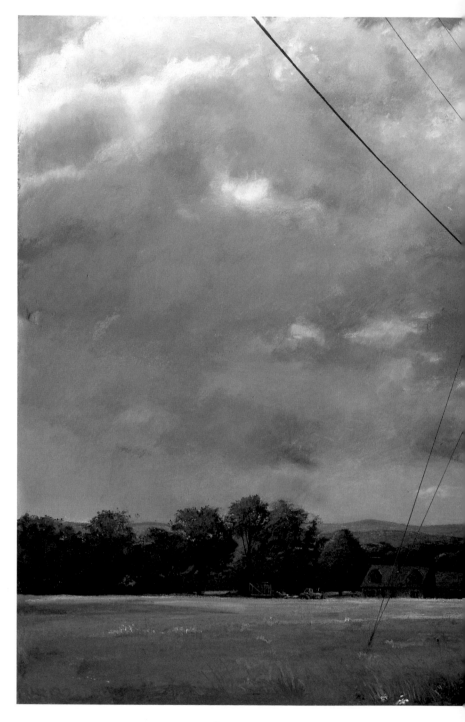

28. William Beckman. *Power Lines*. 1982. Pastel on paper, 24⅜ × 33″
(sight) (61.9 × 83.8)

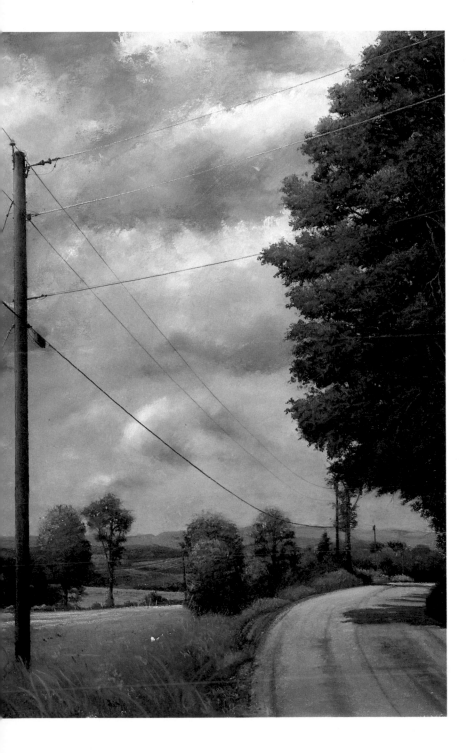

29. Elena Borstein. *Red Gate*. 1983. Gouache on paper, 25¾ × 17¼"
(sight) (65.4 × 43.8)

faithfully recorded his subjects and their environment with a sure yet subtle technique. He made timeless an intimate moment or gesture, as if it were photographed in his mind's eye. Indeed, it is probable that he employed such aids as drawing frames, glass tracings, or perhaps some optical device such as a camera obscura to draw and compose his pictures. If so, he may well be seen as the lineal ancestor of the contemporary Photo Realist.

The seventeenth century was a high point of realism in terms of a cross-cultural interest in exploring, examining, and reproducing the outward appearance of things and people in drawing, painting, and sculpture. Artists explored human psychology and emotion as revealed by physiognomy and gesture. They discovered every imaginable means to heighten the effects of their representation through mastery of a complete range of illusionistic perspective techniques and contrasts of light and dark.

During the late seventeenth century, because of the increasing wealth and power of the French monarchy, the cultural center of Europe shifted from Rome to Paris, where it remained until the latter half of the twentieth century. The French Baroque of the reign of Louis XIV aspired to the magnificence of the Roman era. It was Classical in its balance and proportion, but less concerned with verisimilitude in its figurative art. Under the absolutist reign of the Sun King, a number of institutions were centralized, and organizations were created that had specific governmental or bureaucratic functions. Among these was the Royal Academy, which established not realism but Baroque classicism as the official style of the realm in painting, sculpture, and architecture. By the end of the seventeenth century, the academy was somewhat liberalized by the controversy between the "Rubensistes," who extolled the virtues of sensuously painted color, and the conservative "Poussinistes," who asserted the supremacy of line. The Rubensistes triumphed in the early eighteenth century, when the monarchy and the aristocracy embraced a more sensuous attitude, which was reflected in the style called Rococo.

The Rococo is characterized by a combination of elaborate ornamentation and colorfully decorous images of sophisticated charm and wit that are neither truly Classical nor realistic. This style was adopted by courtly society throughout Europe. To the artists and their patrons, the Ro-

30. Henry Lee McFee. *Buildings, Bellevue.* c. 1932. Graphite on paper, 14⁵⁄₁₆ × 9¼" (sight) (36.4 × 23.5)

31. Charles Sheeler. *Side of a Barn.* 1917. Conté crayon on paper, 4⅛ × 5¹¹⁄₁₆" (sight) (10.5 × 14.5)

coco symbolized success and sophistication; to others, its ostentation stood for the decadence of the aristocracy.

Neoclassicism and Romanticism

If the eighteenth century marked the decline of monarchy, it was also the beginning of the Age of Enlightenment. Through the thoughtful and critical voices of the ever-growing and ever more educated and successful urban middle class, forceful calls for reform were heard. For these people, education was the means to their ultimate goal: the freedom of the individual to succeed through his own abilities. Education meant the study of history, and once again classicism emerged as an intellectual and artistic model. Revolution was seen as a corrective measure.

The eighteenth century spawned three revolutions, all of which are still in progress and the ramifications of which differentiate our world from that of the Renaissance and Baroque eras. Two of these were bloody. The American Revolution, inspired in part by the Dutch Republic and by Cromwell's Commonwealth, created a democratic republic that not only

freed itself from monarchy but also established a means by which this freedom could be perpetuated. The Constitution of the United States, based on human reason and thoughtful interchange, is one of the greatest documents of Enlightenment idealism.

The French Revolution, inspired in part by our own, was less clearly and immediately successful. Nonetheless, egalitarian ideals of freedom and justice aroused the spirit of reform that has kindled the intellectual life of the country ever since.

The most far-reaching revolution of the eighteenth century began before either the American or the French. It was, at least superficially, bloodless. The Industrial Revolution began in England, and it was again a product of eighteenth-century faith in the rewards that accrue to inventive and able individuals: Wealth was created as never before in history. The success of industrialism reinforced democracy, brought about the downfall of kings, changed the world's demographics, and caused the rapid growth of cities. Bit by bit, new systems and inventions improved the human condition, but not without inflicting pain in the process.

The excesses of industrialism fueled social conflict, particularly during the nineteenth and early twentieth centuries, and many bloody revolutions erupted as societies adjusted to accommodate change. Greed and ruthless competition produced wars, injustice, and economic instability. Factories have blighted the landscape and polluted air and water.

The revolutionary spirit in politics, science, and economics, born of the Enlightenment, has been ongoing. Revolution implies change, and certainly it is change—and the conflict change produces—that has characterized the modern era. This revolutionary spirit has certainly informed modern art.

In the late eighteenth century, two distinct styles, the Neoclassical and the Romantic, emerged simultaneously. They represent opposite responses to the Enlightenment and industrialization. The Neoclassical style, which appeared first in England, is a reasoned and rational return to Classical models and ideals. Influenced by the writings of Johann Winckelmann and Edward Gibbon, the leading Neoclassicists of the mid-century attempted, with good historical methodology, to turn to ancient Greece and Rome as sources

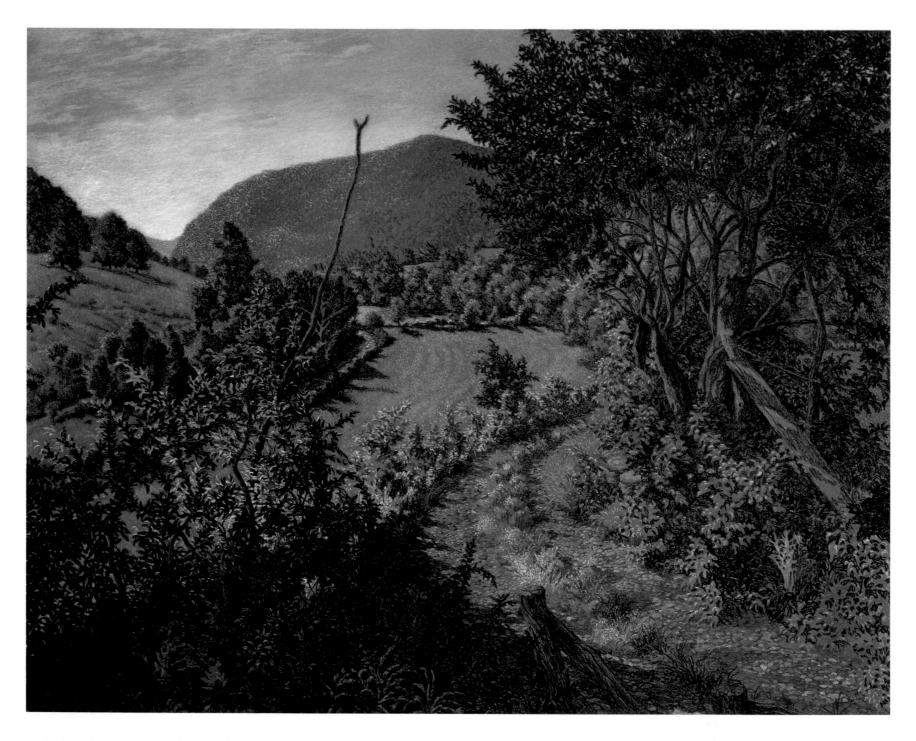

32. Jack Beal. *Oneonta: View from the Studio.* 1983–84. Pastel on board,
32⅛ × 40⅛″ (81.6 × 101.9)

rather than to Renaissance and Baroque interpretations. In general the style, like its artists and its patrons, was cool, detached, and on the whole, somewhat passionless.

Romanticism was not so much a style as an attitude that fostered belief in the value of the irrational and emotional aspects of the human psyche. The expression of intense feeling is the one coherent feature of Romanticism. These feelings were highly personal, and they were depicted in very different manners of execution. The power of nature, visions, fantasies, the horrors of war, exotica, and erotica were all subjects for exploration by such artists as William Blake, Henry Fuseli, J.M.W. Turner, or John Constable in England; Philipp Otto Runge and Caspar David Friedrich in Germany; Francisco Goya in Spain; and, somewhat later, Théodore Géricault and Eugène Delacroix in France.

Generally speaking, neither Neoclassicism nor Romanticism emphasized realism in a direct way. The realism of Neoclassicism occurs almost coincidentally by reason of its Classical sources. The Romantics espoused nature but approached it in highly subjective ways. The exception occurred in France, where these two forces coexisted in opposition through the first half of the nineteenth century—the first of a continuum of conflicts in the development of modern art. The most significant French Neoclassicist was Jacques-Louis David, who placed the style at the service of the Revolution. He developed an archaeologist's fascination with the art and artifacts of Classical antiquity, which he studied firsthand in Rome. To this he added a profound respect for the Baroque naturalism of Caravaggio.

Under Napoleon, David became the leading figure in the Royal Academy and director of the École des Beaux-Arts. He reestablished a rigorous curriculum and had the power to appoint teachers. He influenced the juries of the Salon, and under his authority the academy became the arbiter of official taste. Under David's direction, the School of Fine Arts was influential in launching the careers of numerous students who would carry classicism into the nineteenth century. Of these Classicists, the most talented and influential was Jean-Auguste-Dominique Ingres. Like David, he became a well-versed student of antiquity. His great love, however, was the art of the Italian Renaissance, particularly that of Raphael. Ingres was doctrinaire in his teaching and in his public remarks, and he became the standard bearer of the aca-

demic—rather than the Neoclassical—ideal. Ingres's idealization in painting and his superb linear draftsmanship made him a formidable opponent for Romantics as well as for the later progenitors of modernism. In the early nineteenth century, two somewhat younger men, Géricault and Delacroix, rose to prominence and represented the Romantic position. Both incorporated into their own more emotive Romanticism the naturalistic elements of the Baroque implicit in David's Neoclassicism.

Géricault and, at times, Delacroix could be called Romantic Realists. In the production of his monumental and highly controversial *The Raft of the "Medusa"* (1819), Géricault went to great lengths to study in detail corpses in the morgue, the severed heads of executed prisoners, and the faces of the deranged. His death in a riding accident prematurely ended one of the most promising careers of the century. Delacroix pioneered in the application of science and technology to artistic ends. He studied Michel Chevreul's recently published *Law of the Simultaneous Contrast of Colors*, a treatise that laid the groundwork for color theory. He also investigated the use of photography as an aid in painting and drawing by using it to record the poses of his models. Though much of his work was inspired by exotic subjects drawn from history, literature, or his fascination with the Orient, he also painted contemporary events in a powerfully emotive, realistic manner. His *Liberty Leading the People* depicted his countrymen's opposition, during the Revolution of 1830, to the dubious monarchy imposed on them after Napoleon's defeat.

Critical attention was focused on the conflict between Ingres and the academics and Delacroix and the Romantics until the middle of the century. By then the issues that divided them became diffused, but conservatives continued to lead official and bourgeois taste. Beginning with Romanticism, however, their values came under increasingly persistent attack until, by the end of the century, their influence became moribund.

Modernism in Europe (1848–1940)

Modernism was more an ideology than a style. Born of revolution, it *was* revolutionary. It was based on the notion of progress, a concept enthusiastically espoused since the sec-

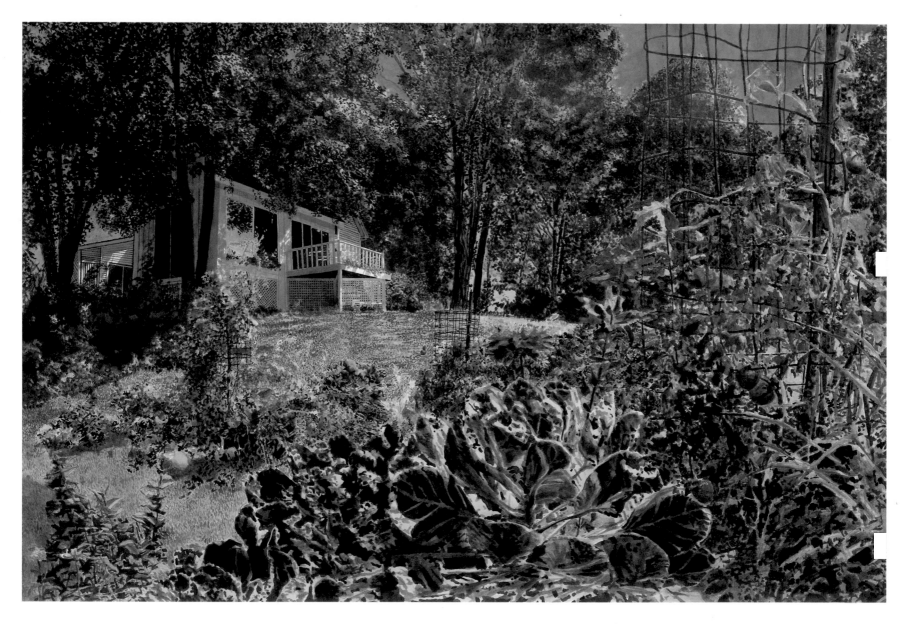

33. Arthur Cady. *Looking Back from the Garden*. 1982. Acrylic on paper,
40⅛ × 59⅞" (101.9 × 152.1)

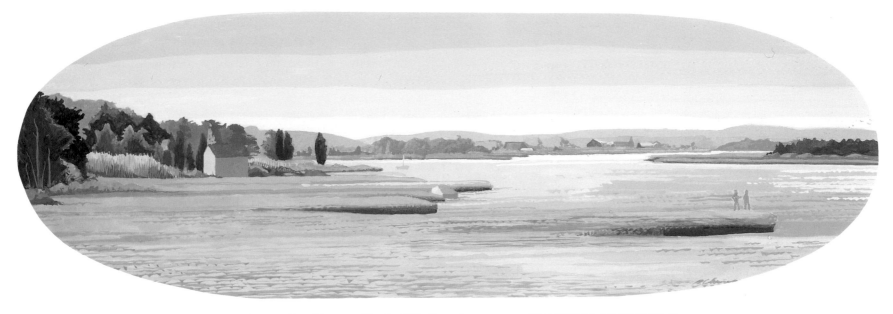

34. Richard Chiriani. *East Hampton Marsh.* 1982. Gouache on paper, 4¼ × 12¾″ (sight) (10.8 × 32.4)

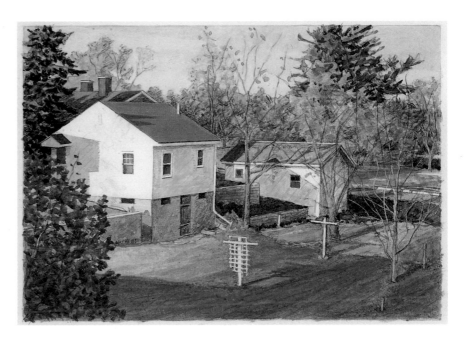

left: 35. Robert Bauer. Untitled. 1982. Oil on paper, 7⁷⁄₁₆ × 7³⁄₈″ (18.9 × 18.7)

above: 36. Walter Hatke. *Sun Yards.* 1981. Alkyd on paper, 4¼ × 6¹⁄₁₆″ (sight) (10.8 × 15.4)

ond half of the nineteenth century. Successive modernist movements emerged, each to replace its predecessor with ever-increasing rapidity. Modernists demanded high intellectual standards and required that these standards be constantly reevaluated and improved upon.

In modernist thinking, unlike that of previous post-Renaissance movements, the present, rather than the past, was considered to be the starting point from which to create an ideal future. To be sure, modernism came to have a tradition, but one that was antitraditional. To be a modernist was to lead, not follow. Therefore, the Classical tradition was viewed not as a source of strength but as something to dismiss. This philosophy dominated serious cultural and artistic discourse for most of the last century and a third, and it continues to be of considerable influence in post-modernist art and thought. Though modernism had roots in Romanticism, it came to be defined in terms of realism.

The realism from which the basic tenets of the modernist movement were drawn was Realism with a capital *R*. The descriptive terms "realism" and "naturalism," which may be used almost interchangeably, are certainly applicable to the art of the Radical Realist movement that emerged in France in the 1840s. But realism in this context represented a political and ideological position that was as much polemical as it was stylistic. Its leading exponents in the visual arts were Jean-François Millet, Honoré Daumier, and Gustave Courbet.

Daumier and Millet were both associated with the Romantic movement in the early 1840s. Each became concerned with the plight of the working classes. Millet turned to the peasants of the countryside and sympathetically rendered the simplicity, the hardship, and the dignity of their daily lives. Daumier was more radical. As the proprietor of a small printing company in Paris, he was a man of the city, both businessman and worker. He had been a supporter of the Revolution of 1830, but he became disillusioned and radicalized by the indifference of the government and the capitalist bourgeoisie to the lower middle class and the workers. Although he was a powerful painter, sculptor, and draftsman, Daumier was best known in his lifetime as a biting political satirist. He worked in the medium of lithography and drew in a powerful, graphic style that was inspired by the prints of Goya, whom he deeply admired.

It was around Gustave Courbet, however, that Realism coalesced. Courbet admired seventeenth-century naturalism, and he studied the work of Louis Le Nain as well as that of the Dutch and Spanish masters. In the mid-1840s he became associated with such freethinkers as Pierre-Joseph Proudhon, the utopian anarchist, and Charles Baudelaire, who, in his essays "The Painter of Modern Life" and "The Heroism of Modern Life," called for an art that portrayed the rich substance of contemporary existence. Courbet became an outspoken socialist and declared his independence from both Romanticism, which he thought insubstantial, and academicism, which he found irrelevant. Through Courbet, the concept of the avant-garde—a military term meaning the spearhead of an attack—was co-opted for artistic purposes, and the term became almost a synonym for modernism. Courbet sought unidealized images of contemporary people and places. Subjects who were ordinary in appearance and occupation were deliberately chosen. Courbet arranged unconventional compositions and painted in a direct and solid way that reflected his characters and their environment. He, like Daumier, was an active supporter of the working-class Revolution of 1848, which led to the founding of the Second Republic. For a few months, the Realists—and Courbet particularly—were seen as reformist heroes. They received recognition and achieved prominent positions in the Salon, a place from which Courbet was not dislodged until 1871, when he was exiled for his role in the Paris Commune following the Franco–Prussian War.

The most influential of Courbet's actions in bringing attention to the Realist avant-garde was his creation of the Pavillon du Réalisme. This large wooden structure was built to protest his exclusion from the French art pavilion at the 1855 Paris Exposition, where particular homage was paid to Ingres and Delacroix. He installed a retrospective of his own work, including *The Studio: A Real Allegory Concerning Seven Years of My Artistic Life* (fig. 6). This gesture, though derided by the conservatives and the public at large, attracted the attention of a number of the younger artists who were to become the next generation of the modernist movement.

Realism—in the general sense of the word—found its place in academic circles after the middle of the century. No doubt some tangential, if grudging, influence of Courbet's ideas contributed to this in France, but academic realism had

Figure 6. Gustave Courbet. *The Studio: A Real Allegory Concerning Seven Years of My Artistic Life*. 1854–55. Oil on canvas, 11' 10" × 19' 7¾". The Louvre, Paris

other sources. In England, John Ruskin, the most influential critic of his day and the spokesman for the Romantic Pre-Raphaelite Brotherhood, urged fidelity to nature. By this he meant that artists should confront the creations of God directly rather than portray them as seen through the Renaissance ideal. Thus, Ruskin and the Pre-Raphaelites were radical anticlassicists seeking their artistic inspiration in the purity that they perceived in Late Gothic art, which in painting led to almost microscopic attention to detail. This revivalist side of Romanticism had its counterparts in Germany and other northern European countries.

The rapid evolution of photography was another contributory factor in the evolution of the academic realist style.

37. Sheila Gardner. *Before the Wind.* 1983. Watercolor on paper, 40⅜ × 59⅞″ (102.6 × 152.1)

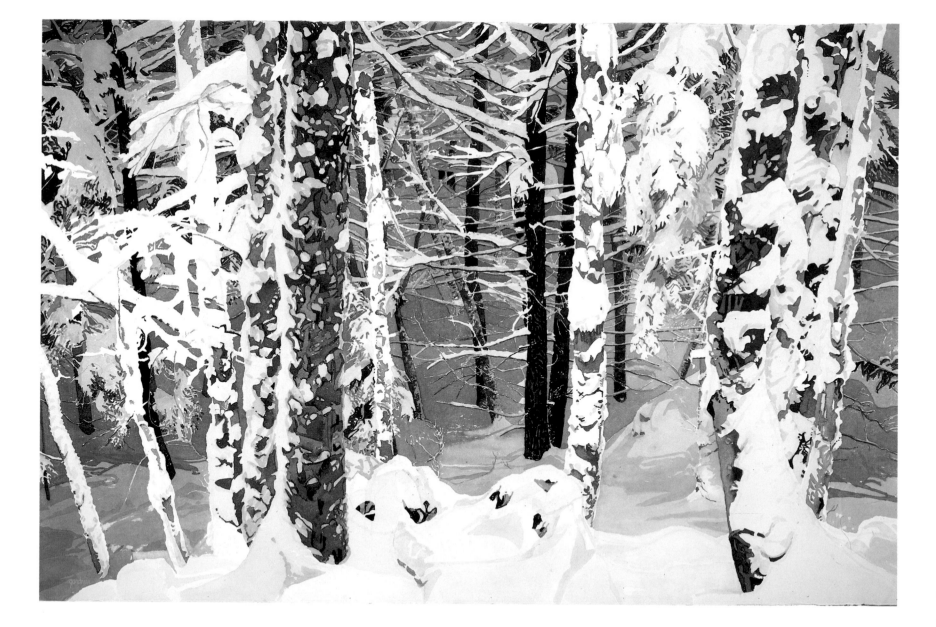

40. Theophil Groell. *Rocks and Trees.* 1982. Lithographic pencil on paper, 17⁵⁄₁₆ × 20⁷⁄₈″ (sight) (44.0 × 53.0)

41. Vija Celmins. *Untitled (Desert).* 1973. Graphite on acrylic ground on paper, 11½ × 14¹⁵⁄₁₆″ (sight) (29.2 × 38.0)

Photography provided artists with both a technical visual aid and a competitor in the creation of naturalistic images. After 1840 there was a growing tendency among academic painters to use photographs not only to record scenes and models but also to challenge their own imitative skills. Such painters as James-Jacques Tissot, Adolphe William Bouguereau, Wilhelm Leibl, and Hubert von Herkomer were capable of rendering their subjects with almost photographic veracity. These artists, however, were overshadowed by the force and breadth of the expansion of modernism.

But photography also had its effect on modernist art. To many artists, photography was not to be imitated; rather, it was a means of liberation from the imitative requirements of painting and drawing. In a few moments a photographer could capture a faithful image in all its detail. Therefore, the artist should involve himself purely with interpretation. The desire to be free of the past combined with liberation from emulation propelled modernist art from imitation to interpretation, to invention, and ultimately to the creation of nonrepresentational abstract forms.

If Courbet established the modernist imperative of the avant-garde, his younger colleague Édouard Manet consolidated and further developed the doctrine. Courbet's rugged style and his commonplace subjects challenged official canons with images of modern life and social injustice. Manet came from an upper-class background, but he too was bent on reform, though he insisted that the academy itself had to change. To this end, he also resorted to confrontation. In his *Luncheon on the Grass (Le Déjeuner sur l'Herbe)*, the scandal of the Salon des Refusés of 1863, he transposed Renaissance themes into contemporary bohemian contexts. Manet used Marcantonio Raimondi's sixteenth-century engraving, *The Judgment of Paris*, not only as a source for his central group of figures but also as an exquisite pun on the judgmental hypocrisy of conservative Parisian critics and connoisseurs. In his *Olympia* of 1863 he transformed Titian's Venus of Urbino into a contemporary prostitute. Courbet had elevated the commonplace, and now Manet was seen to be vulgarizing the classics. Further, he was deliberately affronting not only taste but also public morals.

Manet and Edgar Degas were what might be termed "street realists." Courbet tended to moralize, and the later academic realists sentimentalized the treatment of their

42. Joseph Raffael. *Lily Pad*. 1975. Ink on paper, 22⅜ × 29⅞"
(56.8 × 75.9)

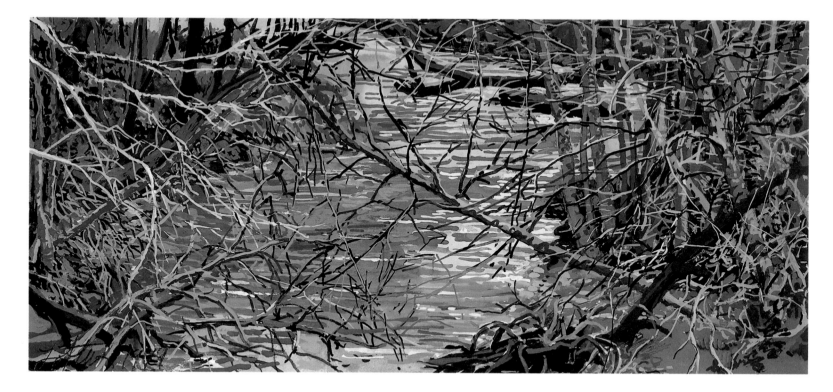

43. Peter Loftus. *Shanton Wood No. 5.* 1979. Gouache on paper, 5 × 10⅞″ (sight) (12.7 × 27.6)

44. Neil Anderson. *Study-Luna.* 1983. Watercolor on paper, 22¼ × 30⅛″ (56.5 × 76.5)

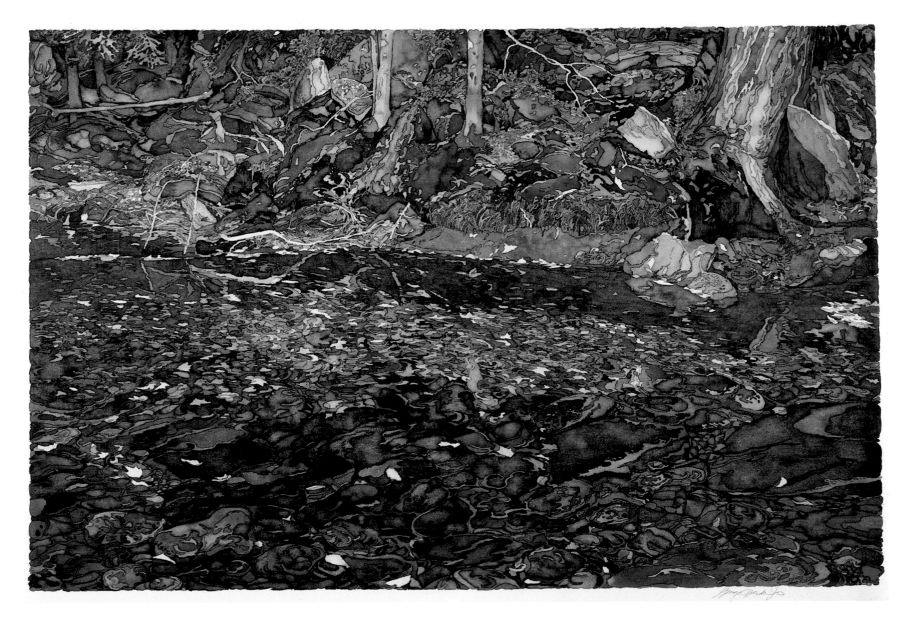

45. George Harkins. *September Gathering*. 1982. Watercolor on paper,
40¼ × 59½″ (102.2 × 151.1)

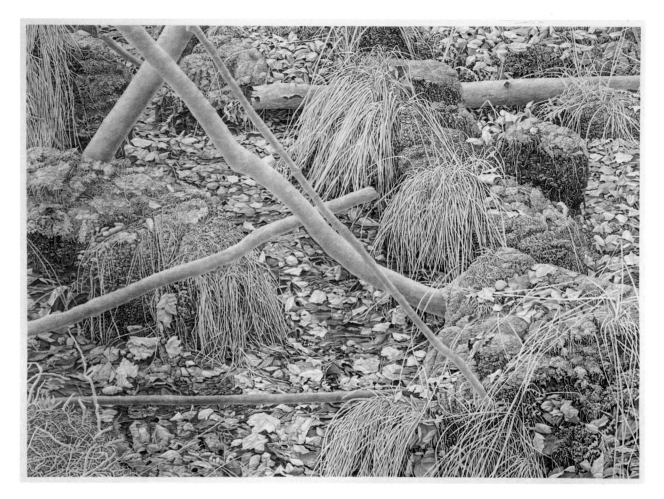

46. Bill Richards. *Shadow Brook.* 1978. Graphite on paper, $11 \times 15\frac{5}{16}''$ (sight) (27.9×38.9)

opposite: 47. Juan Gonzalez. *Sara's Garden.* 1977. Graphite on paper, $21\frac{7}{8} \times 17\frac{7}{8}''$ (sight) (55.6×45.4)

scenes. Manet and Degas chose subjects from the lower social ranks and also from outside the normal social structure altogether: drunks, prostitutes, and such exotics as acrobats, clowns, musicians, and actors—and even their fellow artists. Their subject matter was provocative, but their representations were neutral. They did not preach to their audience; they challenged it.

Manet added lofty wit to modernist thinking and brought the technique of *succès de scandale* to a high art. It was not, however, his subjects but his style that had the most immediate and enduring impact on modernist painting and drawing. He worked in broad, flat areas of color and tone with a loose and economical brush. So vehemently was he criticized that his friend, the Realist novelist Émile Zola,

wrote that his subjects were but pretexts for formal innovation.

This concept of innovative form in the hands of Manet's younger colleagues, the Impressionists, further set the course of modernism toward abstraction. In the 1860s the Impressionists Claude Monet, Paul Cézanne, Camille Pissarro, Frédéric Bazille, Berthe Morisot, Pierre-Auguste Renoir, and Alfred Sisley formed the first of the many groups in the history of the modernist movement. They explored the formal elements of color, tone, and texture, and their sensuous surfaces and overall compositions enhanced not the realism of their scenes but rather the reality of their paintings and drawings as tangible objects of art.

By the 1880s the Impressionists had won a hard-fought

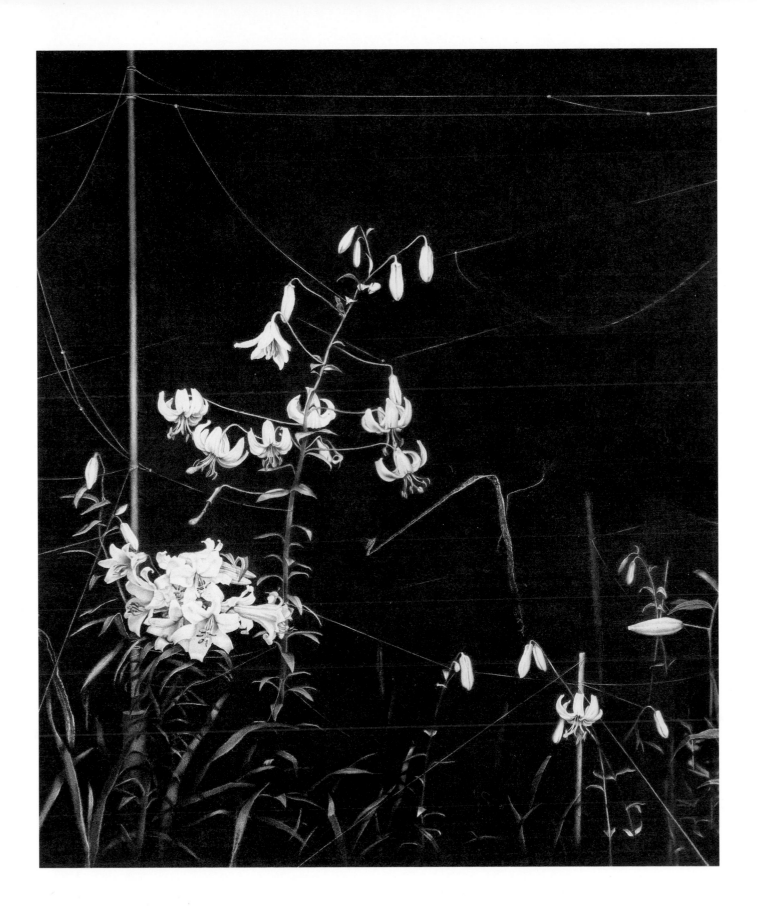

48. Charles Burchfield. *Rain and Wind.* 1949. Conté crayon on paper, 11 × 16¹⁵⁄₁₆″ (27.9 × 43.0)

left: 49. Joe Nicastri. *Three Arrangements.* 1975. Graphite on paper, 38 × 38¼″ (96.5 × 97.2)

above: 50. Peter Blume. *Landscape and Poppies.* 1938. Charcoal on paper, 15⅝ × 13⁷⁄₁₆″ (sight) (39.7 × 34.1)

victory for the evolving modern movement. Their work had become internationally accepted, and it was emulated by artists throughout the Western world. Many of the originators of Impressionism became disaffected with the style and sought other directions, but Monet carried the formal implications of Impressionism to their logical conclusion. The paintings of his Water Lilies series, created between 1903 and 1926, though inspired by direct observation of nature, were such expressive and lyrical essays in pure painting that they became a point of departure for the Abstract Expressionists in the 1940s.

In the late 1880s and the 1890s, four artists—Paul Cézanne, Paul Gauguin, Georges Seurat, and Vincent van Gogh—moved to positions of influence and became the most significant figures in Post-Impressionism. These artists established two trends that were to shape the development of twentieth-century modernist painting and drawing.

Gauguin and Van Gogh believed that the Impressionist emphasis on form had sacrificed content. To them, content had to symbolize deep spiritual and emotional feelings. In this they were in tune with another important movement, Symbolism, which derived to a degree from the English Pre-Raphaelites and emerged in France in the 1860s as a literary and artistic style. Symbolism became international by the late 1880s, and by the 1890s it was influencing the arts throughout Europe and the United States. This style was characterized by sinuous shapes and moody colors and textures, used to evoke dreamlike images of erotic fantasy or profound despair. Gauguin and Van Gogh combined Impressionist brushwork, vivid color, and bold, flat pattern with the earlier Symbolist vocabulary, which had a profound impact on the movement's later generations. Symbolism represented an upwelling of the Romantic spirit, which remained a powerful undercurrent in both nineteenth- and twentieth-century avant-garde art.

Cézanne and Seurat represent another aspect of Post-Impressionism. They accepted the Impressionist use of patches of broken color and a relatively saturated palette but felt that strong composition and structural order had been lost.

To rectify this problem, Seurat proposed a scientific approach. He drew on classical geometry to develop a complex compositional grid system, based on the Golden Sec-

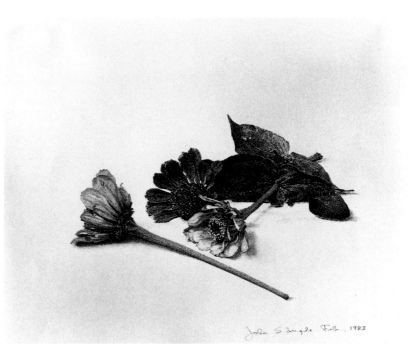

51. John Stuart Ingle. *Three Flowers.* 1983. Charcoal on paper, 17¼ × 21″ (43.8 × 53.3)

tion, for dividing the canvas. He studied the color theories of Chevreul, Rood, and Helmholtz and attended lectures by the experimental psychologist Charles Henry, who attempted to quantify the effects of color and field organization on human perception. Seurat developed a meticulous technique of disposing his colors in subtle transitions of tiny dots. He and his followers created a style variously called Chromoluminarism, Pointillism, or Divisionism, but usually known as Neo-Impressionism.

Cézanne saw geometric order as the underlying basis of composition. He wanted to put into Impressionism something "strong and solid like the art of the museums." He emphasized vertical and horizontal elements to give his motifs stability and used rhythmic sequences of layered diagonal brush strokes to strengthen his compositions. His drawings and watercolors are masterpieces of economy that unite the medium and the page in an almost abstract harmonious

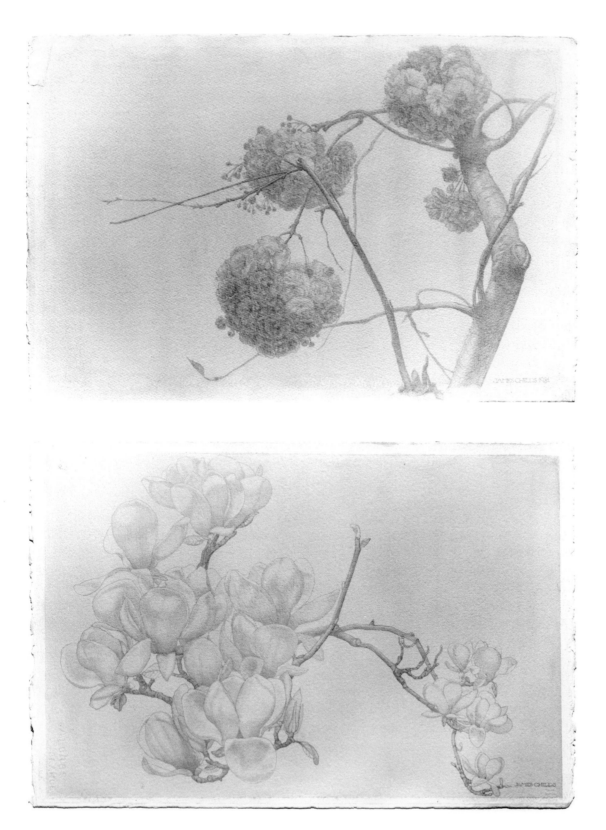

52. James Childs. *Double Cherry Blossoms.* 1981. Silverpoint on paper, 14 15/16 × 22 1/2″ (37.9 × 57.2)

53. James Childs. *Saucer Magnolia.* 1981. Silverpoint on paper, 15 1/8 × 22 5/8″ (38.4 × 57.5)

whole. His visual dialogue between the flatness of the canvas and the space implied by the imagery and color became a fundamental element of modernist abstraction.

The concept of primitivism was another factor that played a prominent role in shaping the antirealist direction of European modernism in the late nineteenth century, and it interested artists for several reasons. From the very beginning of the Romantic movement, one of its most influential doctrines was that the natural state of things is superior to the anthropocentric world-view of the rationalists. Civilization was seen as ever more corrupt and corrupting. The search for man in his natural state brought into being the sciences of ethnology and anthropology. Museums of ethnology brought together collections of artifacts fashioned by the so-called primitive colonial peoples of Africa, Indonesia, Oceania, Australia, and the Americas. Simultaneously, European cultural anthropologists began to unearth the traces of man's origins in their own native lands. Their searches uncovered the art of the Paleolithic caves, which had lain dormant in France, Spain, and elsewhere for ten to thirty-five millennia. To those seeking liberation from cultural decadence and searching for alternatives to the Classical tradition, the ethnological collections were rich resources.

Another kind of primitivism that proved attractive to the late-nineteenth-century avant-garde was that of the intelligent mind uncorrupted and unfettered by traditional learning—the untutored genius. The common sense and earthy dignity of peasants and laborers had been extolled in avant-garde art and literature since the Romantic period, and by the end of the century, many artists attempted to escape the confines of society and the city by moving to simpler rural surroundings.

All of the great originators of Post-Impressionism left the city. Gauguin made the most dramatic departure of all. Abandoning wife, family, and a successful career, he left Paris, first for Brittany, then Martinique. After a brief return to France, where he spent a few ill-fated months with Van Gogh in Arles, he left Europe and ended his days in Tahiti.

Vincent van Gogh, whose intensely brilliant but brief career ended in suicide in 1890, saw artistic endeavor as a religious undertaking. In 1888, he moved to Arles in southern France, hoping to establish a utopian artists' commune. His plan, like his career, was a glorious failure. In the five years

that he painted, he created more than a thousand paintings and drawings, which were all but unknown at the time of his death. Posthumously, however, he became a tragic hero, and his belief in the spiritual value of art was absorbed as an essential ingredient of modernist theory.

Cézanne also took on the authority of a moral force. In his self-imposed exile in Aix-en-Provence, he doggedly determined to reach an objectified integration of form and content in response to nature. In 1895 Ambroise Vollard, his dealer, held a major retrospective exhibition, which greatly enhanced Cézanne's reputation and his influence. He died in the autumn of 1906, and in the following October the recently formed modernist Salon d'Automne honored him with a large posthumous exhibit that had profound implications for the evolution of modern art in the twentieth century.

Post-Impressionism is a term first used in 1910 by the English art critic Roger Fry. The appellation is imprecise but useful. Fry was referring to the work of the major figures discussed above, but he also meant to characterize the complex situation of avant-garde art during *la belle époque* (c.1890–1914).

When the Universal Exposition of 1900 opened in Paris, it brought together a compendium of industrial man's achievements. It seemed clear that mankind was not only entering a new century but also a new age—that of science, technology, and the machine. The world had changed more since 1800 than it had in the entire span of human history up to that point, and the pace was quickening. Railroads, steamships, airplanes, the telegraph and the telephone, automobiles, trucks, and buses revolutionized transportation and communication. Motion pictures created a new form of illusionistic magic, and gramophones brought the concert hall into the home. Pasteurization, radiology, and the aspirin tablet revolutionized health care. Freud plumbed the depths of the human psyche and Einstein redefined the universe.

The period between 1900 and 1914 was also one of the most energetic in the history of art. It saw the triumph of the modern movement in art and theory. By 1912, when Fry reviewed recent art, most of the new and influential styles of early-twentieth-century modernism had been invented and were being elaborated. Paris remained the epicenter of avant-garde modernism, but its manifestations could be seen in every European capital and cosmopolitan city. Innumer-

able magazines and periodicals proliferated to spread artistic gossip, discourse, and controversy, both modernist and academic. Private art galleries first rivaled and then surpassed the official salons as the proving grounds for artists' reputations. Experimentation was the byword in science and technology, and so it became in art. Many of the old-guard academics still produced fine conservative works and continued to denounce the whole radical modernist continuum, but their influence had waned. The Impressionists continued to work—and were well established and widely acclaimed. Symbolists in their many variations also occupied a large part of the artistic stage. All of the major Post-Impressionists were dead by 1906, but their legacy formed the new century's vanguard.

The group known as Nabis (from the Hebrew word for prophet) was formed in the 1890s. Their theorists, the artist/writers Maurice Denis, Paul Sérusier, and Émile Bernard, had all been personally acquainted with Gauguin in the late 1880s in Brittany. In their writings they synthesized the ideas of Gauguin, Van Gogh, and Cézanne with Symbolism, creating a theoretical amalgamation of signs, symbols, numerology, mysticism, and abstraction. They soon divided into several distinct camps, but all of them remained essentially attached to the Symbolists' Romantic tradition.

The Fauves, or Wild Beasts, formed the first movement to be created entirely in this century, although their nineteenth-century ancestry remains clearly evident. Theirs was an art that celebrated color and animated brushwork. They derived their expressive forms from the examples of Gauguin, Van Gogh, the primitivists, and, to a slightly lesser extent, Seurat. The group began to form about 1902 when Henri Matisse—the leader and oldest member—André Derain, and Maurice de Vlaminck began to share ideas. In 1903–4 they were joined by Albert Marquet, Henri-Charles Manguin, Charles Camoin, Georges Rouault, Jean Puy, and Kees van Dongen. In 1905–6 the group was completed when Raoul Dufy, Othon Friesz, and finally, Georges Braque became associated with it.

The Fauves exhibited together at the Salon des Indépendants and the Galerie Berthe Weill as early as 1903. They obtained their sobriquet at the modernist Salon d'Automne in 1905 when an admiring critic, Louis Vauxcelles, writing in *Gil Blas*, compared a single traditional sculpture in the same

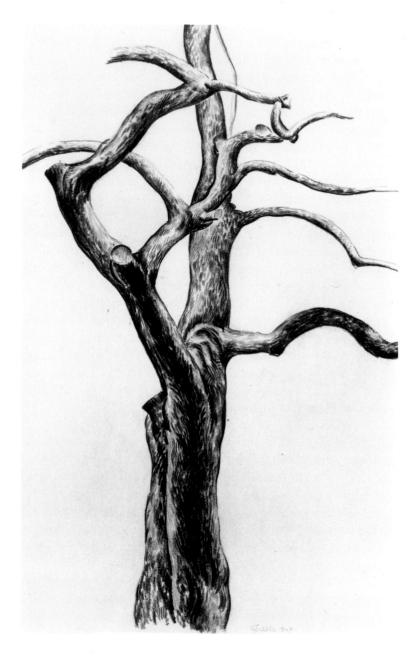

54. Charles Sheeler. *Tree Trunk #2*. 1924. Charcoal on paper, 12 × 7⁹⁄₁₆″ (sight) (30.5 × 19.2)

opposite: 55. George Ault. *Apple Trees*. 1933. Graphite on paper, 14¾ × 9¹¹⁄₁₆″ (sight) (37.5 × 24.6)

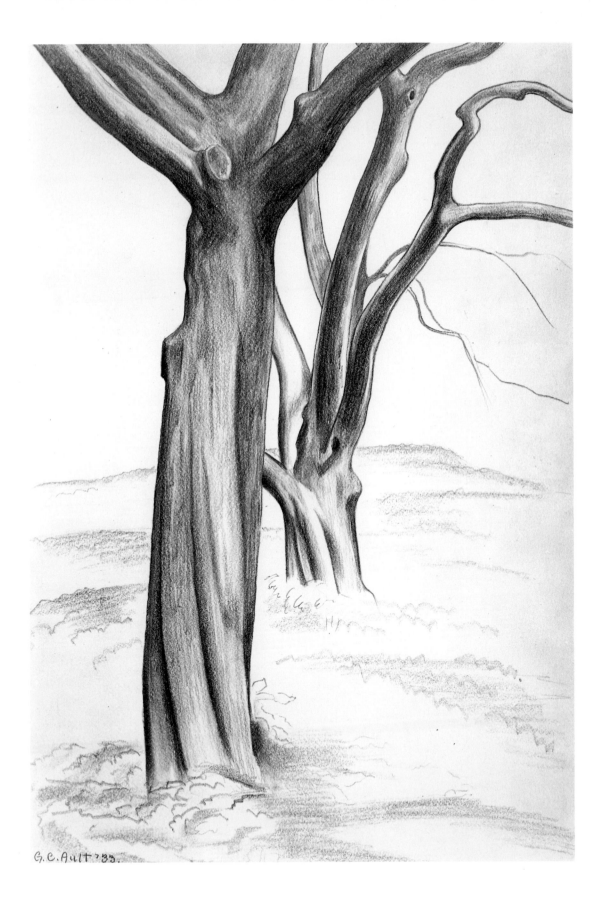

G.C.Ault '35.

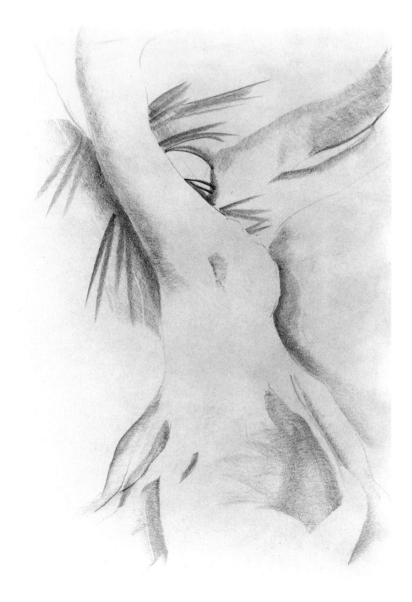

56. Charles Demuth. *Tree Trunk No. 1*. 1916. Graphite and charcoal on paper, 9¹⁵⁄₁₆ × 7⅞″ (25.2 × 20.0)

57. Georgia O'Keeffe. *Bermuda Tree*. 1934. Graphite on paper, 21⅜ × 14⁹⁄₁₆″ (sight) (54.3 × 37.0)

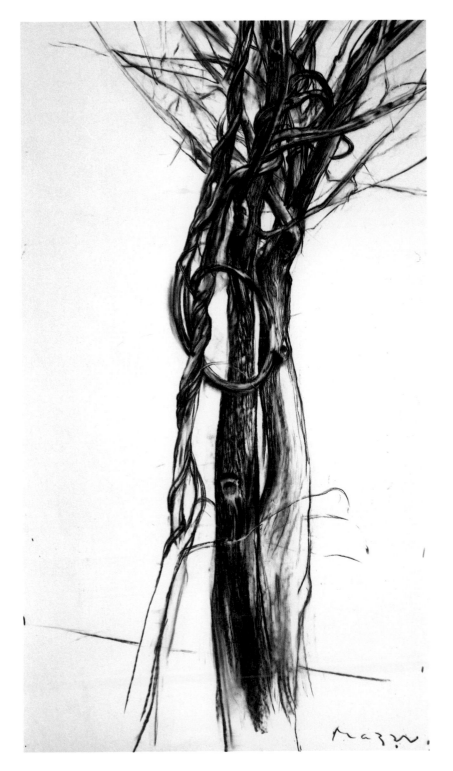

58. Michael Mazur. *Vine Tree I*. 1984. Charcoal on paper, 68¹¹/₁₆ × 38¾″
(177.0 × 98.4)

room to their work, saying it was like a Donatello in a "cage of wild beasts." Vauxcelles praised their energetically bold colors and primitivistic distortions, but his words were removed from context in the popular press. Fauvism became another *succès de scandale*. By 1908 most of the Fauves were seeking different directions, but their distorted representations in vivid, unnatural colors moved modern art one step further away from realism and established the word "expressionism" in the vocabulary of modern art.

Also about 1905 other Expressionist groups became visible in Germany. These artists were influenced by international Symbolism, particularly that of northern Europe. Their styles grew out of examples of German *Jugendstil*, the Symbolist works of Arnold Böcklin, Edvard Munch, and James Ensor, as well as those of primitive and naive art.

All of the German Expressionists had been to Paris and were aware of the late Impressionists and the Post-Impressionists, as well as the Fauves. In Germany, cultural activity was not centralized in one capital city as in France, so German Expressionism had several centers of activity. In northern Germany Emil Nolde, Christian Rohlfs, and Paula Modersohn-Becker formed one group. The first German Expressionist avant-garde association, *Die Brücke*, was formed in Dresden in 1905 by Ernst Ludwig Kirchner, Erich Heckel, Karl Schmidt-Rottluff, and Max Pechstein. Like the Fauves, the German Expressionists emphasized the emotive power of strong primary color, aggressive brushwork, and primitive figural distortions. Their work, however, was more internalized and more savage than that of the French. French Expressionism reflected the joy of life, German, the anxiety and alienation of repression.

The year 1907 was of monumental importance to the abstract direction advanced modernist art was taking. Georges Braque abandoned the Fauve circle and, inspired by the Cézanne retrospective, started a series of paintings that in 1908 would give Cubism—the most revolutionary and influential movement of the early twentieth century—its name. In November, 1907, he met Pablo Picasso who, having put Symbolism behind him, had just completed a remarkably complex Expressionist work that has generally been conceded to be one of the most radical pictures ever painted, *Les demoiselles d'Avignon* (fig. 7). The following year these two artists took the lead in the avant-garde. They formed an alli-

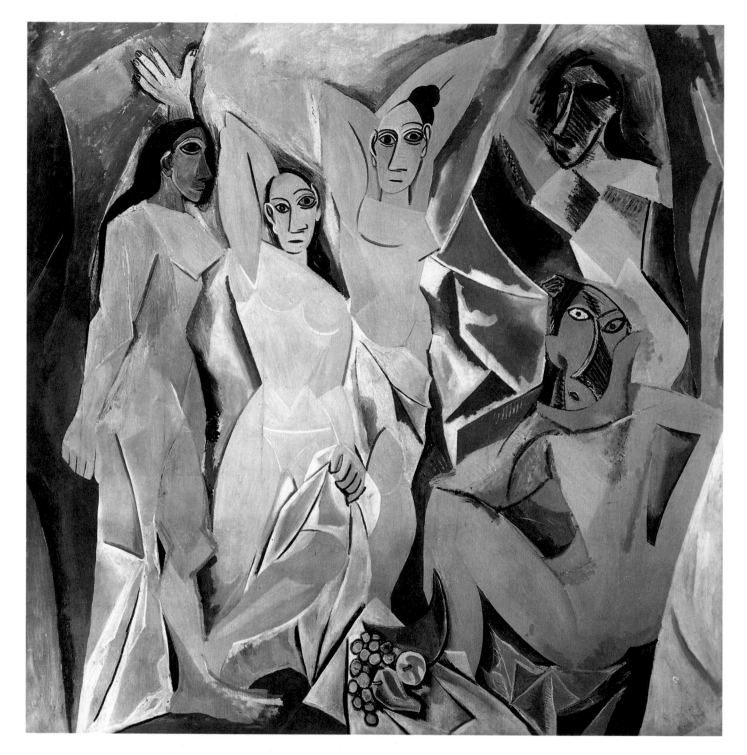

Figure 7. Pablo Picasso. *Les demoiselles d'Avignon*. 1907. Oil on canvas, 96 × 92″. Museum of Modern Art, New York. Lillie P. Bliss Bequest

ance that was to inform twentieth-century art for the next sixty years. Between 1909 and 1911, the analytic phase of their Cubist partnership, they so fragmented natural appearances in their geometric imagery that they pushed their art to the very brink of pure abstraction. From 1912 to 1914 they turned from the abstract implications of their previous creations, not toward realism but toward reality itself. In this "Synthetic" period of Cubism, they combined the use of newspaper, wallpaper, cigarette packs, and ropes with the art-making process of collage and *papiers collés*. Two essential lines of inquiry in twentieth-century art derived from Cubism. The abstractions of Analytical Cubism made nonrepresentational art possible. From Synthetic Cubist collage came the dialogue about the relationship of actual materials from everyday life to the object of art, which has since informed Duchamp and Dada, Assemblage, Surrealism, and Pop Art.

Cubism's influence was immediate and far-reaching. In 1908 the work of Derain and Vlaminck began to show Cézannesque Cubist tendencies. By 1910 Juan Gris and then Fernand Léger became associates of Braque and Picasso and adopted a geometric style. By 1912 Jean Metzinger, Albert Gleizes, and Henri Le Fauconnier, along with Jacques Villon and his brothers, Raymond Duchamp-Villon and Marcel Duchamp, had joined them to form the nucleus of a Cubist group called the *Section d'Or*. That same year Robert Delaunay combined Cubist form with Neo-Impressionist color theory to create abstractions in a style later called Orphism.

Cubism also moved into foreign territory. By 1910 the Italian Futurists Umberto Boccioni, Gino Severini, and Giacomo Balla adopted the Cubist vocabulary to express their enthusiasm for the "dynamism" of the Machine Age. Vorticism, which reflected the geometric elements of Cubism, had come into being in England by 1912. Piet Mondrian had also moved into an abstract vocabulary based on geometry. In Munich, under the leadership of Wassily Kandinsky, the Expressionist *Blaue Reiter* group was founded. This association, which included Franz Marc, August Macke, Alexei Jawlensky, Gabriele Munter, and Paul Klee, had its roots in Symbolism, but its members were well aware of contemporary currents emanating from Paris. By 1910 the abstractionist and constructivist elements of Cubism were assimilated by the group, and Kandinsky, like Mondrian, had pushed beyond representational art into a pure expressionistic form of romantic abstraction.

David Burliuk, Kasimir Malevich, Natalia Goncharova, Vladimir Tatlin, and others translated French Cubism and Italian Futurism into Russian. The geometric abstract styles Rayonism, Suprematism, and Constructivism, though conceived in Paris, were all born in Moscow and St. Petersburg between 1912 and 1914.

In 1910, when Fry first used the term Post-Impressionism, an interested observer of art was offered a vast array of options. The aging academics were still formidable conservative presences. John Singer Sargent and Giovanni Boldini were admired for their realistic idealizations. Monet, Renoir, Mary Cassatt, and a host of younger international Impressionists were much in evidence. Auguste Rodin, Munch, Eugène Carrière, Sir Edward Burne-Jones, Jean Delville, Ensor, and other members of the Belgian Société de XX, Joséphin Péladan's Rose-Croix, Gustav Klimt, Egon Schiele, the Vienna Secessionists, and other groups from Russia, Germany, and Switzerland could be seen exhibiting in the Symbolist idiom. The *fin-de-siècle* modernist movements such as Neo-Impressionism, represented by Paul Signac and Henri-Edmond Cross, or the Nabis and its subdivisions (Denis and Serusier's Neo-Christians or Pierre Bonnard and Edouard Vuillard's Intimists) still vied with the new-century movements such as Fauvism, German Expressionism, Cubism, Purism, Orphism, Futurism, and the nascent abstractionists of the *Blaue Reiter*, Rayonism, Constructivism, and Suprematism for the central position in the avant-garde. By 1914 the modernist avant-garde was clearly in the ascendant. Then came August—and World War I.

During the war and immediately after, the most stridently avant-garde movement was not modernist but nihilistic. From Zurich, New York, Berlin, and Paris the Dada artists and writers created manifestations that aimed criticism at what they believed to be the morally, spiritually, and intellectually corrupt social order that had fostered the conditions and conflicts that led to war. They included as part of this order the artists, both conservative and modernist, who were patronized by it.

After 1918 Paris again resumed its position as the leading center for advanced artistic ideas. Activity, however, was

much less intense than before the hostilities. In the generally apprehensive atmosphere of the 1920s and 1930s, many artists examined their positions in the light of tradition. Picasso, Braque, Severini, and Giorgio de Chirico incorporated ancient and Classical myth or style into their work.

Surrealism was the most significant international movement to be formed between the end of the First World War and the beginning of the Second. Initially a literary movement led by the poet-critic André Breton, who was inspired by the works of Stéphane Mallarmé, Arthur Rimbaud, Lautréamont, Apollinaire, and Sigmund Freud, Surrealism attracted the talents of the Symbolist and Dada writers Tristan Tzara, Louis Aragon, Blaise Cendrars, Max Jacob, and Jean Cocteau. The visual component of Surrealism developed along two different paths during the late 1920s and the 1930s. Jean Arp, André Masson, Joan Miró, Matta, and to some extent Max Ernst and Kurt Schwitters used spontaneous calligraphy to generate the forms of their biomorphic abstractions. Ernst and Schwitters also introduced imagery and incidental items from commonplace reality into their work and invented techniques derived from Cubist collage and Dada found objects.

The other aspect of Surrealist painting and sculpture also engaged the world of the subconscious, but in representational terms. Salvador Dali, René Magritte, Paul Delvaux, Victor Brauner, and others employed academic techniques to recreate images of dreams and fantasies in what has been variously called veristic, fantastic, or descriptive Surrealism.

Surrealism's influence was pervasive in both European and American art in the 1920s and the 1930s. Established artists associated with other styles, such as Picasso, Braque, and Klee, indirectly responded to elements of its imagery and mood.

Abstraction also continued to develop in the years between the wars, but at a halting pace. In France, the Purism of Le Corbusier and Amédée Ozenfant encompassed such Cubists as Léger and Juan Gris. The journal *L'Esprit Nouveau* promoted their structural and mathematical aesthetic.

In Holland Mondrian's Neo-Plasticism found voice in Theo van Doesburg's periodical, *De Stijl*, which also championed constructivist and geometric abstractionist ideas, not only in painting but also in sculpture, architecture, and design, expressing the desire to unify the fine and industrial arts. This theme of functional unity through simple geometry was expressed most forcefully in Germany. There Walter Gropius and Ludwig Mies van der Rohe founded the Bauhaus in 1919. This school for the training of architects, artists, and designers of all kinds placed abstraction into the context of education. The fine-arts faculty included Johannes Itten, Josef Albers, Paul Klee, Wassily Kandinsky, and László Moholy-Nagy. The curriculum was based on the principle that all students, regardless of specialization, should share a common core of educational experience during their first year of study. Organized under the title Basic Design, the course emphasized the abstract elements of form and color more than the Classical representational drawing and composition then normally taught in art academies. Basic Design theory was ultimately adopted by many art schools around the world and was particularly embraced in the United States after World War II.

In spite of the innovations of the Bauhaus, however, figurative Expressionism continued as the mainstream of German art between the wars. Older Expressionists became even more anguished in their imagery. In modernist art circles, as in society itself in Europe during the 1930s, there was a mood of apprehension, an anticipation of some impending cataclysm. The apprehension proved justified. Disaster came as economic instability and postwar bitterness turned nations inward toward nationalism, which in turn gave rise to the twentieth-century's most loathsome social invention, totalitarianism. Modernism, with its radical identity, was viewed with hostility.

For a time modernism found a welcome in the Soviet Union. Between 1918 and the late 1920s, Moscow rivaled Paris as the leading center of abstract and experimental innovation in the arts. The Civil War in the mid-1920s, the death of Lenin, the exile and assassination of Trotsky, the purges, and the rise of Stalin put an end to artistic liberalism by the end of the 1930s.

The rise of totalitarianism set the stage for a sinister return of realism in European art. Virtually all the dictatorships, of the left or the right, repressed artistic experimentation as provocative. Centralized ministries of culture employed traditional realist artists in didactic roles. Germany was particularly repressive and forbade the exhibition of both Expressionists and Abstractionists, calling them decadent.

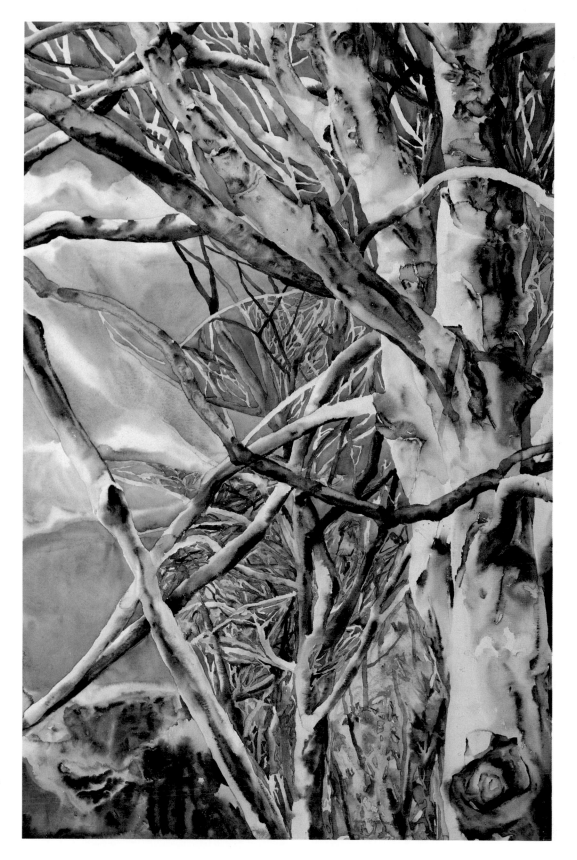

59. Patricia Tobacco Forrester. *At Cabin John*.
1982. Watercolor on paper,
39¾ × 25⅝″ (sight) (101.0 × 65.1)

60. Marcea Rundquist. *Leaf and Winter Landscape* (detail). 1981. Watercolor on paper, 22⅝ × 30³⁄₁₆″ (57.5 × 76.7)

61. Charles Demuth. *Cyclamen.* 1918. Watercolor and graphite on paper, 13⅝ × 9⅞″ (sight) (34.6 × 25.1)

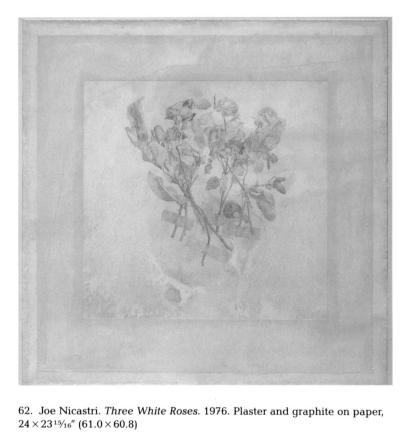

64. Herman Rose. *White Hibiscus.* 1982. Watercolor on paper, 9⅝ × 10¾″ (sight) (24.5 × 27.3)

62. Joe Nicastri. *Three White Roses.* 1976. Plaster and graphite on paper, 24 × 23¹⁵⁄₁₆″ (61.0 × 60.8)

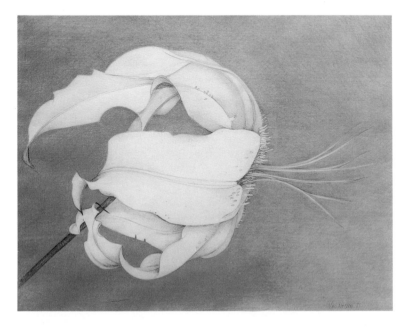

63. Beth Van Hoesen. *Lily.* 1981. Colored pencil on paper, 12⅞ × 16⅛″ (sight) (32.7 × 41.0)

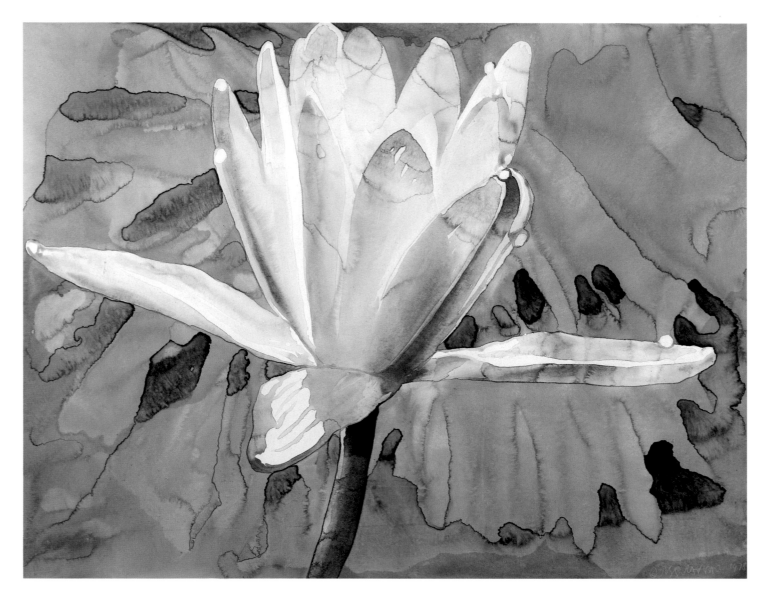

65. Joseph Raffael. *White Lily in Blue Water*. 1978. Watercolor with rain-
water on paper, 33⁷⁄₁₆ × 43⁷⁄₁₆″ (84.9 × 110.3)

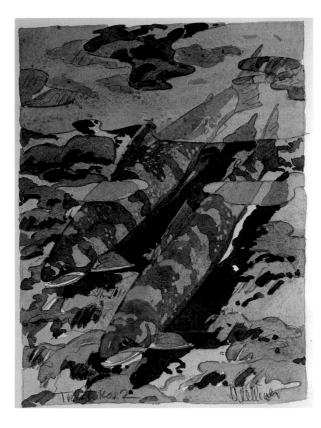

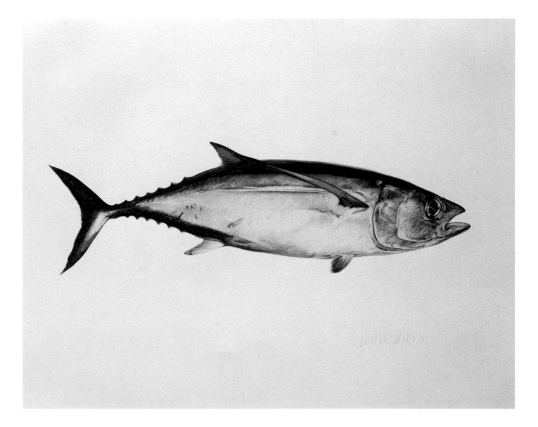

66. Neil Welliver. Study for *Trout No. 2*. 1982. Watercolor and graphite on paper, 11⅞ × 9″ (sight) (30.2 × 22.9)

above right: 67. William Allan. *Albacore* (detail). 1980. Watercolor on paper, 23¹¹⁄₁₆ × 37¾″ (sight) (60.2 × 95.9)

By 1939 modernism's retreat from Moscow was complete. France was surrounded by Fascist governments. Paris was virtually the last safe haven in Continental Europe for the avant-garde, which only twenty-five years earlier had emanated from it. With the outbreak of World War II and the fall of France in 1940, the modernist movement could find only two major places of sympathetic refuge, the United States and Great Britain, and the latter was at war.

American Art and the Modern Movement

On the whole, art flourishes best in centers of activity where active patronage, educated criticism, and ambitious artists are concentrated in an arena that fosters frequent interchange at a high level. Usually such circumstances occur in cosmopolitan urban settings. Before the twentieth century, no such center existed in North America.

From the time of its colonial origins in the seventeenth century to the latter part of the nineteenth century, American

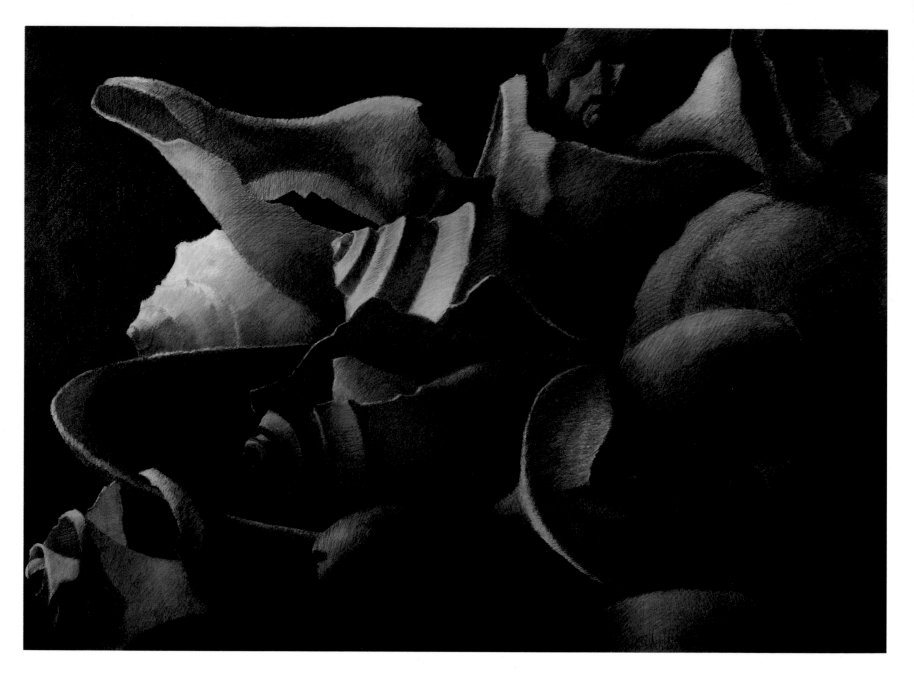

68. Richard Chiriani. *Shell Space III*. 1982. Graphite and pastel on paper, 35¹⁵⁄₁₆ × 49⅞″ (sight) (91.3 × 126.7)

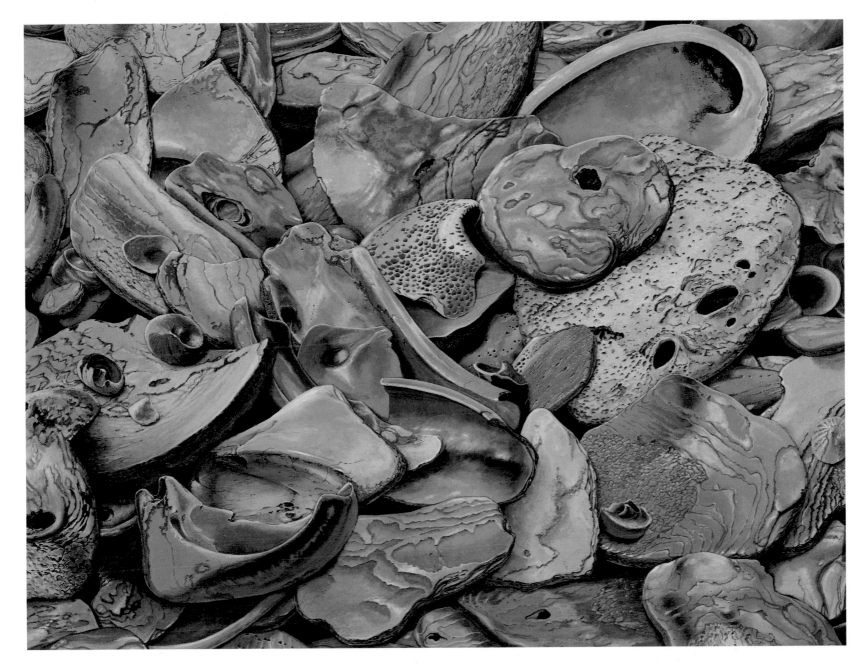

69. Bill Martin. *Abalone Shells.* 1982. Gouache on paper, 11⅞ × 15¾″
(sight) (30.2 × 40.0)

below: 70. Joseph Stella. *Bird of Paradise*. 1920. Crayon and silverpoint on paper, 13⅝×8″ (sight) (34.6×20.3)

right: 71. Joseph Raffael. *Birds in the Sky*. 1978. Watercolor on paper, 33¼×44″ (84.5×111.8)

art, like America itself, struggled to find its identity. From the founding of Jamestown in 1607 to the election of Lincoln in 1860, the visual arts played a minor role in the shaping of American culture. During the first hundred and fifty years of this period there were few professional artists on this continent. Objects of art were developed from folk and craft traditions. They were made by people whose primary occupations were other than artistic. Such works of sophisticated art as existed in America at this time were imported from Europe.

By the mid-eighteenth century, increased trade and interchange brought a more sophisticated cultural awareness to the citizenry of the increasingly prosperous towns and cities along the northeastern seaboard. More and more patrons and practitioners of the arts looked to the cultural centers of Europe for leadership. There were no art academies in eighteenth-century America, so most aspiring artists and architects went to Europe for their education. Patrons were few, and they tended to collect European works as often as

72. James Cook. *Crows and Sycamores*. 1981. Watercolor on paper,
69¾ × 94″ (3 panels) (sight) (177.2 × 238.8)

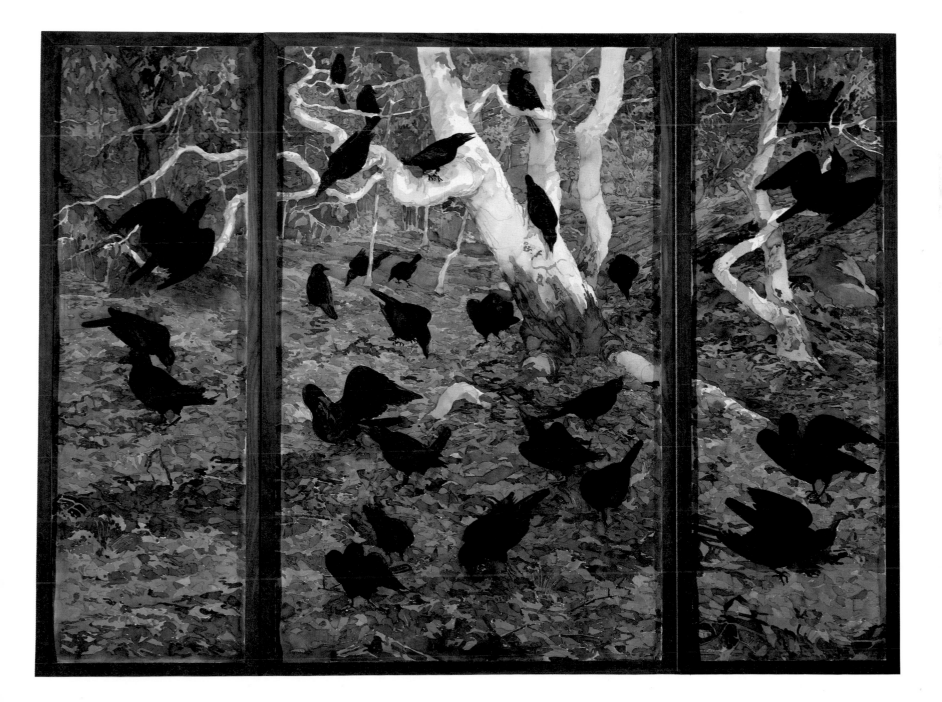

73. Billy Sullivan. *Texas Chianina Cow No. 1.* 1979. Pastel on paper, 41 13/16 × 26 1/8" (106.2 × 66.4)

American. Commissions were mostly limited to portraits and recordings of familiar scenes and possessions.

But American artists had at their disposal subjects available nowhere else—the new world and a revolutionary new country. The landscape and its inhabitants, both native and transplanted, were chronicled by a succession of artists who were trained in Europe or trained by those who had studied there.

By the end of the nineteenth century, two schools of thought in American art had evolved. One looked to Europe for intellectual and aesthetic stimulation; the other looked to nature and native subjects. Both attitudes were strengthened following the Civil War, when industrialism matured and pushed America more prominently into the mainstream of international affairs. The nation absorbed waves of immigrants from Europe, and the populations of the eastern seaport cities—as well as the nation's wealth—expanded rapidly. In these centers the necessary intellectual, social, and economic critical mass was reached—the stage when culture fuses and begins to grow of its own accord. By the beginning of this century, Philadelphia, Boston, and particularly New York had fully developed cultural institutions and the support systems necessary for them to flourish. Conditions for the living American artist, however, remained precarious. Many, indeed most, American artists continued to find that a period of time spent in Europe was essential to their training. But many American artists returned home either as missionaries of European styles or as informed seekers of something that would express their American origins.

The two most significant American artists of the late nineteenth century, Winslow Homer and Thomas Eakins, however, were largely indifferent to the art of Europe. Certainly they were familiar, from firsthand experience, with both academic art and early modernist styles such as Realism and Impressionism. They were also well versed in the styles of the great masters of the Renaissance, particularly the naturalists of the Dutch and Spanish Baroque. Their experience of European art, however, was absorbed as technical information. Both aligned themselves with the American realist tradition and turned their eyes with penetrating objectivity to the sights and people of the United States.

At the turn of the century, when the modernist spirit emerged in America, it took two parallel directions. One

left: 74. Don Nice. *Sun Valley Totem.* 1983. Watercolor on paper, 60 × 40″ (152.4 × 101.6)

above: 75. Ellen Lanyon. *Autumn,* from the series "Four Seasons." 1981. Colored pencil and watercolor on paper, 43¾ × 29¾″ (111.1 × 75.6)

evolved from native realism; the other was more intimately associated with contemporary European modernist schools and movements.

The first truly avant-garde association of artists in America was formed under the realist banner. This group, known as the "Ash Can School" or the "Eight," formed around Robert Henri (plate 127), a student of Thomas Anshutz, who had been Eakins's pupil and his successor as a teacher at the Pennsylvania Academy of the Fine Arts. The group originated in Philadelphia, then moved the center of its activities to New York in 1905. All of its original members, John Sloan (plate 128), George Luks, Everett Shinn (plate 130), and William Glackens (plate 129), were trained in the art of journalistic illustration. This gave them direct knowledge of the human drama in the rapidly growing cities in which they worked. Drawing was at the heart of their styles. Their activities as professional visual journalists demanded a quick eye for both the humor and the pathos of everyday life and an equally ready hand capable of direct and rapid notation. This necessity for sure and instantaneous transcription of momentary events gives each of these artists' drawings a robust immediacy that underlies their painting techniques. They were able to capture the fleeting gesture, the intimate view, or the anecdotal character of human interchange with a directness that recalls their roots in the work of the French Realists Courbet and Daumier. Like those artists of fifty years earlier, their motives were democratic and revolutionary. Their goal was to direct the attention of the inhabitants of Fifth Avenue mansions and Wall Street boardrooms away from the comfortable idealization of academic art to the vitality of modern life.

In 1908 Henri, Sloan, Glackens, Luks, and Shinn were joined in a group exhibition by three sympathetic but stylistically different painters: Ernest Lawson, Maurice Prendergast, and Arthur B. Davies. Lawson and Prendergast were both Impressionists in technique, but their subject matter, like that of the Realists, was drawn from the contemporary urban scene. Davies was a Symbolist who would soon bridge the gap between the Eight and the transatlantic group forming around the gallery of photographer Alfred Stieglitz.

Other artists, though not directly associated with the Ash Can School, were drawn into their orbit through sympathy with their aims. George Bellows (plate 124) knew and ad-

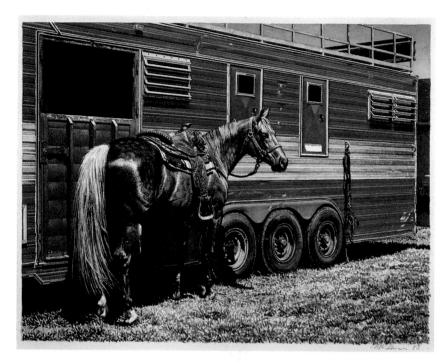

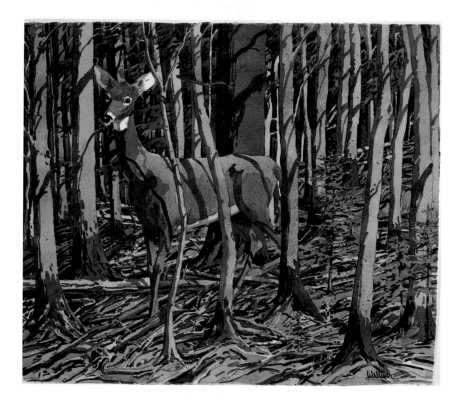

opposite above: 76. Richard McLean. *Sunduster.* 1983. Watercolor on paper, 12¾ × 16″ (sight) (32.4 × 40.6)

opposite below: 77. Neil Welliver. *Deer.* 1979. Watercolor on paper, 22³⁄₁₆ × 25⅜″ (56.4 × 64.5)

right: 78. Robert Laurent. *Dog.* c. 1920. Graphite on paper, 8¹⁄₁₆ × 12¼″ (sight) (20.5 × 31.1)

below right: 79. Joseph Piccillo. *Edge Event XXVI.* 1982. Graphite on canvas, 44⅞ × 60⅛″ (114.0 × 152.7)

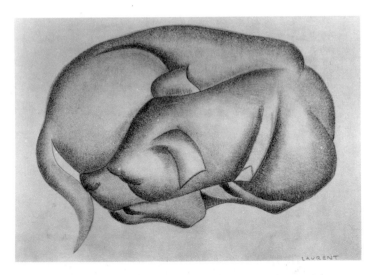

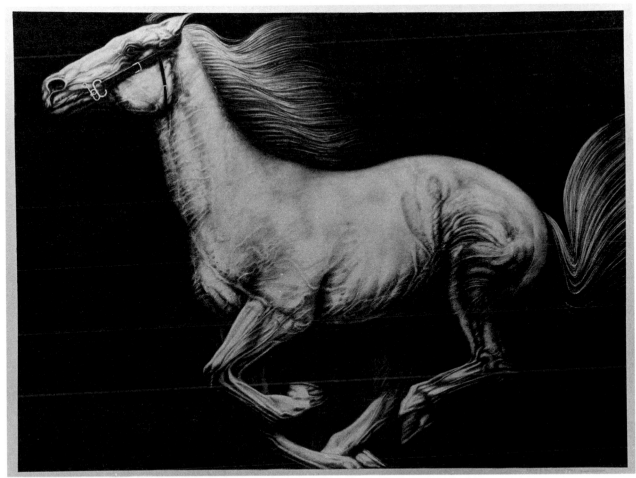

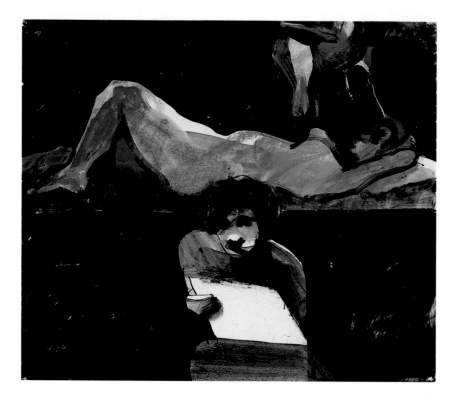

80. Theophilus Brown. *Three Figures.* 1965. Casein on paper, 11⅞ × 13¾″ (sight) (30.2 × 34.9)

81. Manuel Neri. *Gesture Study No. 11.* 1980. Oil crayon, turpentine, and acrylic on paper, 11¾ × 8¹¹⁄₁₆″ (sight) (29.8 × 22.1)

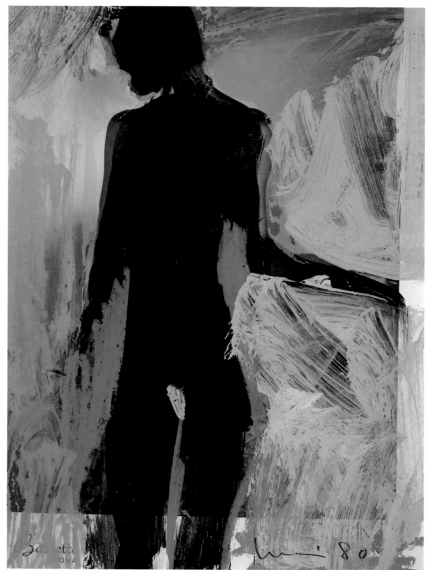

mired these artists, and his own gritty scenes of city life, particularly his images of workingmen and the boxing clubs they attended for entertainment, represent, in both style and subject matter, affinities not only for such Ash Can Realists as Luks but also for their predecessors Anshutz and Eakins. Other artists, such as John Rutherford Boyd (plate 214), who later created extremely sophisticated and elegant abstract sculpture, were also drawn to the subject of the city in the years before World War I. The iconography of the urban landscape and the direct representation of it as celebrated by the Eight became a continuous theme in American art of this century.

The years from 1905 until 1908 were as important in the history of American modernist art as they were to the art of Paris. These years saw the coalescence of the Eight in Manhattan and also the opening of the first private gallery in America devoted to the exhibition of the most advanced work of European artists and of those Americans who were inspired by them. The gallery, originally called the Photo-Secessionist, was founded by Alfred Stieglitz and his fellow photographer Edward Steichen in 1905. They immediately fell into financial difficulties, but the gallery was soon re-

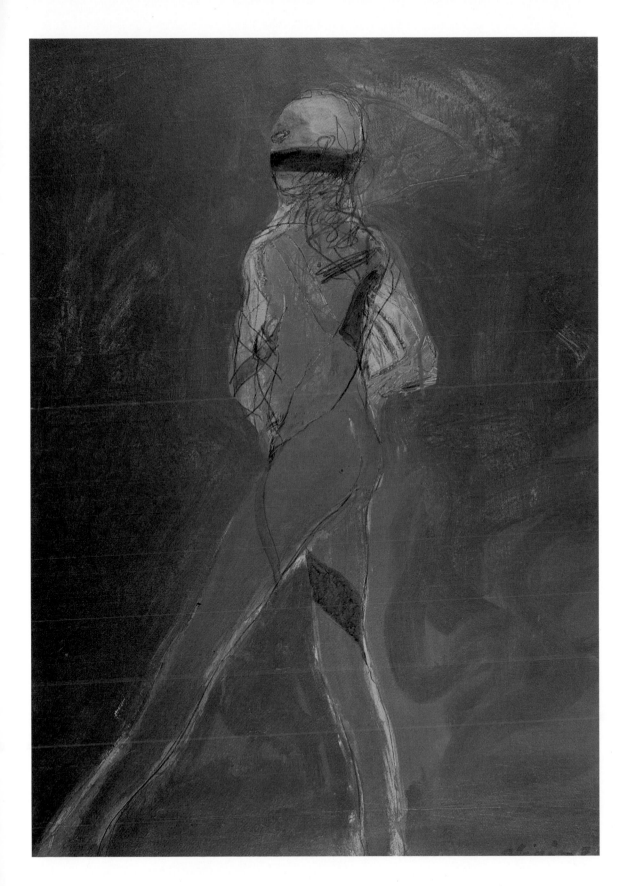

82. Nathan Oliveira. *Standing Figure with Black Band on Face*. 1979. Watercolor and acrylic on paper, 28¹⁵⁄₁₆ × 20¹⁄₁₆″ (sight) (73.5 × 51.0)

83. William Bailey. *Untitled (Figure Drawing).* 1975. Graphite on paper, 14⅜ × 10¹¹⁄₁₆″ (sight) (36.5 × 27.2)

84. Martha Mayer Erlebacher. *Woman in Chair I.* 1982. Graphite on paper, 13¹⁵⁄₁₆ × 10¹⁵⁄₁₆″ (sight) (35.4 × 27.8)

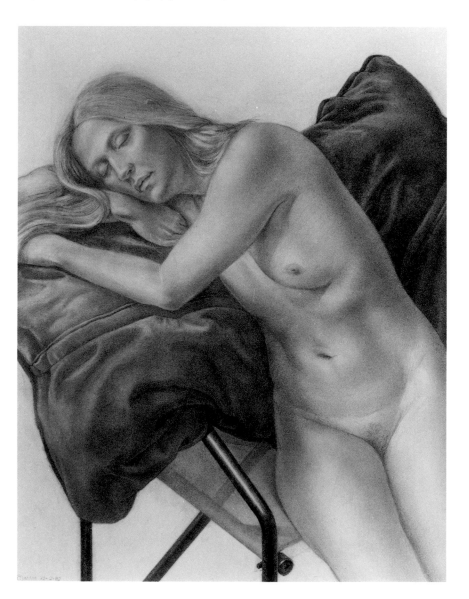

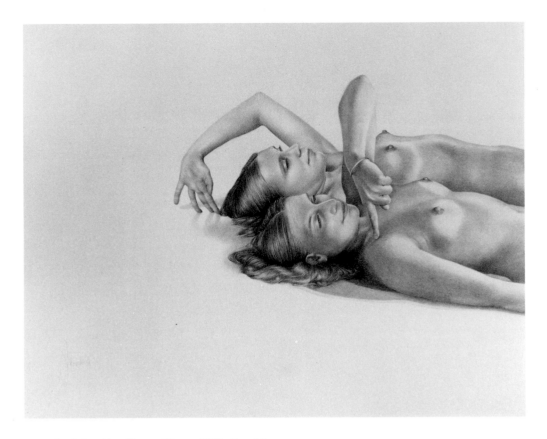

85. Julie Schneider. *House Wrens.* 1983. Graphite on paper, 22 × 28″ (sight) (55.9 × 71.1)

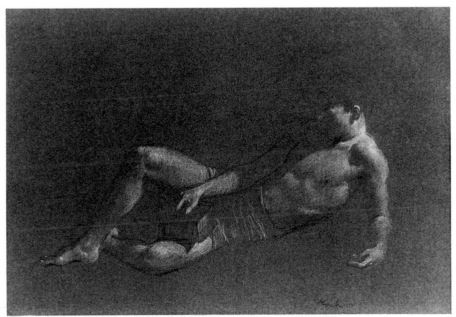

86. John Koch. *Nude Reclining—Study for Summer Night.* 1965. Graphite and chalk on paper, 9⅛ × 13⁵/₁₆″ (sight) (23.2 × 33.8)

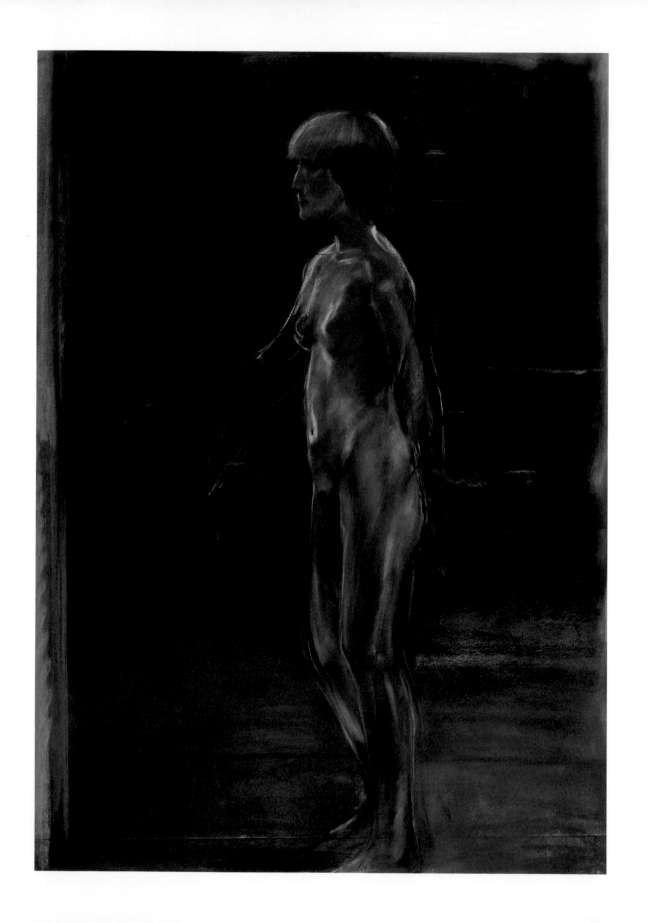

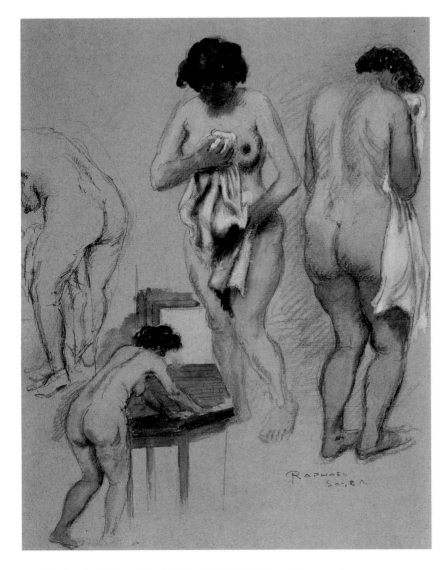

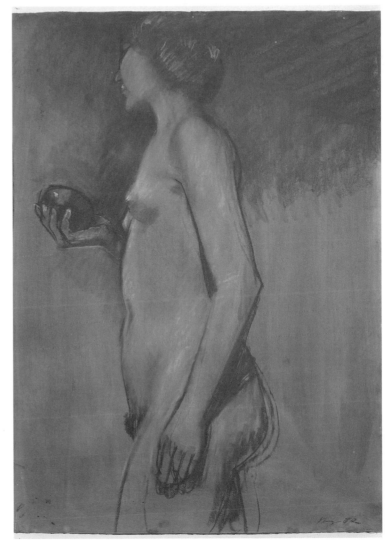

88. Raphael Soyer. Untitled. c. 1940. Graphite and watercolor on paper, 15½ × 11⅞″ (sight) (39.4 × 30.2)

89. Paul Georges. *Female Model with Apple.* 1982. Sanguine on paper, 41 × 29¼″ (104.1 × 74.3)

opposite: 87. Michael Mazur. *Gloria.* 1979. Pastel on paper, 49¼ × 34⅝″ (sight) (125.1 × 88.0)

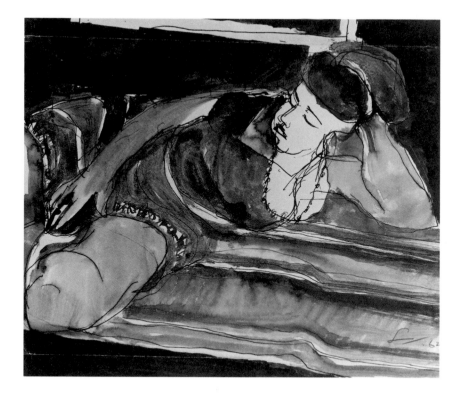

90. Frank Lobdell. *Reclining Woman*. 1962. Ink on paper, 13⁷⁄₁₆ × 15¹³⁄₁₆″ (sight) (34.1 × 40.2)

opened by Stieglitz in different rooms at the same address, 291 Fifth Avenue, from which the gallery took its name, 291.

Between 1908 and 1917, 291 was the showcase in America for such European luminaries as Matisse, Picasso, Constantin Brancusi, and Rodin. Stieglitz's interest in Cubism, Futurism, Fauvism, and Expressionism was also reflected in the American artists he showed. Marsden Hartley, Arthur Dove, Charles Demuth (plates 56 and 61), Charles Sheeler (plates 31, 54, and 152), Georgia O'Keeffe (plate 57), Joseph Stella (plates 70 and 112), Stanton Macdonald-Wright (plate 12), John Marin, and Max Weber all exhibited their works at 291 before World War I. Stieglitz was a frequent traveler in Europe, particularly France, where he became friendly with Gertrude Stein and her circle of artists and intellectuals. Thus such expatriates and transatlantic Ameri-

cans as Patrick Henry Bruce, Arthur B. Frost, Jacob Epstein, Alfred Maurer, Gaston Lachaise, and Elie Nadelman became associated to a lesser or greater extent with 291 or Stieglitz's other pioneering modernist art enterprise, his magazine *Camera Work*.

If modernism was late to arrive in America it was quick to take root. The Eight and other similarly disposed realists formed an uneasy alliance with the Stieglitz transatlantic circle. Both groups wished to oppose the stuffy conventionality of such institutions as the National Academy of Design and

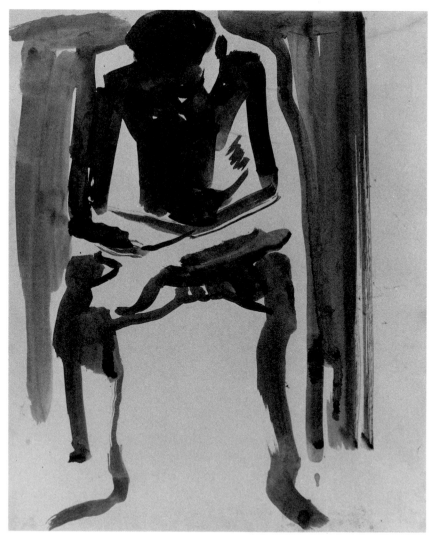

91. David Park. Untitled. c. 1955–59. Ink on paper, 16½ × 13⁵⁄₁₆″ (sight) (41.9 × 33.8)

92. Elmer Bischoff. *Figure with Knee Up.* 1959. Ink on paper, 13¼ × 16¹⁄₁₆″ (sight) (33.7 × 40.8)

Romanticism, Realism, Impressionism, Post-Impressionism and Symbolism. The show was at once an outrage and an enormous success. Irate conservative journalists, politicians, and public officials saw the exhibit as subversive and anarchistic, and they demanded its closing. The publicity, of course, attracted enormous public attendance. Many came to jeer but many more to try to understand. The exhibit's tour to New York, Chicago, and Boston was seen by an estimated half million viewers.

In addition to scoffers and the curious, the Armory Show attracted the attention of a number of serious collectors who became part of an ever-growing number of major patrons of modernist art. Among these were Arthur Jerome Eddy of Chicago, who in 1914 wrote an authoritative book on Cubism called *Cubists and Post-Impressionists* and who became a founder of the Chicago Arts Club; Dr. Albert C. Barnes of Merion, Pennsylvania, founder of the Barnes Collection; and John Quinn of New York, who became an important early collector of modernist painting and sculpture. In addition, Walter Arensberg of New York and Philadelphia,

the Metropolitan Museum of Art and to bring to public attention the achievements of the vanguard art of Europe and America. To this end a committee under the leadership of Arthur B. Davies was formed in 1911 to create a major international exhibit. This group, called the Association of American Painters and Sculptors, despite much competitive acrimony and internal squabbling, produced the *International Exhibition of Modern Art.* This comprehensive survey of recent and contemporary art included some sixteen hundred works by modernist artists from Europe and America. It opened in Manhattan's 69th Infantry Regiment Armory on Lexington Avenue between Twenty-fifth and Twenty-sixth streets on February 17, 1913, and became known as the Armory Show. The exhibit placed contemporary art within a historic framework established by works of art from such recent schools as

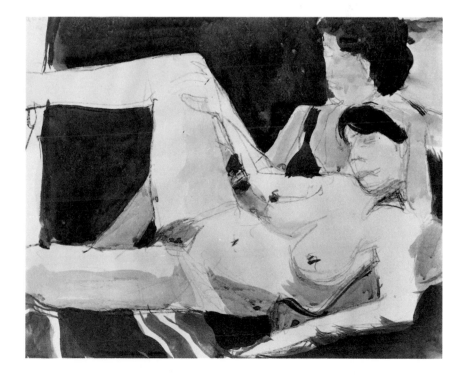

93. Richard Diebenkorn. *Two Nudes.* 1962. Graphite and gouache on paper, 13¹⁵⁄₁₆ × 16⅞″ (35.4 × 42.9)

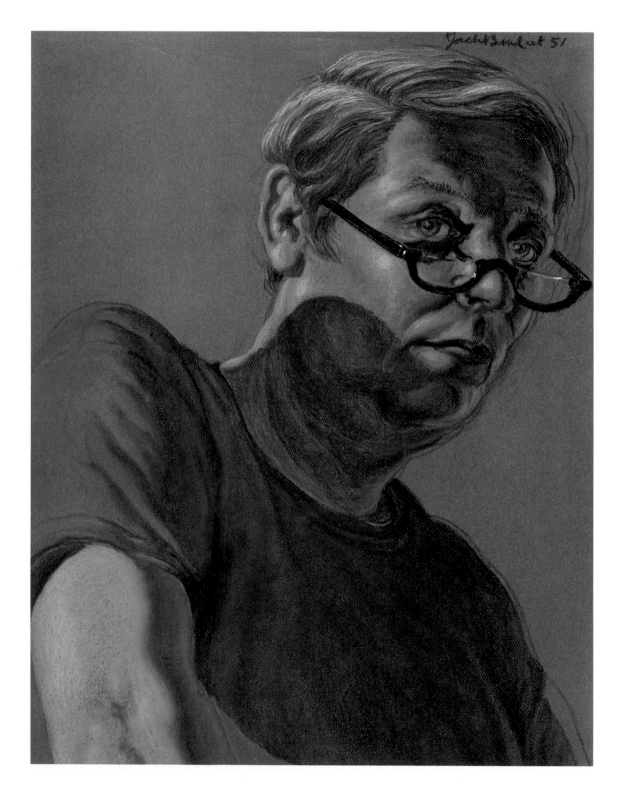

94. Jack Beal. *Self-Portrait*. 1982.
Pastel on paper, 25½ × 19¹¹⁄₁₆″
(64.8 × 50.0)

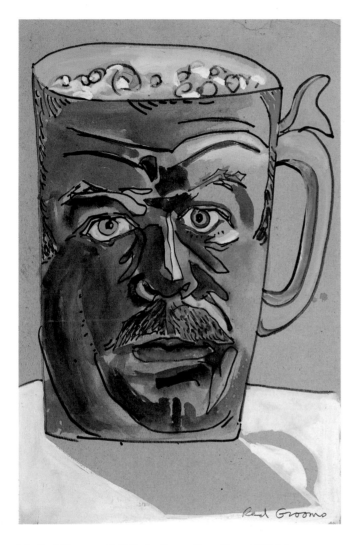

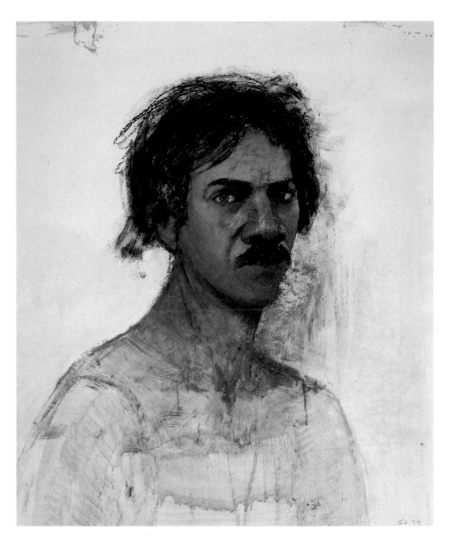

95. Red Grooms. *Self-Portrait as a Beer Mug*. 1977. Water-color on cardboard, 25 × 16¹⁄₁₆″ (63.5 × 40.8)

96. Gregory Gillespie. *Self-Portrait*. 1979. Oil on paper, 24 × 20″ (sight) (61.0 × 50.8)

Abby Aldridge Rockefeller, Lillie P. Bliss, Gertrude Vander-bilt Whitney, Katherine S. Dreier, and A. E. Gallatin were not only inspired to begin major collections but also to become involved with the founding, during the 1920s, of new and permanent public institutions, which would become America's premier showplaces of modern and contemporary art.

For the American artists who were among the organiz-ers and participants in the Armory Show, its results were de-cidedly mixed. They had hoped to show their work to be coequal to that of their European counterparts. In this they were disappointed. The vitality and quality of the European art were distinctly greater than in the American, and amid the revolutionary works of the Fauves, Expressionists, and Cubists, the Realist school particularly was temporarily eclipsed. Nonetheless, modernist art had arrived in America as a force to be reckoned with.

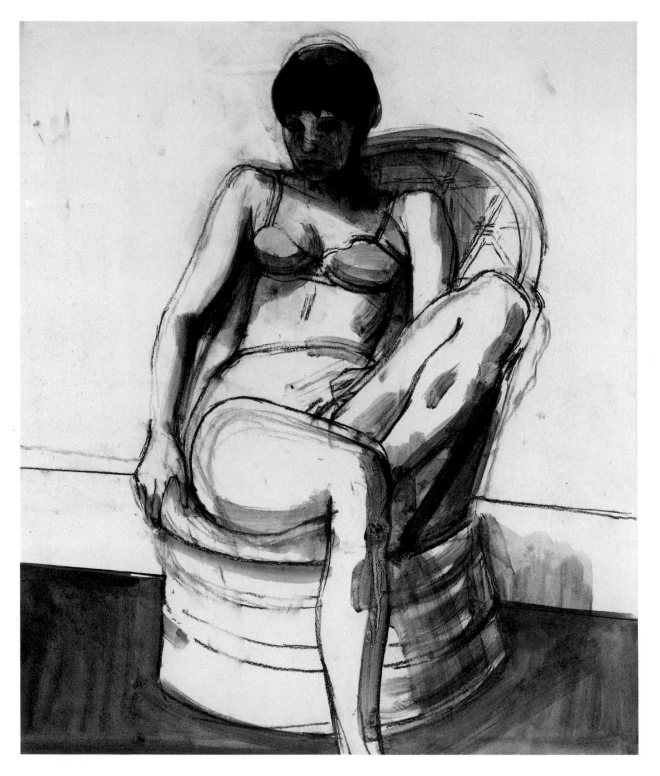

97. James Weeks. *Girl in Oval Chair.* 1966. Charcoal and gouache on paper, 22⅝ × 19″ (sight) (57.5 × 48.3)

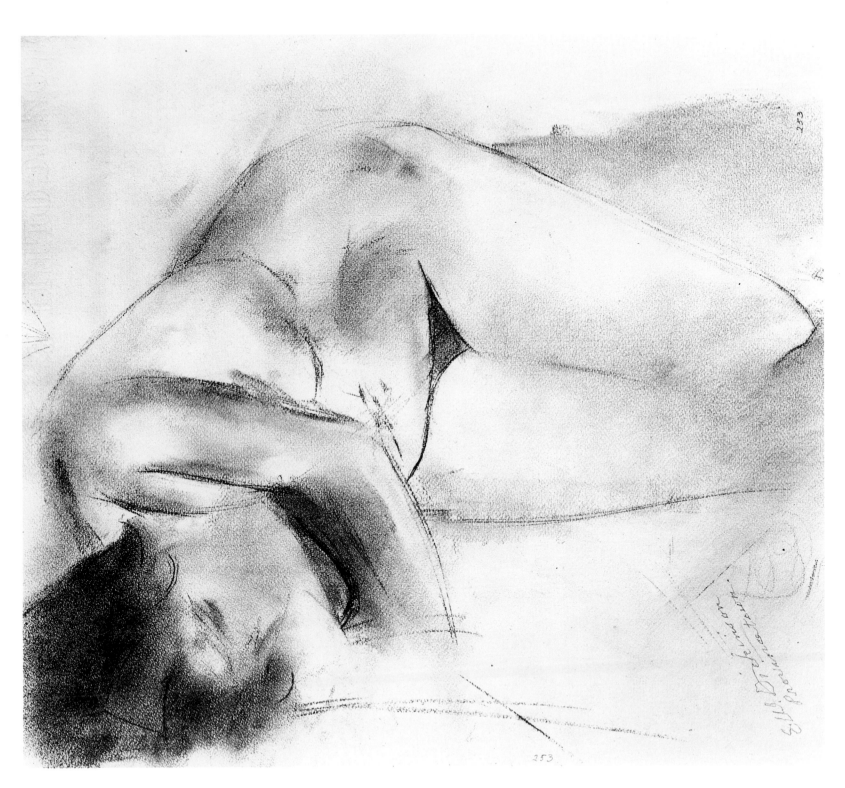

98. Edwin Dickinson. *Nude, Provincetown.* c. 1920. Charcoal on paper,
13 × 14¾″ (33.0 × 37.5)

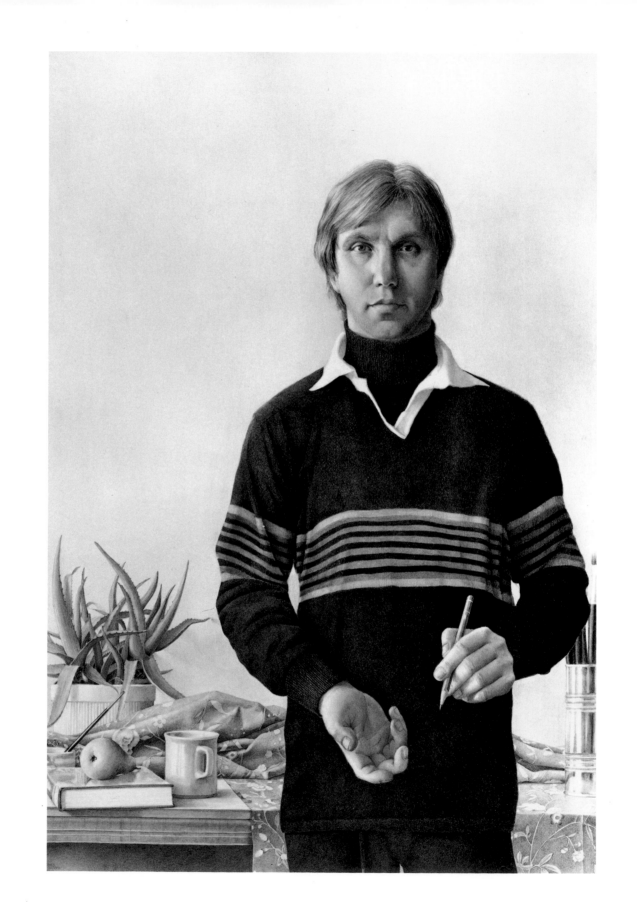

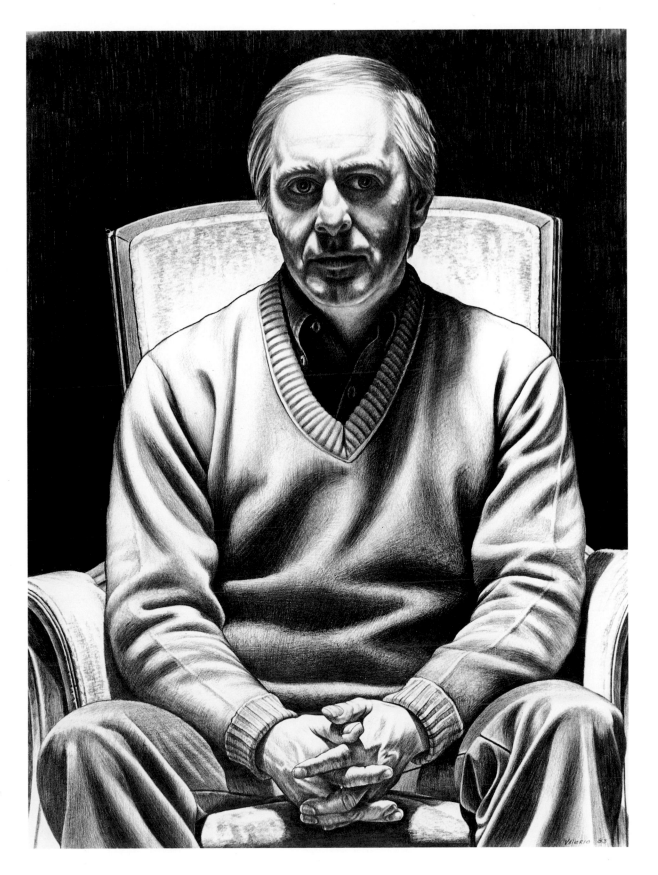

opposite: 99. James Aponovich. *Self-Portrait with Aloe.* 1983–84. Graphite on board, 23 11/16 × 15 15/16" (sight) (60.2 × 40.5)

100. James Valerio. *Self-Portrait.* 1983. Charcoal on paper, 30 1/8 × 22 3/8" (76.5 × 56.8)

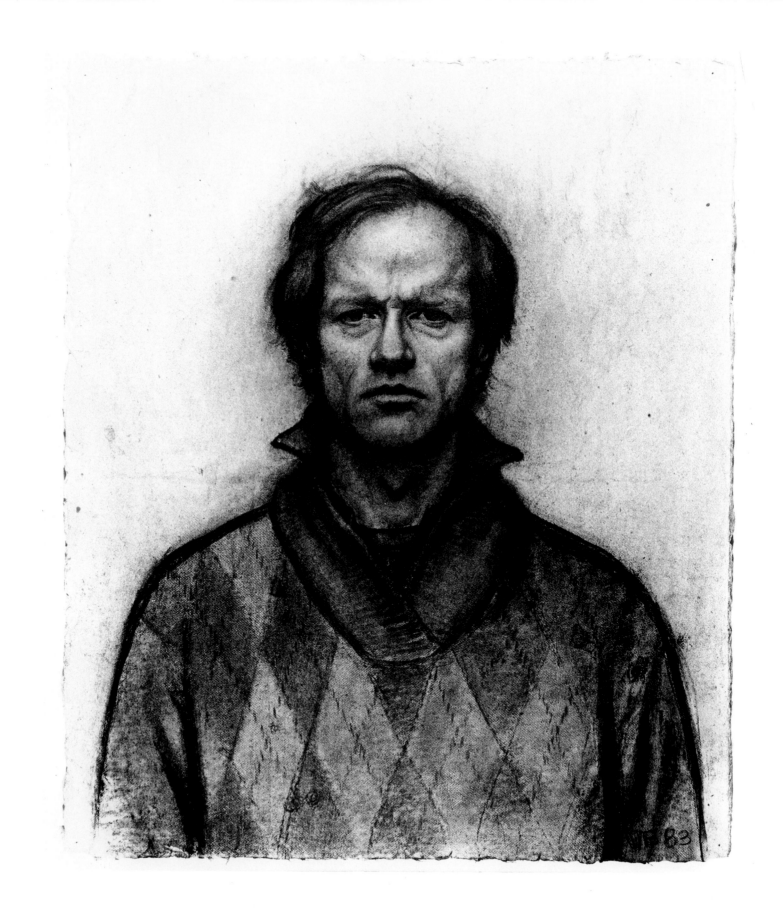

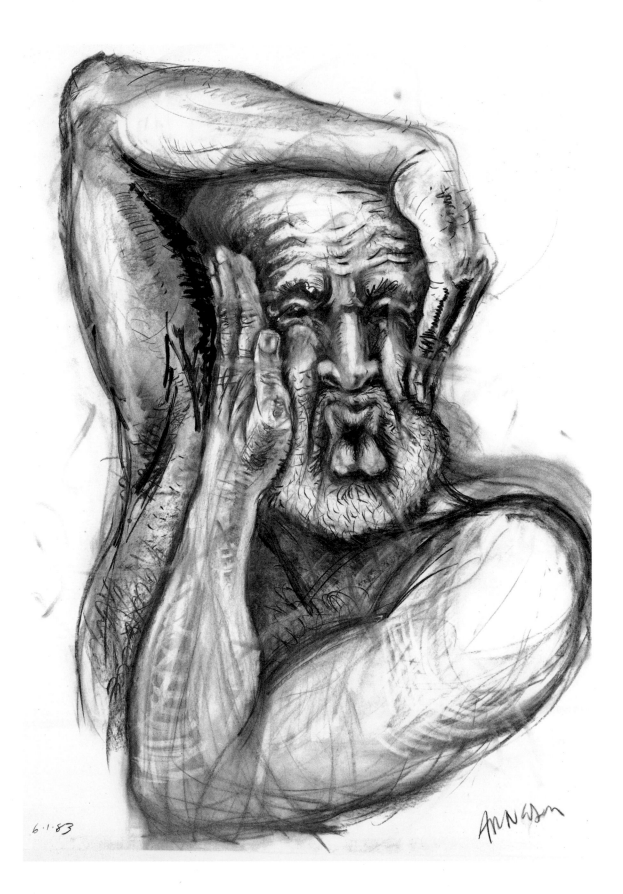

6·1·83

Arneson

opposite: 101. William Beckman.
Self-Portrait. 1983. Charcoal on
paper, 29⅛ × 24⅜″ (74.0 × 61.9)

right: 102. Robert Arneson. Head
Squeeze. 1984. Charcoal on paper,
59⁹⁄₁₆ × 42¼″ (151.3 × 107.3)

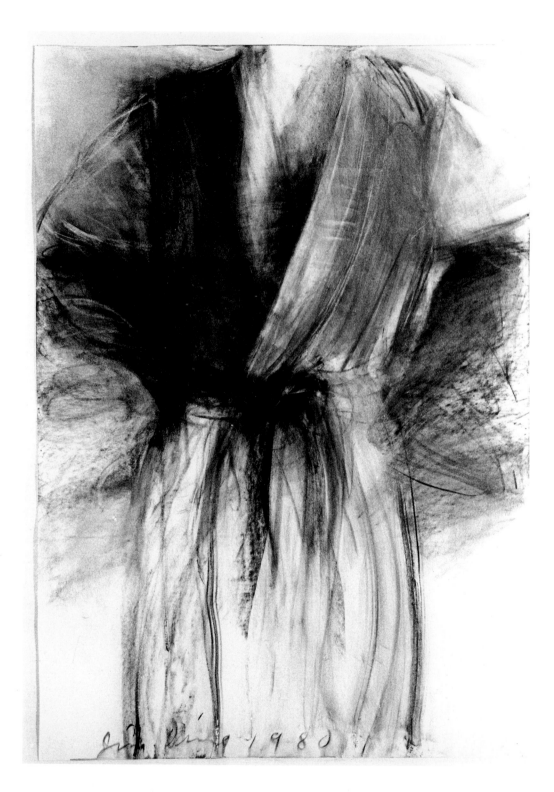

103. Jim Dine. *Visiting with Charcoal II*. 1980.
Charcoal on paper, 59¼ × 41¹⁄₁₆″
(150.5 × 104.3)

The outbreak of war in Europe in 1914 had a chilling effect on transatlantic artistic interchange. Many American artists who lived in Germany, France, or Italy were forced to return home, and some Europeans who disapproved of the war immigrated to America. Most significant among these was Marcel Duchamp, a central figure in the Armory Show, who, along with Francis Picabia and the American expatriate Man Ray, came to New York to form the core of the Dada movement in the United States. Duchamp lived in America for most of the remainder of his career and became a major figure in the expansion of modernism here.

Following the war, the modern movement again took on momentum in the United States. Institutions supporting modernism flourished. Duchamp became an advisor to Arensberg—whose collection became the core of the Modern Art department of the Philadelphia Museum of Art—and joined with Katherine Dreier to form the Société Anonyme. This organization produced a series of avant-garde exhibits, published pamphlets and catalogues, and sponsored lectures. In 1927 A. E. Gallatin opened, at New York University, his Museum of Living Art (which became the Gallery of Living Art in 1933), in which he used his own collection to form the foundation of a series of historical surveys of modernist art. Lillie P. Bliss and Abby Aldridge Rockefeller formed the collection that in 1929 became the nucleus of the Museum of Modern Art in New York, the first and most prestigious institution of its kind. During the 1920s, Gertrude Vanderbilt Whitney, herself a talented sculptor, formed an association of artists called the Whitney Studio Club, which in 1930 became the Whitney Museum of American Art.

The philosophical and stylistic polarity between the American Realists and the transatlantic Abstractionists became more pronounced after World War I. Disillusioned by the war, Americans became increasingly disenchanted with their relationship to Europe. Many American artists who, before the war, had been attracted to such movements as Cubism abandoned their abstractionist inclinations and turned to the realist tradition.

In the 1920s such artists as Charles Sheeler (plates 31, 54 and 152), Charles Demuth (plates 56 and 61), Joseph Stella (plates 70 and 112), Preston Dickinson (plate 126), and Georgia O'Keeffe (plate 57) denied the abstract or expressive tendencies in their earlier work to form the core of the Preci-

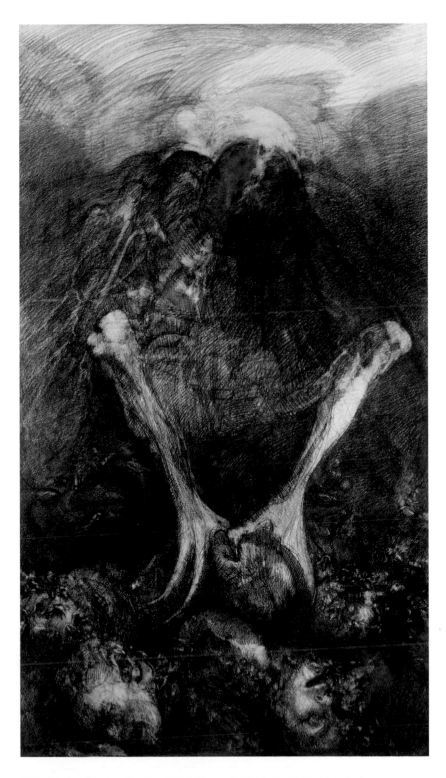

104. Hyman Bloom. *On the Astral Plane: Beelzebub*. 1966. Charcoal on paper, 65⅝ × 36¼″ (sight) (166.7 × 92.1)

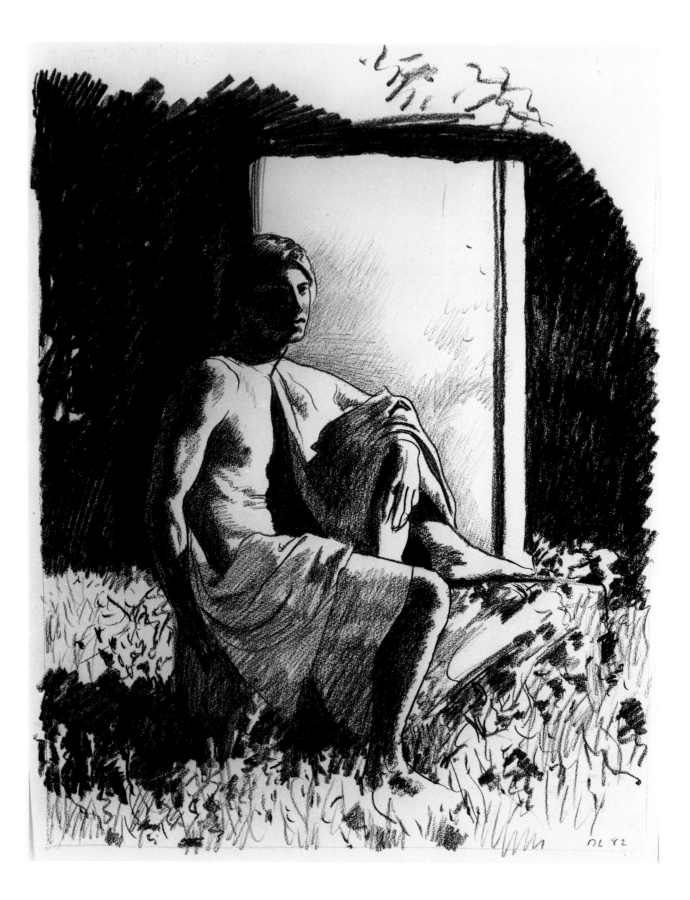

sionist movement. Precisionism—sometimes called Cubist Realism—attempted to combine the underlying geometrical order of Cubism, Futurism, and Constructivism with direct and analytical observation of the natural and architectural forms visible in the American landscape. The rigorous nature of their technique was in accord with that quintessentially American tradition, Puritanism, and the highly finished surfaces of their work inspired another name for these artists: the "Immaculates."

Their drawings and watercolors, like their paintings, indicate the mechanistic, rational, and nationalistic aesthetic of this group. Sheeler, who had encountered Fauvism before World War I, began his Precisionist style through a series of drawings—such as *Side of a Barn*, 1917 (plate 31)—of buildings in Bucks County, Pennsylvania, where he lived prior to his move to New York City about 1919. The crystalline draftsmanship of these pictures was extended to become the basic vocabulary of his celebrations of American industry. Sheeler's vision, like that of O'Keeffe, was also informed by his association with the photographers of the Stieglitz circle. He was an excellent photographer himself and was on intimate terms with Edward Steichen, Paul Strand, and Edward Weston. O'Keeffe's own close-up views of plants and flowers and her stark renderings of architecture stem from her association with Stieglitz—whom she married—and his colleagues. To a lesser degree, the clarity and accuracy of the photographic image played a part in the styles of all of the Precisionists.

Charles Demuth, who had been an Expressionist, began the works that brought him to Precisionism on a trip to Bermuda in 1917 with his close friend Marsden Hartley. His intimate watercolor still lifes with their emphasis on highly controlled, transparent overlapping contours give insight into the origins of the light planes and rays he used so emphatically in his industrial landscapes.

George Ault had been academically trained at the Slade School in London, but upon his return to the United States in 1911, he began to seek inspiration from American primitive art.

Other artists drew upon Precisionism in the 1920s. Henry Lee McFee (plate 30) turned his Cubistic Cézanneism toward American subjects. Blanche Lazzell (plate 26), Louis

Bouché, and Frank Stamato also revealed Precisionist affinities in otherwise Cubist styles.

The Precisionist aesthetic had a lasting effect on American painting. A latecomer to the movement, Peter Blume (plate 50), was initially attracted to a neo-primitive style similar to that of Ault. In the 1930s his imagery was influenced by the Fantastic Surrealism of Magritte and Dali, but he maintained the smooth surfaces and taut contours of Precisionism. He and Andrew Wyeth, who was also influenced by the Precisionist circle, became known as Magic Realists. Other artists, such as George Tooker, Jared French, and Grant Wood (plate 224), also exhibited compulsive clarity and control that show at once inflections proposed by Sheeler, O'Keeffe, and their circle, as well as those of Surrealism. Even today, in the works of certain Photo Realists such as Robert Bechtle (plate 135), Robert Cottingham (plate 229), and Richard Estes (plate 231), we can feel the influence of the hard-edged images of industrial America produced by the Precisionists.

Other figurative artists who were disaffected with European modernism began to turn a suspicious eye on their transatlantic abstractionist colleagues and on the euphoric urban sophistication of Jazz Age society, which they viewed as decadent. Thomas Hart Benton (plates 132 and 206), Grant Wood (plate 224), Charles Burchfield (plate 48), and John Steuart Curry (plate 133) turned toward a troubled American heartland.

Successive years of bad weather in the Great Plains and the Midwest, combined with poor conservation methods, created the preconditions for economic disaster in American agriculture, and it came in the dust-bowl years of the late 1920s and early 1930s. Benton, Curry, and Wood sought to record the dignity and despair, the simplicity and durability of the pioneer spirit that had formed the agricultural regions of the country. To this end they traveled, taught, and painted in the Midwest, the South, and the Southwest and became the driving spirits of Regionalism in American art of the late 1920s and early 1930s.

It has become customary to denigrate the Regionalists—also called the artists of the "American Scene"—as reactionaries. It should be recalled, however, that the authors of such criticism usually write from an abstractionist point of

opposite: 105. David Ligare. Study for *Et in Arcadia Ego.* 1982. Charcoal on paper, 18⅜ × 14⅛" (sight) (46.7 × 35.9)

view. Although it is true that the American Scene painters were vociferous in their denouncements of transatlantic abstraction and its supporters, it is also true that the regionalists' artistic intentions were not reactionary or even conservative. In spirit, their aims were positive, similar to those of Courbet in the 1840s or the Ash Can School in 1908, but their styles did not come from these sources. Benton, for example, in his agitated elongations and mannered, almost caricatured representations, shows considerable affinity with an international style of representational social-protest art of the period, particularly with that of such German *Neue Sachlichkeit* (New Objectivity) painters as Otto Dix and Max Beckmann. Curry's heroic poses and gestures emphasize his subjects in a way that is similar to the political imagery of his Mexican contemporaries José Clemente Orozco, Diego Rivera, and David Alfaro Siqueiros.

The disintegrating conditions in the rural economy heralded the general economic catastrophe that followed the Wall Street crash of 1929. America, along with Europe, descended into the Great Depression.

As the economy worsened and unemployment grew, the concern implicit in the populist art of the Regionalists of the American Scene found more overtly political expression in the work of the Social Realist artists who depicted the people of urban America. Edward Hopper (plates 123 and 203), whose long career began at the turn of the century, depicted incidentally observed scenes of loneliness. Reginald Marsh (plate 204) and the brothers Moses, Isaac, and Raphael Soyer (plate 88) studied individuals lonely in the crowd or crowds losing their individual identity. Ben Shahn, William Gropper (plate 134), and Jack Levine took a more blatantly polemical stance. Like the painters of George Grosz's *Neue Sachlichkeit* and the Mexican muralists, they sympathetically portrayed the downtrodden and attacked the oppressors, corruptors, and the corrupted through expressionistic satire and irony.

During the 1920s and 1930s, the momentum of America's representational artists gained strength and exposure at the expense of the transatlantic abstractionist avant-garde. Despite the enthusiastic support of European modernism from the Société Anonyme, Gallatin, and the Museum of Modern Art, under the directorship of Alfred H. Barr, Jr., American nonrepresentational artists were, if not ignored, at

106. Laurence Dreiband. *Rodin, A Loan No. 1*. 1984. Charcoal and oil stick on paper, 57¹/₁₆ × 42¹/₁₆" (144.9 × 106.8)

107. Laurence Dreiband. *Rodin, A Loan No. 2*. 1984. Charcoal and oil stick on paper, 57¼ × 42⅛″ (145.3 × 107.0)

the least treated coolly. Many Americans who embraced abstraction and identified with European movements chose to live abroad or to spend long periods of time there.

Other American artists who had seemed closely aligned with abstraction vacillated in their styles. Stuart Davis, for example, despite his interest in Cubism, adapted it to represent an American urban iconography. Arthur Dove experimented with several styles simultaneously. He remained comfortable with abstraction, employed popular imagery inspired by Dada, and even explored the machine aesthetic of the Precisionists, albeit in a more Expressionist mode.

Social reforms instituted by New Deal reformers led to the creation of centralized governmental patronage of the arts. Public art commissions instituted by the Federal Art Project of the Works Progress Administration had far-reaching consequences that increased the level of competitive vituperation between the representational artists and the abstractionists. As these public projects were done in concert with state and local governments, the more accessible nature of representational and realistic imagery resulted in more awards for the realists than for the abstract artists' works, which often seemed foreign and arcane to local populations. The influence of the Regionalists spread to the provinces as federal and state officials contracted with such nationally known figures as Benton and Curry and with local artists to create murals and sculptures to adorn hundreds of post offices, courthouses, libraries, banks, parks, and airports. This regional exposure had one very positive influence on the art of the nation. State and private universities began to adopt the role of the Academy. Art departments were created in practically every state, and they required faculty. This supplied an additional form of patronage—teaching—which has since become the fundamental support of artists in America. The creation of art and art-history departments brought increased artistic awareness to Americans and lent authority to the professional practice of art. New York continued to be the artistic epicenter and point of exchange, but young artists from other areas of the United States were added to the ranks of the country's creative population.

Abstract Expressionism

In the 1920s and early 1930s the abstract movement was in retreat in America. By the mid-1930s, however, with the help

107

of some timely reinforcements from Europe, abstraction made a remarkable counterattack. As one European country after another succumbed to totalitarianism and war broke out, America welcomed dozens of the most talented European modernist artists. In return, as lecturers, teachers, or simply by example, they provided catalytic energy that rapidly transformed American painting and sculpture. The leading figures of the Bauhaus, Mies van der Rohe, Walter Gropius, and Josef Albers, came to America and continued their distinguished careers. The Surrealists came to America almost in toto, as did such prominent *Neue Sachlichkeit* artists as Grosz and Dix. The Purists Ozenfant and Léger, the Constructivists Moholy-Nagy and Naum Gabo, and the Geometric Abstractionists Mondrian and Jean Hélion all settled in or around New York City in the years just before or during World War II. They were joined by their formerly expatriated American associates.

The presence of such luminaries and their accessibility to the maturing generation of American artists and critics revitalized American abstraction. Particularly important was the influence of Albers, Mondrian, and Hans Hofmann—as exemplars of abstract theory and practice—and that of Miró and Masson.

The mingling of biomorphic Surrealist subconscious symbolism with the formal principles of pure abstraction and expressionistic angst resulted in America's first significant contribution to international modernism, Abstract Expressionism. This movement, which gathered momentum in the late 1930s and consolidated its aims in the 1940s, was founded by the immigrant Americans Mark Rothko, Arshile Gorky, Willem de Kooning, Jack Tworkov, and Hans Hofmann, and a band of artists from diverse regions of the United States: Jackson Pollock, Franz Kline, James Brooks, William Baziotes, Mark Tobey, Robert Motherwell, Bradley Walker Tomlin, Clyfford Still, Richard Pousette-Dart, Lee Krasner, Grace Hartigan, Ad Reinhardt, Sam Francis, and Philip Guston. They received critical support from three important literary men, the art critics Clement Greenberg, Harold Rosenberg, and, somewhat later, Leo Steinberg. New galleries such as Peggy Guggenheim's Art of This Century showed the New York School artists in favorable comparison to their European colleagues.

Between 1941 and 1945, the art world in New York remained viable and growing despite the war effort, whereas in Europe modernist artistic activity had slowed almost to a halt. When peace came, the geopolitical poles had shifted. The United States emerged as the world's most powerful nation, and its cultural influence changed. Between 1945 and 1955, New York superseded Paris as the leading center for advanced art. It was here, between 1945 and 1969, that the modernist movement was to experience another brilliant period.

The first ten years following World War II saw the maturation of the Abstract Expressionist style and the phenomenal growth of its influence. The importance of art criticism in this period cannot be overstated. Enrollments in art schools and art departments increased steadily in the postwar years, and museums, art centers, and university art galleries with an interest in contemporary art increased in number and in quality. The combined educational impact of these institutions increased the audience for contemporary art, instituting a trend that has been gaining momentum ever since. This audience brought about a dramatic expansion of the art press. Before World War II, the main source of publication for avant-garde criticism had been intellectual journals with relatively small circulations. By the late 1950s, however, the art press had avid readers among art students, teachers, curators, and patrons throughout the country. This gave critical writing a national forum and national influence.

From the late 1940s until the late 1960s, abstraction was dominant in American art and art education. The importance of the monumental achievements of the Abstract Expressionists and their sponsoring critics during this period was largely responsible for the tidal wave of influence abstraction had on the shape of art in this country. Particularly influential was the writing of Clement Greenberg, whose contribution to critical and theoretical thinking about art in the first two decades after World War II cannot be overestimated. Greenberg became an outspoken advocate of avant-garde art in the late 1930s, and during the next three decades he became a theorist and defender of the New York School and charted the direction of abstract movements thereafter. He developed his concept of formalism with such high-minded intellectual rigor that it became the guiding force in

modernist thinking. To Greenberg, quality in art was a matter of reduction and purification. Abstract Expressionism rid itself of representation and left, through this gesture, the trace of pure emotional energy. Art's form and content should be one and the same, Greenberg believed. Therefore the next step was to reduce further the art object to a completely self-contained entity devoid of external reference. So powerfully was he able to elaborate this theory that not only was it accepted by most of his contemporaries but it also influenced a generation of younger artists, critics, and curators. Abstract Expressionism, Post-Painterly Abstraction, Color Field, and Primary Form aesthetics, all governed by formalist theory, seemed to project an irreversibly abstract course for the art of the twentieth century.

But just as the abstract formalist consensus reached its maximum influence, cracks began to appear at its base. One

108. Joan Brown. *Monika and Bird*. 1977. Acrylic on paper, 22 × 16½″ (55.9 × 41.9)

right: 109. Mel Ramos. *I Still Get a Thrill When I See Bill No. 10*. 1976. Watercolor on paper, 22⁷⁄₁₆ × 29⅝″ (57.0 × 75.3)

110. Aaron Shikler. *Head of a Man: Back View*. 1982. Charcoal on paper, 9⅝ × 9½″ (sight) (24.5 × 24.1)

111. Alex Katz. *Ronnie*. 1978. Graphite on paper, 22 1/16 × 14 15/16″ (56.0 × 37.9)

opposite: 112. Joseph Stella. *Peasant of Muro Lucano*. 1943. Silverpoint and graphite on paper, 29¾ × 21⅝″ (sight) (75.6 × 54.9)

Joseph Stella 1943

113. Paul Wonner. *Portrait of Bart Howard in a Mirrored Room*. 1964.
Casein on paper, 16⅝ × 13¾″ (sight) (42.2 × 34.9)

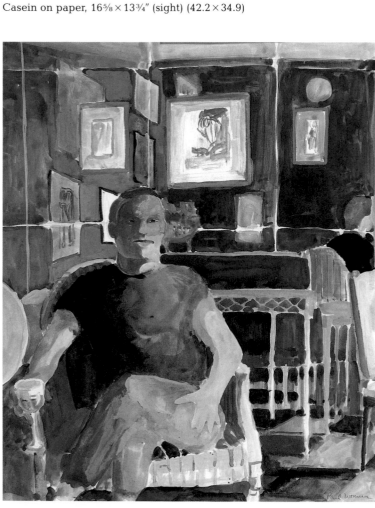

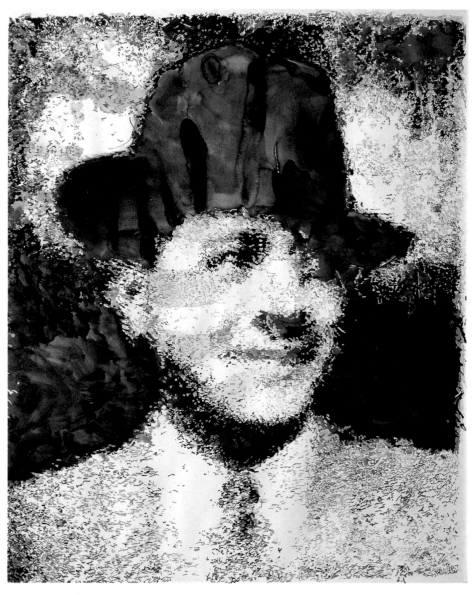

114. Judy North. *Quantrell II*. 1979. Watercolor on paper,
52⁹⁄₁₆ × 42⁹⁄₁₆″ (sight) (133.5 × 108.1)

opposite: 115. Alfred Leslie. *Pierre and Marcel Monnin*. 1975. Graphite and
wash on paper, 39⅝ × 29½″ (sight) (100.7 × 74.9)

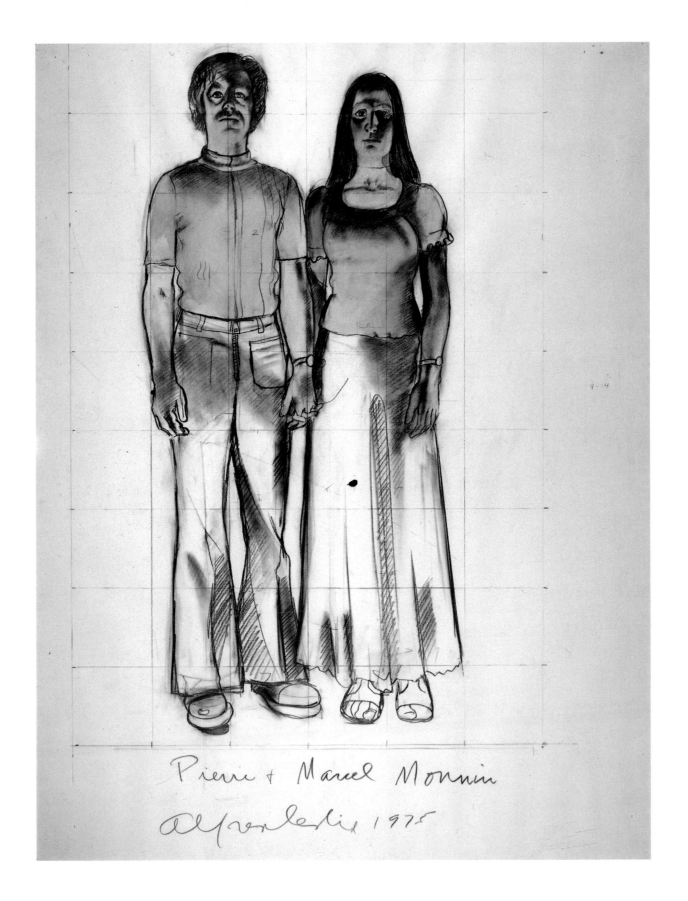

Pierre & Marcel Monnin

Alfred Leslie 1975

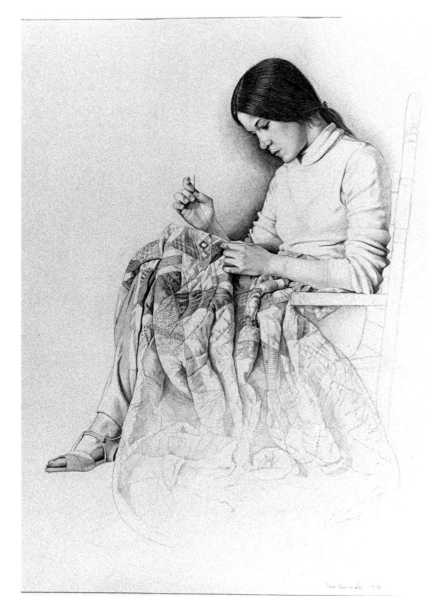

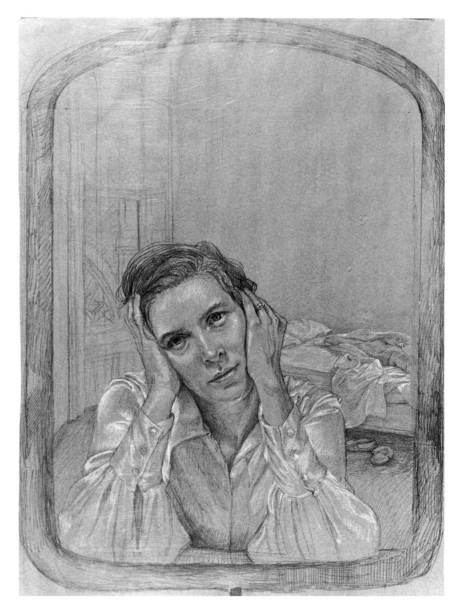

116. Ian Hornak. *Marcia Sewing No. 4*. 1978. Graphite on paper, 41¹⁵⁄₁₆ × 29¼″ (sight) (106.5 × 74.3)

117. Willard Midgette. Study for *Portrait of Sally*. 1977. Charcoal on paper, 34¾ × 25⅝″ (88.3 × 65.1)

opposite: 118. Chuck Close. *Gwynne*. 1981. Stamp-pad ink on paper, 43³⁄₁₆ × 30⁵⁄₁₆″ (109.7 × 77.0)

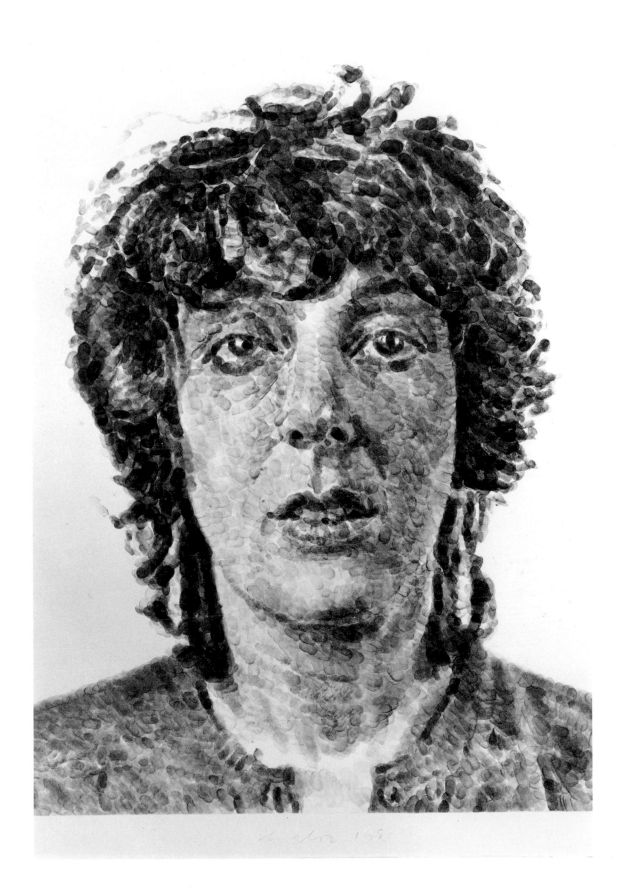

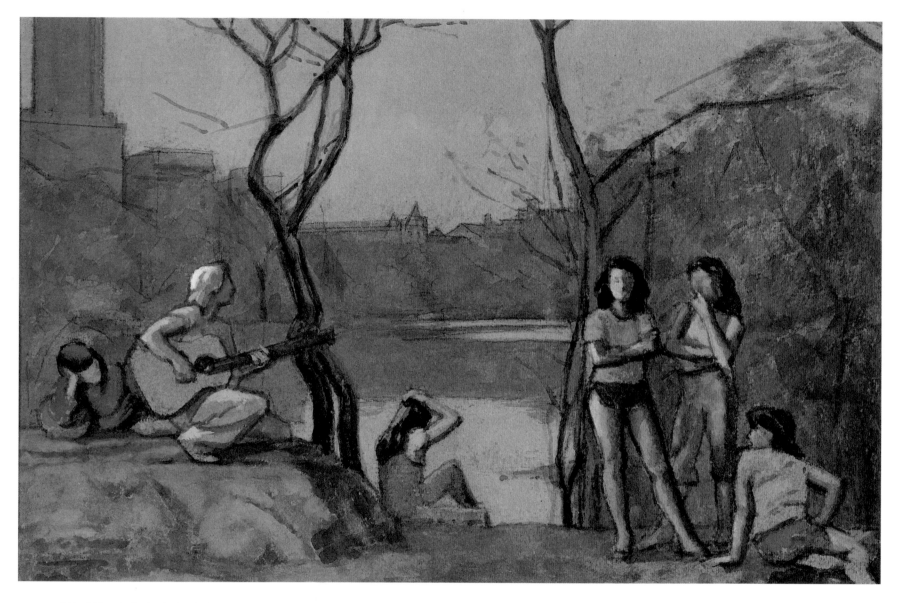

119. Milet Andrejevic. Study for *Apollo and Daphne*. 1982. Gouache on paper, 7½ × 11½″ (sight) (19.1 × 29.2)

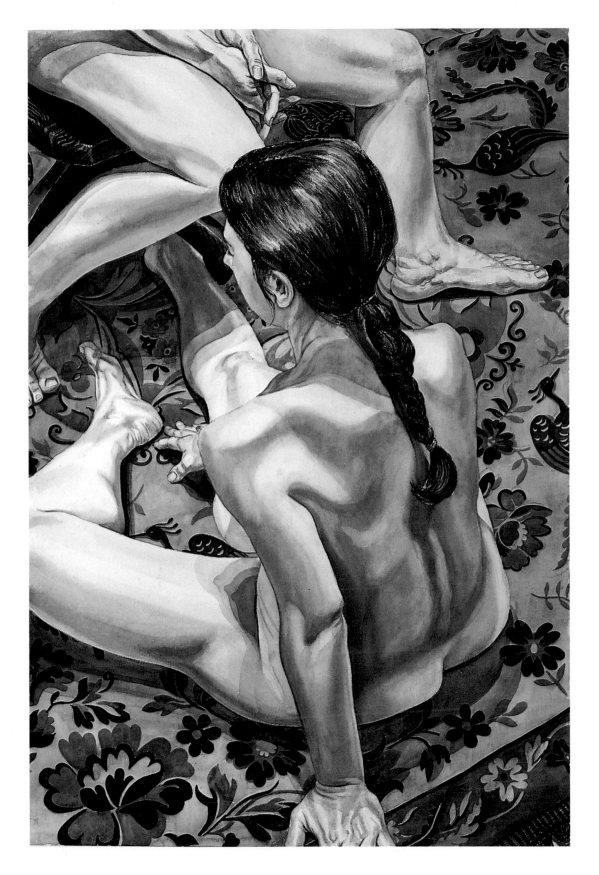

120. Philip Pearlstein. *Two Models on Spanish Rug*. 1982. Watercolor on paper, 59¹³⁄₁₆ × 39¹⁵⁄₁₆″ (151.9 × 101.4)

of the most fundamental tenets of avant-garde thinking was the belief in artistic freedom. If formalist abstraction set proscriptions against representation in art, it was inevitable that these rules would be challenged, and they were. The first signs of revolt occurred in the early 1950s and came from within the Abstract Expressionist circle itself. Two of its leading figures, de Kooning and Pollock, reintroduced figurative imagery in their work. About 1955 there emerged, simultaneously in England and in the United States, a number of artists who drew upon the Dadaist example by dealing with contemporary reality on its own terms. They challenged the inevitability of abstract form by co-opting both images and actual objects from the mundane reality of the commercial detritus of modern life, thus founding the phenomenon that came to be called Pop Art.

Pop Art

Pop Art was decidedly impure and apparently impudent in its confrontation with the seriousness of formalist theoretical principles and with life itself. The irreverent images of Jasper Johns's flags or Robert Rauschenberg's combinations of newspaper-image silk screens with junkyard symbols of American culture took an undifferentiated view of art and mass society. Other artists associated with Pop seemed to celebrate the intersection of culture and vulgarity with a non-specific irony. Andy Warhol's soup cans, Roy Lichtenstein's comic strips, Claes Oldenburg's fast foods, and Tom Wesselmann's American nudes confronted the mass media, assembly-line banality, cheap imagery, commercial nourishment, and vicarious sex with bemused detachment and deadpan satirical wit. Initially, Pop Art, or Neo-Dada, was met with predictable hostility from abstract purists. By the mid-1960s, however, it had gained a number of its own critical defenders, and it took a major place on the stage of contemporary art. Its lineage, traceable to Duchamp, was impeccably avant-garde, but its confrontation with abstract formalism opened a number of possibilities, including a reexamination of the possibilities of representation by extending the limits of visual expression beyond the art object into reality itself.

The emergence of Pop Art in the early 1960s coincided with one of the most cacophonous periods in American social and political history. Pop Art was introduced as a full-fledged movement at the Sidney Janis Gallery in a survey exhibition called *New Realists* in 1962, the year of the Cuban missile crisis. One year later President John F. Kennedy was assassinated, ushering in the troubled Lyndon B. Johnson presidency.

Art, it is said, reflects the age in which it is created. It is not strange that the modernist consensus, in motion since the 1840s, should break apart at the end of the 1960s. To many artists and critics—and to the art market, always looking for something new—abstract formalism, with its implied proscriptions and inherent projection of the linear stylistic inevitability of abstract art, seemed to have become academic. The term avant-garde lost its meaning as other artistic options were explored. Just as science and technology offered a post-industrial society, art entered the post-modernist era, in which we remain.

The last fifteen years, like the Post-Impressionist period before World War I, have seen the evolution of many styles. So many, in fact, that the 1970s has been called a styleless decade. Criticism, too, has become highly diverse, with no overriding theoretical ideology. Of course, formalists, Minimalists, and Pop artists continue their work. High technology inspired the use of computers for artistic purposes. In the 1960s, the collaborative events and happenings of the dancer Merce Cunningham, Rauschenberg, Johns, and the composer John Cage led to art as living sculpture or performance. Conceptual art, inspired by the literature of science and sociology, also abandoned the conventional forms of painting and sculpture. Earthworks and environmental-project works aligned art with myth, natural history, geology, and landscape architecture. The trend toward the dematerialization of the object, noted by Lucy Lippard in 1968, was paralleled by another and opposite option, Realism.

Realism and Representational Art (1945–1960)

Historically, assertive swings toward realism denote both the end and the beginning of a stylistic consensus. Representation through acute observation of the phenomenal world marked the end of the Gothic and the beginning of the Renaissance, the end of Mannerism and the beginning of the Baroque, the end of the Rococo and the beginning of Neo-

classicism, the end of the Romantic and the beginning of the modernist era, and so it may be that the sudden and unpredicted reappearance of a large, vocal, and radical realist movement in the 1960s indicated the waning of modernism and ushered in the current state of stylistic flux in contemporary art.

Of course, realism never stopped informing a considerable portion of twentieth-century art any more than it had ceased to inform aspects of Mannerism in the sixteenth century. Certainly, committed twentieth-century realist artists did not retire, die, or change their styles to accommodate the tide of abstract critical opinion. Edward Hopper, Thomas Hart Benton, Charles Sheeler, and many other artists continued to develop their respective styles. In the 1940s and 1950s, scores of artists worked well in various representational modes, which if not, strictly speaking, realist, were at least realistic by comparison to Abstract Expressionism. Fantastic Surrealism remained as influential in certain quarters of American painting, drawing, and sculpture as biomorphic Surrealist abstraction had been in the evolution of the Abstract Expressionists. Artists such as Peter Blume, Bernard Perlin, Paul Cadmus, George Tooker, Jared French, Philip Evergood, Ivan Le Lorraine Albright, Robert Vickrey, and even, on occasion, Andrew Wyeth—all associated in one way or another with American Magic Realism—made consistently fine, highly articulated images of veristic fantasy throughout the period between 1940 and 1970. Many of them continue to do so.

Other artists of more traditional realist orientation, such as Joseph Hirsch, Harvey Dinnerstein, John Koch (plate 86), Priscilla Roberts, Walter Stuempfig, and Robert Brackman, maintained distinguished and admired careers as artists and teachers during the same period. But on the whole, their achievement went largely unnoticed in the face of the critical acclaim generally accorded to Abstract Expressionism and its successor movements. When referred to at all by critical supporters of the abstract avant-garde, it was usually deprecated as being "mere illustration" or dealing with themes and techniques that, in comparison to abstract art, were simply passé or even kitsch.

By the mid-1950s, however, the realist and representational artists mounted a concerted defense and gradually found critical support. In 1953 a group that included most of the artists mentioned above and others of the pre-World War II Precisionist and Social Realist camps created a periodical called *Reality: A Journal of Artists' Opinion*. In the first issue, published in New York in the spring of 1953, the group declared that its aims were to keep art from becoming the property of an "esoteric cult" and to "restore to art its freedom and dignity as a living language." At about the same time, dissension appeared in the ranks of the Abstract Expressionists as Pollock, de Kooning, and Grace Hartigan reintroduced figurative elements into their art. In the mid-1950s an important critical voice was found, in the person of Fairfield Porter, to support the art of representation and defy the inevitability of abstraction.

Porter had studied art history and philosophy at Harvard and painting at the Art Students League in New York. He was, in personality and in opinion, diametrically opposed to Clement Greenberg, whom he knew and with whom he frequently argued. His tastes in art were broad and his understanding sensitive. He admired Abstract Expressionism, but he also admired and wrote about representational art. Porter's own painting was subtle, intimate, and lyrical, and at the same time quite specific in terms of his subjects and their locations in time and space. His writings in such journals as *The Nation* and *Art News* lent moral support to representational artists. His intimate landscapes and interiors (plates 20 and 141) and figurative paintings and drawings of the 1950s, reminiscent of Bonnard and Matisse, also place him at the center of a coterie of friends and associates who became the nucleus of the East Coast Painterly Realists.

This group included the young Larry Rivers and Jane Freilicher (plate 146)—whose portraits Porter painted—Nell Blaine (plate 10), and Neil Welliver (plates 66 and 77). Affinity for the fluid styles and intimacy of observation of these artists is reflected in the work of a number of younger painters such as Elizabeth Osborne (plate 145), Susan Shatter (plate 11), Patricia Tobacco Forrester (plate 59), Janet Fish (plates 161 and 170), and to a lesser extent in the work of Porter's biographer, Rackstraw Downes (plate 207).

In 1957, George Biddle, another Harvard-educated artist/author, also opposed modernist abstraction. His book *The Yes and No of Contemporary Art*, though largely castigated at the time of its publication, is a sensitive and humanistic treatise that persuasively argues the case for the

121. Linda Chapman. *Oasis*. 1985. Watercolor on paper, 41⅞ × 29½"
(106.4 × 74.9)

122. Jack Mendenhall. *Interior with Figures No. 1*. 1983. Watercolor on
paper, 15³⁄₁₆ × 18⅞" (sight) (38.6 × 47.9)

preservation of the realist tradition in art. Abstract Expressionism also met opposition on the West Coast in the 1950s. David Park (plate 91) and Elmer Bischoff (plate 92), both members of the faculty of the California School of Fine Arts (now the San Francisco Art Institute), accepted aspects of Abstract Expressionism but rejected the concept of nonobjectivity. They were soon joined by Richard Diebenkorn (plate 93). These three artists formed the nucleus of a group of figurative painters in the San Francisco area that came to include Manuel Neri (plate 81), Nathan Oliveira (plate 82), Theophilus Brown (plate 80), Joan Brown (plate 108), Paul Wonner (plates 113 and 147), James Weeks (plate 97) and more tangentially, Robert Arneson (plate 102) and Wayne Thiebaud (plates 4 and 208). Though they did not in any way form a collaborative movement, all of these artists shared an interest in figurative and landscape subject matter and a sensitivity to the soft bluish light of northern California, transcribed into images created with creamy-textured gestures of paint and brush. This painterly quality is also evident in the

123. Edward Hopper. *Seated Gentleman in a Cape.* 1901. Ink and gouache on board, 9⅞ × 7¹³⁄₁₆″ (sight) (25.1 × 19.8)

right: 124. George Bellows. *German Sailor.* c. 1918. Graphite on paper, 11¼ × 6¾″ (sight) (28.6 × 17.1)

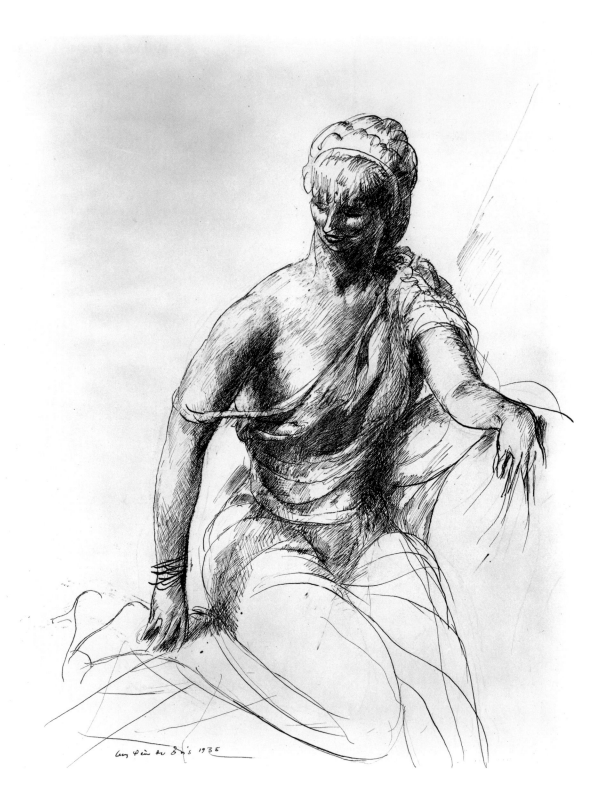

125. Guy Pène du Bois. *Draped Model*. 1935. Ink on paper, 14⅞ × 11⁷⁄₁₆″ (sight) (37.8 × 29.1)

126. Preston Dickinson. *Women at Pool*. 1916. Charcoal on paper, 12 × 10¹¹⁄₁₆″ (sight) (30.5 × 27.2)

below: 127. Robert Henri. *Picnic (Monhegan Island)*. 1918. Crayon on paper, 12 × 19½″ (sight) (30.5 × 49.5)

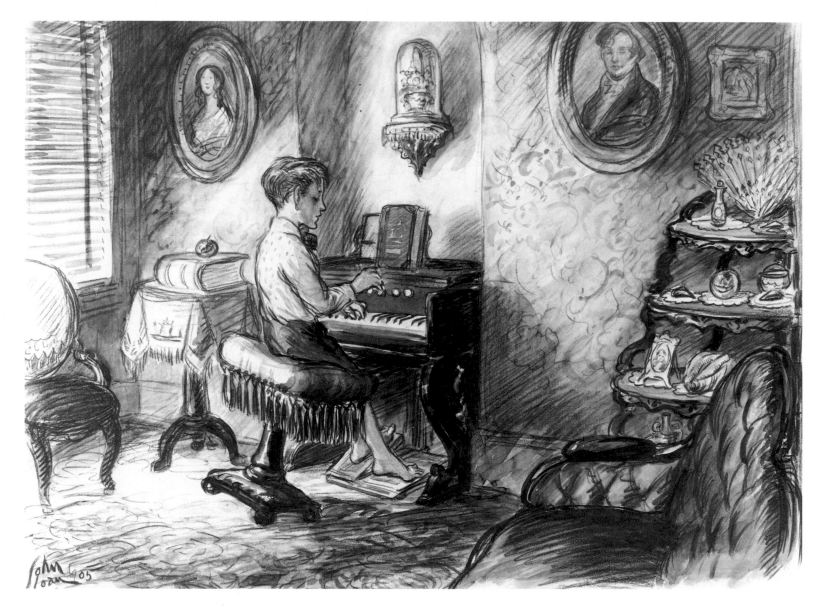

128. John Sloan. *He Lost Himself in the Rehearsal.* 1905. Ink on paper,
11⁷⁄₁₆ × 15½″ (sight) (29.1 × 39.4)

drawings and watercolors of the group. In their works on paper each artist in a personal way combined bold calligraphic line in pencil, ink, or charcoal with softer atmospheric surfaces achieved either through transparent washes or dry techniques.

By 1957 the Bay Area figurative artists and the East Coast Painterly Realists were identifiable camps of representational resistance to the dominance of Abstract Expressionism. It is necessary to recall, however, that what both of these groups were resisting was neither abstraction nor modernist stylistic development and evolution, but rather the dogmatic insistence on nonreferential imagery implicit in Abstract Expressionist theory. Both East Coast and West Coast figurative artists strove to expand their formal vocabularies. Through representations of people, places, and things, they wished to maintain contact with the essence of the Western humanistic tradition, which they felt was threatened.

Concern for the humanist tradition in an existentialist age appeared in a highly controversial exhibition of international representational and figurative art, organized by Peter Selz for the Museum of Modern Art in New York in 1959 and called *New Images of Man*. This exhibition was arranged to show contemporary human images representing the anxious feelings of their respective creators in the nuclear-age, cold-war atmosphere of the time. The show included works by such international figurative Expressionists as Alberto Giacometti, Reg Butler, Francis Bacon, and Jean Dubuffet as well as the Americans Rico Lebrun, Leon Golub, and James McGarrell. The exhibit was panned by most New York critics, including (surprisingly, given both its premise and its content) Fairfield Porter. All the works were overstated and grotesque. Nonetheless, the impact of the exhibit, along with the then-emerging Pop Art phenomenon, gave further weight to the figurative and representational presence in the contemporary arena.

Golub, McGarrell, and another figurative Expressionist, Hyman Bloom, are all interesting figures in the growth of the representational and referential resurgence in art of the late 1950s and early 1960s, each for different reasons. Golub's brutal but socially concerned imagery is characteristic of the Chicago School, and his humane if polemical figurative social messages presage much of what is being called Neo-Expressionism today. Hyman Bloom is one of America's great draftsmen, and drawings, often in monumental scale, form a large part of his oeuvre. Bloom also deals in imaginary subject matter, as shown in his *On the Astral Plane: Beelzebub*, 1966 (plate 104). However, his images have a modeled veracity formed by many thousands of hours of looking and drawing from life, and he views the dark side of the human condition with the frightening visionary perspicacity of a Goya. McGarrell (plate 23), too, is an artist whose imagery has verisimilitude but is not realistic in the sense of being transcribed from direct observation. Nonetheless, the apparent realism of his work has intimately connected him with what is called the New Realism.

The New Realism (1960–1985)

The work of the Bay Area figurative artists and the East Coast Painterly Realists denied the abstract demands of modernist theory, but stylistically it had much in common with Abstract Expressionism in terms of gestural handling of materials. Indeed, both Bischoff and Diebenkorn ultimately became abstract artists.

Nell Blaine and Jane Freilicher had close personal contact with Hans Hofmann, who had no theoretical difficulty with referential imagery and occasionally drew and painted landscapes himself, as his drawing Untitled, 1942 (plate 21), attests. Porter was very concerned that his own work and the humanistic figurative art that he hoped to see evolve would not be viewed as a realist revival but as genuinely innovative art in harmony with Abstract Expressionist aesthetic ideals. Despite philosophical differences about subject matter, the East Coast and West Coast painterly artists were avowedly modernist.

So too were the first generation of the New Realists, whose work began to be seen at the end of the 1950s and in the early 1960s. These artists were radically rebellious in their reaction to abstract formalist theory and style. They may therefore be clearly differentiated, both from earlier realists and from the expressive realism of the Park and Porter circles. They are slightly younger than the leaders of the two coastal figurative schools and were educated under the influence of the insurgent Abstract Expressionist generation. They fall into two groups, representing distinctly different

129. William Glackens. *Andersonville*. c. 1905–10. Ink on paper, 14¾ × 11⁷⁄₁₆″ (sight) (37.5 × 29.1)

aesthetic and methodological viewpoints, though their works often have superficially similar appearances.

One group might be called the Classicistic New Realists and is composed of such artists as James McGarrell (plate 23), William Bailey (plates 83 and 186), Paul Georges (plate 89), Milet Andrejevic (plate 119), and Lennart Anderson. The work of all these artists is more realistic than realist. That is, they depict their subjects with highly believable verisimilitude but do not emphasize a direct response to actual things, spaces, or models, but rather recreate, reinterpret, or, in the cases of McGarrell and Bailey, frequently invent the objects and locales of their subject matter. Their art, though compositionally quite modernist, evokes nostalgic reverence for the art of times past without directly referring to specific examples. They achieve not immediacy but timelessness in their work.

The artists more often—and more accurately—referred to as the originators of New Realism differ from their more interpretive contemporaries in that they all demand of themselves, at least at the outset, direct scrutiny of specific subjects in specific places. These are Philip Pearlstein (plate 120), Alfred Leslie (plate 115), Jack Beal (plates 32, 94, and 160), Neil Welliver (plates 66 and 77), Willard Midgette (plate 117), and, with reservations, Alex Katz (plate 111). Katz is difficult to place stylistically within this group. His flat, emblematic compositions in vivid color on the one hand associate him with a Pop Art sensibility, and on the other, the enigmatic, somewhat vulnerable expressions of his subjects give them a general and timeless look somewhat akin to that of the Classicistic group.

The New Realists also shared a modernist attitude in the early 1960s. All were conversant with contemporary abstract theory and most had been abstract artists, at least as students. Each had rejected modernist abstract form, but not pictorial organization. In their move toward extreme realism they opposed formalism on its own terms. Their compositions were as frontal and as graphic—and their pictorial space as compressed—as any contemporaneous abstract work. Abstract painting had also changed in the late 1950s and early 1960s. The heirs of Reinhardt and Newman, rather than of Pollock, Kline, and de Kooning, were in the ascendant in formalist circles, and the flat surfaces of Post-Painterly Abstraction and Color Field superseded the anxious gestures of

130. Everett Shinn. *Double Crossed*. 1916. Ink and charcoal on paper, 14¾ × 9⅜" (sight) (37.5 × 23.8)

action painting. The New Realists' paintings, too, were characteristically smooth-surfaced and, for the most part, their forms were also hard and flat. These formal characteristics were also evident in Pop Art, which, in the first half of the 1960s, created confusion.

By 1962 the confrontation between Pop Art's imagism and formalist abstract art riveted critical attention. The fact that the East Coast and West Coast painterly representationalists, the Classicistic Realists, the New Realists, and the figuratively grotesque Expressionists of the *New Images of Man* constituted a very vital and highly motivated group went largely unnoticed in the art press. It took nearly a decade for Pearlstein, Beal, Leslie, Katz, and the next arrivals on the realist stage, the Photo Realists, to extricate their art from erroneous critical associations with Pop Art. During this period, from 1960 to 1968, national critical attention to realism generally and New Realism particularly was scant and largely negative.

During the early 1960s, probably the single most important voice in establishing an identity for the New Realism was that of Philip Pearlstein. From the late 1950s, when he rejected both abstract art and Pop imagery in favor of his uncompromising hard-edge figurative style, Pearlstein—in his art, in his teaching at Yale, the Pratt Institute, and Brooklyn College, and in his public lectures and published papers— has emphatically declared New Realism's independence from older realisms, Pop Art, and abstraction. At the same time he insisted that New Realism be perceived within the context of modernism's avant-garde.

In the mid-1960s another type of realism began to be seen. Howard Kanovitz, Malcolm Morley, Audrey Flack (plate 154), John Clem Clarke, and Chuck Close (plate 118) on the East Coast and Robert Bechtle (plate 135), Joseph Raffael (plates 42, 65, and 71), and Richard McLean (plates 76 and 201) in California approached the contemporary world through photographically generated images appropriated from newspapers, postcards, and snapshots. Their work, like that of the New Realists, was generally identified with Pop Art. In the cases of Kanovitz and Morley there is considerable justification for this association. There is a Warholesque tongue-in-cheek detachment in their selection of banal images. Flack, however, is more personally involved in her iconography. Her earliest appropriated subjects were wire-

service photographs of the John F. Kennedy assassination, which she transformed into a series of monochrome paintings. She then began composing and photographing her own subject matter, which became increasingly personal and complex. Though she, like the Pop artists, employed the colors and the items normally seen in the context of advertising, her involvement with these images was active and poetic.

By the late 1960s artists who were transforming photographic visual information into drawn or painted images were called Photo Realists. These artists addressed different subjects with very different sensibilities, but their utilization of the camera, their obsessive techniques, and their documentary interest in contemporary life placed them in the context of the New Realism, which was still confused with Pop Art. Photo Realism represented a different aesthetic point of view from that of such New Realists as Beal or Pearlstein, Bailey or McGarrell, and it was also quite different from Pop Art. All of the artists associated with this movement used the photographic image as the starting point for their paintings, whereas the "eyeball realists" did not. Although the Photo Realists were nonjudgmental in their selection of the objects and locations of commonplace contemporary reality, their approach was not generalized like that of the Pop artists. It was very specific. All of the Photo Realists are meticulous in their rendering of photographic sources into paintings or drawings. This reflects their obsessive fascination with recording and transcribing the maximum amount of visual information that can be drawn from their subject matter. By 1970 the Photo Realist movement had grown to include such artists as Tom Blackwell (plate 230), Ron Kleeman (plate 213), Don Eddy (plate 194), Robert Cottingham (plate 229), Charles Bell (plate 193), Richard Estes (plate 231), John Salt (plate 212), and Ben Schonzeit (plate 143). These artists had moved painting and drawing to an extreme of realistic mimesis that had never before been attained in the history of art. They did so, interestingly, at exactly the same time that the Minimalists achieved an identical extreme in abstract art, but the realist direction proved to be the stronger influence.

The turbulent events of the late 1960s focused attention on realist art. In the context of the times the formalist artists and critics had inadvertently painted themselves into a corner. In an age when every convention, presupposition, and rule was treated with suspicion—if not vocally at-

131. Stuart Davis. *Friendly Neighbors.* c. 1910–15. Ink on paper, 19⁹⁄₁₆ × 15½" (sight) (49.7 × 39.4)

132. Thomas Hart Benton. *Lonesome Road*. 1927. Ink and lithographic
crayon on paper, 9³⁄₁₆ × 11⁷⁄₁₆″ (sight) (23.3 × 29.1)

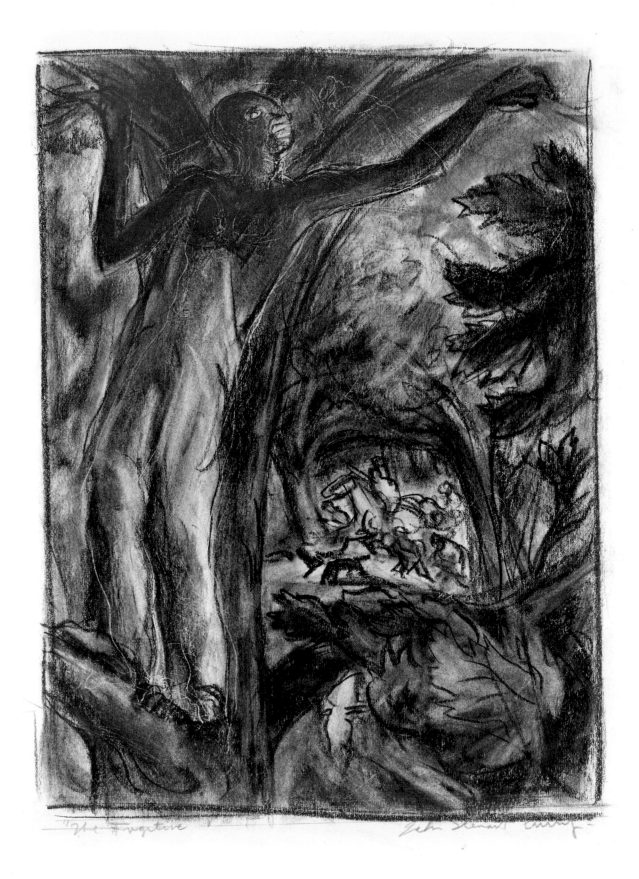

"The Fugitive" John Steuart Curry

tacked—the cool, authoritarian position of formalism seemed to many to be decidedly elitist—and irrelevant. Pop Art, which had started the shift away from formalist abstraction, also seemed to have run its course. Conceptual and performance art almost completely abandoned the art object. The realists were, one way or another, just as in Courbet's time, directly addressing contemporary life in powerful and accessible terms.

Perhaps the earliest significant documentation of realism's coming of age in the late 1960s came, appropriately, from an art historian, Linda Nochlin, an authority on Courbet and nineteenth-century Realism. In 1968 Nochlin, then a professor at Vassar College, produced an exhibition and catalogue for the Vassar College Art Gallery called *Realism Now*. In this she not only separated recent realism from other representational movements such as Pop Art and figurative Expressionism but also began to differentiate the various attitudes contained in contemporary realism as a whole. In 1969 the Denver Art Museum produced a show called *Report on the Sixties*, which gave prominence to realism, and the Milwaukee Art Center created a major exhibit called *Aspects of a New Realism*. Also in 1969 the Whitney Museum, just a decade after the *New Images of Man*, mounted a similar exhibit called *Human Concern/Personal Torment*. Realist and representational figurative work was shown which responded to the chaotic conditions of war and social protest. Superrealist sculptor Duane Hanson and painters Sidney Goodman (plate 217) and Norman Lundin all addressed social evils powerfully in realistic styles.

In 1970 the Whitney Museum produced *22 Realists*, which showed New Realist and Photo Realist artists from the East and West coasts. The Chicago Museum of Contemporary Art held an exhibit called *Radical Realism* in 1971. In 1972 New Realism and Photo Realism were exhibited in a major survey at the Sidney Janis Gallery called *Sharp-Focus Realism*. Coming as it did on the tenth anniversary of the *New Realists* show, which had launched Pop Art, the exhibit created some predictable negative reaction and some further confusion about the nature of the very art it contained. Formalist Barbara Rose in *New York Magazine* saw the exhibit as hype. Calling it "Son of Pop," she thought it an attempt to create a new fashion and believed the work to be so academic that it might appear in a nineteenth-century French salon. This indicated just how unused to looking at realistic art formalist eyes had become. The work represented at Janis's show was, in fact, exactly what academic salon juries hated—unidealized representations of actuality. Though few critics praised the show, some approached it with guarded interest. Harold Rosenberg, in *The New Yorker*, grudgingly found the show preferable to many contemporaneous shows of Color Field and Minimalist abstraction. Robert Hughes, in *Time*, had mixed feelings but mainly saw Sharp-Focus Realism as one more passing fad.

The exhibit's title implied that all of the artists had some relationship to the photographic image. This was particularly annoying to such participants as Pearlstein, Beal, and Leslie. Further, the location of the show, at the Janis Gallery, tended to reaffirm—erroneously—the relationship of New Realism and Photo Realism to Pop Art. Further, the show implied that the realist movement was much newer than it was. In fact, many of the exhibiting artists had been actively represented by other galleries in New York for some time. The pioneer exhibitors of modern realist art in the 1960s included the Tibor de Nagy, Fischbach, Allan Stone, and Terry Dintenfass galleries. Particularly active were the Robert Schoelkopf Gallery—which produced *Nine American Realists* as early as 1964—and the Allan Frumkin Gallery, which has championed realism from the early 1960s, with the work of Pearlstein, Beal, McGarrell, and many others. Late in the 1960s and early in the 1970s Ivan Karp, O.K. Harris Gallery, Louis K. Meisel, and Nancy Hoffman Gallery supported Photo Realism and other meticulously rendered realistic styles.

Robert Hughes's estimate of the faddish nature of contemporary realism proved incorrect. Also in 1972 *Sharp-Focus Realism* traveled to Holland, and the centerpiece of *Documenta 5* in Kassel, West Germany, was American realism, which the Europeans called Hyperrealism. Important American New Realist and Photo Realist exhibits also appeared in France, Germany, Sweden, England, Italy, and Belgium between 1972 and 1974. For the rest of the decade, realism, under a variety of names—Sharp-Focus Realism, New Realism, Neo-Realism, Photo Realism, Superrealism, and Hyperrealism—proved to be one of the most durable and viable of the panoply of post-modernist styles visible in the styleless 1970s. Critical and curatorial interest in realism

opposite: 133. John Steuart Curry. *The Fugitive.* 1935. Charcoal on paper, 12½ × 10⅛" (sight) (31.8 × 25.7)

grew. In addition to Nochlin, Robert Rosenblum, Udo Kultermann, Lawrence Alloway, Robert Doty, Gregory Battcock, John Perrault, Linda Chase, and John Arthur turned their attention sympathetically to the realist cause. Other major modernist authors such as Sam Hunter, Robert Hughes, Hilton Kramer, and John Canaday also gave realism a significant place in the art of the pluralistic 1970s and early 1980s.

The critical literature on recent realism swelled enormously. In 1975 Gregory Battcock published *Super Realism: A Critical Anthology*, which included seventeen articles, the earliest of which had been published in 1966. By the end of the decade the number of serious articles published in newspapers, magazines, journals, and museum and gallery exhibition catalogues numbered in the hundreds. By the beginning of the 1980s New Realism was no longer new, and retrospective exhibitions and surveys came forth. (See the Selected Bibliography.) Monographs about most of the pioneers of the New Realism have recently been published or are in preparation.

The hard-won battle of the New Realists and the Photo Realists to establish the mimetic extreme on the scale of aesthetic alternatives as a viable position has had a profound impact on contemporary art. Many younger artists have matured and are discovering new modes of seeing and representing the things, places, and events of the nominal world. The determined example of the realists has been largely responsible for the change of focus now evident in the artistic spectrum. Twenty years ago the vast majority of the art being shown and being taken seriously was abstract. Today the reverse is true. In the pluralistic art world of the last ten or fifteen years, most of the new art forms have been, if not realist, at least figurative or representational. To their credit, the realist revolutionaries of the 1960s have proved that there is much still to be discovered in the world by looking.

The Plates

Realism is not a style but an attitude of mind. The realist is first an empiricist who wants to perceive, comprehend, and explain the things and events of the nominal world. He or she may wish to be aligned with one or more philosophical or theoretical positions, but this is not necessary. Seeing and perceiving the appearance of things and then expressing

what has been observed are at the heart of the realist approach to art. Thus, for the realist the subjects of his work are of primary importance. At the core of the process is the problem of translating perception into expression, and the essence of the solution is drawing. Drawing provides the most intimate access we have to the artist's mind, eye, and hand. No two individuals will perceive the same thing in the same way. No two artists, no matter how much they may share a philosophy or an ideology, will represent their perceptions in the same manner in their drawings. Drawing is as individual as handwriting or fingerprints.

The representational arts originated as a means by which our prehistoric ancestors could come to grips with the natural world they inhabited. This basic urge, to define the self in relationship to the environment by description, has been a continuous thread in the development of art and in the evolution of thought. Because definition and description are simultaneously so primal and yet so continuous, and because they underlie all realistic art, the plates that follow

134. William Gropper. *Shoemakers.* c. 1935. Charcoal and gouache on paper, 12⅜ × 15¾" (sight) (31.4 × 40.0)

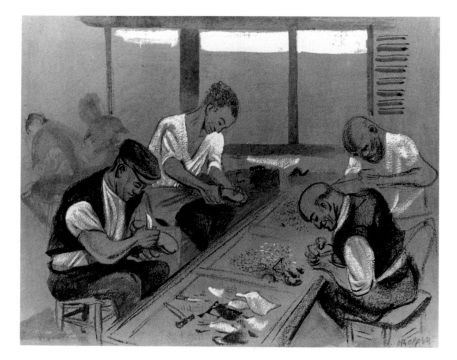

135. Robert Bechtle. *Portrait of Richard McLean*. 1983. Watercolor on paper, 14⅛ × 17⅝″ (sight) (35.9 × 44.8)

have been grouped in an evolutionary fashion. The categories that have been chosen correspond roughly to the historic development of the world and the changing relationship of humanity toward it. Realism is always of its time, yet evolution is ongoing. The categories are as follows.

1. Primordial Nature: The Natural Landscape

Long before the appearance of man there was wilderness. Even though the representation of landscape was almost the last subject to be mastered in the evolution of art, it is an appropriate subject to begin with from a modern point of view. Emphasis on landscape became a preoccupation of Romantic

and Impressionist artists of the late eighteenth and the nineteenth century. In many ways this reverence for the timeless sweep of nature was a nostalgic reaction to rapid social changes—and the encroachments of man into God's world—that were provoked by the Industrial Revolution. Today, nature is more precious than ever in our increasingly technological age. The artists in this group have selected different sites and aspects of nature to represent in their various individual styles and techniques. Peter Holbrook composes his *Silent City III*, 1983 (plate 5), with a frontality reminiscent of the abstract paintings of Clyfford Still, yet he delineates his strong structures with a massing of detail that reflects the in-

133

fluence of his fellow Chicagoan Ivan Le Lorraine Albright. Like the nineteenth-century American Romantic landscapists Albert Bierstadt and Thomas Moran, Holbrook evokes the power of nature and the duration of geologic time. By contrast, Painterly Realist Nell Blaine's flowing watercolor, *Cloud Opening*, 1981 (plate 10), says as much about the materials she used as it does about the atmospheric changes of spring weather on New England's shores. Blaine's admiration for Hans Hofmann (plate 21), with whom she studied, is revealed in the free handling of the paint, while the poetic interpretation of the place itself recalls her affinity to Fairfield Porter (plates 20 and 141). Susan Shatter's enormous watercolor, *Channel to the Sea*, 1982 (plate 11), places her somewhere between Blaine and Holbrook in style, and like Neil Welliver (plates 66 and 77), she treats her site, in this case Maine, with immediacy and specificity, while revealing it in flat, overlapping layers of translucent color. Conversely, Daniel Chard (plate 14) works in miniature, as do many other realists. He uses his acrylic washes and hairline brushes to develop his images of the gentle valleys of upstate New York with a controlled love of miniature that recalls the eighteenth-century watercolors of Thomas Girtin or even the background landscapes of northern European Late Gothic illuminators. Sylvia Plimack Mangold's crepuscular pastel (plate 22) replicates the experience of dawn or dusk with a Minimalist's sensibility, while Keith Jacobshagen (plate 17), James Winn (plate 16), and Barbara Cushing (plate 18) look skyward, recreating sunset's pyrotechnics with an action painter's élan.

2. Altered Nature: The Bucolic Scene

The subjects of this group are outdoor settings touched by the civilizing hand of humanity. The domesticated landscape is a tradition in Western art that goes back at least to the fourteenth century. In 1338 Ambrogio Lorenzetti depicted the farmlands outside Siena on a monumental scale in his frescoes for the Palazzo Pubblico. Farms and gardens appear in the fifteenth-century books of hours. They were painted in loving detail, along with their husbandmen and women, by such sixteenth-century masters as Pieter Bruegel the Elder. In the seventeenth century, country fields and the edges of towns were favorite subjects of Dutch painters such as Jacob van Ruisdael. In the eighteenth century, artists of the caliber

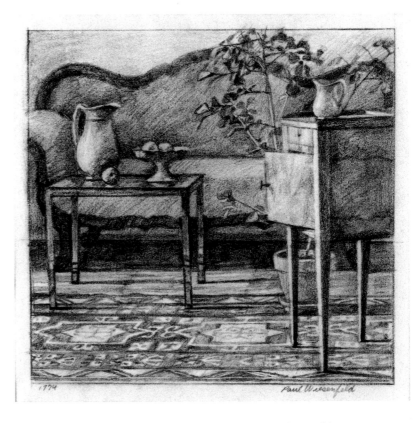

137. Paul Weisenfeld. *Still Life with Oranges*. 1974. Lithographic crayon on paper, 5¹⁵⁄₁₆ × 6″ (sight) (15.1 × 15.2)

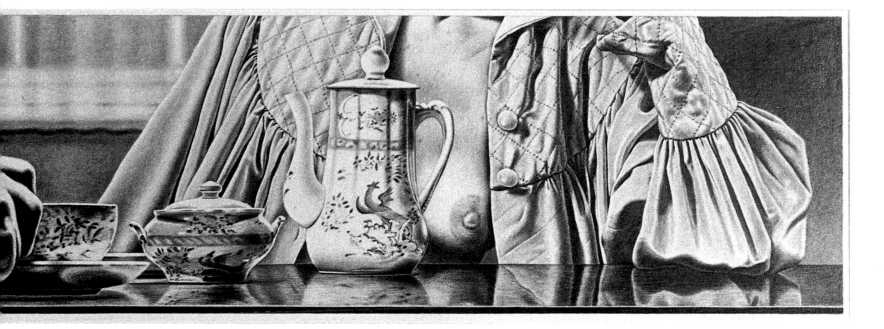

136. Douglas Bond. *Mets, Buttons, Etc.* 1982–83.
Graphite on paper, 10½ × 41⁷⁄₁₆″ (sight)
(26.7 × 105.4)

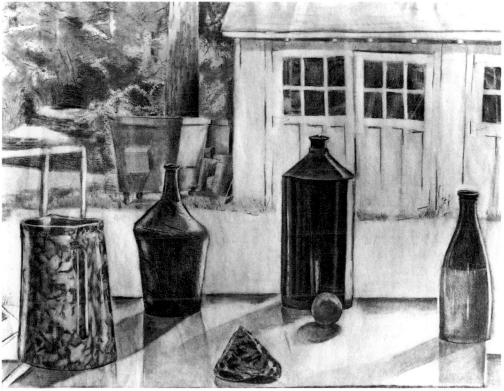

138. Gabriel Laderman. *Still Life in Landscape.* 1981. Graphite on paper,
17½ × 22¾″ (sight) (44.5 × 57.8)

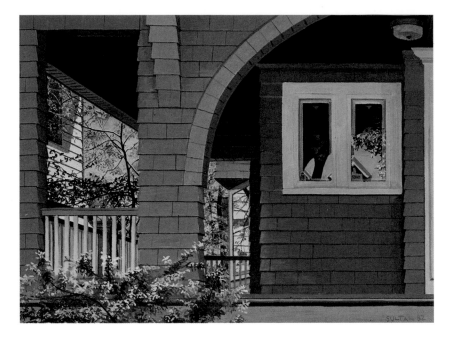

139. Altoon Sultan. *Grey Arch, Brooklyn, New York*. 1982. Gouache on paper, $5 \times 6^{13}/_{16}''$ (12.7 × 17.3)

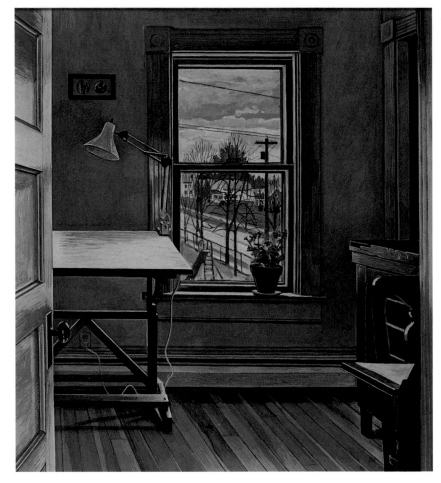

140. Diane Sophrin. *View of Studio*. 1983. Gouache on paper, $9^{9}/_{16} \times 8^{9}/_{16}''$ (sight) (24.3 × 21.8)

of Thomas Gainsborough and George Stubbs—as well as in-numerable journeymen, amateurs, limners, and folk artists—rendered the rural scene in England and America.

The nineteenth century saw the landscape, both culti-vated and savage, become a grand theme. The Romantics Turner, Constable, and Friedrich, the Barbizon masters Corot and Daubigny, the Realists Millet and Courbet, and all of the Impressionists, but particularly Monet and Cézanne, used farms and gardens as points of departure, not only to symbol-ize the harmony of humankind and nature but also to create some of the world's most beautiful paintings, drawings, and

watercolors. The landscape as touched by man was also a particularly compelling subject for American painters of the nineteenth century. To the Hudson River School, to Winslow Homer, Martin Johnson Heade, and dozens of others, the taming of the continent by the yeoman farmer represented not only subject matter but also the American dream.

In the twentieth century, artists have been less atten-tive to the bucolic landscape. On the whole, the major art of this century, guided by modernist ideology, has been more attuned to reflecting the complexities of technology and in-dustry and the urban society from which they stem. Nonethe-

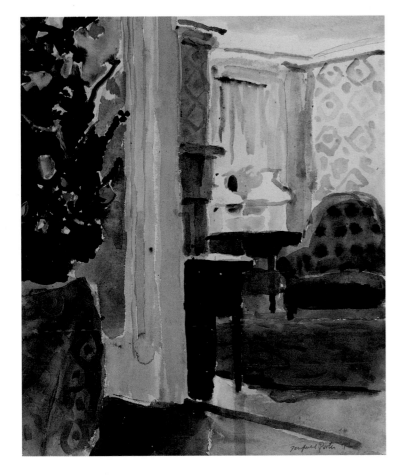

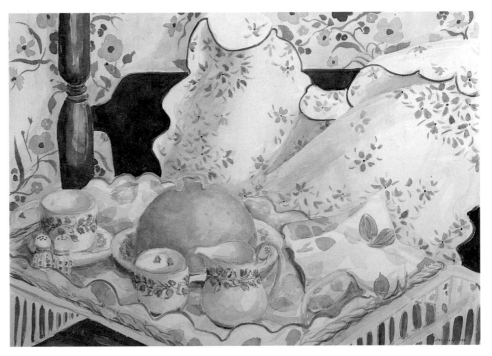

142. Joan Brady. *Breakfast in Bed.* 1982. Watercolor on paper, 22⅛ × 30½″ (56.2 × 77.5)

141. Fairfield Porter. Sketch for *Lizzie and Christmas Tree.* 1972. Watercolor on paper, 19¾ × 15⅝″ (sight) (50.2 × 39.7)

less, the tilled land has a timeless appeal for both artists and viewers.

The artists represented here exhibit both traditional and modernist sensibilities in their approaches to the subject matter. Three of the drawings—Henry Lee McFee's *Buildings, Bellevue,* c. 1932 (plate 30), Blanche Lazell's *Provincetown Houses,* 1922 (plate 26), and Charles Sheeler's *Side of a Barn,* 1917 (plate 31)—are by Precisionist artists with strong ties to the Cubist movement. McFee's drawing, in fact, looks back through Cubism to the movement's progenitor in the nineteenth century, Cézanne himself. Lazell's work is also

both Cubistic and Cézannesque, while Sheeler's drawing marks a consolidation of his earlier Cubist and Cézannean influences and a first step toward his forthright Precisionist style.

The more recent drawings exhibit the breadth of contemporary realist approaches to style and subject. Wolf Kahn, Richard Chiriani, and Walter Hatke (plate 36) are unapologetically traditional in their works. Kahn's *Deer Isle, North West Harbor,* 1967 (plate 24), reinterprets such American Impressionists as Ernest Lawson and John Henry Twachtman, and Chiriani's *East Hampton Marsh,* 1982 (plate 34), strongly

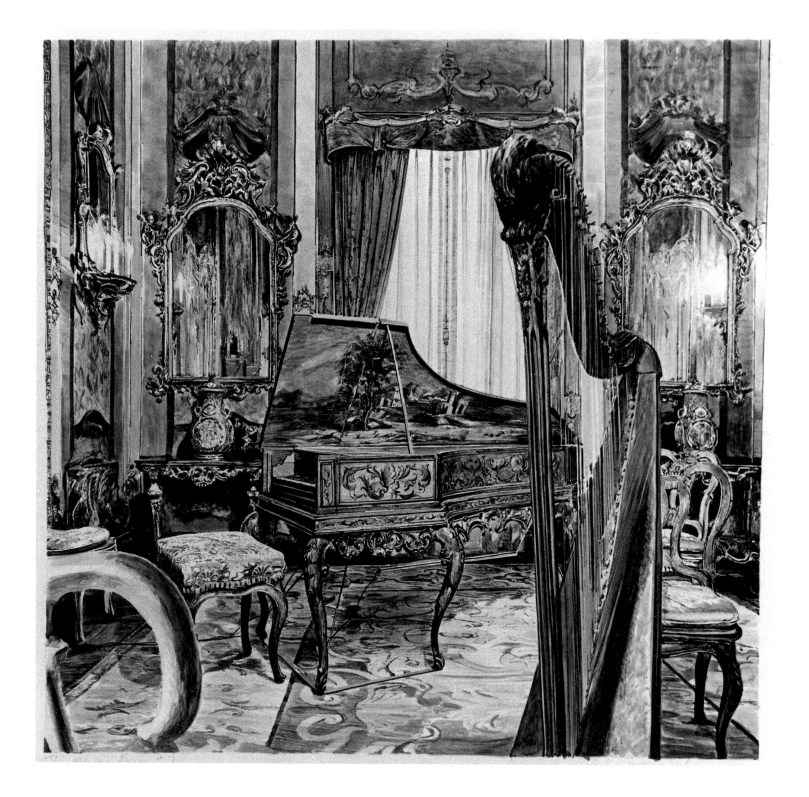

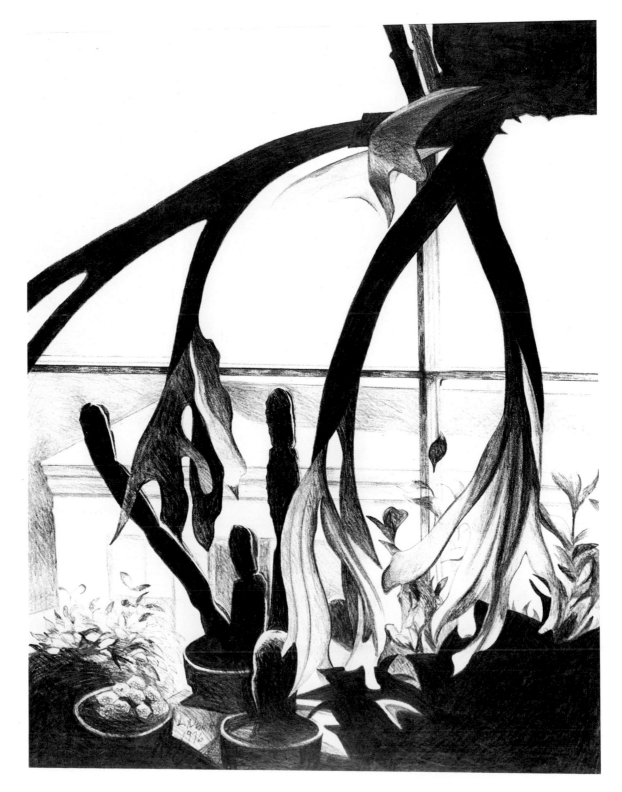

opposite: 143. Ben Schonzeit. *The Music Room No. 7.* 1977. Watercolor on paper, 30¹⁄₁₆ × 30³⁄₁₆″ (76.4 × 76.7)

144. Lowell Nesbitt. *Broome Street Window.* 1976. Graphite on paper, 38³⁄₁₆ × 29³⁄₁₆″ (sight) (97.0 × 74.1)

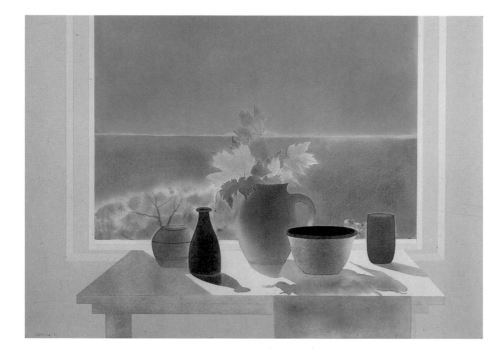

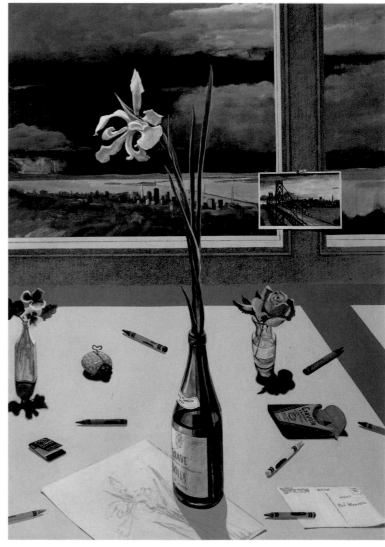

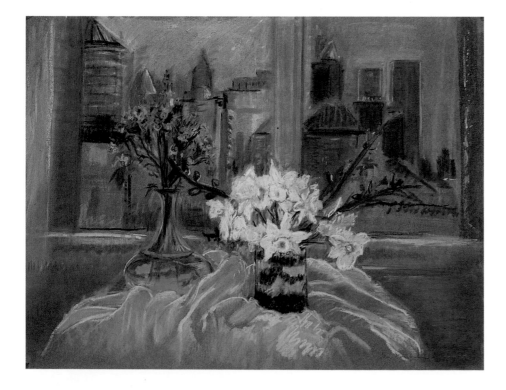

above left: 145. Elizabeth Osborne. *Autumn Still Life.* 1981. Watercolor on paper, 29⁹⁄₁₆ × 41½″ (75.1 × 105.4)

left: 146. Jane Freilicher. *Daffodils.* 1979. Pastel on paper, 19⅝ × 25½″ (49.9 × 64.8)

above: 147. Paul Wonner. Study for *Still Life with Iris, Crayolas, and Two Views of San Francisco.* 1980. Acrylic and charcoal on paper, 38⅜ × 26¹³⁄₁₆″ (sight) (97.5 × 68.1)

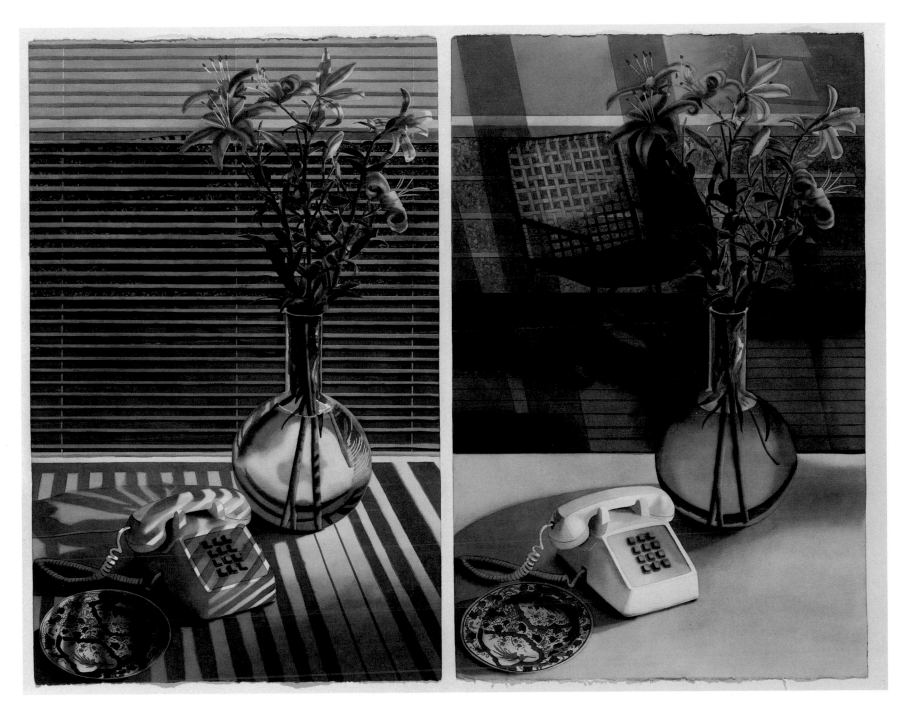

148. Leigh Behnke. *Still Life with Telephone*. 1983. Watercolor on paper,
40½ × 52¼″ (102.8 × 132.7)

149. Michael Webb. *The Studio No. 2.* 1978. Graphite on paper,
45³⁄₁₆ × 83¾″ (sight) (114.8 × 212.7)

recalls the salt-marsh landscapes of Heade. James McGarrell and Claire Khalil take a more fanciful view of nature. McGarrell's *Plough and Plenty*, 1982 (plate 23), is richly ornamental and reflects a Symbolist sensitivity that has its sources in the art of the turn of the century. Khalil's imaginative representations bring both innocence and a Surrealistic quality—guided by an understanding of Persian miniature painting—to bear on specific places and environments. Her watercolors (plates 25 and 27) are both inspired by Sun Valley, Idaho, and the Janss household.

Jack Beal, an originator of New Realism, is outspoken in his belief that art should speak of moral issues and great traditions. He spends much of his time in the country in upstate New York, and his respect for this old but fertile farmland is reflected in his *Oneonta: View from the Studio*, 1983–84 (plate 32).

3. Nature Close-up

The artists in this group examine not the continuum of nature but rather the small elements of which it is composed. Since the medieval nominalists determined that God was as much present in his small works as in his universe as a whole, artists and scientists have studied basic truths by examining individual components of the natural world. In the Middle Ages, herbariums provided the basis for botanical studies. The studies of plants, twigs, acorns, and weeds found in the notebooks of Renaissance polymaths Albrecht Dürer and Leonardo da Vinci probed nature and patterns of growth in a way that not only informed their more monumental works but also revealed as much about their inquiring age as did an altarpiece. That contemporary artists reaffirm their links to this tradition confirms the ageless and eternal beauty of the life cycle.

William Nichols, James Weidle, Peter Loftus, George Harkins, Patricia Tobacco Forrester, Theophil Groell, and Bill Richards all examine the landscape in part, without horizon, as if through a close-up lens. Their views explore the cyclical nature of the seasons and the relationship of life and water. Peter Loftus's gouache, *Shanton Wood No. 5*, 1979 (plate 43), depicts the spring runoff, and William Nichols's *Fallen Log across Bradley Creek*, 1983 (plate 39), shows the dead past of rotting trees against the new foliage that is nourished by the brook in full, verdant summer. George Harkins's large water-

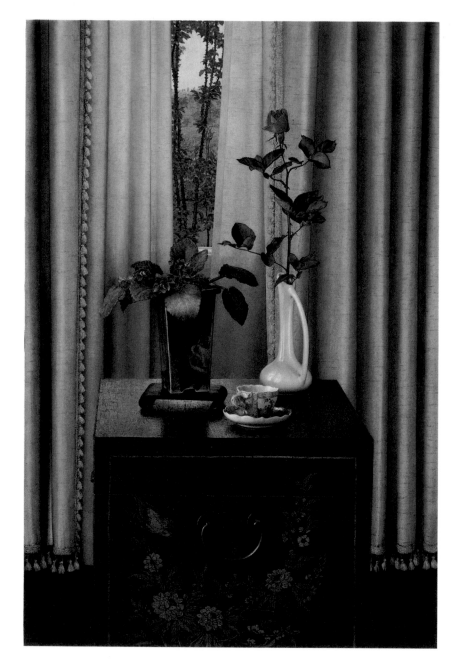

151. Roger Howrigan. *Night Greenhouse No. 3.* 1982. Watercolor on paper, 44 1/2 × 44 1/8″ (sight) (113.0 × 112.1)

150. John Stuart Ingle. *Still Life with Rose and View into the Landscape.* 1984. Watercolor on paper, 59 1/4 × 39 1/8″ (sight) (150.5 × 99.4)

color, *September Gathering*, 1982 (plate 45), renders early autumn, while James Weidle's *First of the First Snow*, 1982 (plate 38), depicts late fall in miniature. Both Sheila Gardner's *Before the Wind*, 1983 (plate 37), and Patricia Tobacco Forrester's *At Cabin John*, 1982 (plate 59), depict the frozen sleep of winter in watercolor, on a monumental scale for this medium but in very different ways. Gardner's image is almost photographic, and the paint is tightly controlled, whereas Forrester allows the watercolor to flow more freely, accentuating the physical qualities of both paint and paper. Monochromatic dry media are used by Theophil Groell (plate 40) and Bill Richards (plate 46) to portray rich layers of the rotting compost that fertilizes new growth. Groell works in lithographic pencil; Richards, in various grades of graphite. Richards gathers his information with a camera, but he alters the photographs liberally in the laborious and refined technique he uses to make these drawings.

Neil Anderson (plate 44), Joseph Raffael (plates 42 and 65), and Vija Celmins (plate 41) move closer still, taking a magnifying-glass view of their subjects. The effect of this vantage point adds such density to the massed forms that, ironically, the images appear almost abstract. Other artists in this group divorce their studies entirely or in part from the landscape setting. Artists of an earlier generation reveal not only their interest in nature but also their own stylistic relationship to the art of their time. Precisionist Charles Demuth's watercolor, *Cyclamen*, 1918 (plate 61), reveals his Cubist roots, just as Charles Burchfield's *Rain and Wind*, 1949 (plate 48), confirms his Expressionist origins. Magic Realist Peter Blume's free calligraphy in *Landscape and Poppies*, 1938 (plate 49), shows him to be as aware of the meandering lines of Masson's automatism as was Gorky or Pollock. Juan Gonzales's more recent *Sara's Garden*, 1977 (plate 47), has a Surrealist or Magic Realist lineage, modified by the camera's lens. Marcea Rundquist also shows Surrealist affinities in her *Leaf and Winter Landscape*, 1981 (plate 60).

Herman Rose (plate 64), Joe Nicastri (plates 49 and 62), James Childs (plates 52 and 53), and John Stuart Ingle (plate 51) all examine their subjects at arm's length and against a blank page. They reveal the relationships between the parts and the whole of the plant, devoid of other context. Gnarled trees are a subject that is of personal interest to the creator of this collection, Glenn C. Janss. Four tree studies by

Precisionists—Charles Demuth's *Tree Trunk No. 1*, 1916 (plate 56), Charles Sheeler's *Tree Trunk #2*, 1924 (plate 54), George Ault's *Apple Trees*, 1933 (plate 55), and Georgia O'Keeffe's *Bermuda Tree*, 1934 (plate 57)—show that in spite of their collective interest in the pursuit of a style, each artist maintains a different individual manner of representing very similar subjects. A more recent drawing, *Vine Tree I*, 1984 (plate 58), by Michael Mazur, like those of his Precisionist predecessors, is also a study. Mazur, who is best known for his enigmatic narrative paintings and drawings, has used this image as part of the background in several pictures of a recent series.

4. Animals

The animal kingdom forms the mobile population of the world. Though animals evolved earlier than man, they bear a special relationship to us. The earliest representational images known are of animals that provided food, symbolized gods, and supplied labor. Animals in the wild continue to be a source of beauty and excitement. Once domesticated, they nourish, transport, amuse, love, and depend upon us.

Four pictures—Richard Chiriani's *Shell Space III*, 1982 (plate 68); Bill Martin's *Abalone Shells*, 1982 (plate 69); William Allan's *Albacore*, 1980 (plate 67); and Neil Welliver's Study for *Trout No. 2*, 1982 (plate 66)—represent aquatic creatures or their remnants. Chiriani, Martin, and Welliver each take a perspective on their subjects that creates a massed pattern of light and dark, which emphasizes the abstract forms of their compositions as much as the descriptive nature of their depictions. Welliver, a first-generation New Realist, has always acknowledged his compositional debt to modernist abstraction. To him, the importance of overall distribution of form and flat, abstract design are fundamental to his revelation of his subject. He is devoted to nature, and for years he has painted the woodlands surrounding his home in Maine—and the creatures within them. Welliver's Study for *Trout No. 2* and his *Deer*, 1979 (plate 77), both anticipate larger works in oil.

William Allan's *Albacore* is in emblematic format. Separating figure from ground in the most primary fashion, he graphically forces attention onto the image of the composition and the detail of the fish itself. This simple figure/ground division is also used in Joseph Stella's *Bird of Paradise*, 1920

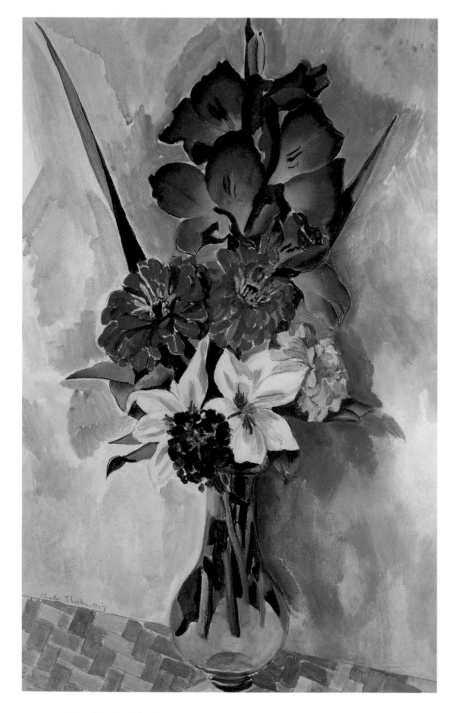

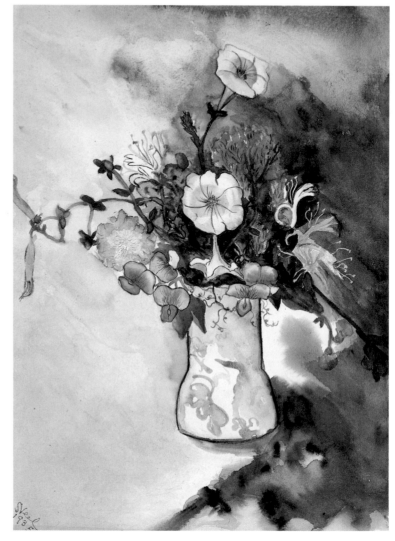

153. Alice Neel. *Still Life: Flowers*. 1935. Watercolor on paper, 13¾ × 9¾″ (sight) (34.9 × 24.8)

152. Charles Sheeler. *Summer Flowers*. 1922. Watercolor and crayon on paper, 22⅛ × 13¾″ (56.2 × 34.9)

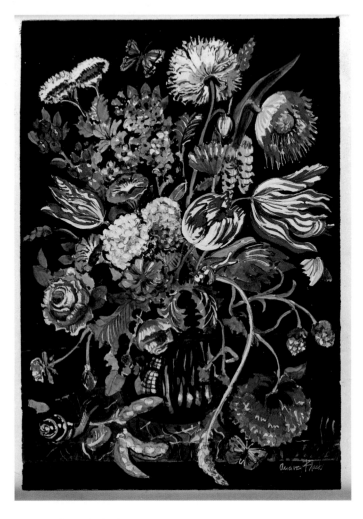

154. Audrey Flack. *Parrot, Tulips and Peapods from De Heem*. 1979.
Watercolor on paper, 7⅞ × 5½″ (sight) (20.0 × 14.0)

155. W. Louis Jones. *Study of Yellow Crocus*. 1979. Watercolor on paper,
29⅞ × 22³⁄₁₆″ (75.9 × 56.4)

(plate 70); Joseph Piccillo's *Edge Event XXVI*, 1982 (plate 79); and Robert Laurent's *Dog*, c. 1920 (plate 78). In each case the compositional dynamic is achieved by the placement of the subject directly on the support rather than by its integration into background forms or spaces. The high, asymmetrical location of Stella's bird enhances the lightness of the creature and the impression of its potential to fly. Conversely, the central placement and ovoid contour of Laurent's amusingly caricatured dog support the perception of the creature's sound and secure sleep. Piccillo's horse looks back to the photographs of Eakins and Muybridge as resources for his image of this powerful animal in motion. His tonal treatment of image and field is the opposite of that of Stella, Allan, and Laurent. The white horse emerges from a ground of black graphite rubbed over a canvas support. That the horse's extremities just touch the edge of the canvas adds visual tension to the design and reinforces the movement and rhythm of the image.

Piccillo's graphic composition and bold presentation are the opposite of the restrained technique of Richard McLean's *Sunduster*, 1983 (plate 76). To Photo Realist McLean, human gesture is subordinated to informational detail. The power of his watercolor image comes not from brushwork but from the obsessive control of tonal contrast and rich local color. Don Nice and Ellen Lanyon (plate 75) take emblematic representation a stage further, moving their composite images almost into the realm of heraldry. Nice, like Welliver, is an avowed modernist and is also one of America's most renowned *animaliers*. His watercolor on a shaped-paper support, *Sun Valley Totem*, 1983 (plate 74), is one of many pictures in his Totem series. Done on a visit to Sun Valley, the picture is dedicated to Glenn and William Janss and is composed of a collection of images that are attributes of their daily activities and environment. Mrs. Janss is an ardent farmer, hence the sunglasses, garden gloves, and vegetables. The depictions are disposed on the support like emblems on a ceremonial shield.

5. The Human Figure: Nude and Seminude

Since the beginnings of art, the human body has provided artists with profound challenges. Indeed, prehistoric cave painters seemed reluctant to make representations of human beings. The few that survive from Ice Age art are much less realistic than the animal images or effigies done during the same period. This probably had to do with magical proscriptions against enslaving or harming human spirits by capturing their images. Such proscriptions still exist in a number of primitive cultures, and image magic remains a part of voodoo.

In Classical antiquity, however, the human form was celebrated, and it was equated with the appearance of the gods themselves. During the Renaissance, humanist philosophy and art represented man as God's highest creation, and the nude became the most exalted image an artist could create. Since then, anatomical study and life-drawing have been a fundamental part of all artists' training. Although the primacy of this activity has been somewhat deemphasized in the twentieth century, it has remained essential to artists interested in realism or figurative art.

All of the drawings in this section fall into the classification "studies." The study, as the word implies, is to the artist as reading or research is to the scholar. Studies may be done to gain understanding and improve the mind, eye, and hand, or they may anticipate another specific work, or they may be made for future reference. They may be highly finished, as is John Koch's *Nude Reclining—Study for Summer Night*, 1965 (plate 86), or Martha Mayer Erlebacher's *Woman in Chair I*, 1982 (plate 84). Julie Schneider's delicate *House Wrens*, 1983 (plate 85), and Michael Mazur's boldly gestural pastel, *Gloria*, 1979 (plate 87), are two highly developed studies done in vastly different styles and techniques. Edwin Dickinson's *Nude, Provincetown*, c. 1920 (plate 98), Raphael Soyer's Untitled, c. 1940 (plate 88), and Paul Georges's *Female Model with Apple*, 1982 (plate 89), are studies of a different kind. They are abbreviated notations, or "sketches," used to record a fleeting gesture or to make note of an appealing pose.

The drawings by David Park, Elmer Bischoff, Richard Diebenkorn, James Weeks (plate 97), Manuel Neri (plate 81), and Theophilus Brown (plate 80) represent the work of Bay Area figurative artists. In the use of line and wash, Park's Untitled, c. 1955-59 (plate 91), Bischoff's *Figure with Knee Up*, 1959 (plate 92), and Diebenkorn's *Two Nudes*, 1962 (plate 93), share a painterly quality that links these pioneers of Bay Area figuration not only to Expressionism but also to the flowing sketches of Rembrandt. The colored drawings of Nathan Oliveira (plate 82), Neri, and Brown also exhibit painter-

ly handling but result in more direct images, akin to late 1950s figurative Expressionists such as Jean Dubuffet and Francis Bacon.

6. Self-Portraits

The self-portrait is a means by which the outward-looking realist artist looks inward. The image reflected in a mirror allows reflection on the self. The self-portrait has a history that goes back at least to the Late Gothic, and it has been used by artists for a variety of reasons. Sometimes self-portraits are created as a matter of convenience, using oneself rather than a model to study facial expression. They also provided some artists, particularly Rembrandt and Van Gogh, with opportunities to penetrate beyond physiognomy to the very nature of being.

In their drawings of themselves, James Valerio, William Beckman (plate 101), James Aponovich (plate 99), Jack Beal (plate 94), and Gregory Gillespie (plate 96) all attempt to reveal not only appearance but also character and personality. Valerio's *Self-Portrait*, 1983 (plate 100), is also a study for a larger painted image of himself seated in a mysteriously darkened room. Gillespie and Beal pay homage to past styles of realism, the Northern Renaissance and the Baroque, respectively.

Jim Dine's *Visiting with Charcoal II*, 1980 (plate 103), Robert Arneson's *Head Squeeze*, 1984 (plate 102), and Red Grooms's *Self-Portrait as a Beer Mug*, 1977 (plate 95), all represent more comical approaches. Dine and Grooms use disembodied objects as personal attributes. Arneson's large drawing is a playful visual pun on his primary artistic activity, ceramic sculpture, a medium in which he has also made self-portraits. Here he represents his hands squeezing his head just as they might mold a lump of clay.

7. Figures: Art and Mythology

The artists in this small category do not respond solely to a model or a nude; they also refer to past art or its great themes.

Monika and Bird, 1977 (plate 108), by Joan Brown, another Bay Area artist, is one of several watercolors in which she placed a somewhat innocent and vulnerable figure, often a self-portrait, in association with artistic symbols and monuments of some past epoch, in this case Egypt. Another California artist, Mel Ramos, who has been associated with both realism and Pop Art, integrates his figure with a modern art-historical monument, Willem de Kooning, in his playful *I Still Get a Thrill When I See Bill No. 10*, 1976 (plate 109). Ramos has done a series of spoofs on great artists and their works, including Manet's *Olympia* and Ingres's *La Source*. Laurence Dreiband's powerful double image preserves figure/ground tonalities, using a Rodin torso as a point of departure in *Rodin, A Loan No. 1*, 1984 (plate 106), and *Rodin, A Loan No. 2*, 1984 (plate 107).

The two other artists in this section take quite different approaches, both from the artists mentioned above and from each other. David Ligare's *Study for Et in Arcadia Ego*, 1982 (plate 105), relates him to a contemporary international trend that looks to eighteenth-century Neoclassicism as a stylistic resource. Hyman Bloom, an American Francis Bacon in terms of his fearful imagery and masterful technique, looks into the black side of myth and religion in his *On the Astral Plane: Beelzebub*, 1966 (plate 104). At first glance the picture is almost abstract, but gradually, through a dark fog of massed black graphite marks, the horrible image reveals itself, making references to the literature of black magic, the Old Testament, and Milton's *Paradise Lost*. Bloom depicts the monstrous fallen angel, Beelzebub, in Hades, toying with the skulls of lost souls. Though this is not, strictly speaking, a realist work, Bloom's great draftsmanship is revealed in the articulation of the anatomical forms that are obscured in his black mist.

8. Portraits

Portraiture can trace its lineage back at least to ancient Egypt, and some of the greatest works in the history of art have been portraits. Such artists as the anonymous portrayer of Queen Nofretete, Titian, Velázquez, Rembrandt, Hals, Ingres, Sargent, Manet, and Cézanne have not only preserved in image the character of their subjects but have also provided examples of stylistic innovation.

Joseph Stella, Alex Katz, and Willard Midgette render their subjects in traditional line drawing. In *Peasant of Muro Lucano*, 1943 (plate 112), Stella represents his subject with a simple dignity and sure directness of line born of the artist's Precisionist background. Katz's *Ronnie*, 1978 (plate 111), is also executed with reductive simplicity, which shows his affinities to such modern masters as Matisse. In his *Study for*

156. Heidi Endemann. *Rose Cycle*. 1978. Watercolor and gold leaf on paper, 29½ × 22″ (sight) (74.9 × 55.9)

157. John Stuart Ingle. *The Good Life*. 1978. Watercolor on paper, 23½ × 18¾″ (sight) (59.7 × 47.6)

158. P. S. Gordon. *Flora, Flora, Where's the Fauna? (Starling under Glass).*
1984. Watercolor on paper, 52½ × 40¼″ (133.4 × 102.2)

Portrait of Sally, 1977 (plate 117), Midgette combines a lacy swirling of agitated lines with tonal accents to enhance the face, recalling Ingres's portrait drawings.

Alfred Leslie (plate 115), like Katz a progenitor of New Realism, and Ian Hornak combine line and tone in their renderings. Leslie, known for his interest in narrative subjects in dramatic Baroque tonalities, draws his figures in subtle colors, as if they are lit from the footlights of a stage. Hornak's *Marcia Sewing No. 4*, 1978 (plate 116), is a detailed study for a larger painting of the same subject. Aaron Shikler relies entirely on subtle tonal gradations of charcoal—recalling the drawings of Georges Seurat—to depict his *Head of a Man: Back View*, 1982 (plate 110).

Judy North and Chuck Close (plate 118) both amalgamate unconventional systems with technological effects in their portraits. North's watercolor, *Quantrell II*, 1979 (plate 114), uses a Pointillistic technique to create an image that looks as if it might be made by a computer. Photo Realist Close's photographically derived subjects are the starting point from which he uses various systems to achieve his ultimate rendition. The photograph is enlarged to an expanded grid system, and the tonal differentiations characteristic of Close's portraits are achieved by employing a variety of small modular units. These may be straight lines, dots, or, as in this case, fingerprints.

Juan Gonzales brings a Surrealist's sensibility to his *Double-Portrait of Jimmy in New York City*, 1984 (title page). The work is an amalgamation of personal symbols and possessions rendered in a minutely obsessive style that recalls Northern Renaissance miniatures, which Gonzales greatly admires.

9. People in Places: Figures in Environments

In this section, we see the artists approach reality anthropocentrically. The works reveal, through the artists' eyes, humanity's association with and impact upon the natural environment—the things, places, inventions, and actions that define mankind's world.

We look again at images of men and women in the context of their clothes, and of the places where they live or work. The earliest work in the exhibition is Edward Hopper's 1901 drawing, *Seated Gentleman in a Cape* (plate 123), done with a stylish nineteenth-century academic flourish that be-

lies Hopper's future direction. Ash Can Realists John Sloan (plate 128), Robert Henri (plate 127), William Glackens (plate 129), and Everett Shinn (plate 130) each use their reportorial training to create narrative, anecdotal images. Their contemporary and sometime colleague George Bellows, in his *German Sailor*, c. 1918 (plate 124), indicates that you *can* tell a man by the clothes he wears.

American Scene Regionalists Thomas Hart Benton and John Steuart Curry depict hardship in rural America. Benton's *Lonesome Road*, 1927 (plate 132), uses caricatural distortion to evoke sympathy for the impoverishment of his subject. Curry's *The Fugitive*, 1935 (plate 133), is an Expressionistic drawing depicting a Southern black attempting to escape a lynch mob. Social Realist William Gropper turns his polemical attention toward urban oppression by representing sweatshop conditions in *Shoemakers*, c. 1935 (plate 134).

Two recent works by DeWitt Hardy (plate 2) and Philip Pearlstein (plate 120) place the nude in a specific interior setting and exemplify the difference between traditional realism and New Realism. Hardy sets his scene in a conventional space with foreground, middle distance, and a deep background, as if viewed from a standing person's eye-level. The scene suggests intimacy and familiarity between the artist or the viewer and the place and the figure. Pearlstein's approach is more analytic; the subjects and the background are treated with equal objectivity, and any psychological or emotional relationship to the people is coincidental. The subject matter is subordinated to the formal arrangement of form and pattern.

10. Intimate Spaces

The subjects represented in this section are things within a specific space. All of the elements depicted are man-made, but the selection of the objects and the means of representing the locales suggest particular kinds of human presences, even though no person is portrayed.

Nine of these artists overview a foreground surface covered with objects and located in an interior adjacent to a window through which an exterior space may be seen. Painting the different lights or changes of scale in the simultaneous representation of interior and exterior space is a formidable challenge that has attracted artists since early-fifteenth-century Netherlandish masters such as Robert

Campin and Van Eyck first proposed their solutions. John Stuart Ingle makes use of their example in his meticulously executed watercolor tour de force, *Still Life with Rose and View into the Landscape*, 1984 (plate 150).

Three artists—Leigh Behnke in *Still Life with Telephone*, 1983 (plate 148); Roger Howrigan in *Night Greenhouse No. 3*, 1982 (plate 151); and Paul Wonner in Study for *Still Life with Iris, Crayolas, and Two Views of San Francisco*, 1980 (plate 147)—use hard-edged shapes and highly structured compositions that show familiarity with and admiration for the theory and practice of geometric abstraction. Behnke, for example, organizes her diptych with subtle reversals of tone and color on either side. She arranges the pattern of intersections and continuations of the edges of furniture and architecture to create an underlying compositional grid with the structural simplicity and frontality of a Mondrian.

Three other artists, Jane Freilicher, Diane Townsend (plate 176), and Elizabeth Osborne, approach the same problem in a more gentle and painterly manner. The intimacy of feeling evoked in Osborne's watercolor, *Autumn Still Life*, 1981 (plate 145), and Freilicher's *Daffodils*, 1979 (plate 146), shows the kinship of their sensibility to that seen in Fairfield Porter's Sketch for *Lizzie and Christmas Tree*, 1972 (plate 141). Paul Weisenfeld (plate 137) and Ben Schonzeit each address themselves to formal domestic spaces. Schonzeit's *The Music Room No. 7*, 1977 (plate 143), is one of a number of studies for a monumental polyptych also called *The Music Room*.

Superrealists Michael Webb and Douglas Bond and the naive painter Joan Brady all deal with highly informal aspects of home life and the work place. Webb's *The Studio No. 2*, 1978 (plate 149), represents the ordered chaos of the artist's work table, while Bond (plate 136), comically, and Brady (plate 142), rather charmingly, look at domesticity in the morning.

11. Nature Indoors: Food and Flowers

The works in this category represent the transformation, by human intervention, of natural vegetation into either a source of nourishment or a decoration. These still lifes conjoin the products of nature with the habitat of humanity.

The still life as an artist's subject, separate from a larger context, is as old as Roman antiquity. Wall and floor decorations depicting fruits and flora are commonly seen in the ruins of the kitchens of Classical villas. The still life with food or flowers was of special interest for seventeenth-century painters, particularly in the Netherlands, and has remained since then a mainstay in the representational artist's repertoire. Indeed, Audrey Flack, in her *Parrot, Tulips and Peapods from De Heem*, 1979 (plate 154), pays homage to Jan de Heem, a seventeenth-century Dutch master.

Four artists in this group—W. Louis Jones (plate 155), Mark Adams (plate 159), John Stuart Ingle, and Alice Neel—minimize the importance of the ambience and location, focusing their attention, more as a botanist might, on the nature of the plants they depict. Jones and Adams use strong, rectilinear compositional devices and dark backgrounds to isolate their subjects. Ingle draws heavily on the Baroque tradition in his meticulous watercolor, *The Good Life*, 1978 (plate 157), while Alice Neel's more expressive *Still Life: Flowers*, 1935 (plate 153), recalls the work of Odilon Redon.

Two large watercolors, Carolyn Brady's *Pink Table*, 1979 (plate 162), and P. S. Gordon's *Flora, Flora, Where's the Fauna? (Starling under Glass)*, 1984 (plate 158), are technical tours de force in the medium. So too are the pastels *Pink Paper and Blue Pitcher*, 1982 (plate 161), and *Autumn Leaves and Fruit*, 1982 (plate 170), by Janet Fish and *Still Life with Tulips*, 1982 (plate 160), by Jack Beal.

Beal's wife, Sondra Freckelton (plates 171 and 172), is, like Brady and Gordon, one of the most gifted of contemporary realist watercolor technicians. Unlike Brady, however, Freckelton, like Beal, Leslie, and Pearlstein, is an "eyeball" realist and places no reliance on photography for the development of her entirely perceptual realizations of lush natural forms.

Barnet Rubinstein (plate 165), Sally Sturman (plate 164), and Martha Mayer Erlebacher (plate 175) create fragmented images seen from a high vantage point, and they emphasize the pattern and the vivid colors of their compositions. Conversely, in George Ault's *Corn from Iowa*, 1940 (plate 168), Mary Ann Currier's *Mushrooms*, 1983 (plate 173), Paul Linfante's *Black Grapes*, 1969 (plate 174), and Mary Snowden's *Jersey Pears*, 1982 (plate 169), each artist takes a close-up and worm's-eye view of the still-life objects, giving them a larger-than-life monumentality.

Delicacy characterizes Tomar Levine's *Still Life with*

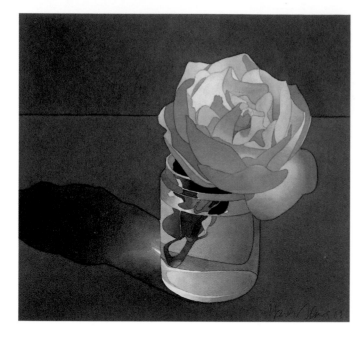

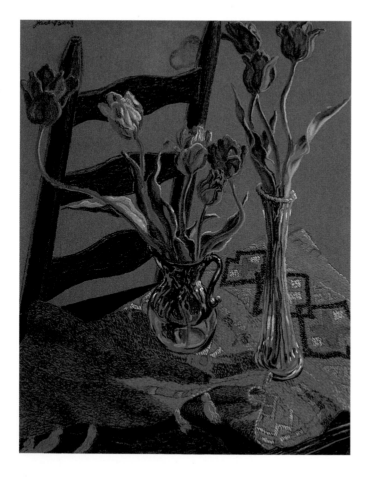

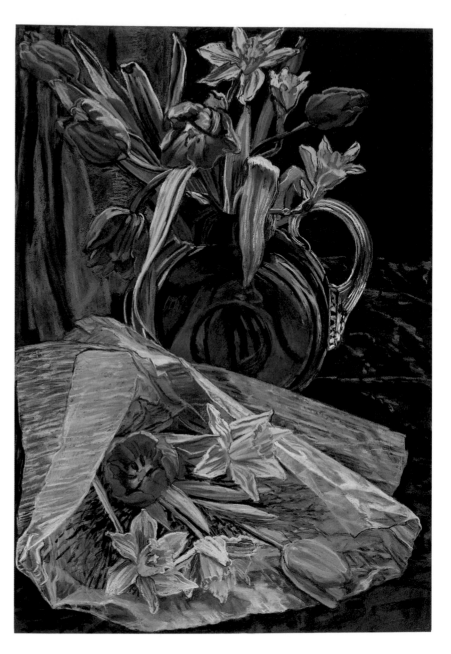

above left: 159. Mark Adams. *Pink Rose.* 1982. Watercolor on paper,
13⅝ × 14⅞″ (sight) (34.6 × 37.8)

left: 160. Jack Beal. *Still Life with Tulips.* 1982. Pastel on paper,
25⁹⁄₁₆ × 19⅝″ (64.9 × 49.9)

above: 161. Janet Fish. *Pink Paper and Blue Pitcher.* 1982. Pastel on paper,
39⅞ × 27¾″ (sight) (101.3 × 70.5)

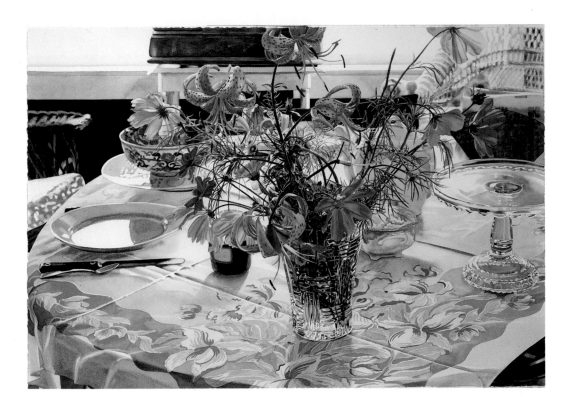

162. Carolyn Brady. *Pink Table*. 1979. Watercolor on paper, 28⁷⁄₁₆ × 41⅛" (72.2 × 104.5)

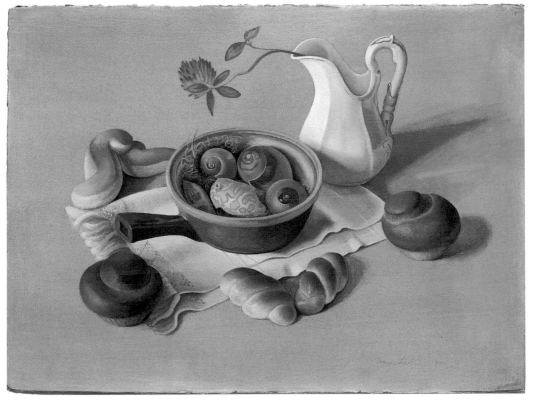

163. Tomar Levine. *Still Life with Two Brioches*. 1982. Egg tempera on paper, 22⅜ × 30¼" (56.8 × 76.8)

Two Brioches, 1982 (plate 163), Robert Kinmont's *How Do You Tell Someone What You've Seen?*, 1982 (plate 166), and Sandra Mendelsohn-Rubin's *Cherries*, 1981 (plate 167). The artists set off their subjects with backgrounds of subtly variegated tones of white and gray, which gives these pictures an oriental simplicity.

Nature is finally vulgarized in a most American way in the works of Photo Realists Marianne Boers and Ralph Goings. The natural spring water in Boers's *Perrier '82—10 Bottles*, 1982 (plate 177), rolls off a bottling-plant assembly line. Nature, both animal and vegetable, is totally transformed in Goings's powerful fast-food still lifes, *Still Life Group*, 1983 (plate 178), and *Burger*, 1982 (plate 179), which lend new meaning to the French term *nature-morte*. If we are what we eat, Goings's watercolors might well cause us to look even more respectfully at Freckelton's *Cabbage & Tomatoes*, 1981 (plate 172).

12. Intimate Objects

This section also deals with the still life. Here, however, the artists transcribe the appearance of inanimate objects—some exotic, some mundane—into works of art. The depiction of precious objects and the discovery of beautiful relationships of form and color in the commonplace have preoccupied many artists since the seventeenth century. Dutch still-life painters such as Willem Claesz Heda and De Heem wove intricate, symbolic moral lessons into their paintings of subjects of great temporal wealth. In the eighteenth century, Chardin was capable of investing the humblest of objects with great dignity. Nineteenth-century American *trompe l'oeil* artists such as William Harnett gave firm root to the allegorical or narrative still life. Cézanne, the father figure of twentieth-century modernism, stated that the role of the artist is to find the extraordinary in the ordinary.

Each of the artists in this section—either by the selection and representation of objects of intrinsic visual interest or by discovering fascinating formal relationships in the shapes and shadows formed by mundane things—makes something wondrous out of small, man-made items that might otherwise go unnoticed.

Walter Murch—whose still lifes supplied the covers for dozens of issues of *Scientific American*—William Bailey, John Moore (plate 182), and Laura Shechter (plate 195) each approach their subjects at eye-level, giving their compositions stability and monumentality. Murch's Study for *The Sounds of Silver*, 1965 (plate 180), uses an almost alchemical blend of mixed media to achieve his rich, painterly, translucent surfaces. Bailey, who dislikes being called a realist, created the shapes that make up his *Still Life—Ginepro No. 2*, 1979 (plate 186), in his imagination, as did the Dutch still-life painters of the seventeenth century. He achieves a dignified grandeur in his subjects that is reminiscent of both Chardin and the Italian metaphysical painter Giorgio Morandi. Norman Lundin (plate 197) also invents his forms and lonely spaces as well as the hieroglyphics on his imaginary blackboard, yet, like Bailey, he is able to infuse his images with an almost palpable believability.

Domestic utensils, toys, and shoes are made magical in Wayne Thiebaud's pastel, *Shoe Rows*, 1975 (plate 4), Charles Bell's *Curtain Call*, 1982 (plate 193), Kay Kurt's *Terry's Chocolate Animal Friends*, 1983 (plate 188), and Don Eddy's Drawing for *Glassware I*, 1978 (plate 194). Thiebaud's lush colors and textures exemplify his ability to discover the wondrous aspect of otherwise banal subject matter. Eddy's drawing reexamines one of his complex, reflective airbrush paintings. Bell and Kurt reexplore sources of the wonderment of childhood in their depictions of toys and candy molds. Photo Realist Bell has an enormous collection of tin toys, to which he often gives life in his nostalgic, inanimate dramas.

Richard McLean and David Parrish, both Photo Realists, use recreational objects in their work. McLean's tackroom composition (plate 201) is treated with detached clarity, whereas Parrish explores the patterns made by the reflections from a shiny motorcycle that create an almost abstract composition (plate 199). This approach is reversed in Stephen Posen's *Untitled*, 1973 (plate 196). Posen creates assembled constructions of boxes and cloth that he transforms into *trompe-l'oeil* drawings and paintings. Ellen Lanyon, James Aponovich, and Susan Hauptman, through their selection of things and viewpoints, create images that engage fantasy. Lanyon's *Parnassus Apollo*, 1975 (plate 185), creates a fascinating but believable image of a magical construction of the mind. Aponovich views his *Still Life with Oranges and Glasses*, 1981 (plate 189), from above, discovering extraordinary patterns of light and dark that become more important

164. Sally Sturman. *Pears.*
1983. Pastel on paper,
19⅞ × 24¹³⁄₁₆″
(50.5 × 63.0)

below: 165. Barnet Rubenstein.
Still Life with Watermelon.
1981. Colored pencil, graphite,
and watercolor on paper,
21³⁄₁₆ × 30″ (53.8 × 76.2)

166. Robert Kinmont. *How Do You Tell Someone What You've Seen?* 1982. Watercolor on paper, 25⅜ × 34¼" (sight) (64.5 × 87.0)

167. Sandra Mendelsohn-Rubin. *Cherries.* 1981. Colored pencil on paper, 11 × 16⅞" (27.9 × 42.9)

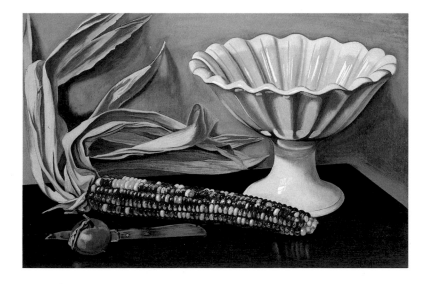

168. George Ault. *Corn from Iowa*. 1940. Gouache on paperboard, 13 × 19⁷⁄₁₆" (sight) (33.0 × 49.4)

than the objects, which almost lose their identity. Hauptman's Untitled, 1981 (plate 200), is a close-up view of the simple forms of beach ball, shell, and spiral, drawn in rich, dark tonalities that create an almost science-fiction image, reminiscent of a still life with navigational and astronomical instruments in the background, Holbein's sixteenth-century *French Ambassadors*.

Paul Sarkisian and Sylvia Plimack Mangold translate the modernist avant-garde into realist terms. Sarkisian's *Untitled* (*Sunset*), 1979 (plate 202), is a *trompe l'oeil* interpretation of a Synthetic Cubist collage. Mangold's *One Exact, One Diminishing on a Random Floor*, 1976 (plate 198), is a meticulously rendered mixed-media drawing that recalls a Conceptual artist's documentation.

13. The Urban Scene

One of the primary tenets of realism—and modernism—is the necessity to be of its time. Life in the twentieth century

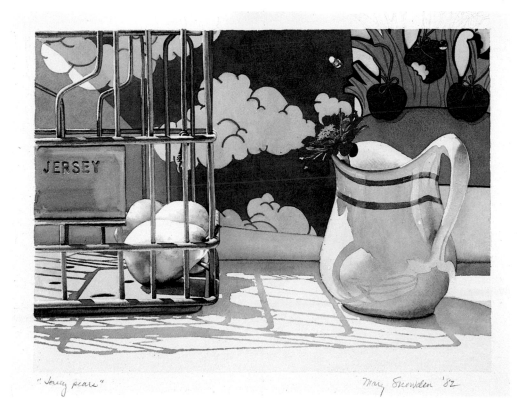

169. Mary Snowden. *Jersey Pears*. 1982. Watercolor on paper, 16¹⁵⁄₁₆ × 21¹⁵⁄₁₆" (sight) (43.0 × 55.7)

159

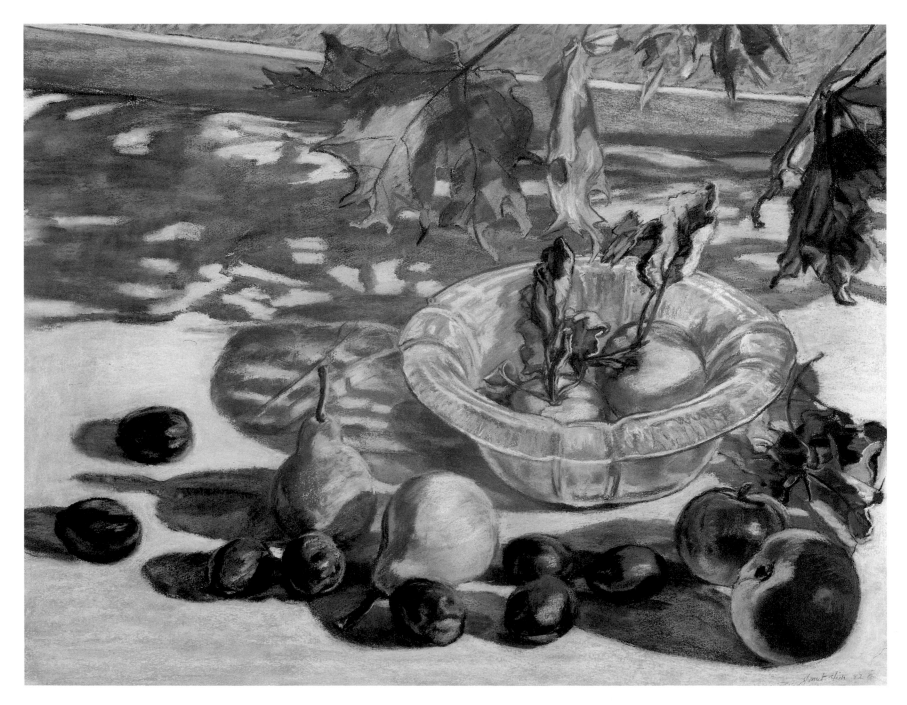

170. Janet Fish. *Autumn Leaves and Fruit*. 1982. Pastel on paper,
27⅝ × 35″ (sight) (70.2 × 88.9)

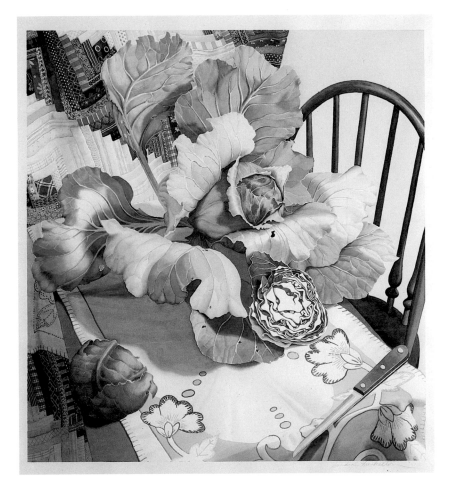

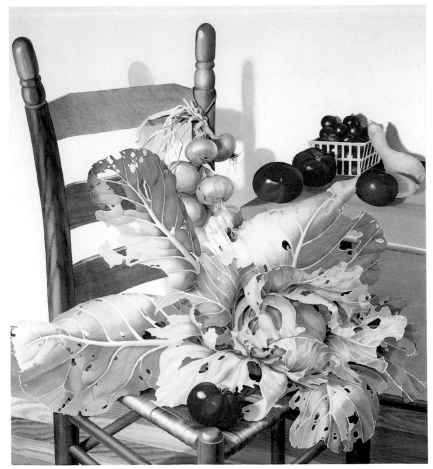

171. Sondra Freckelton. *Red Cabbage*. 1982. Watercolor on paper, 34⁷/₁₆ × 32″ (sight) (87.5 × 81.3)

172. Sondra Freckelton. *Cabbage & Tomatoes*. 1981. Watercolor on paper, 33⅛ × 30¹⁵/₁₆″ (sight) (84.1 × 78.6)

has become increasingly urban. For better or for worse, the city is where most of us live. It is an environment created by us that in many ways both circumscribes our lives and defines our activities. The artists in this section depict urban America from many points of view.

Transportation and access are the most important means by which urbanization was achieved and by which it functions. Louis Lozowick (plate 215), John Rutherford Boyd (plate 214), Thomas Hart Benton (plate 206), and Edward Hopper (plate 203) depict the means of access to the city, its bridges, boat yards, and harbors, from their vantage point in

the first half of the century. Susan Hall's *Landfall*, 1981 (plate 218), and Leigh Behnke's *Brooklyn Bridge Compositional Study*, 1983 (plate 220), are of similar subjects seen with contemporary eyes. Transportation to and from the city is also the subject of Reginald Marsh, James Torlakson, Sidney Goodman, and John Salt. Marsh's *West Shore R. R. Weehawken*, 1941 (plate 204), and *Locomotive Engine No. 15 Moving Right*, c. 1928–32 (plate 216), and Torlakson's *2266*, 1978 (plate 211), depict the railroad, the means by which American cities first became easily interconnected. The internal-combustion vehicle, our primary means of transport today, is

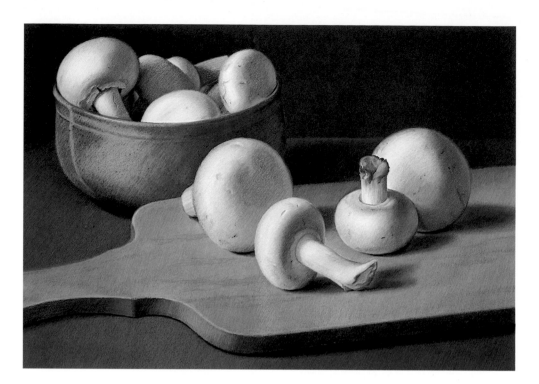

173. Mary Ann Currier. *Mushrooms*. 1983. Oil pastel on board, 27 1/16 × 38 1/4″ (sight) (68.7 × 97.2)

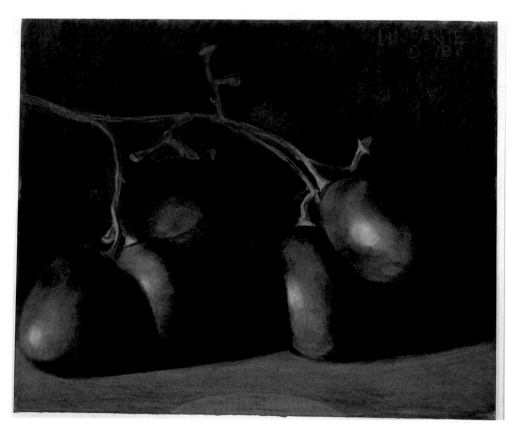

174. Paul Linfante. *Black Grapes*. 1969. Pastel on paper, 37 5/8 × 45 5/16″ (95.6 × 115.1)

175. Martha Mayer Erlebacher. *Still Life Supreme*. 1979. Watercolor on paper, 16⁹⁄₁₆ × 19⁷⁄₈″ (sight) (42.1 × 50.5)

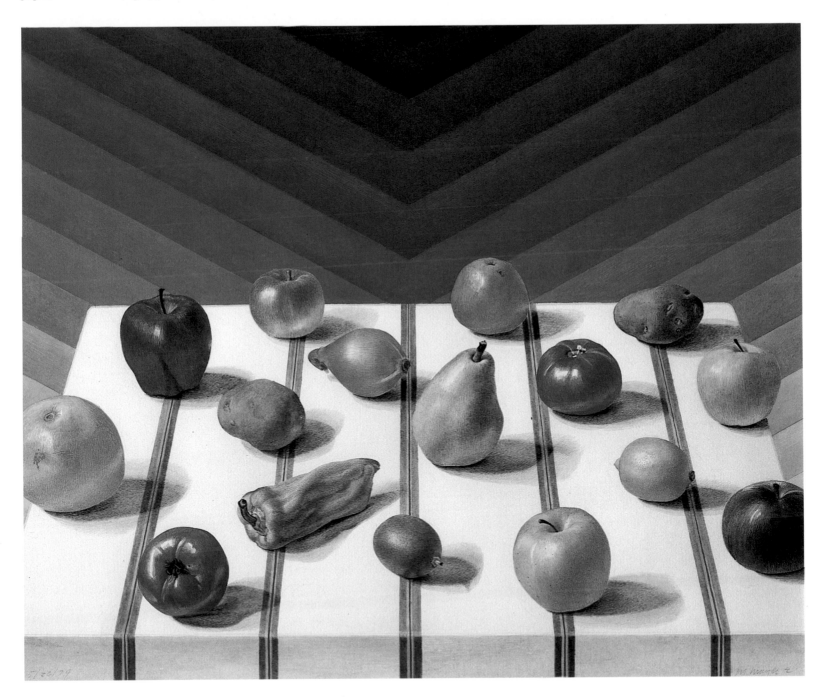

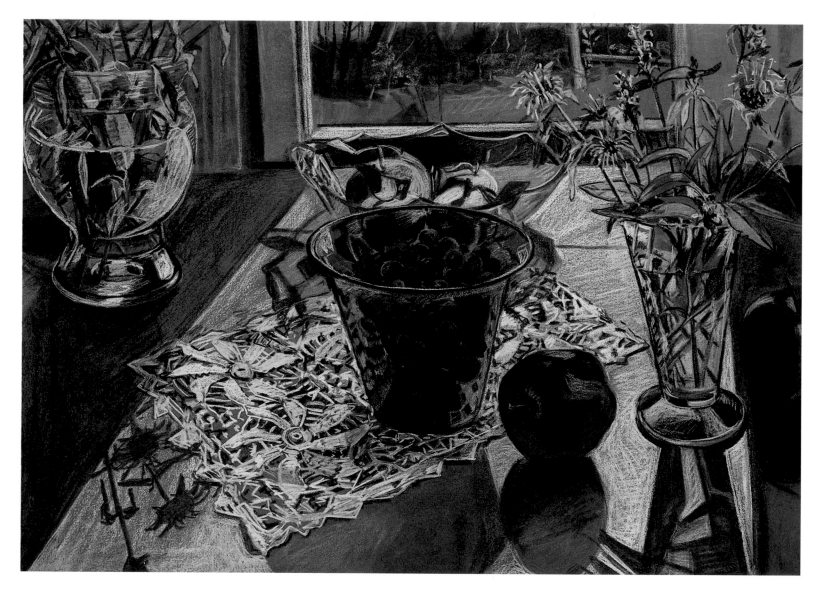

176. Diane Townsend. *Blueberries and Apple.* 1982. Pastel on paper,
29 1/16 × 41 15/16″ (sight) (73.8 × 106.5)

viewed somewhat cynically in Goodman's *Burning Vehicles*,
1979 (plate 217), and Salt's *Parked Riviera*, 1982 (plate 212).

Urban decay is the subject of John Murray's *Wooster
Street Champ*, 1981 (plate 225), Idelle Weber's *Ivory Salt*,
1979 (plate 227), John Baeder's *Gunter's Diner*, 1982 (plate
226), and Robert Cottingham's *Carry Out*, 1983 (plate 229).
With a Photo Realist's analytical eye, each of these artists re-

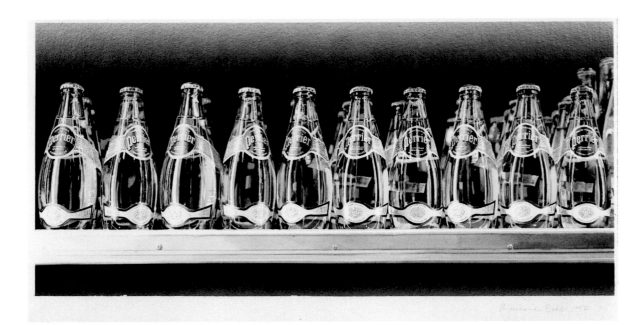

177. Marianne Boers. *Perrier '82—10 Bottles.* 1982. Watercolor on paper, 21⅞ × 30⅜″ (55.4 × 77.2)

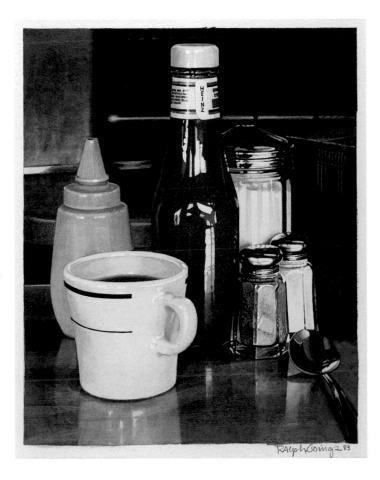

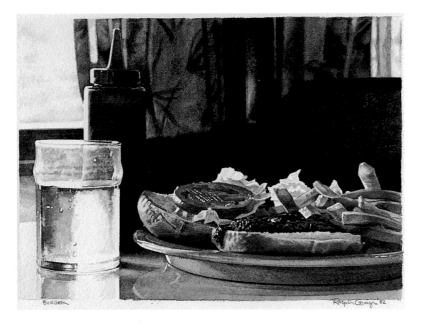

left: 178. Ralph Goings. *Still Life Group.* 1983. Watercolor on paper, 10⅞ × 8¾″ (sight) (27.6 × 22.2)

above: 179. Ralph Goings. *Burger.* 1982. Watercolor on paper, 8⅝ × 11¼″ (sight) (21.9 × 28.6)

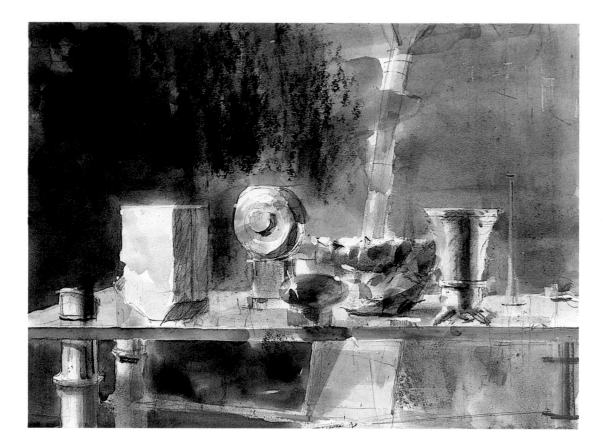

180. Walter Murch. Study for *The Sounds of Silver*. 1965. Watercolor, graphite, and varnish on board, 9 13/16 × 13 1/8″ (sight) (24.9 × 33.3)

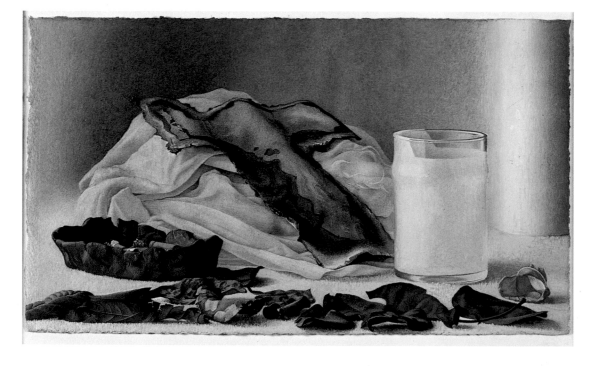

181. Maxwell Hendler. *Heart Knows*. 1977. Watercolor on paper, 6 3/4 × 11 3/4″ (17.1 × 29.8)

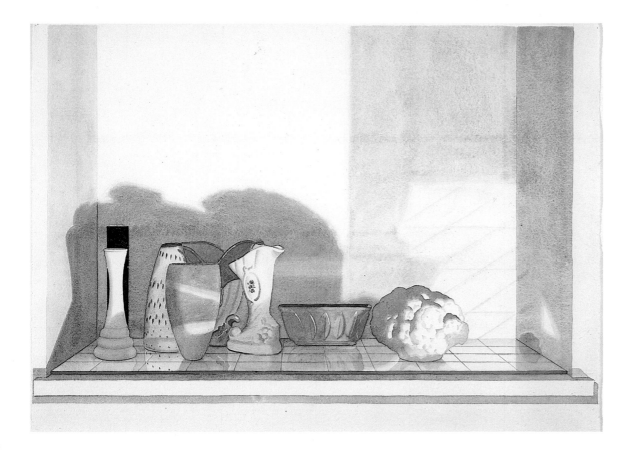

182. John Moore. *Nightlight*. 1980. Watercolor on paper, 22½ × 29⅞" (57.2 × 75.9)

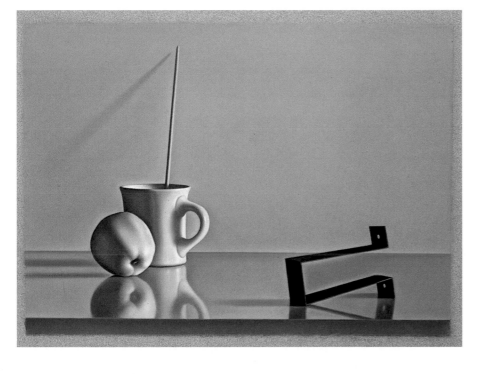

183. G. Daniel Massad. *"Things That Are Everywhere."* 1985. Pastel on paper, 15½ × 20⅞" (sight) (40.0 × 53.1)

184. Gordon Cook. *Head Shape on Stand.* 1976.
Watercolor on paper, 10³⁄₁₆ × 8¹¹⁄₁₆″ (sight)
(25.9 × 22.1)

185. Ellen Lanyon. *Parnassus Apollo.* 1975. Colored pencil on paper,
19³⁄₈ × 25¹⁄₈″ (sight) (49.2 × 63.8)

cords the detritus and neglect that affect the forgotten corners of every metropolis. Yet, even in these unprepossessing subjects, the artists discover subtle relationships of color and form that transform and transcend unsightliness. On the sinister side, cities have their cores of menace and require protection from within and without. Photo Realist Ron Kleeman gives a glistening interpretation of the police presence in his *Police Horse Trailer*, 1982 (plate 213), and Conceptual Realist Paul Caranicas interprets not only civic but also national protection in his series of images of abandoned buildings, of which *Guernsey I*, 1983 (plate 209), is part.

For all its faults and tensions, the urban complex is civilization's ultimate creation. It is both haven and jungle, a place of labor and love, intimacy and grandeur. Tom Black-

well's *Van Dyke at Bonwit's*, 1981 (plate 230), David Campbell's *Reading*, 1982–83 (plate 221), and Richard Raiselis's *Yard*, 1982 (plate 210), view small portions of the urban scene. The city in its kaleidoscopic magnificence is observed in all its aspects in Yvonne Jacquette's *Broadway Night I*, 1983 (plate 222), Richard Haas's *View of 55th and 5th*, 1977 (plate 233), and *Lower Manhattan, Twilight*, 1982 (plate 234), Seaver Leslie's *Brooklyn Bridge Celebration*, 1983 (plate 235), and John Button's *View: East at Sunset*, 1975 (plate 236). Humanity's best endeavors and worst frustrations are acted upon in close proximity on the urban stage. One must hope that civilization's most dynamic concentrations of human energy are not as Superrealist Edward Ruscha's blackboard image states: *The Absolute End*, 1982 (plate 237).

186. William Bailey. *Still Life—Ginepro No. 2*. 1979. Gouache on paper,
11⅞ × 17⅞" (sight) (30.2 × 45.4)

187. Lorraine Shemesh. *Paint Box*. 1983. Graphite on paper, 22¼ × 30⅛″
(56.5 × 76.5)

188. Kay Kurt. *Terry's Chocolate Animal Friends.* 1983. Graphite on paper, 12³/₁₆ × 18⁷/₈″ (31.0 × 47.9)

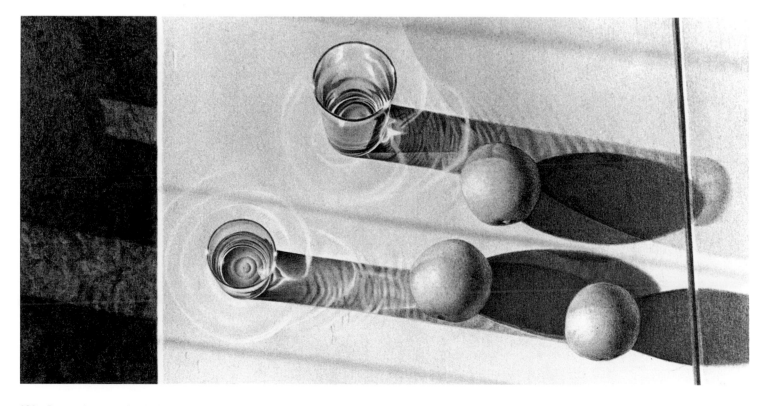

189. James Aponovich. *Still Life with Oranges and Glasses.* 1981. Graphite on paper, 5⁷/₈ × 11⁵/₈″ (sight) (14.9 × 29.5)

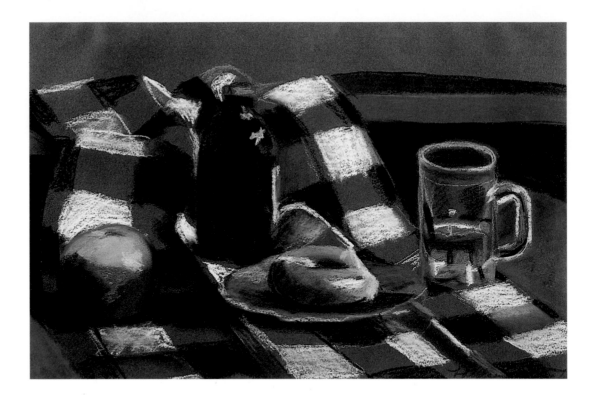

190. Louisa Matthiasdottir. *Still Life with Checked Cloth*. 1982. Pastel on paper, 12⁵/₁₆ × 18⁵/₈″ (31.3 × 47.3)

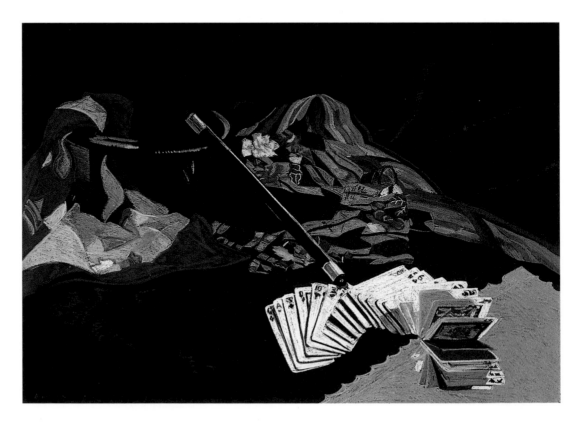

191. Harriet Shorr. *Trick Deck*. 1984. Pastel on paper, 29 × 40¾″ (sight) (73.7 × 103.5)

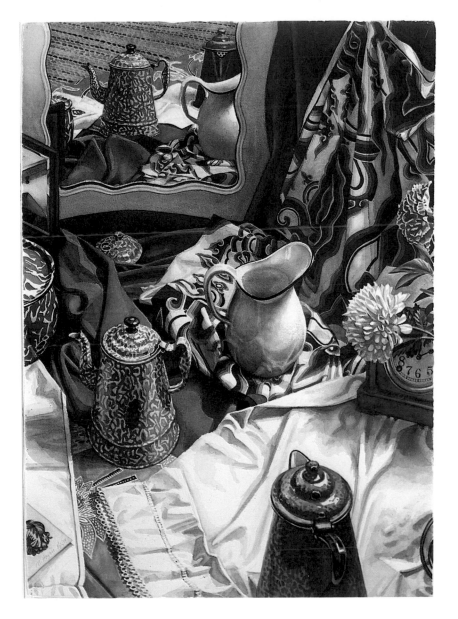

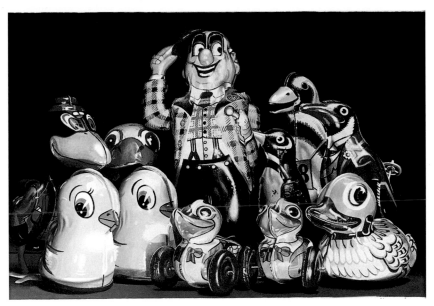

193. Charles Bell. *Curtain Call*. 1982. Watercolor on paper, 9⅞ × 14⅛″ (sight) (25.1 × 35.9)

192. Nancy Hagin. *Blue Agate*. 1984. Watercolor on paper, 41⁷⁄₁₆ × 31⁷⁄₁₆″ (105.3 × 79.9)

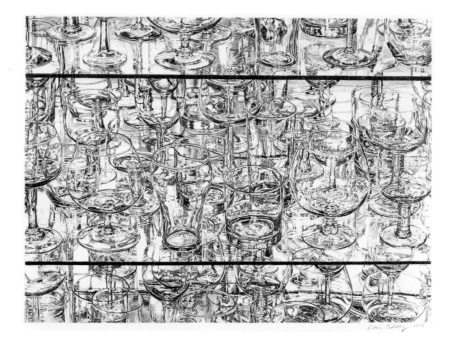

194. Don Eddy. Drawing for *Glassware I*. 1978. Graphite on paper, 8⁹⁄₁₆ × 11³⁄₁₆″ (sight) (21.8 × 28.4)

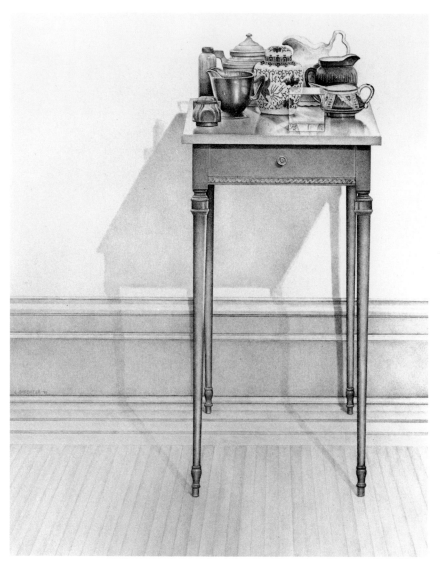

195. Laura Shechter. *A Ginger Jar and Milk Pitcher*. 1982. Graphite on paper, 13³⁄₈ × 10¼″ (sight) (34.0 × 26.0)

opposite: 196. Stephen Posen. *Untitled*. 1973. Graphite on paper, 40 × 32″ (101.6 × 81.3)

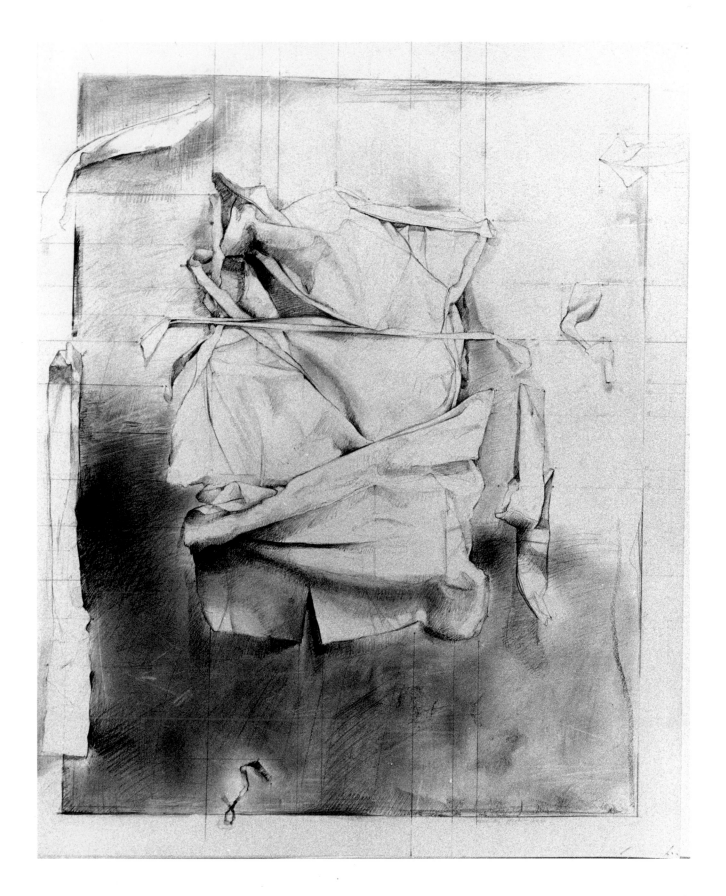

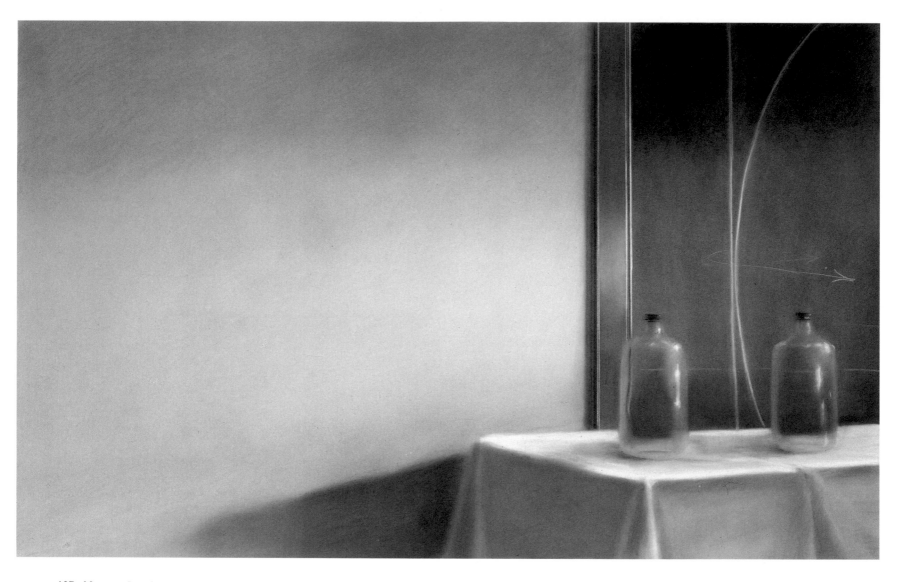

197. Norman Lundin. *60th St. Studio: Two Bottles and a Blackboard*. 1984.
Pastel on paper, 28⅛ × 44⅛″ (sight) (71.4 × 112.1)

198. Sylvia Plimack Mangold. *One Exact, One Diminishing on a Random Floor*. 1976. Acrylic and ink on paper, 29¹⁵⁄₁₆ × 39⅞″ (76.0 × 101.3)

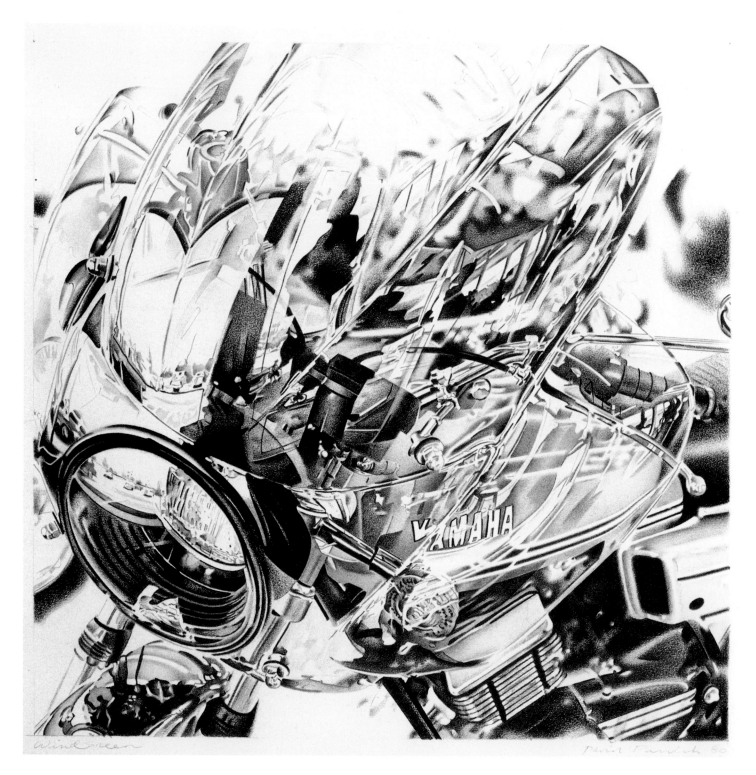

199. David Parrish. *Windscreen*. 1980. Graphite on paper, 11⅛ × 11⅛″
(sight) (28.3 × 28.3)

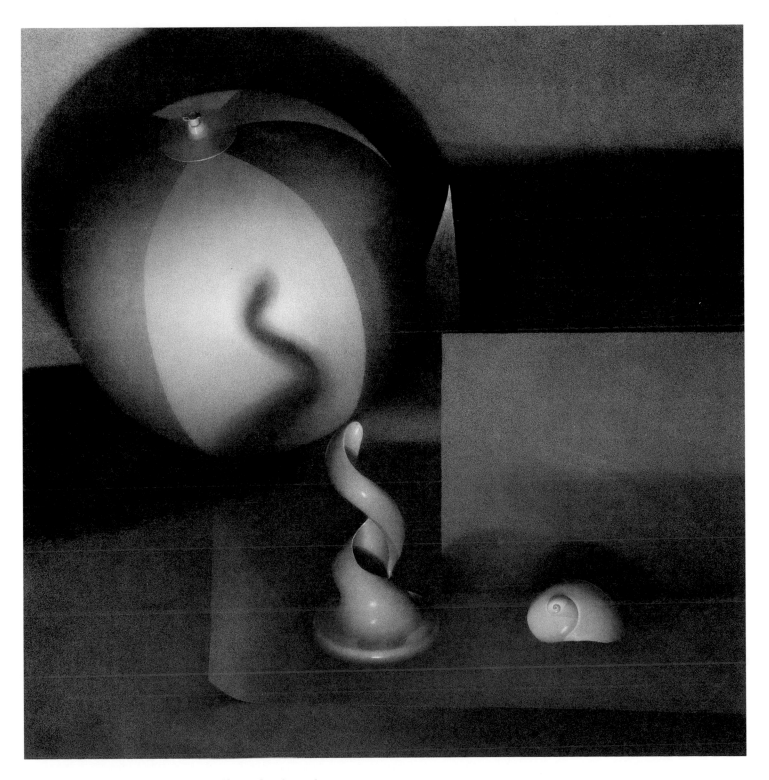

200. Susan Hauptman. Untitled. 1981. Charcoal and pastel on paper,
36¼ × 36¼" (sight) (92.1 × 92.1)

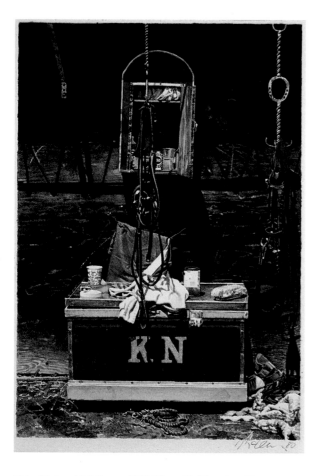

201. Richard McLean. *Still Life with Hanging Harness*.
1980. Watercolor on paper, 12¼ × 8¼" (sight)
(31.1 × 21.0)

202. Paul Sarkisian. *Untitled (Sunset)*. 1979. Acrylic on board, 32 × 40"
(81.3 × 101.6)

203. Edward Hopper. *Gloucester Boats at Wharf.* 1923. Charcoal on paper,
11⅜ × 17¼″ (sight) (28.9 × 43.8)

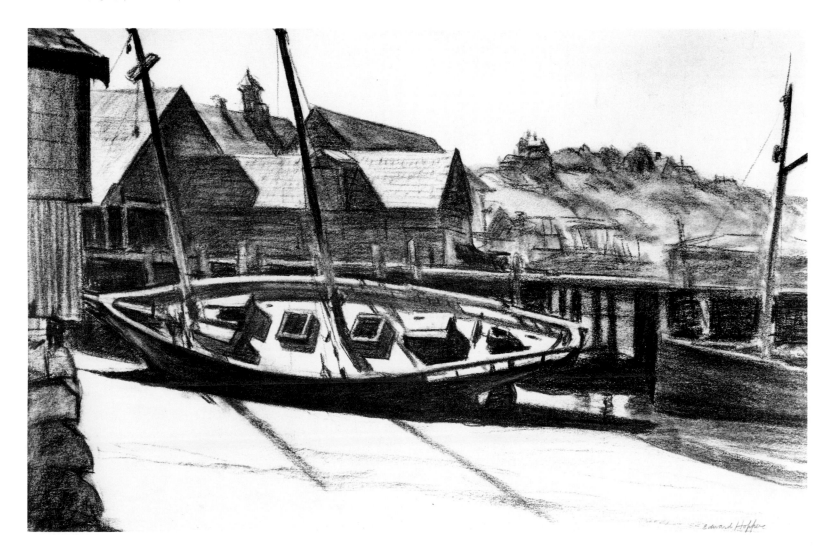

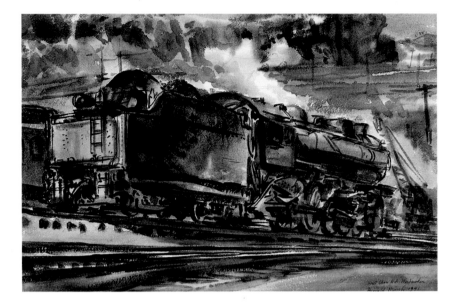

204. Reginald Marsh. *West Shore R. R. Weehawken*. 1941. Watercolor, gouache, and ink on paper, 14⅞ × 21⅞″ (sight) (37.8 × 55.6)

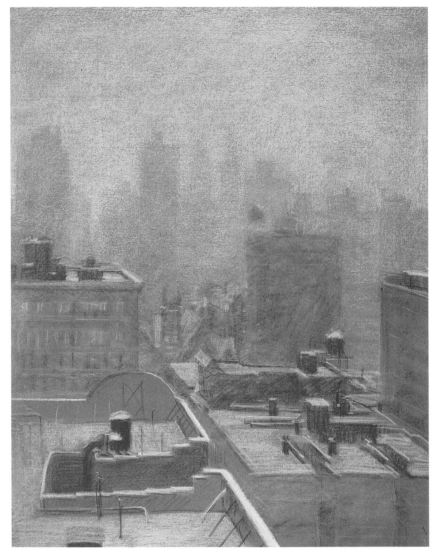

205. Lloyd Goldsmith. *Snow*. 1982. Chalk on paper, 25 × 19¹⁵⁄₁₆″ (63.5 × 50.6)

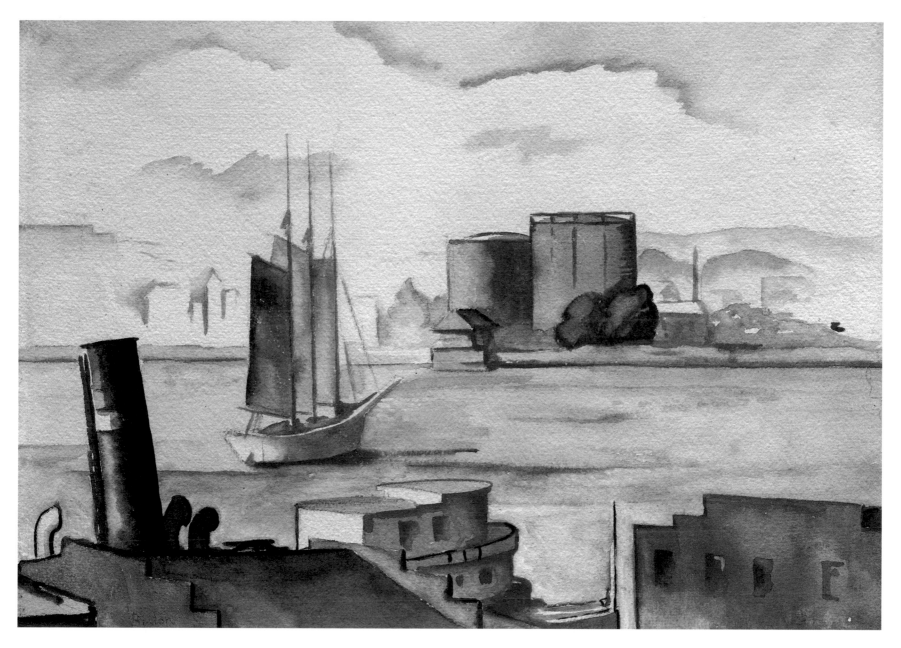

206. Thomas Hart Benton. *Harbor Scene*. 1918. Watercolor on paper, 10⅜ × 14½" (sight) (26.4 × 36.8)

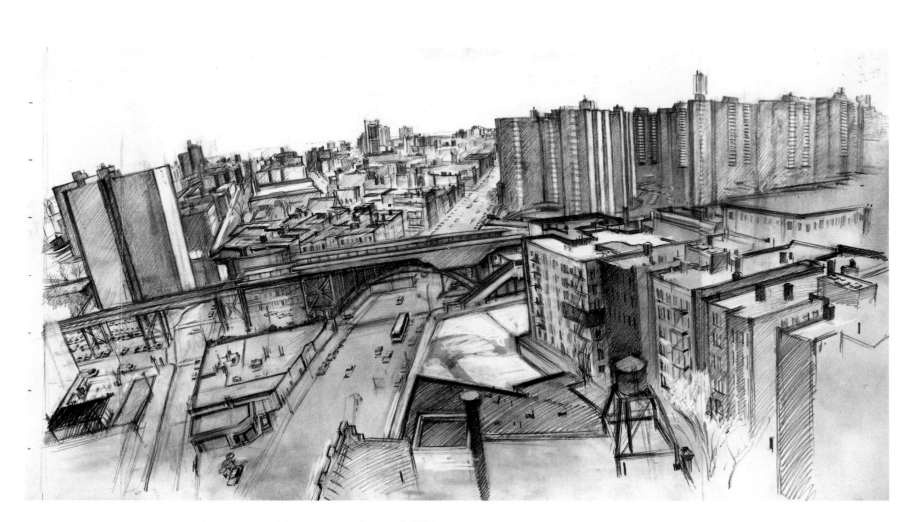

207. Rackstraw Downes. *The IRT Elevated Station at Broadway and 125th St.* 1982. Graphite on paper, 19×35″ (48.3×88.9)

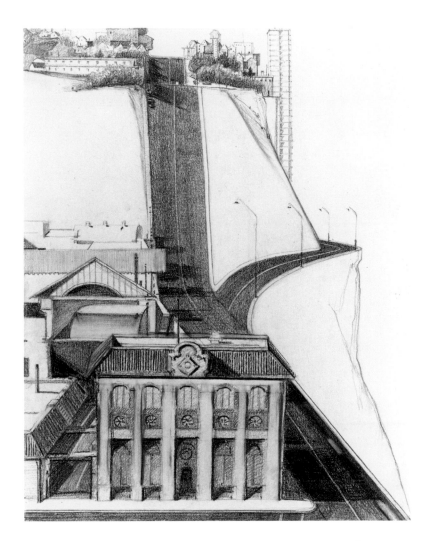

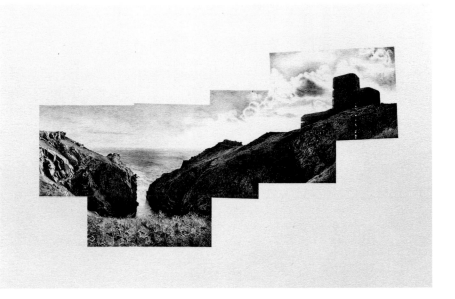

209. Paul Caranicas. *Guernsey I* (detail). 1983. Graphite on paper, 30⅛ × 53 1/16″ (78.4 × 134.8)

208. Wayne Thiebaud. *Drawing of San Francisco*. 1978. Graphite on paper, 17 5/16 × 13⅞″ (44.0 × 35.2)

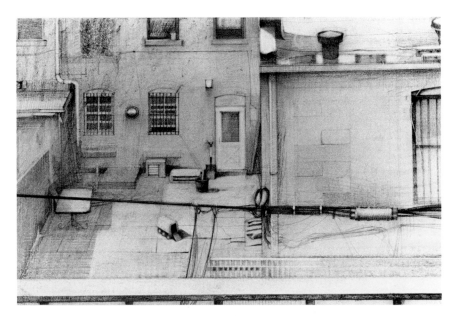

210. Richard Raiselis. *Yard*. 1982. Charcoal on paper, 15 × 22½″ (sight) (38.1 × 57.2)

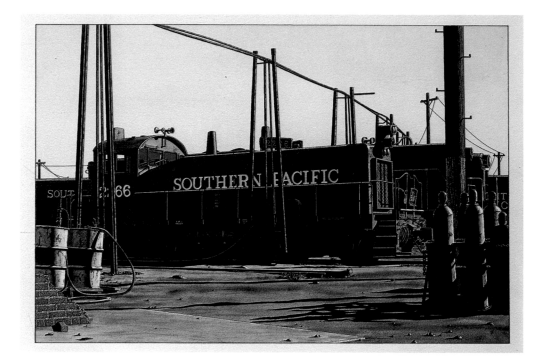

211. James Torlakson. *2266*. 1978. Watercolor on paper, 12¹⁵⁄₁₆ × 19″ (sight) (32.9 × 48.3)

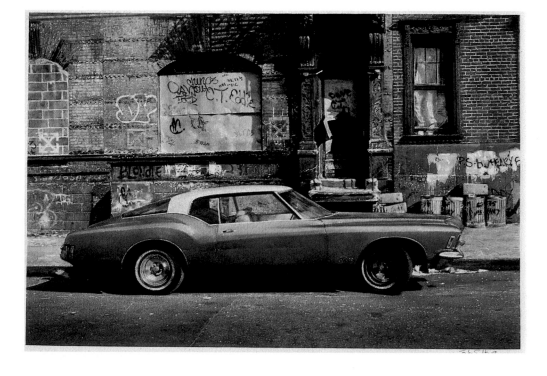

212. John Salt. *Parked Riviera*. 1982. Watercolor on paper, 12¾ × 18⅜″ (sight) (32.3 × 46.7)

213. Ron Kleeman. *Police Horse Trailer*. 1982. Acrylic on paper,
11⅝ × 15⅝″ (sight) (29.5 × 39.7)

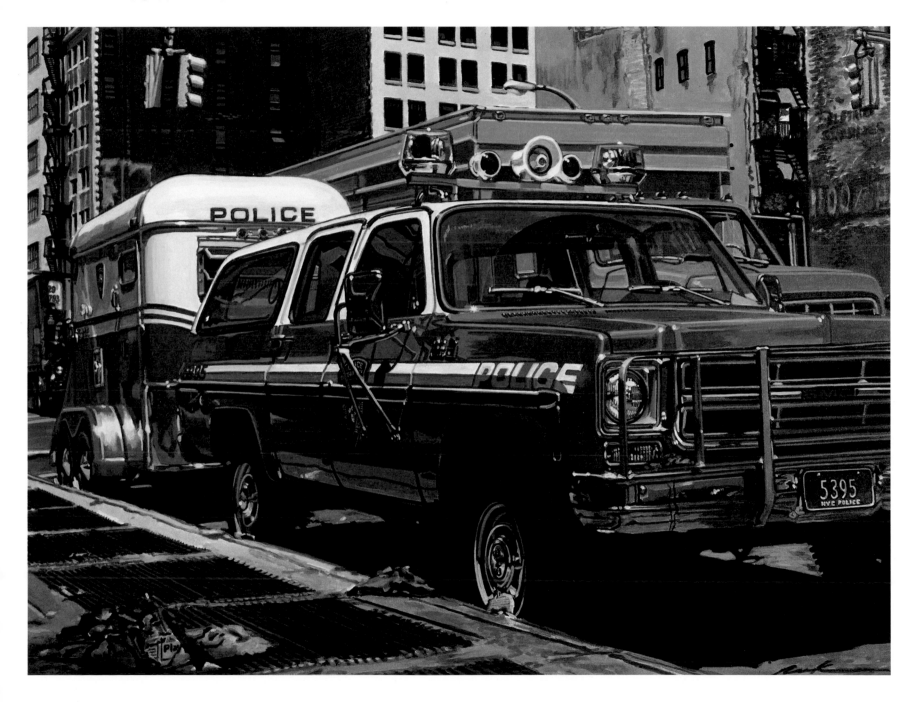

214. John Rutherford Boyd. *Lady on a Barge under Manhattan Bridge*. 1906–7. Charcoal on paper, 16⁵⁄₁₆ × 25⁵⁄₁₆″ (sight) (41.4 × 64.3)

215. Louis Lozowick. *Williamsburg Bridge*. 1945. Carbon pencil on paper, 9⁷⁄₁₆ × 12³⁄₄″ (sight) (24.0 × 32.4)

216. Reginald Marsh. *Locomotive Engine No. 15 Moving Right.* c. 1928–32.
Ink on paper, 21¹¹⁄₁₆ × 30¼″ (sight) (55.1 × 76.8)

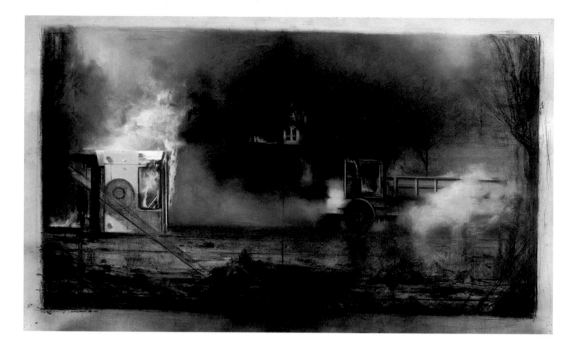

217. Sidney Goodman. *Burning Vehicles*. 1979. Charcoal and pastel on paper, 35¾ × 59″ (90.8 × 149.9)

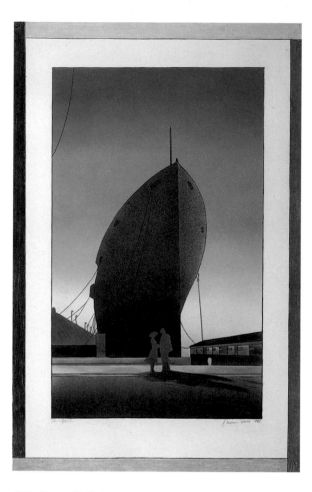

218. Susan Hall. *Landfall*. 1981. Watercolor, pastel, crayon, gouache, and graphite on paper, 40¹¹⁄₁₆ × 26¹⁄₁₆″ (103.4 × 66.2)

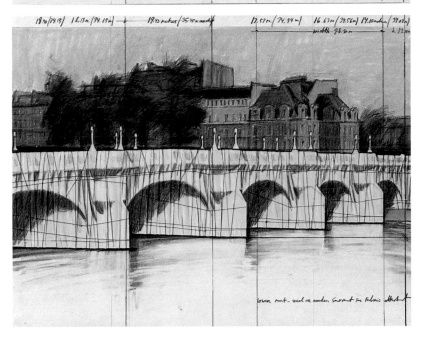

219. Christo. *Pont Neuf Wrapped*. 1980. Fabric, twine, pastel, charcoal, graphite, and crayon on paper, 11 × 28″ (27.9 × 71.1) and 22 × 28″ (55.9 × 71.1)

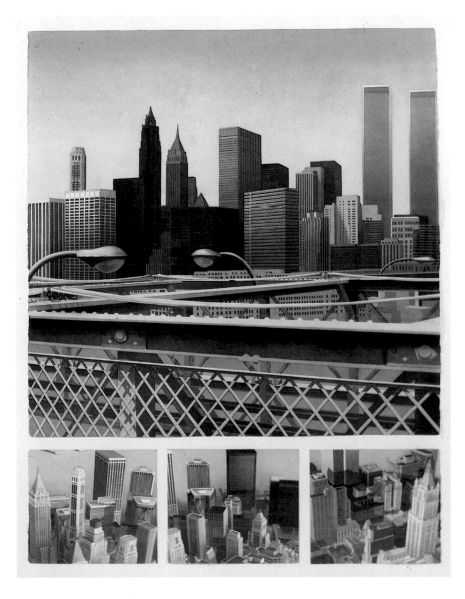

220. Leigh Behnke. *Brooklyn Bridge Compositional Study*. 1983. Watercolor on paper, 52³⁄₁₆ × 40¹⁄₁₆″ (132.6 × 101.8)

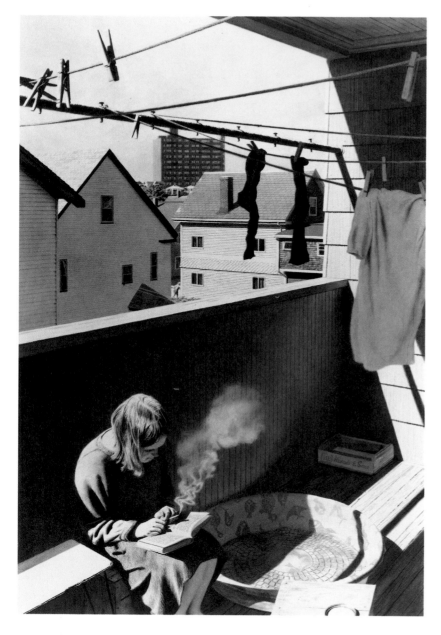

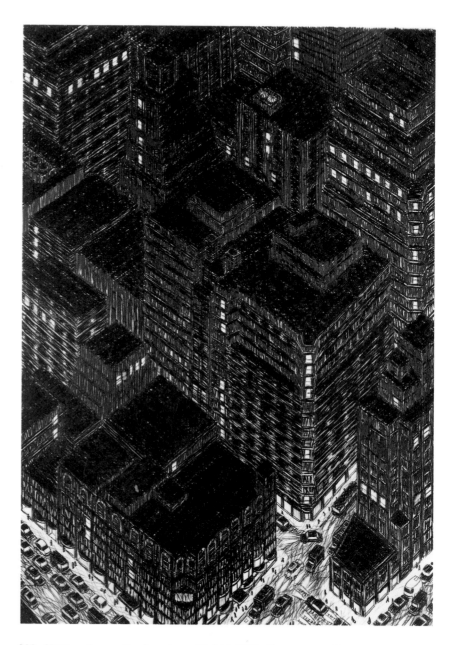

221. David Campbell. *Reading*. 1982–83. Ink and watercolor on paper, 37⁹⁄₁₆ × 25⁵⁄₈″ (95.4 × 65.1)

222. Yvonne Jacquette. *Broadway Night I*. 1983. Crayon on vellum, 52¹⁄₁₆ × 35¾″ (sight) (132.2 × 90.8)

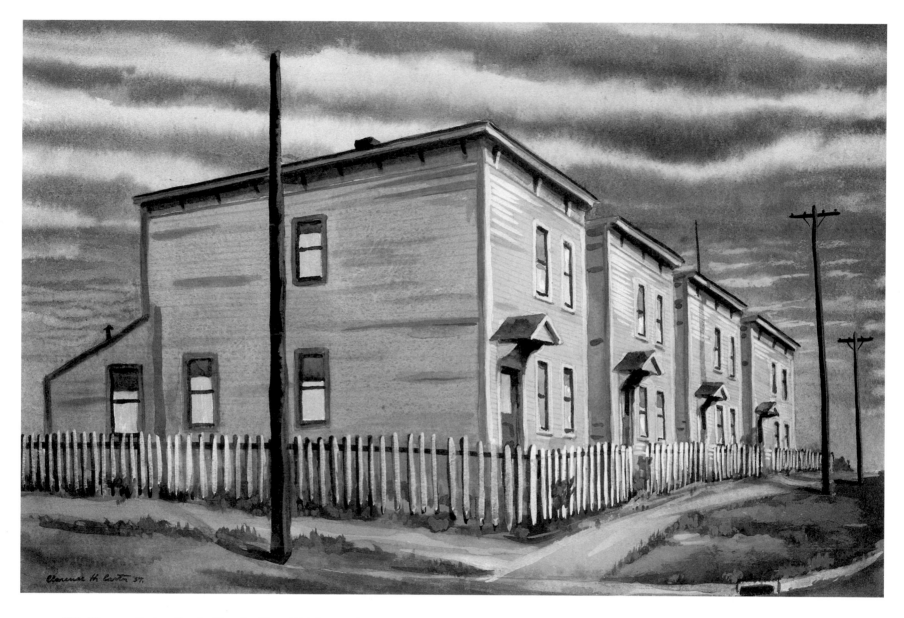

223. Clarence Carter. *Overlooking the Flats.* 1937. Watercolor on paper,
14⁷⁄₁₆ × 21⁷⁄₁₆″ (sight) (36.7 × 54.5)

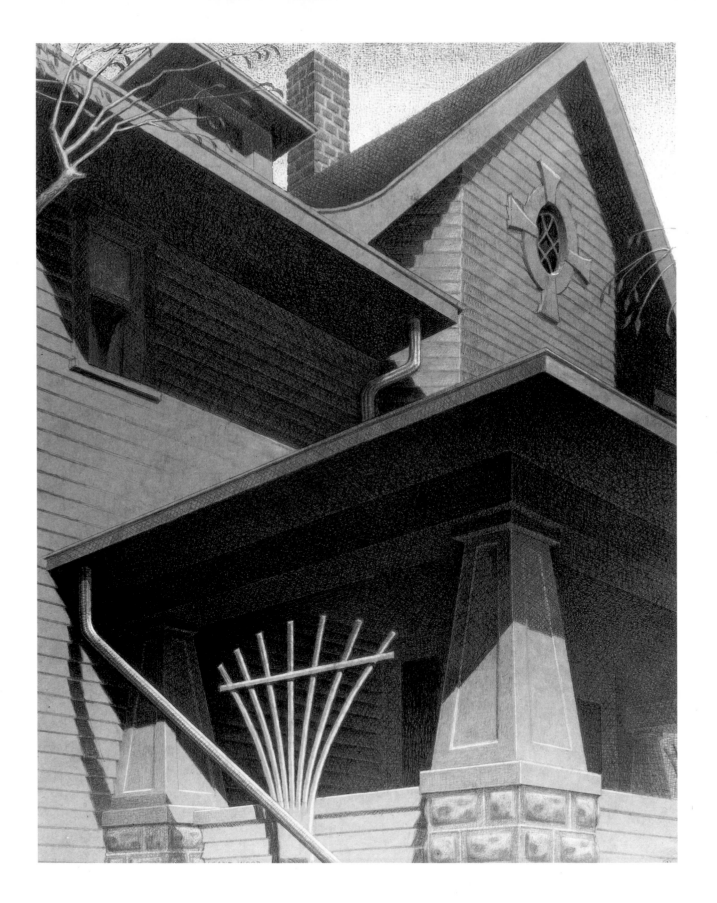

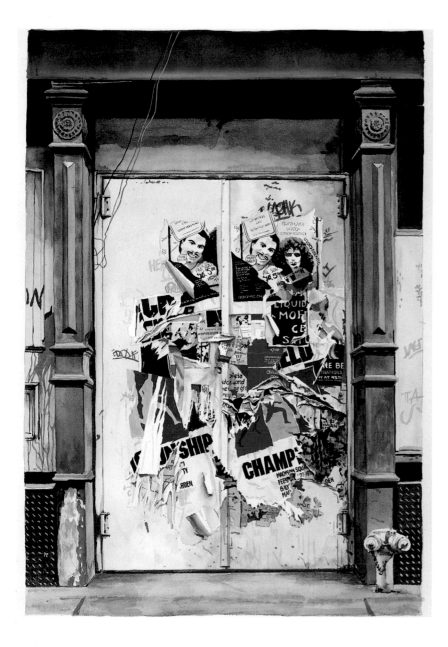

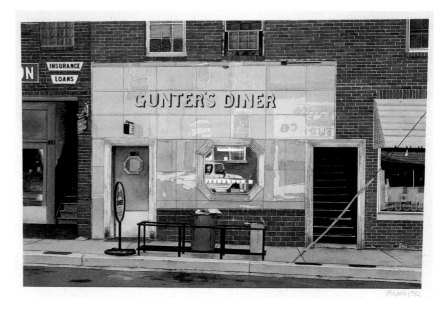

226. John Baeder. *Gunter's Diner*. 1982. Watercolor on paper, 18⅛ × 26³/₁₆″ (sight) (46.0 × 66.5)

opposite: 224. Grant Wood. *Main Street Mansion*. c. 1936–37. Pencil, chalk, and charcoal on paper, 20¼ × 15⅞″ (sight) (51.4 × 40.3)

above: 225. John Murray. *Wooster Street Champ*. 1981. Watercolor on paper, 29⅞ × 22¼″ (75.9 × 56.5)

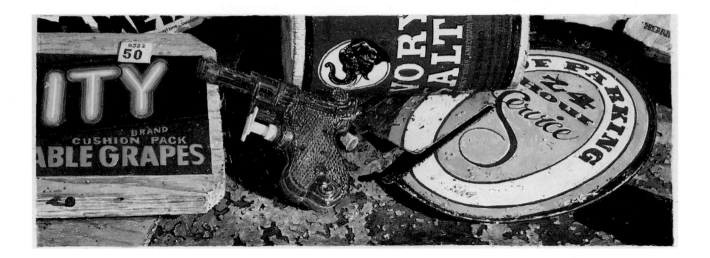

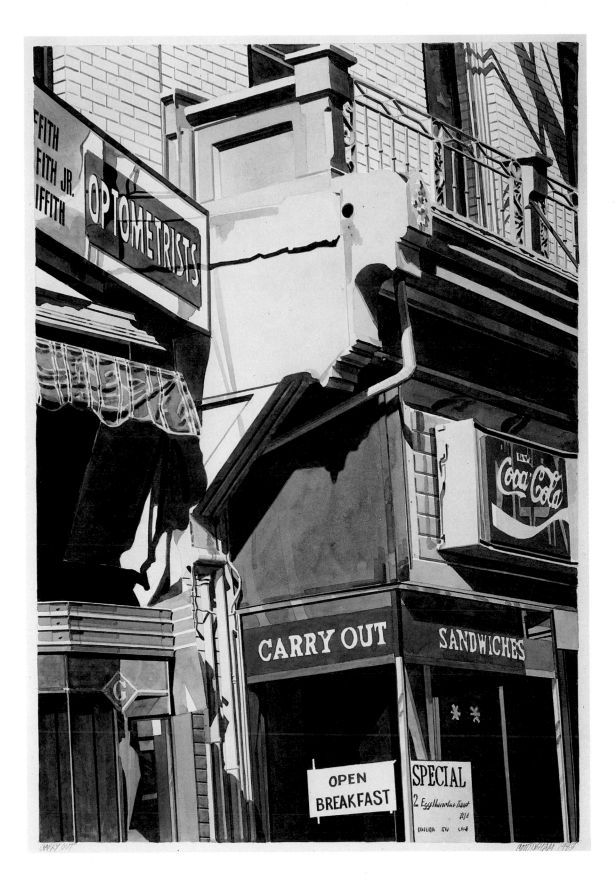

opposite above: 227. Idelle Weber. *Ivory Salt.* 1979. Watercolor on paper, 6½ × 16¹¹⁄₁₆″ (sight) (16.5 × 42.4)

opposite below: 228. Yvonne Jacquette. *Chinatown I, San Francisco.* 1983. Pastel on paper, 19¼ × 23³⁄₁₆″ (sight) (48.9 × 58.9)

229. Robert Cottingham. *Carry Out.* 1983. Watercolor on paper, 26³⁄₁₆ × 18⁷⁄₁₆″ (sight) (66.5 × 46.8)

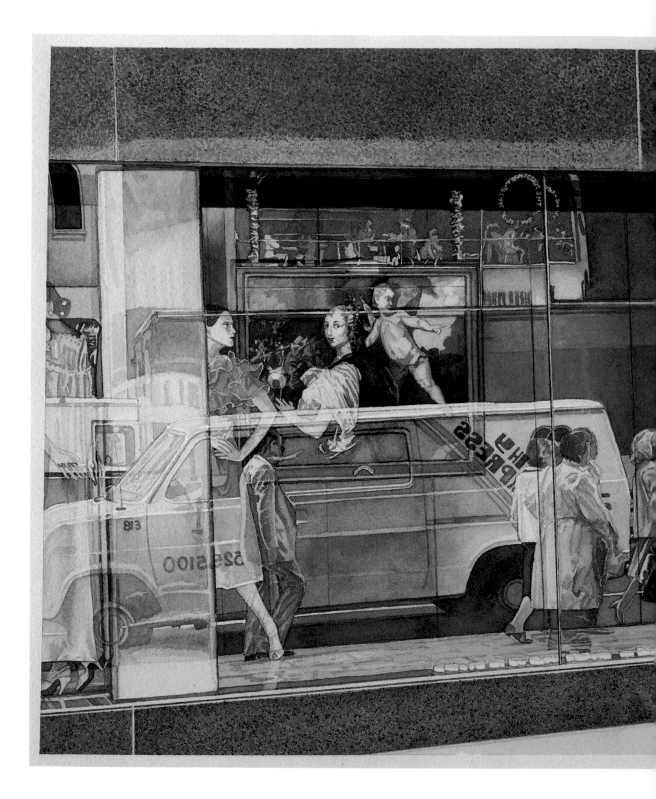

230. Tom Blackwell. *Van Dyke at Bonwit's.* 1981. Watercolor on paper, 22½ × 30⅛" (57.2 × 76.5)

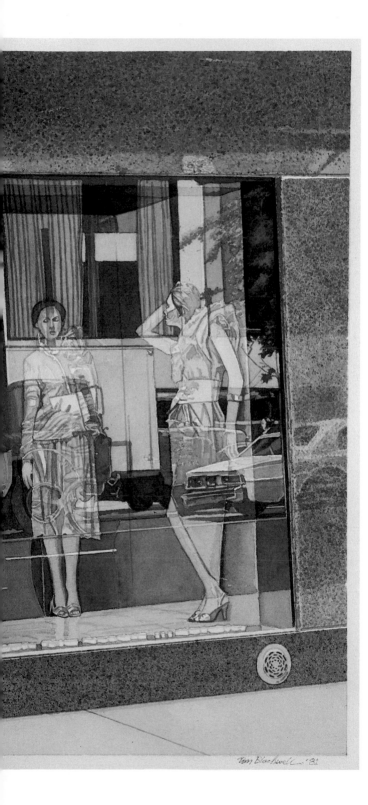

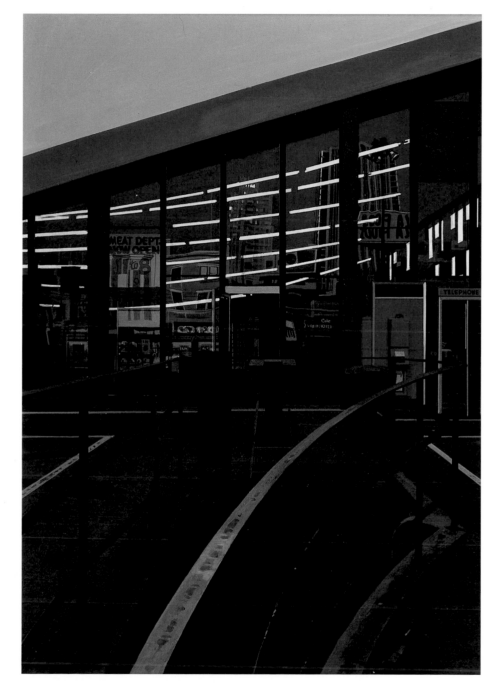

231. Richard Estes. *Meat Market*. 1978. Acrylic on board, 18¹¹/₁₆ × 12¹¹/₁₆″ (sight) (47.5 × 32.2)

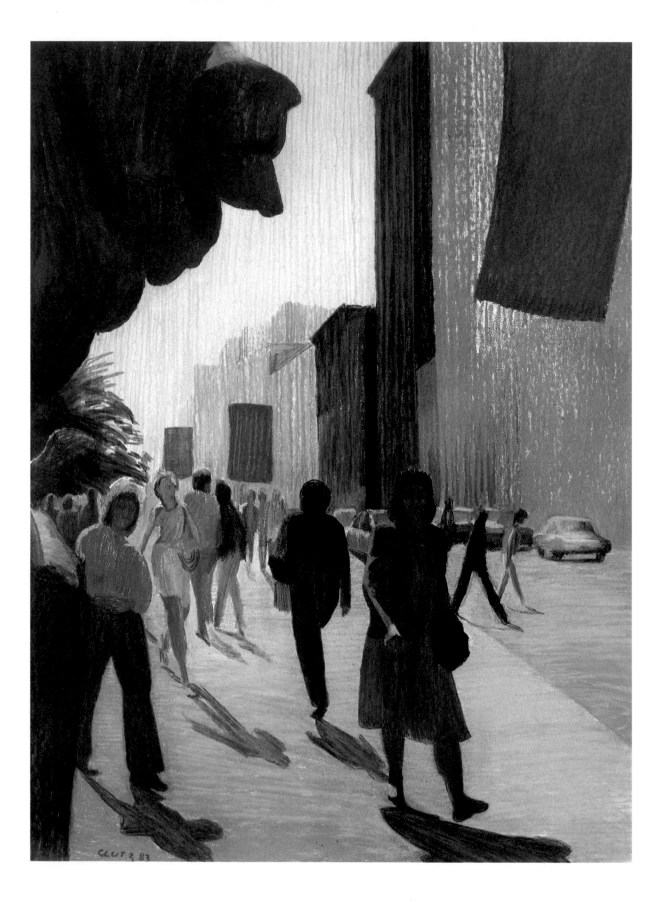

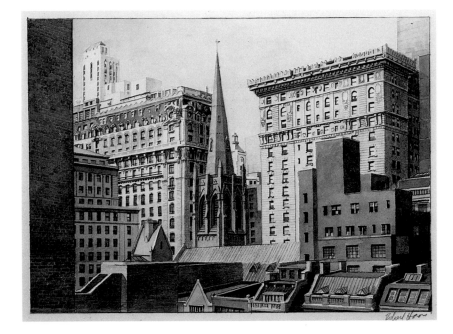

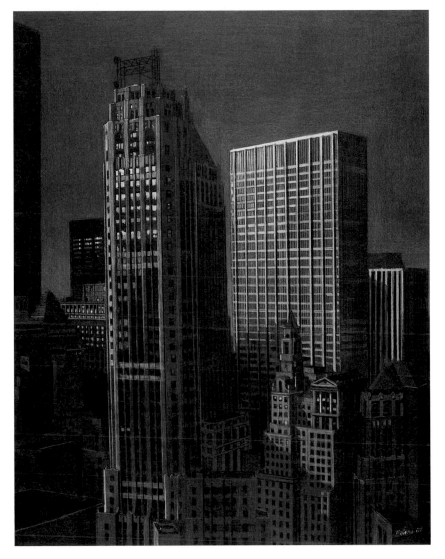

opposite: 232. William Clutz. *Downtown Light, Art Institute.* 1983. Pastel on paper, 40 1/16 × 29 3/8″ (101.8 × 74.6)

above: 233. Richard Haas. *View of 55th and 5th.* 1977. Watercolor on paper, 15 15/16 × 20 7/8″ (sight) (40.5 × 53.0)

234. Richard Haas. *Lower Manhattan, Twilight.* 1982. Pastel on paper, 26 × 20 3/16″ (sight) (66.0 × 51.3)

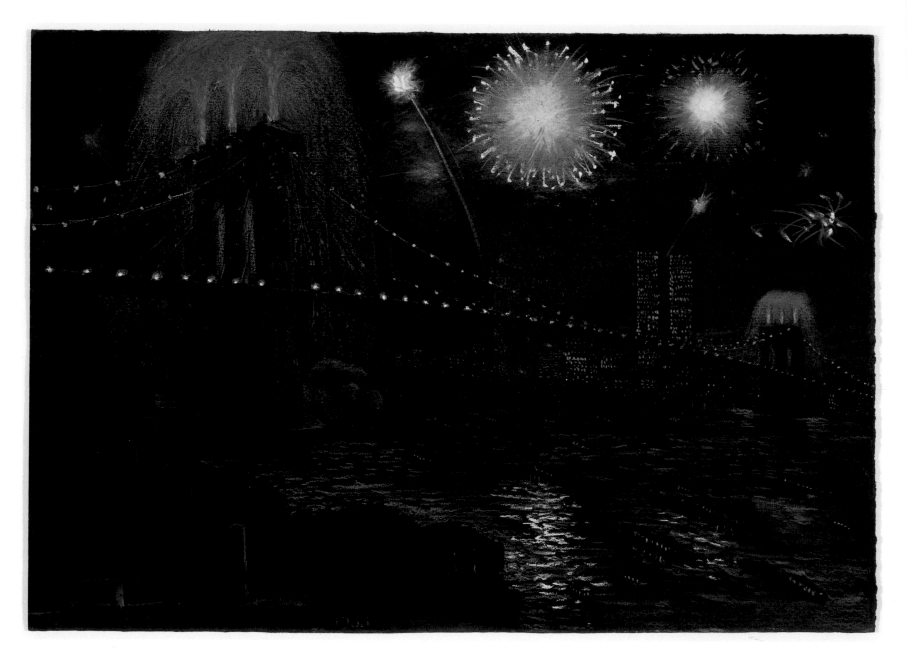

235. Seaver Leslie. *Brooklyn Bridge Celebration*. 1983. Pastel on paper,
13¾ × 19⅝″ (34.9 × 49.9)

236. John Button. *View: East at Sunset*. 1975. Gouache on paper,
12³⁄₁₆ × 16⅛″ (31.0 × 41.0)

237. Edward Ruscha. *The Absolute End*. 1982. Pastel on paper, 23 × 29″
(58.4 × 73.7)

Artists' Biographies

Compiled by Donna Graves and Katherine Church Holland

Mark Adams. Born in 1925 in Fort Plain, New York. Studied at Syracuse University, New York, 1943–46; Atelier 17, New York, 1946; Hans Hofmann School of Fine Arts, New York, 1946, 1948; Columbia University, New York, 1947; Jean Lurcat, St.-Céré, France, 1955; École des Arts Décoratifs, Aubusson, France, 1955. Teaching experience includes San Francisco Art Institute, 1961, 1972. Adams's first one-person exhibition took place at Gump's Gallery, San Francisco, 1953; subsequent solo exhibitions include M. H. de Young Memorial Museum, San Francisco, 1959 (cat.); California Palace of the Legion of Honor, San Francisco, 1961 (cat.), 1970 (cat.); John Berggruen Gallery, San Francisco, 1978, 1980 (cat.), 1983, 1985. Currently resides in San Francisco.

William Allan. Born in 1936 in Everett, Washington. Studied at California School of Fine Arts (now San Francisco Art Institute), 1954–58, B.F.A. 1958. Teaching experience includes University of California, Davis, 1965–67; San Francisco Art Institute, 1967–69; University of California, Berkeley, 1969–70; Sacramento State College (now California State University, Sacramento), California, 1968–present. Allan's first one-person exhibition took place at Scott Galleries, Seattle, 1964; subsequent solo exhibitions include Whitney Museum of American Art, New York, 1974 (cat.); Western Association of Art Museums, San Francisco (now The Art Museum Association), 1974 (circulated); The Baltimore Museum of Art, 1979. Currently resides in Sacramento, California.

Neil Anderson. Born in 1933 in Chicago. Studied at St. Olaf College, Northfield, Minnesota, 1951–55, A.B. 1955; State University of Iowa, Iowa City, 1955–58, M.F.A. 1958. Teaching experience includes Bucknell University, Lewisburg, Pennsylvania, 1958–present. Anderson's first one-person exhibition took place at St. Olaf College, Northfield, Minnesota, 1958; subsequent solo exhibitions include Fischbach Gallery, New York, 1975, 1978, 1981, 1983. Currently resides in Lewisburg, Pennsylvania.

Milet Andrejevic. Born in 1925 in Petrovgrad, Yugoslavia. Studied at Škola za Primenjenih Umetnosti, Belgrade, Yugoslavia, 1941–44; Akademija za Likovni Umetnosti, Belgrade, Yugoslavia, 1944–51, Diploma; Specijalni Tecaj Akademija za Likovni Umetnosti, Belgrade, Yugoslavia, 1951. Teaching experience includes New York University, 1965–66; Brooklyn College, 1974–76; Pratt Institute, Brooklyn, 1981–82; New York Academy of Art, 1982–present. Andrejevic's first one-person exhibition took place at Galerie Ulus, Belgrade, Yugoslavia, 1953; subsequent solo exhibitions include Galerie Creuze, Paris, 1956, 1957; Green Gallery, New York, 1961, 1963; Bellamy-Goldowsky Gallery, New York, 1970, 1972, 1976; Robert Schoelkopf Gallery, New York, 1980. Currently resides in New York.

James Aponovich. Born in 1948 in Nashua, New Hampshire. Studied at University of New Hampshire, Durham, 1967–71, B.A. 1971. Teaching experience includes Manchester Institute of Arts and Sciences, New Hampshire, 1973–78; Sharon Arts Center, New Hampshire, 1978–83; Rivier College, Nashua, New Hampshire, 1981–present. Aponovich's first one-person exhibition took place at New England College, Henniker, New Hampshire, 1976; subsequent solo exhibitions include Chapel Art Center,

St. Anselm College, Manchester, New Hampshire, 1976, 1982; The Currier Gallery of Art, Manchester, New Hampshire, 1979, 1985 (circulated; cat.); The Alpha Gallery, Boston, 1982; Robert Schoelkopf Gallery, New York, 1985 (cat.). Currently resides in Nashua, New Hampshire.

Robert Arneson. Born in 1930 in Benicia, California. Studied at College of Marin, Kentfield, California, 1949–51; California College of Arts and Crafts, Oakland, 1952–54, B.A. 1954; Mills College, Oakland, 1957–58, M.F.A. 1958. Teaching experience includes Mills College, Oakland, 1960–62; University of California, Davis, 1962–present. Arneson's first one-person exhibition took place at Oakland Art Museum (now The Oakland Museum), 1960; subsequent solo exhibitions include Museum of Contemporary Art, Chicago, in collaboration with San Francisco Museum of Art (now San Francisco Museum of Modern Art), 1974 (cat.); Moore College of Art, Philadelphia, 1979 (cat.); Allan Frumkin Gallery, New York, 1975, 1977, 1978, 1979 (cat.), 1981 (cat.), 1983 (cat.), 1984 (cat.). Currently resides in Benicia, California.

George Ault. Born in 1891 in Cleveland. Studied at University College School, London; Slade School of Fine Art, London; London University; St. John's Wood Art School, London. Teaching experience included John Reed Club School of Art, New York, 1933. First one-person exhibition took place at Sea Chest Gallery, Provincetown, Massachusetts, 1922; subsequent solo exhibitions included Downtown Gallery, New York, 1927, 1928; Zabriskie Gallery, New York, 1957 (cat.), 1963, 1969 (cat.), 1973 (cat.); Whitney Museum of American Art, New York, 1973 (cat.). Died in 1948 in Woodstock, New York.

John Baeder. Born in 1938 in South Bend, Indiana. Studied at Auburn University, Alabama, 1956–60, B.A. 1960. Baeder's first one-person exhibition took place at Hundred Acres Gallery, New York, 1972 (also 1974, 1976); subsequent solo exhibi-

tions include O. K. Harris Gallery, New York, 1978, 1980, 1982; Thomas Segal Gallery, Boston, 1982. Currently resides in Nashville, Tennessee.

William Bailey. Born in 1930 in Council Bluffs, Iowa. Studied at University of Kansas, Lawrence, 1948–51; Yale University, New Haven, Connecticut, 1953–57, B.F.A. 1955, M.F.A. 1957. Teaching experience includes Yale University, New Haven, Connecticut, 1957–62, 1969–present; Indiana University, Bloomington, 1962–69. Bailey's first one-person exhibition took place at Robert Hull Fleming Museum, University of Vermont, Burlington, 1956; subsequent solo exhibitions include Robert Schoelkopf Gallery, New York, 1968, 1971, 1974, 1979 (cat.), 1982 (cat.); Tyler School of Art, Temple University, Philadelphia, 1972; Galerie Claude Bernard, Paris, 1978 (cat.). Currently resides in New Haven, Connecticut.

Robert Bauer. Born in 1942 in Millersburg, Iowa. Studied at Pennsylvania Academy of the Fine Arts, Philadelphia, 1965–67. Teaching experience includes Cedar Rapids Art Center (now Cedar Rapids Museum of Art), Iowa, 1971–72; Coe College, Cedar Rapids, Iowa, 1975. Bauer's first one-person exhibition took place at Kenmore Galleries, Philadelphia, 1968 (also 1971); subsequent solo exhibitions include Muscatine Art Center, Iowa, 1971; Davenport Art Gallery, Iowa, 1973; Cedar Rapids Art Center (now Cedar Rapids Museum of Art), 1975; Allan Stone Gallery, New York, 1981. Currently resides in Middle Amana, Iowa.

Jack Beal. Born in 1931 in Richmond, Virginia. Studied at College of William and Mary, Williamsburg, Virginia, 1950–53; School of The Art Institute of Chicago, 1953–56; University of Chicago, 1954–56. Beal's first one-person exhibition took place at Allan Frumkin Gallery, New York, 1965 (twice; also 1967, 1968 [cat.], 1970, 1972, 1973, 1975, 1980); subsequent solo exhibitions include The Virginia Museum,

Richmond, 1973 (circulated; cat.); Madison Art Center, Wisconsin, 1977 (circulated; cat.). Currently resides in New York and Oneonta, New York.

Robert Bechtle. Born in 1932 in San Francisco. Studied at California College of Arts and Crafts, Oakland, 1950–54, B.A. 1954; 1956–58, M.F.A. 1958; University of California, Berkeley, 1960–61. Teaching experience includes California College of Arts and Crafts, Oakland, 1957–present; University of California, Berkeley, 1965–66; University of California, Davis, 1967–68; San Francisco State University, 1968–present. Bechtle's first one-person exhibition took place at Berkeley Gallery, California, 1965; subsequent solo exhibitions include O. K. Harris Gallery, New York, 1971, 1974, 1977, 1981, 1984; E. B. Crocker Art Gallery (now Crocker Art Museum), Sacramento, California, 1973 (circulated; cat.); University Art Museum, Berkeley, 1980 (cat.). Currently resides in San Francisco.

William Beckman. Born in 1942 in Maynard, Minnesota. Studied at St. Cloud State University, Minnesota, 1962–66, B.A. 1966; University of Iowa, Iowa City, 1966–69, M.A. 1968, M.F.A. 1969. Beckman's first one-person exhibition took place at Hudson River Museum, Yonkers, New York, 1969; subsequent solo exhibitions include Allan Stone Gallery, New York, 1970, 1971, 1974, 1976, 1978, 1980; Allan Frumkin Gallery, New York, 1982 (cat.), 1985 (cat.); Rose Art Museum, Brandeis University, Waltham, Massachusetts, 1984 (circulated; cat.). Currently resides in Wassair, New York.

Leigh Behnke. Born in 1946 in Hartford. Studied at Pratt Institute, Brooklyn, 1965–69, B.F.A. 1969; New York University, 1974–76, M.A. 1976. Teaching experience includes School of Visual Arts, New York, 1979–present. Behnke's first one-person exhibition took place at Fischbach Gallery, New York, 1978 (also 1979, 1982, 1985); subsequent solo exhibitions include Thom-

as Segal Gallery, Boston, 1981. Currently resides in New York.

Charles Bell. Born in 1935 in Tulsa. Studied at University of Oklahoma, Norman, 1953–57, B.A. 1957. Bell's first one-person exhibition took place at Louis K. Meisel Gallery, New York, 1972 (also 1974, 1977 [cat.], 1980, 1983 [cat.]); subsequent solo exhibitions include Morgan Gallery, Shawnee Mission, Kansas, 1976; Hokin/Kaufman Gallery, Chicago, 1983. Currently resides in New York.

George Bellows. Born in 1882 in Columbus, Ohio. Studied at Ohio State University, Columbus, Ohio, 1901–4; New York School of Art, 1904–6. Teaching experience included Art Students League, New York, 1910–17, 1923. Bellows's first one-person exhibition took place at Madison Gallery, New York, 1911; subsequent solo exhibitions included The Art Institute of Chicago, 1914 (circulated; cat.), 1946 (cat.); Albright Art Gallery (now Albright-Knox Art Gallery), Buffalo, New York, 1919 (circulated), 1926 (cat.); The Metropolitan Museum of Art, New York, 1925, 1982 (circulated; cat.) Cleveland Museum of Art, 1926; Phillips Memorial Gallery (now The Phillips Collection), Washington, D.C., 1945 (cat.); National Gallery of Art, Washington, D.C., 1957 (cat.), 1982 (cat.); The Gallery of Modern Art, New York, 1966 (cat.); Columbus Museum of Art, Ohio, 1979 (circulated; cat.). Died in 1925 in New York.

Thomas Hart Benton. Born in 1889 in Neosho, Missouri. Studied at School of The Art Institute of Chicago, 1907–8; Académie Julian, Paris, 1908–11. Teaching experience included Art Students League, New York, 1926–36; Kansas City Art Institute, Missouri, 1935–40. Benton's first one-person exhibition took place at Daniel Gallery, New York, 1919 (also 1924); subsequent solo exhibitions included Associated American Artists, New York, 1939 (cat.), 1940 (cat.), 1946 (cat.), 1969 (cat.); Spencer Museum of Art, University of Kansas, Lawrence, 1958

(cat.); University Art Gallery (now University of Arizona Museum of Art), University of Arizona, Tucson, 1962 (circulated; cat.); Madison Art Center, Wisconsin, 1970 (cat.). Died in 1975 in Kansas City, Missouri.

Elmer Bischoff. Born in 1916 in Berkeley. Studied at University of California, Berkeley, 1934–39, B.A. 1938, M.A. 1939. Teaching experience includes California School of Fine Arts (now San Francisco Art Institute), 1946–52, 1956–63; University of California, Berkeley, 1963–present. Bischoff's first one-person exhibition took place at California Palace of the Legion of Honor, San Francisco, 1947; subsequent solo exhibitions include The Oakland Museum, 1975 (cat.); John Berggruen Gallery, San Francisco, 1979, 1983; The Arts Club of Chicago, 1980 (cat.); Laguna Beach Museum of Art, California, 1985 (circulated; cat.). Currently resides in Berkeley.

Tom Blackwell. Born in 1938 in Chicago. Studied at Otis Art Institute, Los Angeles, 1957–61, B.A. 1961. Teaching experience includes Dartmouth College, Hanover, New Hampshire, 1980; University of Arizona, Tucson, 1981; School of Visual Arts, New York, 1985–present. Blackwell's first one-person exhibition took place at Roy Parsons Gallery, Los Angeles, 1961; subsequent solo exhibitions include Sidney Janis Gallery, New York, 1975 (cat.); Louis K. Meisel Gallery, New York, 1977 (cat.), 1980, 1982, 1985 (cat.); Jaffe-Friede & Strauss Galleries, Hopkins Center, Dartmouth College, Hanover, New Hampshire, 1980 (cat.); University of Arizona Museum of Art, Tucson, 1981. Currently resides in New York and Peterborough, New Hampshire.

Nell Blaine. Born in 1922 in Richmond, Virginia. Studied at Richmond School of Art (now Virginia Commonwealth University), 1939–42; Hans Hofmann School of Fine Arts, New York, 1942–44; Atelier 17, New York, 1945; New School for Social Research, New York, 1952–53. Blaine's first one-person exhibition took place at Jane

Street Gallery, 1945 (also 1948); subsequent solo exhibitions include Poindexter Gallery, New York, 1956, 1958, 1960, 1966 (cat.), 1968, 1970, 1972 (cat.), 1976; The Picher Gallery, Dana Arts Center, Colgate University, Hamilton, New York, 1974 (circulated; cat.); Fischbach Gallery, New York, 1979, 1981 (cat.), 1983 (cat.). Currently resides in New York.

Hyman Bloom. Born in 1913 in Brunovski, Lithuania. Studied at School of the Museum of Fine Arts, Boston, 1926–29; West End Community Center, Boston, 1927–33; Fogg Art Museum, Harvard University, Cambridge, Massachusetts, 1929–32. Teaching experience includes Wellesley College, Massachusetts, 1949–51; Harvard University, Cambridge, Massachusetts, 1951–53. Bloom's first one-person exhibition took place at Stuart Gallery, Boston, 1945; subsequent solo exhibitions include Albright Art Gallery (now Albright-Knox Art Gallery), Buffalo, 1954 (cat.); The University of Connecticut Museum of Art, Storrs, 1968 (circulated; cat.); Terry Dintenfass Gallery, New York, 1972, 1975, 1982. Currently resides in Nashua, New Hampshire.

Peter Blume. Born in 1906 in Smorgon, Russia. Studied at The Educational Alliance, New York, 1921–24; The Beaux-Arts Institute of Design, New York, 1921; Art Students League, New York, 1921. Blume's first one-person exhibition took place at Daniel Gallery, New York, 1930; subsequent exhibitions include The Currier Gallery of Art, Manchester, New Hampshire, in collaboration with Wadsworth Atheneum, Hartford, 1964 (cat.); Kennedy Galleries, Inc., New York, 1968 (cat.); Museum of Contemporary Art, Chicago, 1976. Currently resides in Sherman, Connecticut.

Marianne Boers. Born in 1945 in Modesto, California. Studied at Immaculate Heart College, Los Angeles, 1963; San Francisco State University, 1969–75, B.A. 1971, M.A. 1975. Boers's first one-person exhibition took place at John Berggruen Gallery, San

Francisco, 1974 (also 1976, 1983); subsequent solo exhibitions included University Gallery, California State University, Hayward, 1976; University Art Gallery, California State University, Chico, 1982. Died in 1984 in San Francisco.

Douglas Bond. Born in 1937 in Atlanta. Studied at Georgia State College, Atlanta, 1956; Pasadena City College, California, 1956–59, A.A. 1959; Otis Art Institute, Los Angeles, 1960; California State University, Los Angeles, 1961–66, B.A. 1965, M.A. 1966. Teaching experience includes Pasadena City College, California, 1970–present. Bond's first one-person exhibition took place at Bottega Gallery, Pasadena, California, 1966; subsequent solo exhibitions include O. K. Harris Gallery, New York, 1973, 1975, 1976, 1978, 1981; The Fine Arts Gallery, California State University, Los Angeles, 1978 (cat.); Tortue Gallery, Santa Monica, California, 1984. Currently resides in Pasadena, California.

Elena Borstein. Born in 1946 in Hartford. Studied at Skidmore College, Saratoga Springs, New York, 1964–68, B.S. 1968; University of Pennsylvania, Philadelphia, 1968–70, B.F.A., M.F.A. 1970. First one-person exhibition took place at Soho 20, New York, 1974; subsequent solo exhibitions include André Zarre Gallery, New York, 1978–81; Kathryn Markel Gallery, New York, 1983. Currently resides in New York.

John Rutherford Boyd. Born in 1884 in Philadelphia. Studied at Central Manual Training School, Philadelphia, 1898–1901; Darby School, Fort Washington, Pennsylvania, 1902; Pennsylvania Academy of the Fine Arts, Philadelphia, 1902–3; Art Students League, New York, 1905–6. Boyd's first one-person exhibition took place at Dibble Gallery, Leonia, New Jersey, 1937; subsequent solo exhibitions included Hirschl & Adler Galleries, New York, 1983. Died in 1951 in Leonia, New Jersey.

Carolyn Brady. Born in 1937 in Chickasha, Oklahoma. Studied at Oklahoma State University, Stillwater, 1955–58; University of Oklahoma, Norman, 1958–61, B.F.A. 1959, M.F.A. 1961. Teaching experience includes University of Missouri, St. Louis, 1974. Brady's first one-person exhibition took place at Nancy Singer Gallery, St. Louis, 1975; subsequent solo exhibitions include Nancy Hoffman Gallery, New York, 1977, 1980, 1983; Thomas Segal Gallery, Boston, 1982; Mint Museum, Charlotte, North Carolina, 1982 (circulated). Currently resides in Baltimore.

Joan Brady. Born in 1934 in New York. Studied at Art Students League, New York, 1954–58; with Paul Wood, Port Washington, New York, 1956. Brady's first one-person exhibition took place at Spook Farm Gallery, Far Hills, New Jersey, 1968 (also 1973, 1977); subsequent solo exhibitions include Country Art Gallery, Locust Valley, New York, 1970; Tatistcheff & Co., Inc., New York, 1983. Currently resides in Far Hills, New Jersey.

Joan Brown. Born in 1938 in San Francisco. Studied at California School of Fine Arts (now San Francisco Art Institute), 1955–60, B.F.A. 1959, M.F.A. 1960. Teaching experience includes San Francisco Art Institute, 1960–68; University of California, Berkeley, 1974–present. Brown's first one-person exhibition took place at 6 Gallery, San Francisco, 1957; subsequent solo exhibitions include Hansen Gallery (now Fuller-Goldeen Gallery), San Francisco, 1968, 1976, 1978, 1979, 1980, 1982, 1983; University Art Museum, Berkeley, 1974 (cat.), 1979 (cat.); Newport Harbor Art Museum, Newport Beach, California, 1978 (cat.); Mills College Art Gallery, Oakland, 1983 (cat.). Currently resides in San Francisco.

Theophilus Brown. Born in 1919 in Moline, Illinois. Studied at Yale University, New Haven, Connecticut, 1937–41, B.A. 1941; with Amédée Ozenfant, New York, 1948; with Fernand Léger, Paris, 1949; University of California, Berkeley, 1952–53, M.A. 1953. Teaching experience includes University of California, Berkeley, 1954–56;

California School of Fine Arts (now San Francisco Art Institute), 1955–57; University of California, Davis, 1956–60, 1975–76. Brown's first one-person exhibition took place at San Francisco Museum of Art (now San Francisco Museum of Modern Art), 1957; subsequent solo exhibitions include Felix Landau Gallery, Los Angeles, 1958 (cat.), 1960, 1963 (cat.), 1967 (cat.), 1971; Spencer Museum of Art, University of Kansas, Lawrence, 1967 (cat.); Charles Campbell Gallery, San Francisco, 1972, 1975, 1978; John Berggruen Gallery, San Francisco, 1983. Currently resides in San Francisco.

Charles Burchfield. Born in 1893 in Ashtabula Harbor, Ohio. Studied at Cleveland School of Art (now Cleveland Institute of Art), 1912–16. Teaching experience included University of Minnesota, Duluth, 1949; Art Institute of Buffalo, 1949–52; Buffalo Fine Arts Academy, 1951–52. Burchfield's first one-person exhibition took place at Sunwise Turn Bookshop, New York, 1916; subsequent solo exhibitions included Montross Gallery, New York, 1924, 1926, 1928; Frank M. Rehn Gallery, New York, 1930, 1931, 1934, 1935, 1936, 1939, 1941, 1943, 1946, 1947, 1950, 1952, 1954; Whitney Museum of American Art, New York, 1956 (cat.); University of Arizona Art Gallery (now University of Arizona Museum of Art), Tucson, 1965 (cat.). Died in 1967 in West Seneca, New York.

John Button. Born in 1929 in San Francisco. Studied at University of California, Berkeley, 1947–50; California School of Fine Arts (now San Francisco Art Institute), 1949–50; with Howard Warshaw and Altina Barrett, Beverly Hills, California, 1951–52; Hans Hofmann School of Fine Arts, New York, 1953. Teaching experience included Skowhegan School of Painting and Sculpture, Maine, 1964–65; School of Visual Arts, New York, 1965–67; Swarthmore College, Pennsylvania, 1969–70. Button's first one-person exhibition took place at Tibor de Nagy Gallery, New York, 1957; subsequent solo exhibitions included Kornblee

Gallery, New York, 1963–66, 1968–76; Fischbach Gallery, New York, 1977, 1978, 1980; Visual Arts Museum, School of Visual Arts, New York, 1984 (cat.). Died in 1982 in New York.

Arthur Cady. Born in 1920 in Buffalo. Studied at Antioch College, Yellow Springs, Ohio, 1937–41; Art Students League, New York, 1941–45. Teaching experience included School of Visual Arts, New York, 1961–63. Cady's first one-person exhibition took place at Westwood Gallery, Massachusetts, 1975; subsequent solo exhibitions included Fischbach Gallery, New York, 1978, 1981, 1983, 1984; Stonington Gallery, Connecticut, 1977; The Kenan Center, Lockport, New York, 1980. Died in 1983 in Brewster, New York.

David Campbell. Born in 1936 in Takoma Park, Maryland. Studied at the Art Students League, New York, 1958, 1961. Campbell's first one-person exhibition took place at Galleria III, Florence, 1966; subsequent solo exhibitions include Bowery Gallery, New York, 1971, 1973; Creiger Sesen Gallery, Boston, 1979, 1980; Thomas Segal Gallery, Boston, 1984. Currently resides in Somerville, Massachusetts.

Paul Caranicas. Born in 1946 in Athens, Georgia. Studied at Georgetown University, Washington, D.C., 1964–68; Corcoran School of Art, Corcoran Gallery of Art, Washington, D.C., 1968–70; École des Beaux-Arts, Paris, 1970–72; Art Students League, New York, 1977–79. Caranicas's first one-person exhibition took place at Galería 10, Barcelona, Spain, 1971; subsequent solo exhibitions include Galerie du Luxembourg, Paris, 1975; Nuage Gallery, Los Angeles, 1977; Fischbach Gallery, New York, 1979, 1982. Currently resides in New York.

Clarence Carter. Born in 1904 in Portsmouth, Ohio. Studied at Cleveland School of Art, 1923–27. Teaching experience includes Cleveland Museum of Art, 1930–37; Carnegie Institute of Technology (now Carnegie-Mellon University), Pittsburgh, 1938–44. Carter's first one-person exhibition took place at Ferargil Gallery, New York, 1936 (also 1939, 1941, 1944, 1947); subsequent solo exhibitions include Museum of Art, Carnegie Institute, Pittsburgh, 1940 (cat.); Gimpel & Weitzenhoffer, Ltd., New York, 1971, 1972, 1974, 1976 (circulated; cat.), 1978, 1982 (cat.); New Jersey State Museum, Trenton, 1974 (cat.); Philbrook Art Center, Tulsa, 1975 (cat.); Southern Ohio Museum and Cultural Center, Portsmouth, 1979 (cat.), 1984 (cat.); Hirschl & Adler Galleries, New York, 1981 (cat.). Currently resides in Milford, New Jersey.

Vija Celmins. Born in 1939 in Riga, Latvia. Studied at John Herron Art Institute, Indianapolis, 1958–62, B.F.A. 1962; University of California, Los Angeles, 1962–65, M.F.A. 1965. Teaching experience includes California State College (now California State University), Los Angeles, 1965–66; University of California, Irvine, 1967–72; California Institute of the Arts, Valencia, 1976, 1980. Celmins's first one-person exhibition took place at David Stuart Galleries, Los Angeles, 1965; subsequent solo exhibitions include Whitney Museum of American Art, New York, 1973 (cat.); Newport Harbor Art Museum, Newport Beach, California, 1979 (circulated; cat.); David McKee Gallery, New York, 1983. Currently resides in New York.

Linda Chapman. Born in 1952 in Bradenton, Florida. Studied at University of Florida, Gainesville, 1970–76, B.F.A. 1976; University of South Florida, Tampa, 1976–79, M.F.A. 1979. Teaching experience includes University of South Florida, Tampa, 1979–83. Chapman's first one-person exhibition took place at Hippodrome Theatre Gallery, Gainesville, Florida, 1976; subsequent solo exhibitions include USF Art Gallery, University of South Florida, Tampa, 1980; Deland Museum, Florida, 1980 (cat.); Gallery Gemini, Palm Beach, Florida, 1981; Miller/Papis Gallery, Tampa, 1982; ACA Galleries, New York, 1984. Currently resides in New York.

Daniel Chard. Born in 1938 in Camden, New Jersey. Studied at University of South Dakota, Vermillion, 1956–61, B.F.A. 1961; Columbia University, New York, 1972–75, M.F.A. 1975. Teaching experience includes Glassboro State College, New Jersey, 1968–present. Chard's first one-person exhibition took place at Art Alliance, Philadelphia, 1975; subsequent solo exhibitions include Philadelphia College of Textiles and Science, 1976; O. K. Harris Gallery, New York, 1980, 1982. Currently resides in Thorofare, New Jersey.

James Childs. Born in 1948 in Grand Forks, North Dakota. Studied at University of Minnesota, Minneapolis, 1965–66; Minneapolis College of Art and Design, 1966–70, B.F.A. 1970; Atelier 63, Haarlem, The Netherlands, 1968–69; Atelier Lack, Minneapolis, 1970–75; R. H. Ives Gammell Studios, Williamstown, Massachusetts, 1971–73 (summers). Teaching experience includes Minnesota Museum School, Minneapolis, 1974–79; Minneapolis Area Technical-Vocational Institute, 1970–80. Childs's first one-person exhibition took place at Tatistcheff & Co., Inc., New York, 1980 (cat.) (also 1983). Currently resides in St. Paul, Minnesota.

Richard Chiriani. Born in 1942 in Staten Island, New York. Studied at Art Students League, New York, 1963; Pratt Institute, New York, 1960–64, B.F.A. 1964; Brooklyn College, 1965–67, M.F.A. 1967. Teaching experience includes Queens College, New York, 1980–82. Chiriani's first one-person exhibition took place at Tibor de Nagy Gallery, New York, 1974 (also 1978, 1980, 1982, 1984). Currently resides in New York.

Christo. Born Christo Javacheff in 1935 in Gabrovo, Bulgaria. Studied at Fine Arts Academy, Sofia, Bulgaria, 1952–56; Burian Theatre, Prague, Czechoslovakia, 1956; Vienna Fine Arts Academy, Austria, 1957. Christo's first one-person exhibition took place at Galerie Haro Lauhus, Cologne,

West Germany, 1961; subsequent solo exhibitions include The Museum of Modern Art, New York, 1968 (cat.); Rijksmuseum Kröller-Müller, Otterlo, The Netherlands, 1978 (cat.); La Jolla Museum of Contemporary Art, California, 1981 (cat.). Projects include *Valley Curtain*, Rifle, Colorado, 1972; *Running Fence*, Sonoma and Marin counties, California, 1976; *Surrounded Islands*, Greater Miami, Florida, 1983. Currently resides in New York.

Chuck Close. Born in 1940 in Monroe, Washington. Studied at Everett Community College, Washington, 1958–60; University of Washington, Seattle, 1960–62, B.A. 1962; Yale Norfolk Music and Art Program, Connecticut, 1961 (summer); Yale University, New Haven, Connecticut, 1962–64, B.F.A. 1963, M.F.A. 1964; Akademie der Bildenden Künste, Vienna, 1964–65. Teaching experience includes University of Massachusetts, Amherst, 1965–67; School of Visual Arts, New York, 1967–71; New York University, 1970–73. Close's first one-person exhibition took place at Art Gallery, University of Massachusetts, Amherst, 1967; subsequent solo exhibitions include Bykert Gallery, New York, 1970, 1971; Laguna Gloria Art Museum, Austin, Texas, 1975 (circulated; cat.); Wadsworth Atheneum, Hartford, 1977 (cat.); Pace Gallery, New York, 1977 (cat.), 1979 (cat.), 1983 (cat.); Walker Art Center, Minneapolis, 1980 (circulated; cat.). Currently resides in New York.

William Clutz. Born 1933 in Gettysburg, Pennsylvania. Studied at University of Iowa, Iowa City, 1951–55, B.A. 1955. Teaching experience includes Parsons School of Design, New York, 1969–present. Clutz's first one-person exhibition took place at Bertha Schaefer Gallery, New York, 1963 (also 1964, 1966, 1969); subsequent solo exhibitions include Addison Gallery of American Art, Phillips Academy, Andover, Massachusetts, 1973; Tatistcheff & Co., Inc., New York, 1981, 1982, 1984. Currently resides in New York.

Gordon Cook. Born in 1927 in Chicago. Studied at Illinois Wesleyan University, Bloomington, 1946–50, B.F.A. 1950; the American Academy of Art, Chicago, 1948–49; School of The Art Institute of Chicago, 1949; State University of Iowa, Iowa City, 1950–51. Teaching experience includes San Francisco Art Institute, 1960–71; Academy of Art College, San Francisco, 1971–74. Cook's first one-person exhibition took place at San Francisco Museum of Art (now San Francisco Museum of Modern Art), 1958 (also 1966); subsequent solo exhibitions include Achenbach Foundation for the Graphic Arts, California Palace of the Legion of Honor, San Francisco, 1964 (cat.); Charles Campbell Gallery, San Francisco, 1973, 1974, 1976, 1978, 1980, 1981, 1983, 1984; Allan Stone Gallery, New York, 1982. Currently resides in San Francisco.

James Cook. Born in 1947 in Topeka, Kansas. Studied at Emporia State University, Kansas, 1965–70, B.A. 1969, M.A. 1970; Wichita State University, Kansas, 1970–72, M.F.A. 1972. Teaching experience includes University of Arizona, Tucson, 1972–78. Cook's first one-person exhibition took place at Frumkin & Struve, Chicago, 1982; subsequent solo exhibitions include Tatistcheff & Co., Inc., New York, 1984. Currently resides in Tucson, Arizona, and Galena, Illinois.

Robert Cottingham. Born in 1935 in Brooklyn. Studied at Pratt Institute, Brooklyn, 1959–63. Teaching experience includes Art Center College of Design, Los Angeles, 1969–70. Cottingham's first one-person exhibition took place at Molly Barnes Gallery, Los Angeles, 1968 (also 1969, 1970); subsequent solo exhibitions include O. K. Harris Gallery, New York, 1971, 1974, 1976, 1978; Thomas Segal Gallery, Boston, 1980; Coe Kerr Gallery, New York, 1982 (cat.). Currently resides in Newtown, Connecticut.

Mary Ann Currier. Born in 1927 in Louisville, Kentucky. Studied at American Academy of Art, Chicago, 1945–47; Louisville

School of Art, Kentucky, 1958–62. Teaching experience includes Louisville School of Art, Kentucky, 1962–82. Currier's first one-person exhibition took place at Byck Gallery, Lexington, Kentucky, 1977 (also 1980); subsequent solo exhibitions include Bellarmine College, Louisville, Kentucky, 1978; Brescia College, Owensboro, Kentucky, 1980; Alexander F. Milliken, Inc., New York, 1984. Currently resides in Atlantic Beach, Florida.

John Steuart Curry. Born in 1897 near Dunavant, Kansas. Studied at Kansas City Art Institute, Missouri, 1916; School of The Art Institute of Chicago, 1916–18; Geneva College, Beaver Falls, Pennsylvania, 1918–19. Teaching experience included Cooper Union School of Art, New York, 1932–34; Art Students League, New York, 1932–36. Curry's first one-person exhibition took place at Whitney Studio Galleries, New York, 1930; subsequent solo exhibitions included Ferargil Gallery, New York, 1930, 1931; Lakeside Press Galleries, Chicago, 1939; Milwaukee Art Institute, 1946; National Collection of Fine Arts (now National Museum of American Art), Smithsonian Institution, Washington, D.C., 1971 (cat.). Died in 1946 in Madison, Wisconsin.

Barbara Cushing. Born in 1948 in New York. Studied at Skidmore College, Saratoga Springs, New York, 1966–70, B.S. 1970; Pennsylvania State University, University Park, 1970–72, B.F.A. 1972. Teaching experience includes University of Maine at Orono, 1975–83. Cushing's first one-person exhibition took place at Carnegie Hall Gallery, University of Maine at Orono, 1978; subsequent solo exhibitions include Maine Statehouse, Augusta, 1980; Robert Schoelkopf Gallery, New York, 1983. Currently resides in New York.

Daniel Dallman. Born in 1942 in St. Paul. Studied at St. Cloud State College, Minnesota, 1961–65, B.S. 1965; University of Iowa, Iowa City, 1966–69, M.A. 1968, M.F.A. 1969. Teaching experience includes Tyler School of Art, Temple Univer-

sity, Philadelphia, 1969–present. Dallman's first one-person exhibition took place at Philadelphia Print Club, 1972; subsequent solo exhibitions include West Chester State College, Pennsylvania, 1973; Ronnie Brenner Gallery, New Orleans, 1974; Robert Schoelkopf Gallery, New York, 1980, 1984; J. B. Speed Art Museum, Louisville, Kentucky, 1984 (cat.). Currently resides in North Wales, Pennsylvania.

Stuart Davis. Born in 1894 in Philadelphia. Studied with Robert Henri, New York, 1910–13. Teaching experience included Art Students League, New York, 1931–32; New School for Social Research, New York, 1940–50. Davis's first one-person exhibition took place at Sheridan Square Gallery, New York, 1917; subsequent solo exhibitions included Downtown Gallery, New York, 1927, 1930, 1932, 1934, 1943, 1946, 1952, 1954, 1956, 1960, 1962; Whitney Studio Galleries, New York, 1929; Walker Art Center, Minneapolis, 1957 (circulated; cat.); The Brooklyn Museum, 1978 (circulated; cat.); Whitney Museum of American Art, New York, 1980 (cat.). Died in 1964 in New York.

Charles Demuth. Born in 1883 in Lancaster, Pennsylvania. Studied at Franklin and Marshall Academy, Lancaster, Pennsylvania, 1899–1901; Drexel University, Philadelphia, 1901–5; School of Industrial Art, Philadelphia, 1903–5; Pennsylvania Academy of the Fine Arts, Philadelphia, 1905–7, 1908–10; Académie Colarossi and Académie Julian, Paris, 1912–14. Demuth's first one-person exhibition took place at Daniel Gallery, New York, 1914 (thereafter annually until 1923); subsequent solo exhibitions included An American Place, New York, 1930; Whitney Museum of American Art, New York, 1937 (cat.); The Museum of Modern Art, New York, 1950 (cat.); Akron Art Institute (now Akron Art Museum), 1968 (cat.); Art Galleries (now University Art Museum), University of California, Santa Barbara, 1971 (circulated; cat.). Died in 1935 in Lancaster, Pennsylvania.

Edwin Dickinson. Born in 1891 in Seneca Falls, New York. Studied at Pratt Institute, Brooklyn, 1910–11; Art Students League, New York, 1911–13; Cape Cod School of Art, Provincetown, Massachusetts, 1912–14 (summers); Académie de la Grande Chaumière, Paris, 1919–20. Teaching experience included Art Students League, New York, 1922–23, 1945–78; Brooklyn Museum Art School, 1950–58. Dickinson's first one-person exhibition took place at Albright Art Gallery (now Albright-Knox Art Gallery), Buffalo, 1927; subsequent solo exhibitions included Passedoit Gallery, New York, 1936, 1938, 1939 (twice), 1940–42; The Museum of Modern Art, New York, 1961 (circulated); Whitney Museum of American Art, New York, 1965 (cat.); Hirshhorn Museum and Sculpture Garden, Smithsonian Institution, Washington, D.C., 1980 (circulated; cat.). Died in 1978 in Orleans, Massachusetts.

Preston Dickinson. Born in 1889 in New York. Studied at Art Students League, New York, 1906–10; École des Beaux-Arts and Académie Julian, Paris, c. 1910–14. Dickinson's first one-person exhibition took place at Daniel Gallery, New York, 1923 (also 1924, 1927); subsequent solo exhibitions included M. Knoedler Gallery, New York, 1943; Zabriskie Gallery, New York, 1974; Sheldon Memorial Art Gallery, University of Nebraska, Lincoln, 1979 (circulated; cat.). Died in 1930 in Irún, Spain.

Richard Diebenkorn. Born in 1922 in Portland, Oregon. Studied at Stanford University, California, 1940–43, 1949, B.A. 1949; University of California, Berkeley, 1943–44; California School of Fine Arts (now San Francisco Art Institute), 1946; University of New Mexico, Albuquerque, 1950–52, M.A. 1952. Teaching experience includes University of Illinois, Champaign-Urbana, 1952–53; California College of Arts and Crafts, Oakland, 1955–57; California School of Fine Arts (now San Francisco Art Institute), 1959–63; University of California, Los Angeles, 1966–73. Diebenkorn's first one-person exhibition took place at

California Palace of the Legion of Honor, San Francisco, 1948 (also 1960 [cat.]); subsequent solo exhibitions include The Phillips Collection, Washington, D.C., 1961 (cat.); San Francisco Museum of Art (now San Francisco Museum of Modern Art), 1972 (cat.), 1983 (cat.); Albright-Knox Art Gallery, Buffalo, 1976 (circulated; cat.). Currently resides in Santa Monica, California.

Jim Dine. Born in 1935 in Cincinnati. Studied at Cincinnati Art Academy, 1951–53; Ohio University, Athens, 1954–58, B.F.A. 1957. Dine's first one-person exhibition took place at Reuben Gallery, New York, 1960; subsequent solo exhibitions include Sidney Janis Gallery, New York, 1963 (cat.), 1964 (cat.), 1967; Stedelijk Museum, Amsterdam, 1966 (cat.); The Museum of Modern Art, New York, 1967 (circulated; cat.), 1978 (circulated; cat.); Whitney Museum of American Art, New York, 1970 (cat.); Kestner-Gesellschaft, Hannover, West Germany, 1970 (cat.); The Pace Gallery, New York, 1971 (cat.), 1978 (cat.), 1980 (cat.); Richard Gray Gallery, Chicago, 1981 (cat.); Walker Art Center, Minneapolis, 1984 (circulated; cat.). Currently resides in Putney, Vermont.

Rackstraw Downes. Born in 1939 in Pembury, England. Studied at Cambridge University, England, 1958–61, B.A. 1961; Yale University, New Haven, Connecticut, 1961–64, M.F.A. 1964; University of Pennsylvania, Philadelphia, 1964–65. Teaching experience includes Parsons School of Design, New York, 1964–67; University of Pennsylvania, Philadelphia, 1967–79; Yale University, New Haven, Connecticut, 1979–80. Downes's first one-person exhibition took place at Swarthmore College, Pennsylvania, 1969; subsequent solo exhibitions include Kornblee Gallery, New York, 1972, 1974, 1975, 1978, 1980; Tatistcheff & Co., Inc., New York, 1980; Hirschl & Adler Modern, New York, 1984 (cat.). Currently resides in New York and Portland, Maine.

Laurence Dreiband. Born in 1944 in New York. Studied at Chouinard Art Institute, Los Angeles, 1961; Art Center College of Design, Los Angeles, 1964–68, B.F.A. 1967, M.F.A. 1968. Teaching experience includes California State University, Los Angeles, 1970; Art Center College of Design, Pasadena, California (moved from Los Angeles in 1978), 1970–present. Dreiband's first one-person exhibition took place at David Stuart Galleries, Los Angeles, 1970 (also 1972 [cat.]); subsequent solo exhibitions include The Los Angeles Institute of Contemporary Art, 1980; Janus Gallery, Los Angeles, 1983, 1985. Currently resides in Los Angeles.

Don Eddy. Born in 1944 in Long Beach, California. Studied at Fullerton Junior College, California, 1962–63; University of Hawaii, Honolulu, 1963–69, B.F.A. 1967, M.F.A. 1969; University of California, Santa Barbara, 1969–70. Teaching experience includes New York University, 1973–78; School of Visual Arts, New York, 1977–present. Eddy's first one-person exhibition took place at Ewing Krainin Gallery, Honolulu, 1968; subsequent solo exhibitions include Nancy Hoffman Gallery, New York, 1974, 1976, 1979, 1983; Williams College Museum of Art, Williamstown, Massachusetts, 1975 (cat.); Common Gallery, University of Hawaii at Manoa, Honolulu, 1982. Currently resides in New York.

Heidi Endemann. Born in 1940 in Mannheim, Germany. Studied at Universität für Künste und Gestaltung, Cologne, West Germany, 1957–61. Endemann's first one-person exhibition took place at Village Gallery, Fairfax, California, 1975 (also 1977); subsequent solo exhibitions include Goethe Institute, San Francisco, 1977; Paper Mill Gallery, Los Angeles, 1982; Alexander F. Milliken, Inc., New York, 1985. Currently resides in Gualala, California.

Martha Mayer Erlebacher. Born in 1937 in Jersey City. Studied at Gettysburg College, Pennsylvania, 1955–56; Pratt Institute, Brooklyn, 1956–63, B.A. 1960, M.F.A. 1963. Teaching experience includes Pratt Institute, Brooklyn, 1964–65; Philadelphia College of Art, 1966–68, 1975–76, 1978. Erlebacher's first one-person exhibition took place at The Other Gallery, Philadelphia, 1967; subsequent solo exhibitions include Robert Schoelkopf Gallery, New York, 1973, 1975, 1978, 1979, 1982, 1985; Pennsylvania Academy of the Fine Arts, Philadelphia, 1978; Weatherspoon Art Gallery, University of North Carolina, Greensboro, 1983 (cat.). Currently resides in Elkins Park, Pennsylvania.

Richard Estes. Born in 1936 in Kewanee, Illinois. Studied at School of The Art Institute of Chicago, 1952–56. Estes's first one-person exhibition took place at Allan Stone Gallery, New York, 1968 (also 1969, 1970, 1972, 1974, 1977, 1983 [cat.]); subsequent solo exhibitions include Hudson River Museum, Yonkers, New York, 1968; Museum of Fine Arts, Boston, 1978 (circulated; cat.). Currently resides in New York.

Janet Fish. Born in 1938 in Boston. Studied at Smith College, Northampton, Massachusetts, 1956–60, B.A. 1960; Yale University, New Haven, Connecticut, 1960–63, B.F.A., M.F.A. 1963. Teaching experience includes School of Visual Arts, New York, 1968–69. Fish's first one-person exhibition took place at Fairleigh Dickinson University, Madison, New Jersey, 1967; subsequent solo exhibitions include Kornblee Gallery, New York, 1971–76; Robert Miller Gallery, New York, 1978, 1979, 1980 (cat.), 1983, 1985 (cat.); Delaware Art Museum, Wilmington, 1982. Currently resides in New York.

Audrey Flack. Born in 1931 in New York. Studied at Cooper Union School of Art, New York, 1948–51; Yale University, New Haven, Connecticut, 1951–52, B.F.A. 1952; New York University, 1953. Teaching experience includes Pratt Institute, Brooklyn, 1960–68; New York University, 1960–68; School of Visual Arts, New York, 1970–74. Flack's first one-person exhibition took place at Roko Gallery, New York, 1959

(also 1963); subsequent solo exhibitions include Louis K. Meisel Gallery, New York, 1974, 1976 (cat.), 1978 (cat.), 1983 (cat.); Carlson Gallery, University of Bridgeport, Connecticut, 1975. Currently resides in New York.

Patricia Tobacco Forrester. Born in 1940 in Northampton, Massachusetts. Studied at Smith College, Northampton, Massachusetts, 1958–62, B.A. 1962; Yale University, New Haven, Connecticut, 1962–65, B.F.A. 1963, M.F.A. 1965. Teaching experience includes California College of Arts and Crafts, Oakland, 1972–81. Forrester's first one-person exhibition took place at San Francisco Museum of Art (now San Francisco Museum of Modern Art), 1967; subsequent solo exhibitions include M. H. de Young Memorial Museum, San Francisco, 1977; Kornblee Gallery, New York, 1978, 1979, 1981, 1982; Contemporary Arts Center, Honolulu, 1984 (cat.). Currently resides in Washington, D.C.

Sondra Freckelton. Born in 1936 in Dearborn, Michigan. Studied at School of The Art Institute of Chicago, 1954–56. Teaching experience includes Downtown Community School, New York, 1960–63. Freckelton's first one-person exhibition took place at Tibor de Nagy Gallery, New York, 1960 (also 1961, 1963); subsequent solo exhibitions include Allan Frumkin Gallery, New York, 1977; Brooke Alexander, Inc., New York, 1976, 1979–81; John Berggruen Gallery, San Francisco, 1982. Currently resides in New York and Oneonta, New York.

Jane Freilicher. Born in 1924 in New York. Studied at Brooklyn College, 1943–47, B.A. 1947; Columbia University, New York, 1948–49, M.A. 1949; Hans Hofmann School of Fine Arts, New York, 1947–48. Freilicher's first one-person exhibition took place at Tibor de Nagy Gallery, New York, 1952 (also 1953–56, 1958, 1960–63, 1966–68); subsequent solo exhibitions include Wadsworth Atheneum, Hartford, 1976; Fischbach Gallery, New York, 1975, 1977, 1979, 1980, 1983; Utah Museum of Fine

Arts, Salt Lake City, 1979 (cat.); Charlotte Crosby Kemper Gallery, Kansas City Art Institute, Missouri, 1983 (cat.). Currently resides in New York.

Sheila Gardner. Born in 1933 in Jersey City, New Jersey. Studied at Endicott College, Beverly, Massachusetts, 1950–52, A.A. 1952; Pratt Institute, Brooklyn, Art Students League, New York, and New York University, 1952–59. Gardner's first one-person exhibition took place at Peterborough Historical Society, New Hampshire, 1966; subsequent solo exhibitions include Galerie Baumeister, Munich, West Germany, 1975; Studiengalerie, Universität, Stuttgart, West Germany, 1976; Barridoff Gallery, Portland, Maine, 1982, 1983; Tatistcheff & Co., Inc., New York, 1982, 1984. Currently resides in Georgetown, Maine.

Paul Georges. Born in 1923 in Portland, Oregon. Studied at University of Oregon, Eugene, 1946–48; Hans Hofmann School of Fine Arts, New York, and Provincetown, Massachusetts, 1947; with Fernand Léger, Paris, 1949–52. Teaching experience includes Brandeis University, Waltham, Massachusetts, 1977–present. Georges's first one-person show took place at Reed College, Portland, Oregon, 1948 (also 1956, 1961); subsequent solo exhibitions include Allan Frumkin Gallery, New York, 1962–64, 1966, 1968; Rose Art Museum, Brandeis University, Waltham, Massachusetts, 1981; Manhattan Art, New York, 1984. Currently resides in New York.

Gregory Gillespie. Born in 1936 in Roselle Park, New Jersey. Studied at Cooper Union School of Art, New York, 1954–60; San Francisco Art Institute, 1960–62, M.F.A. 1962. Gillespie's first one-person exhibition took place at Forum Gallery, New York, 1966 (also 1968 [cat.], 1970 [cat.], 1973, 1976); subsequent solo exhibitions include Smith College Museum of Art, Northampton, Massachusetts, 1971; Hirshhorn Museum and Sculpture Garden, Smithsonian Institution, Washington, D.C.,

1977 (cat.); Rose Art Museum, Brandeis University, Waltham, Massachusetts, 1984 (cat.). Currently resides in Belchertown, Massachusetts.

William Glackens. Born in 1870 in Philadelphia. Studied at Pennsylvania Academy of the Fine Arts, Philadelphia, 1891–95. Glackens's first one-person exhibition took place at Kraushaar Galleries, New York, 1925 (also 1928, 1935, 1942, 1957); subsequent solo exhibitions included Whitney Museum of American Art, New York, 1938 (circulated; cat.); Carpenter Galleries (now Hood Art Museum), Dartmouth College, Hanover, New Hampshire, 1960 (cat.); City Art Museum of St. Louis (now St. Louis Art Museum), 1966 (circulated; cat.); National Collection of Fine Arts (now National Museum of American Art), Smithsonian Institution, Washington, D.C., 1972 (cat.). Died in 1938 in Westport, Connecticut.

Ralph Goings. Born in 1928 in Corning, California. Studied at California College of Arts and Crafts, Oakland, 1950–53, B.F.A. 1953; Sacramento State College (now California State University, Sacramento), California, 1964–65, M.A. 1965. Teaching experience includes University of California, Davis, 1971. Goings's first one-person exhibition took place at Artists Cooperative Gallery (now Artists Contemporary Gallery), Sacramento, California, 1960 (also 1962, 1964); subsequent solo exhibitions include Candy Store Gallery, Folsom, California, 1966; O.K. Harris Gallery, New York, 1970, 1973, 1975, 1977, 1980, 1983, 1985. Currently resides in Charlotteville, New York.

Lloyd Goldsmith. Born in 1945 in Brooklyn. Goldsmith's first one-person exhibition took place at Exposure Gallery, New York, 1971; subsequent solo exhibitions include The Mall, City University Graduate Center, New York, 1972; The Ackland Art Museum, University of North Carolina, Chapel Hill, 1981; Hirschl & Adler Modern, New York, 1982 (cat.). Currently resides in New York.

Juan Gonzalez. Born in 1945 in Camaguey, Cuba. Studied at University of Miami, Florida, 1965–72, B.F.A. 1971, M.F.A. 1972. Teaching experience includes the School of Visual Arts, New York, 1977–present. Gonzalez's first one-person exhibition took place at Allan Stone Gallery, New York, 1972; subsequent solo exhibitions include Nancy Hoffman Gallery, New York, 1975, 1978, 1982, 1985; Frances Wolfson Art Gallery, Miami-Dade Community College, Miami, Florida, 1980 (circulated; cat.); Center for Inter-American Relations, New York, 1981. Currently resides in New York.

Sidney Goodman. Born in 1936 in Philadelphia. Studied at Philadelphia College of Art, 1954–58; Yale Norfolk Music and Art Program, Connecticut, 1957 (summer). Teaching experience includes Philadelphia College of Art, 1960–78; Pennsylvania Academy of the Fine Arts, Philadelphia, 1979–present. Goodman's first one-person exhibition took place at Terry Dintenfass Gallery, New York, 1961 (also 1963, 1964, 1965, 1966, 1968, 1970, 1973, 1975, 1977, 1978, 1980, 1984 [cat.], 1985); subsequent solo exhibitions include Museum of Art, Pennsylvania State University, University Park, 1980 (circulated; cat.); The Virginia Museum, Richmond, 1981 (circulated; cat.). Currently resides in Philadelphia.

P. S. Gordon. Born in 1953 in Claremore, Oklahoma. Studied at University of Oklahoma, Norman, 1971–72; University of Tulsa, 1972–75, B.F.A. 1974. Gordon's first one-person exhibition took place at Philbrook Art Center, Tulsa, 1977 (also 1985 [cat.]); subsequent solo exhibitions include Arts Signature Gallery, Performing Arts Center, Tulsa, 1980; Fischbach Gallery, New York, 1982, 1985. Currently resides in Tulsa.

Harold Gregor. Born in 1929 in Detroit. Studied at Wayne State University, Detroit, 1947–51, B.S. 1951; Michigan State University, East Lansing, 1951–53, M.S. 1953; Ohio State University, Columbus, 1953–60, Ph.D. 1960. Teaching experience includes

San Diego State University, California, 1960–63; Purdue University, Lafayette, Indiana, 1966–70; Illinois State University, Normal, 1970–present. Gregor's first one-person exhibition took place at Countryside Gallery, Arlington Heights, Illinois, 1973; subsequent solo exhibitions include Nancy Lurie Gallery, Chicago, 1974, 1976–79, 1981; Tibor de Nagy Gallery, New York, 1977–79, 1981, 1982, 1984. Currently resides in Bloomington, Illinois.

Theophil Groell. Born in 1932 in Pittsburgh. Studied at Carnegie Institute of Technology (now Carnegie-Mellon University), Pittsburgh, 1949–53, B.F.A. 1953. Groell's first one-person exhibition took place at Tanager Gallery, New York, 1956; subsequent solo exhibitions include Tomasulo Gallery, Union College, Schenectady, New York, 1977; Green Mountain Gallery, New York, 1970, 1973, 1974, 1977; Tatistcheff & Co., Inc., New York, 1980, 1983. Currently resides in New York.

Red Grooms. Born in 1937 in Nashville. Studied at School of The Art Institute of Chicago, 1955; George Peabody College for Teachers, Nashville, 1956; New School for Social Research, New York, 1956; Hans Hofmann School of Fine Arts, Provincetown, Massachusetts, 1957. Grooms's first one-person exhibition took place at Sun Gallery, Provincetown, Massachusetts, 1958; subsequent solo exhibitions include Rutgers University Gallery of Art, New Brunswick, New Jersey, 1973 (circulated; cat.); Marlborough Gallery, New York, 1976, 1981 (cat.), 1984 (cat.); The New Gallery of Contemporary Art, Cleveland, 1977, 1982 (cat.). Currently resides in New York.

William Gropper. Born in 1897 in New York. Studied at Ferrer School, New York, 1912–15; National Academy of Design, New York, 1913–14; New York School of Fine and Applied Art, 1915–18. Teaching experience included American Art School, New York. Gropper's first one-person exhibition took place at ACA Galleries, New York, 1936 (also 1937–40, 1941 [cat.], 1942 [cat.], 1944 [cat.], 1954, 1956, 1958, 1961–63, 1965, 1968, 1970 [cat.], 1971 [circulated; cat.], 1979, 1983); subsequent solo exhibitions included San Francisco Museum of Art (now San Francisco Museum of Modern Art), 1942; Montclair Art Museum, New Jersey, 1969; Stanford University Museum and Art Gallery, Stanford University, California, 1983. Died in 1977 in Manhasset, New York.

Richard Haas. Born in 1936 in Spring Green, Wisconsin. Studied at University of Wisconsin, Milwaukee, 1955–59, B.A. 1959; University of Minnesota, St. Paul, 1961–64, M.F.A. 1964. Teaching experience includes Michigan State University, East Lansing, 1964–68; Bennington College, Vermont, 1968–79. Haas's first one-person exhibition took place at H.C.E. Gallery, Providence, Rhode Island, 1967; subsequent solo exhibitions include Brooke Alexander, Inc., New York, 1973, 1975, 1977, 1980, 1982; Norton Gallery and School of Art, West Palm Beach, Florida, 1977; Richard L. Nelson Gallery, University of California, Davis, 1981. Currently resides in New York.

Nancy Hagin. Born in 1940 in Elizabeth, New Jersey. Studied at Carnegie Institute of Technology (now Carnegie-Mellon University), Pittsburgh, 1958–62, B.F.A. 1962; Yale University, New Haven, Connecticut, 1962–64, M.F.A. 1964. Teaching experience includes Maryland Institute College of Art, Baltimore, 1964–73; Fashion Institute of Technology, New York, 1974–present; Cooper Union School of Art, New York, 1982–present. Hagin's first one-person exhibition took place at The Alpha Gallery, Boston, 1972 (also 1974, 1976, 1979, 1982); subsequent solo exhibitions include Terry Dintenfass Gallery, New York, 1975, 1978; Fischbach Gallery, New York, 1981, 1982, 1985; Hewlett Gallery, Carnegie-Mellon University, Pittsburgh, 1982 (cat.). Currently resides in New York.

Susan Hall. Born in 1943 in Point Reyes Station, California. Studied at College of Marin, Kentfield, California, 1960–62; California College of Arts and Crafts, Oakland, 1962–65, B.F.A. 1965; University of California, Berkeley, 1965–67, M.A. 1967. Teaching experience includes University of California, Berkeley, 1967–69; Sarah Lawrence College, Bronxville, New York, 1972–75. Hall's first one-person exhibition took place at San Francisco Museum of Art (now San Francisco Museum of Modern Art), 1967; subsequent solo exhibitions include Whitney Museum of American Art, New York, 1972 (cat.); Paule Anglim Gallery, San Francisco, 1975, 1983; Hamilton Gallery, New York, 1978, 1979, 1981, 1983; Neil C. Ovsey Gallery, Los Angeles, 1981, 1982, 1984. Currently resides in New York.

DeWitt Hardy. Born in 1940 in St. Louis. Studied at Syracuse University, New York, 1959–63, A.B. 1963. Hardy's first one-person exhibition took place at Pietrantonio Gallery, New York, 1960; subsequent solo exhibitions include Syracuse University Gallery, New York, 1962; Frank M. Rehn Gallery, New York, 1967–73, 1977; Robert Schoelkopf Gallery, New York, 1981, 1983; Allport Associates Gallery, San Francisco, 1984. Currently resides in North Berwick, Maine.

George Harkins. Born in 1934 in Philadelphia. Studied at Philadelphia College of Art, 1953–56, B.F.A. 1956; University of Arizona, Tucson, 1966–69, M.F.A. 1969. Harkins's first one-person exhibition took place at Larcada Gallery, New York, 1975; subsequent solo exhibitions include Montgomery Museum of Fine Arts, Alabama, 1976; Tatistcheff & Co., Inc., New York, 1980; University of Arizona Museum of Art, Tucson, 1984. Currently resides in New York.

Walter Hatke. Born in 1948 in Topeka, Kansas. Studied at DePauw University, Greencastle, Indiana, 1967–71, B.A. 1971; University of Iowa, Iowa City, 1980–82, M.A. 1981, M.F.A. 1982. Teaching experience includes DePauw University, Greencastle, Indiana, 1971–72; Pennsylvania

State University, University Park, 1982–present. Hatke's first one-person exhibition took place at Washburn University, Topeka, Kansas, 1965; subsequent solo exhibitions include Brookwood Gallery, Topeka, Kansas, 1973; Robert Schoelkopf Gallery, New York, 1977, 1980, 1983; Topeka Public Library, Kansas, 1980. Currently resides in State College, Pennsylvania.

Susan Hauptman. Born in 1947 in Detroit. Studied at Carnegie Institute of Technology (now Carnegie-Mellon University), Pittsburgh, 1965–66; University of Michigan, Ann Arbor, 1967–68, B.F.A. 1968; Wayne State University, Detroit, 1969–70, M.F.A. 1970. Teaching experience includes University of Pittsburgh, 1972–74; Skidmore College, Saratoga Springs, New York, 1974–78; California College of Arts and Crafts, Oakland, 1983–84. Hauptman's first one-person exhibition took place at UP Gallery, University of Pittsburgh, 1972; subsequent solo exhibitions include Richard Brush Gallery, St. Lawrence College, Canton, New York, 1974; Shick Art Gallery, Skidmore College, Saratoga Springs, New York, 1976; Allan Stone Gallery, New York, 1984; Jeremy Stone Gallery, San Francisco, 1984. Currently resides in Oakland.

Maxwell Hendler. Born in 1938 in St. Louis. Studied at University of California, Los Angeles, 1956–62, B.A. 1960, M.A. 1962. Teaching experience includes California State University, Northridge, 1967–69; California State University, Long Beach, 1969–74; Art Center College of Design, Pasadena, California, 1974–76. Hendler's first one-person exhibition took place at Ceeje Gallery, Los Angeles, 1962 (also 1965); subsequent solo exhibitions include The Metropolitan Museum of Art, New York, 1974; Los Angeles County Museum of Art, 1976; Robert Miller Gallery, New York, 1977, 1981. Currently resides in Los Angeles.

David Hendricks. Born in 1948 in Hammond, Indiana. Studied at University of Illinois, Champaign-Urbana, 1966–70, B.F.A. 1970; Skowhegan Summer School of Painting and Sculpture, Maine, 1969; Ox-Bow Summer School of Painting, Saugatuck, Michigan, 1970. Hendricks's first one-person exhibition took place at Monique Knowlton Gallery, New York, 1976 (also 1977); subsequent solo exhibitions include Fischbach Gallery, New York, 1984. Currently resides in New York.

Robert Henri. Born in 1865 in Cincinnati. Studied at Pennsylvania Academy of the Fine Arts, Philadelphia, 1886–88, 1891; Académie Julian, Paris, 1888–91. Teaching experience included New York School of Art, 1902–8; Henri School of Art, New York, 1909–11; Modern School, New York, 1911–18; Art Students League, New York, 1915–28. Henri's first one-person exhibition took place at Pennsylvania Academy of the Fine Arts, Philadelphia, 1897 (also 1908); subsequent solo exhibitions included Macbeth Galleries, New York, 1902, 1924, 1925; John Herron Art Institute (now Indianapolis Museum of Art), Indianapolis, 1925; Detroit Museum of Art (now The Detroit Institute of Arts), 1919 (cat.); Buffalo Fine Arts Academy (now Albright-Knox Art Gallery), 1919; Memorial Art Gallery of the University of Rochester, New York, 1931 (cat.); Vose Gallery, Boston, 1940; Sheldon Memorial Art Gallery, University of Nebraska, Lincoln, 1965 (cat.); Art Gallery, Moore College of Art, Philadelphia, 1976 (cat.). Died in 1929 in New York.

Hans Hofmann. Born in 1880 in Weissenberg, Germany. Studied at Moritz Heymann's Art School, Munich, 1898; Académie Colarossi and Académie de la Grande Chaumière, Paris, 1904–6. Teaching experience included Schule für Moderne Kunst, Munich, 1915–32; Art Students League, New York, 1932–33; Hans Hofmann School of Art, New York, and Provincetown, Massachusetts (summers), 1935–58. Hofmann's first one-person exhibition took place at Galerie Paul Cassirer, Berlin, 1930; subsequent solo exhibitions included California Palace of the Legion of Honor, San Francisco, 1931 (cat.); Art of This Century Gallery, New York, 1944 (cat.); Addison Gallery of American Art, Phillips Academy, Andover, Massachusetts, 1944 (cat.); Art Gallery, Bennington College, Vermont, 1955 (cat.); Whitney Museum of American Art, New York, 1957 (circulated; cat.); The Museum of Modern Art, New York, 1963 (circulated; cat.); University Art Museum, University of California, Berkeley, 1964 (cat.); Stedelijk van Abbemuseum, Eindhoven, The Netherlands, 1966 (cat.); The Currier Gallery of Art, Manchester, New Hampshire, 1974 (organized by International Exhibitions Foundation, Washington, D.C.; circulated; cat.); Hirshhorn Museum and Sculpture Garden, Smithsonian Institution, Washington, D.C., 1976 (circulated; cat.). Died in 1966 in New York.

Peter Holbrook. Born in 1940 in New York. Studied at Dartmouth College, Hanover, New Hampshire, 1957–60, B.A. 1960; Brooklyn Museum Art School, 1962–63. Holbrook's first one-person exhibition took place at Richard Gray Gallery, Chicago, 1964 (also 1966, 1967, 1969, 1970, 1973, 1976); subsequent solo exhibitions include Indianapolis Museum of Art, 1970; Frumkin & Struve, Chicago, 1980, 1982. Currently resides in Redway, California.

Edward Hopper. Born in 1882 in Nyack, New York. Studied at Correspondence School of Illustrating, New York, 1899–1900; New York School of Art, 1900–1906. Hopper's first one-person exhibition took place at Whitney Studio Club, New York, 1920 (also 1922); subsequent solo exhibitions included Frank M. Rehn Gallery, New York, 1924, 1929, 1946, 1948, 1965; The Museum of Modern Art, New York, 1933 (cat.); Whitney Museum of American Art, New York, 1950 (circulated; cat.), 1964 (circulated; cat.), 1971 (circulated; cat.), 1980 (circulated; cat.); Philadelphia Museum of Art, 1962 (circulated; cat.); William A. Farnsworth Library and Art Museum, Rockland, Maine, 1971 (circulated; cat.). Died in 1967 in New York.

Ian Hornak. Born in 1944 in Philadelphia. Studied at University of Michigan, Ann Arbor, 1960–62: Wayne State University, Detroit, 1962–66, B.F.A. 1964; M.F.A. 1966. Teaching experience includes Wayne State University, Detroit, 1965–67; Henry Ford College, Dearborn, Michigan, 1966–67. Hornak's first one-person exhibition took place at Tibor de Nagy Gallery, New York, 1971 (also 1972–76); subsequent solo exhibitions include Jacob's Ladder Gallery, Washington, D.C., 1971–73; Gertrude Kasle Gallery, Detroit, 1974; Fischbach Gallery, New York, 1979, 1981. Currently resides in New York.

Roger Howrigan. Born in 1943 in Washington, D.C. Studied at Philadelphia College of Art, 1963–67, B.F.A. 1967; Yale Norfolk Music and Art Program, Connecticut, 1966 (summer); American University, Washington, D.C., 1968–69; Tyler School of Art, Temple University, Philadelphia, 1969–71, M.F.A. 1971. Howrigan's first one-person exhibition took place at Il Carpine, Rome, 1969; subsequent solo exhibitions include Green Mountain Gallery, New York, 1972, 1974, 1976; St. Thomas Aquinas College Gallery, Sparkill, New York, 1974, 1976, 1978; Josef Gallery, New York, 1981. Currently resides in New York.

John Stuart Ingle. Born in 1933 in Evansville, Indiana. Studied at University of Arizona, Tucson, 1948–52, 1963–66, B.F.A. 1964, M.F.A. 1966. Teaching experience includes University of Minnesota, Morris, 1966–present. Ingle's first one-person exhibition took place at University of Minnesota, Morris, 1967; subsequent solo exhibitions include Tatistcheff & Co., Inc., New York, 1981, 1983, 1985; University of Arizona Museum of Art, Tucson, 1984. Currently resides in Morris, Minnesota.

Keith Jacobshagen. Born in 1941 in Wichita, Kansas. Studied at Wichita State University, Kansas, 1959–60; Art Center College of Design, Los Angeles, 1963–64; Kansas City Art Institute, Missouri, 1960–65, B.F.A. 1965; University of Kansas, Lawrence, 1966–68, M.F.A. 1968. Teaching experience includes University of Nebraska, Lincoln, 1968–present. Jacobshagen's first one-person exhibition took place at Sheldon Memorial Art Gallery, University of Nebraska, Lincoln, 1969 (also 1974); subsequent solo exhibitions include Charles Campbell Gallery, San Francisco, 1976, 1980, 1985; Robert Schoelkopf Gallery, New York, 1979; Roger Ramsay Gallery, Chicago, 1983. Currently resides in Lincoln, Nebraska.

Yvonne Jacquette. Born in 1934 in Pittsburgh. Studied at Rhode Island School of Design, Providence, 1952–56, B.A. 1956. Teaching experience includes University of Pennsylvania, Philadelphia, 1972–75, 1979–82; Parsons School of Design, New York, 1975–78. Jacquette's first one-person exhibition took place at The Wilcox Gallery, Swarthmore College, Pennsylvania, 1965; subsequent solo exhibitions include Fischbach Gallery, New York, 1971; Brooke Alexander, Inc., New York, 1974, 1976 (cat.), 1979, 1981–83; John Berggruen Gallery, San Francisco, 1984. Currently resides in New York and Morrill, Maine.

W. Louis Jones. Born in 1943 in Durham, North Carolina. Studied at East Carolina College, Greenville, North Carolina, 1961–65, B.S. 1965; Pennsylvania Academy of the Fine Arts, Philadelphia, 1964; Cranbrook Academy of Art, Bloomfield Hills, Michigan, 1965–67, M.F.A. 1967. Teaching experience includes Skidmore College, Saratoga Springs, New York, 1969–74; Russell Sage College, Troy, New York, 1969–74. Jones's first one-person exhibition took place at Bobbitt Visual Arts Center, Albion College, Michigan, 1967; subsequent solo exhibitions include Mint Museum of Art, Charlotte, North Carolina, 1970; Kornblee Gallery, New York, 1977. Currently resides in Ashboro, North Carolina.

Wolf Kahn. Born in 1927 in Stuttgart, Germany. Studied at New School for Social Research, New York, 1946; Hans Hofmann School of Fine Arts, New York, and Provincetown, Massachusetts, 1947–49; University of Chicago, 1950–51, B.F.A. 1951. Teaching experience includes Cooper Union School of Art, New York, 1960–77. Kahn's first one-person exhibition took place at Hansa Gallery, New York, 1953 (also 1954); subsequent solo exhibitions include Borgenicht Gallery, New York, 1956, 1958, 1961, 1962, 1965, 1967, 1969, 1971, 1974, 1977; Kroeber Hall, University of California, Berkeley, 1960; The Arts Club of Chicago, 1981 (circulated; cat.). Currently resides in New York.

Alex Katz. Born in 1927 in Brooklyn. Studied at Cooper Union School of Art, New York, 1945–49; Skowhegan School of Painting and Sculpture, Maine, 1949–50. Teaching experience includes Yale University, New Haven, Connecticut, 1961–63; University of Pennsylvania, Philadelphia, 1971–72; New York University, 1983–84. Katz's first one-person exhibition took place at Roko Gallery, New York, 1954 (also 1957); subsequent solo exhibitions include Utah Museum of Fine Arts, University of Utah, Salt Lake City, 1971 (circulated; cat.); Whitney Museum of American Art, New York, 1974 (circulated; cat.); Robert Miller Gallery, New York, 1979 (cat.), 1981 (cat.), 1985 (cat.); Contemporary Arts Center, Cincinnati, 1981. Currently resides in New York.

Claire Khalil. Born in 1944 in Boston. Studied at Emmanuel College, Boston, 1961–65, B.A. 1965; Accademia di Belle Arti, Florence, 1965–66. Khalil's first one-person exhibition took place at FAR Gallery, New York, 1973; subsequent solo exhibitions include Pen and Brush Club, New York, 1978. Currently resides in New York.

Robert Kinmont. Born in 1937 in Los Angeles. Studied at San Francisco Art Institute, 1967–70, B.F.A. 1970; University of California, Davis, 1970–71, M.F.A. 1971. Teaching experience includes Academy of Art, San Francisco, 1972–74; Lone Mountain College, San Francisco, 1972–75;

Coyote Fine Arts/Goddard College and Antioch West, Bishop, California, 1975–79. Kinmont's first one-person exhibition took place at Gallery Reese Palley, San Francisco, 1971 (cat.); subsequent solo exhibitions include Works, San Jose, California, 1979; Fuller-Goldeen Gallery, San Francisco, 1983. Currently resides in Sonoma, California.

Ron Kleeman. Born in 1937 in Bay City, Michigan. Studied at Bay City Junior College, Michigan, 1955–59; University of Michigan, Ann Arbor, 1959–61, B.S. 1961. Kleeman's first one-person exhibition took place at French & Co., New York, 1971; subsequent solo exhibitions include Louis K. Meisel Gallery, New York, 1974, 1976, 1979, 1984; Reed College Faculty Office Building Gallery, Portland, Oregon, 1976; Indianapolis Museum of Art, 1977. Currently resides in Hudson, New York.

John Koch. Born in 1909 in Toledo. Self-taught. Teaching experience included Art Students League, New York, 1944–45. Koch's first one-person exhibition took place at Valentine Gallery, New York, 1935; subsequent solo exhibitions included Kraushaar Galleries, New York, 1939 (cat.), 1941 (cat.), 1949 (cat.), 1951 (cat.), 1958 (cat.); 1961 (cat.), 1963 (cat.), 1965 (cat.), 1969 (cat.), 1972 (cat.), 1974 (cat.), 1980 (cat.); Museum of the City of New York, 1963 (cat.); New York Cultural Center (cat.), 1973. Died in 1978 in New York.

Kay Kurt. Born in 1944 in Dubuque, Iowa. Studied at Clarke College, Dubuque, Iowa, 1962–66, B.A. 1966; University of Wisconsin, Madison, 1966–68, M.F.A. 1968. Kurt's first one-person exhibition took place at Clarke College, Dubuque, Iowa, 1968; subsequent solo exhibitions include Kornblee Gallery, New York, 1970, 1979, 1983; Walker Art Center, Minneapolis, 1980 (circulated; cat.). Currently resides in Duluth.

Gabriel Laderman. Born in 1929 in Brooklyn. Studied at Brooklyn College, 1948–52, B.A. 1952; Hans Hofmann School of Fine Arts, New York, 1949; with Willem de Kooning, New York, 1949–50; Atelier 17, New York, 1949–50, 1952–53; Cornell University, Ithaca, New York, 1955–57, M.F.A. 1957; Accademia di Belle Arti, Florence, 1962–63. Teaching experience includes State University of New York, New Paltz, 1957–59; Pratt Institute, Brooklyn, 1959–69; Queens College, New York, 1969–82. Laderman's first one-person exhibition took place at Cornell University, Ithaca, New York, 1957; subsequent solo exhibitions include Robert Schoelkopf Gallery, New York, 1964, 1967, 1969, 1972, 1974, 1977; Tyler School of Art, Temple University, Philadelphia, 1971, 1972; Sunne Savage Gallery, Boston, 1975; Dart Gallery, Chicago, 1977; Fine Arts Center, University of Arkansas, Fayetteville, 1985. Currently resides in New York.

Ellen Lanyon. Born in 1926 in Chicago. Studied at School of The Art Institute of Chicago, 1944–48, B.F.A. 1948; University of Iowa, Iowa City, 1948–50, M.F.A. 1950; Courtauld Institute, University of London, 1950–51. Teaching experience includes Cooper Union School of Art, New York, 1979–present. Lanyon's first one-person exhibition took place at Bordelon's, Chicago, 1952; subsequent solo exhibitions include Fort Wayne Art Institute, 1966 (cat.); Madison Art Center, Wisconsin, 1972 (circulated); Richard Gray Gallery, Chicago, 1973, 1976, 1979, 1982; N.A.M.E. Gallery, Chicago, 1983 (cat.). Currently resides in New York.

Robert Laurent. Born in 1890 in Concarneau, France. Studied at British Academy, Rome, 1908–9; with Maurice Sterne, Rome, c. 1908; with Hamilton Easter Field. Teaching experience included Indiana University, Bloomington, 1942–60. Laurent's first one-person exhibition took place at Daniel Gallery, New York, 1915 (also 1917); subsequent solo exhibitions included Valentine Gallery, New York, 1926, 1931, 1941; Kraushaar Galleries, New York, 1947, 1952, 1956, 1962, 1972; University Galleries, Paul Creative Arts Center, University of New Hampshire, Durham, 1972 (circulated; cat.). Died in 1970 in Cape Neddick, Maine.

Blanche Lazzell. Born in 1878 near Maidsville, West Virginia. Studied at West Virginia Conference Seminary, Buckhannon, 1898; South Carolina Coeducational Institute, Edgefield; West Virginia University, Morgantown, B.A. 1905. Teaching experience included West Virginia University, Morgantown, 1908–12. Lazzell's first one-person exhibition took place at the Berkeley Art League, California, 1928 (circulated); subsequent solo exhibitions included Creative Arts Center, West Virginia University, Morgantown, 1931, 1932, 1979 (cat.); Memorial Library, University of Delaware, Newark, 1936. Died in 1956 in Morgantown, West Virginia.

Alfred Leslie. Born in 1927 in New York. Studied at Art Students League, New York, 1946–47; New York University, 1947–49. Leslie's first one-person exhibition took place at Tibor de Nagy Gallery, New York, 1951 (also 1952, 1953, 1957); subsequent solo exhibitions include Martha Jackson Gallery, New York, 1960–62; Allan Frumkin Gallery, New York, 1975 (cat.), 1978 (cat.), 1980 (cat.), 1983; The Museum of Fine Arts, Boston, 1976 (circulated; cat.); The Butler Institute of American Art, Youngstown, Ohio, 1984 (circulated; cat.). Currently resides in South Amherst, Massachusetts.

Seaver Leslie. Born in 1946 in Boston. Studied at Rhode Island School of Design, Providence, 1965–70, B.F.A. 1969, M.F.A. 1970; with Peter Blake, London, 1973–74. Teaching experience includes Rhode Island School of Design, Providence, 1971–81; Parsons School of Design, New York, 1980–82; Wellesley College, Massachusetts, 1983–84. Leslie's first one-person exhibition took place at Providence Art Club, Rhode Island, 1970; subsequent solo exhibitions include Woods-Gerry Gallery, Rhode Island School of Design, Providence, 1972; Hirschl & Adler Modern, New York,

1979; Tatistcheff & Co., Inc., New York, 1982. Currently resides in Wiscasset, Maine.

Tomar Levine. Born in 1945 in New York. Studied at City College of New York, 1962–66, B.A. 1966; Brooklyn College, 1972–74, M.F.A. 1974. Levine's first one-person exhibition took place at Prince Street Gallery, New York, 1971 (also 1972, 1974, 1976, 1979); subsequent solo exhibitions include Paul Kessler Gallery, Provincetown, Massachusetts, 1979; Tatistcheff & Co., Inc., New York, 1983. Currently resides in New York.

David Ligare. Born in 1945 in Oak Park, Illinois. Studied at Chouinard Art Institute, Los Angeles, 1963; Art Center College of Design, Los Angeles, 1964–65. Teaching experience includes Hartnell College, Salinas, California, 1977–79. Ligare's first one-person exhibition took place at Wickersham Gallery, New York, 1969; subsequent solo exhibitions include Monterey Museum of Art, California, 1970; Andrew Crispo Gallery, New York, 1974, 1978 (cat.); Phoenix Art Museum, 1977; Koplin Gallery, Los Angeles, 1983; University Gallery, University of California, Santa Barbara, 1984; Robert Schoelkopf Gallery, New York, 1985. Currently resides in Salinas, California.

Paul Linfante. Born in 1940 in East Orange, New Jersey. Studied at Cooper Union School of Art, New York, 1960–62; Jersey City State College, 1959, 1967–69. Linfante's first one-person exhibition took place at Kornblee Gallery, New York, 1977 (also 1978, 1981, 1984). Currently resides in New York.

Frank Lobdell. Born in 1921 in Kansas City, Missouri. Studied at St. Paul School of Fine Arts, 1938–39; California School of Fine Arts (now San Francisco Art Institute), 1947–50; Académie de la Grande Chaumière, Paris, 1950. Teaching experience includes Stanford University, California, 1966–present. Lobdell's first one-person

exhibition took place at Lucien Labaudt Gallery, San Francisco, 1949; subsequent solo exhibitions include Ferus Gallery, Los Angeles, 1962; Pasadena Art Museum (now Norton Simon Museum), California, 1966 (circulated; cat.); San Francisco Museum of Art (now San Francisco Museum of Modern Art), 1969 (cat.), 1983 (cat.). Currently resides in Palo Alto, California.

Peter Loftus. Born in 1948 in Washington, D.C. Studied at The Maryland Institute, College of Art, Baltimore, 1967–71, B.F.A. 1971; University of Pennsylvania, Philadelphia, 1971–74, M.F.A. 1974. Teaching experience includes Cabrillo College, Aptos, California, 1975–present; University of California, Santa Cruz, 1975–present. Loftus's first one-person exhibition took place at Branciforte Branch, Santa Cruz Public Library, California, 1976; subsequent solo exhibitions include San Jose Museum of Art, California, 1980; William Sawyer Gallery, San Francisco, 1980, 1981, 1984; Fischbach Gallery, New York, 1982, 1983. Currently resides in Santa Cruz, California.

Louis Lozowick. Born in 1892 in Ludvinovka, Ukraine. Studied at National Academy School of Fine Arts, New York, 1912–15; Ohio State University, Columbus, 1915–18. Lozowick's first one-person exhibition took place at Twardy Gallery, Berlin, 1922; subsequent solo exhibitions included Museum of New Western Art (now the Pushkin Museum of Fine Arts), Moscow, 1928; Weyhe Gallery, New York, 1929, 1931, 1936; National Collection of Fine Arts (now the National Museum of American Art), Smithsonian Institution, Washington, D.C., 1975, 1983 (cat.). Died in 1973 in East Orange, New Jersey.

Norman Lundin. Born in 1938 in Los Angeles. Studied at Miami University, Hamilton, Ohio, 1957–58; University of Chicago, 1958–61; School of The Art Institute of Chicago, B.A. 1961; University of Cincinnati, 1961–63, M.F.A. 1963; University of Oslo, Norway, 1964. Teaching experience includes University of Washington, Seattle,

1964–present. Lundin's first one-person exhibition took place at Gilman Galleries, Chicago, 1963; subsequent solo exhibitions include Otto Seligman/Francine Seders Gallery, Seattle, 1967, 1969; Viterbo College, La Crosse, Wisconsin, 1974 (cat.); Francine Seders Gallery, Seattle, 1973–75, 1981; Seattle Art Museum, 1984 (cat.). Currently resides in Seattle.

Stanton Macdonald-Wright. Born in 1890 in Charlottesville, Virginia. Studied at Art Students League, New York, 1904–5; La Sorbonne, Paris, 1907–9; briefly at Académie Colarossi, Académie Julian, and École des Beaux-Arts, Paris. Teaching experience included University of California, Los Angeles, 1942–50. Macdonald-Wright's first one-person exhibition took place at Der Neue Kunstsalon, Munich, Germany, 1913; subsequent solo exhibitions included Photo-Secession, New York, 1917; Los Angeles County Museum of Art, 1956 (cat.); National Collection of Fine Arts (now National Museum of American Art), Smithsonian Institution, Washington, D.C., 1967 (cat.); UCLA Art Galleries/The Grunwald Graphic Arts Foundation (now The Frederick S. Wight Art Gallery), University of California, Los Angeles, 1970 (cat.). Died in 1973 in Pacific Palisades, California.

Henry Lee McFee. Born in 1886 in St. Louis. Studied at Washington University, St. Louis; Art Students League, Woodstock, New York, 1908. McFee's first one-person exhibition took place at Rehn Galleries, New York, 1927 (also 1929, 1933, 1936, 1950); subsequent solo exhibitions included Pasadena Art Institute, California, 1950; Lang Gallery, Scripps College, Claremont, California, 1950 (cat.). Died in 1953 in Claremont, California.

James McGarrell. Born in 1930 in Indianapolis. Studied at Indiana University, Bloomington, 1949–53, B.A. 1953; Skowhegan School of Painting and Sculpture, Maine, 1953; University of California, Los Angeles, 1953–55, M.A. 1955. Teaching experience includes Reed College, Port-

land, Oregon, 1956–59; Indiana University, Bloomington, 1959–81; Washington University, St. Louis, 1981–present. McGarrell's first one-person exhibition took place at Frank Perls Gallery, Los Angeles, 1955 (also 1957, 1958, 1962, 1964); subsequent solo exhibitions include Allan Frumkin Gallery, New York, 1961, 1964, 1966, 1969, 1971, 1973, 1977, 1981; University Art Museum, University of New Mexico, Albuquerque, 1982 (cat.). Currently resides in St. Louis.

Richard McLean. Born in 1934 in Hoquiam, Washington. Studied at California College of Arts and Crafts, Oakland, 1955–58, B.F.A. 1958; Mills College, Oakland, 1960–62, M.F.A. 1962. Teaching experience includes California College of Arts and Crafts, Oakland, 1963–65; San Francisco State University, 1963–present. McLean's first one-person exhibition took place at Lucien Labaudt Gallery, San Francisco, 1957; subsequent solo exhibitions include Berkeley Gallery, 1964; Berkeley Gallery, San Francisco, 1966, 1968; O. K. Harris Gallery, New York, 1971, 1973, 1975, 1978, 1981, 1983. Currently resides in Oakland.

Sylvia Plimack Mangold. Born in 1938 in New York. Studied at Cooper Union School of Art, New York, 1956–59; Yale University, New Haven, Connecticut, 1959–61, B.F.A. 1961. Teaching experience includes School of Visual Arts, New York, 1970–71, 1974–present. Mangold's first one-person exhibition took place at Fischbach Gallery, New York, 1974 (also 1975); subsequent solo exhibitions include Contemporary Arts Museum, Houston, 1981 (cat.); Madison Art Center, Wisconsin, 1982 (circulated; cat.); Brooke Alexander, Inc., New York, 1984. Currently resides in Washingtonville, New York.

Reginald Marsh. Born in 1898 in Paris. Studied at Yale University, New Haven, Connecticut, 1916–20, B.A. 1920; Art Students League, New York, 1919, 1920–24, 1927–28. Teaching experience included Art Students League, New York, 1935–41

(summers), 1942–54; Moore Institute of Art, Philadelphia, 1949–54. Marsh's first one-person exhibition took place at Whitney Studio Club, New York, 1924 (also 1928); subsequent solo exhibitions included Valentine Gallery, New York, 1927; Rehn Galleries, New York, 1930–34, 1936, 1938, 1940, 1941, 1943, 1944, 1946, 1948, 1950, 1953, 1956, 1958, 1960, 1962, 1964, 1970; Wadsworth Atheneum, Hartford, 1957; University of Arizona Museum of Art, Tucson, 1969 (cat.); Whitney Museum of American Art, New York, 1955 (circulated; cat.), 1983 (circulated; cat.); Newport Harbor Art Museum, Newport Beach, California, 1972 (cat.). Died in 1954 in Dorset, Vermont.

Bill Martin. Born in 1943 in South San Francisco. Studied at College of San Mateo, California, 1961–63; Academy of Art, San Francisco, 1964–65; San Francisco Art Institute, 1966–70, B.F.A. 1968, M.F.A. 1970. Teaching experience includes Academy of Art, San Francisco, 1970–71; College of Marin, Kentfield, California, 1975–78. Martin's first one-person exhibition took place at San Francisco Museum of Art (now San Francisco Museum of Modern Art), 1973 (cat.); subsequent solo exhibitions include Nancy Hoffman Gallery, New York, 1976, 1979, 1982; Zara Gallery, San Francisco, 1978, 1980; Joseph Chowning Gallery, San Francisco, 1983, 1985. Currently resides in Albion, California.

G. Daniel Massad. Born in 1946 in Oklahoma City. Studied at Princeton University, New Jersey, 1965–69, B.A. 1969; University of Chicago, 1969–70, 1977, M.A. 1977; University of Kansas, Lawrence, 1980–82, M.F.A. 1982. Massad's first one-person exhibition took place at Mulvane Art Center, Washburn University, Topeka, Kansas, 1983; subsequent solo exhibitions include Rosenfeld Gallery, Philadelphia, 1984. Currently resides in Annville, Pennsylvania.

Louisa Matthiasdottir. Born in 1917 in Reykjavik, Iceland. Studied at Kunst-

haandvaerkerskolen, Copenhagen, Denmark, 1934–37; with Marcel Gromaire, Paris, 1938; Hans Hofmann School of Fine Arts, New York, 1943–44. Matthiasdottir's first one-person exhibition took place at Jane Street Gallery, New York, 1948; subsequent solo exhibitions include Tanager Gallery, New York, 1958; University of New Hampshire, Durham, 1978; Robert Schoelkopf Gallery, New York, 1964, 1966, 1968, 1969, 1972, 1974, 1976, 1978, 1980, 1982 (cat.), 1984. Currently resides in New York.

Michael Mazur. Born in 1935 in New York. Studied at Amherst College, Massachusetts, 1954–58, B.A. 1958; Yale University, New Haven, Connecticut, 1958–61, B.F.A. 1959, M.F.A. 1961. Teaching experience includes Rhode Island School of Design, Providence, 1961–64; Brandeis University, Waltham, Massachusetts, 1965–76. Mazur's first one-person exhibition took place at Kornblee Gallery, New York, 1961 (also 1962, 1963, 1965); subsequent solo exhibitions include Rose Art Museum, Brandeis University, Waltham, Massachusetts, 1968; Brockton Art Center-Fuller Memorial, Brockton, Massachusetts, 1976 (circulated; cat.); Hayden Gallery, Massachusetts Institute of Technology, Cambridge, 1983 (cat.). Currently resides in Cambridge, Massachusetts.

Sandra Mendelsohn-Rubin. Born in 1947 in Santa Monica, California. Studied at University of California, Los Angeles, 1972–79, B.A. 1976, M.F.A. 1979. Teaching experience includes Art Center College of Design, Pasadena, California, 1980. Mendelsohn-Rubin's first one-person exhibition took place at L. A. Louver, Venice, California, 1982; subsequent solo exhibitions include Fischer Fine Arts, London, 1985 (cat.); Los Angeles County Museum of Art, 1985 (cat.). Currently resides in Santa Monica, California.

Jack Mendenhall. Born in 1937 in Ventura, California. Studied at California College of Arts and Crafts, Oakland, 1955, 1966–70,

B.F.A. 1968, M.F.A. 1970. Teaching experience includes California College of Arts and Crafts, Oakland, 1970–present. Mendenhall's first one-person exhibition took place at Art Gallery, Chico State College (now California State University, Chico), California, 1965; subsequent solo exhibitions include O. K. Harris Gallery, New York, 1974, 1979, 1981, 1983. Currently resides in Oakland.

Willard Midgette. Born in 1937 in Baltimore. Studied at Skowhegan School of Painting and Sculpture, Maine, 1953–56, 1959 (summers); Boston University, 1955–57; Harvard University, Cambridge, Massachusetts, 1957–58, B.A. 1958; Pratt Institute, Brooklyn, 1959; Indiana University, Bloomington, 1959–62, M.F.A. 1962. Teaching experience included Reed College, Portland, Oregon, 1963–69; St. Ann's Episcopal School, New York, 1971–78. Midgette's first one-person exhibition took place at Reed College Faculty Office Building Gallery, Portland, Oregon, 1963 (also 1965, 1967, 1978); subsequent solo exhibitions included Madison Art Center, Wisconsin, 1971; Allan Frumkin Gallery, New York, 1971, 1972, 1974, 1976; U.S. Courthouse, New York, 1978. Died in 1978 in New York.

John Moore. Born in 1941 in St. Louis. Studied at Washington University, St. Louis, 1962–66, B.F.A. 1966; Yale University, New Haven, Connecticut, 1966–68, M.F.A. 1968. Teaching experience includes Tyler School of Art, Temple University, Philadelphia, 1968–present. Moore's first one-person exhibition took place at Chiaroscuro Gallery, Princeton, New Jersey, 1969; subsequent solo exhibitions include Fischbach Gallery, New York, 1973, 1975, 1978, 1980; Gallery 210, University of Missouri, St. Louis, 1978; Capricorn Gallery, Bethesda, Maryland, 1981; Hirschl & Adler Modern, New York, 1983 (cat.). Currently resides in Wyncote, Pennsylvania.

Walter Murch. Born in 1907 in Toronto. Studied at Ontario College of Art, Toronto,

1924–27; Art Students League, New York, 1929–30; Grand Central School, New York, 1930; with Arshile Gorky, 1931–32. Teaching experience included Pratt Institute, Brooklyn, 1952–61; Boston University, 1961–67. Murch's first one-person exhibition took place at Christodora House, New York, 1929; subsequent solo exhibitions included Betty Parsons Gallery, New York, 1947, 1949, 1951, 1954, 1957, 1959, 1962, 1966, 1970 (cat.), 1971, 1983; Museum of Art, Rhode Island School of Design, Providence, 1966 (cat.). Died in 1967 in New York.

Catherine Murphy. Born in 1946 in Cambridge, Massachusetts. Studied at Pratt Institute, Brooklyn, 1963–67, B.F.A. 1967; Skowhegan School of Painting and Sculpture, Maine, 1966. Murphy's first one-person exhibition took place at First Street Gallery, New York, 1972; subsequent solo exhibitions include Fourcade, Droll, Inc., New York, 1975; The Phillips Collection, Washington, D.C., in collaboration with Institute of Contemporary Art, Boston, 1976 (circulated; cat.); Xavier Fourcade, Inc., New York, 1979. Currently resides in Poughkeepsie, New York.

John Murray. Born in 1929 in Kansas City, Missouri. Studied at Stanford University, California, 1946–51, B.A. 1951; Art Center College of Design, Los Angeles, 1953–55, B.F.A. 1955. Murray's first one-person exhibition took place at Soho Center for Visual Arts, New York, 1977; subsequent solo exhibitions include Elaine Benson Gallery, Bridgehampton, New York, 1979; Bayard Gallery, New York, 1981; Andrew Crispo Gallery, New York, 1982. Currently resides in New York.

Alice Neel. Born in 1900 in Merion Square, Pennsylvania. Studied at Philadelphia School of Design for Women (now Moore College of Art), 1921–25. Neel's first one-person exhibition took place in Havana, Cuba, 1926; subsequent solo exhibitions included Pinacotheca Gallery, New York, 1944; ACA Galleries, New York, 1950,

1954; Graham Gallery, New York, 1963, 1966, 1968, 1970, 1973, 1976, 1977, 1978; Whitney Museum of American Art, New York, 1972 (cat.); Georgia Museum of Art, University of Georgia, Athens, 1975 (cat.); Boston University Art Gallery, 1980 (cat.); Art Gallery, Loyola Marymount University, Los Angeles, 1983 (cat.); Robert Miller Gallery, New York, 1982, 1984. Died in 1984 in New York.

Manuel Neri. Born in 1930 in Sanger, California. Studied at San Francisco City College, 1949–50; University of California, Berkeley, 1951–52; California College of Arts and Crafts, Oakland, 1952–53, 1955–57; California School of Fine Arts (now San Francisco Art Institute), 1957–59. Teaching experience includes California School of Fine Arts (now San Francisco Art Institute), 1959–64; University of California, Davis, 1964–present. Neri's first one-person exhibition took place at 6 Gallery, San Francisco, 1957; subsequent solo exhibitions include E. B. Crocker Art Gallery (now Crocker Art Museum), Sacramento, California, 1977 (cat.); Seattle Art Museum, 1981 (cat.); John Berggruen Gallery, San Francisco, 1981, 1984. Currently resides in Benicia, California.

Lowell Nesbitt. Born in 1933 in Baltimore. Studied at Tyler School of Art, Temple University, Philadelphia, 1950–55, B.F.A. 1955; Royal College of Art, London, 1955–56, A.R.C.A. 1956. Teaching experience includes Baltimore Museum of Art, 1967–68; School of Visual Arts, New York, 1970–71. Nesbitt's first one-person exhibition took place at Baltimore Museum of Art, 1958 (also 1969 [cat.]); subsequent solo exhibitions include Corcoran Gallery of Art, Washington, D.C., 1965, 1973 (cat.); Edwin A. Ulrich Museum of Art, Wichita State University, Kansas, 1977; The Aldrich Museum of Contemporary Art, Ridgefield, Connecticut, 1980 (cat.); The Butler Institute of American Art, Youngstown, Ohio, 1982 (cat.); University of Virginia Art Museum, Charlottesville, 1983 (circulated; cat.). Currently resides in New York.

Joe Nicastri. Born in 1945 in Bayshore, New York. Studied at Marist College, Poughkeepsie, New York, 1963–64; State University of New York at Albany, 1964–67, B.A. 1967; University of Massachusetts, Amherst, 1967–68; State University of New York at Albany, 1968–69, M.F.A. 1969. Teaching experience includes Miami-Dade Community College, Miami, Florida, 1971–73; Florida International University, Miami, 1973–78. Nicastri's first one-person exhibition took place at Nancy Hoffman Gallery, New York, 1979 (also 1980, 1984); subsequent solo exhibitions include Delaware Art Museum, Wilmington, 1980; Tamasulo Gallery, Union College, Cranford, New Jersey, 1980. Currently resides in Miami, Florida.

Don Nice. Born in 1932 in Visalia, California. Studied at University of Southern California, Los Angeles, 1950–54, B.F.A. 1954; Yale University, New Haven, Connecticut, 1962–64, M.F.A. 1964. Teaching experience includes Minneapolis School of Art and Design, 1960–62; School of Visual Arts, New York, 1963–present. Nice's first one-person exhibition took place at Richard Feigen Gallery, New York, 1963; subsequent solo exhibitions include Allan Stone Gallery, New York, 1967, 1969, 1971, 1974; Arnhem Museum, The Netherlands, 1974; Nancy Hoffman Gallery, New York, 1975, 1977, 1978 (circulated), 1979–81, 1984; Newport Harbor Art Museum, Newport Beach, California, 1980. Currently resides in Garrison, New York.

William Nichols. Born in 1942 in Chicago. Studied at School of The Art Institute of Chicago, 1961–66, B.F.A. 1966; University of Illinois, Champaign-Urbana, 1966–68, M.F.A. 1968; Slade School of Art, London, 1968–69. Teaching experience includes University of Wisconsin, Milwaukee, 1970–present. Nichols's first one-person exhibition took place at Fine Arts Galleries, University of Wisconsin, Milwaukee, 1975; subsequent solo exhibitions include O. K. Harris Gallery, New York, 1979, 1981, 1983, 1985. Currently resides in Milwaukee.

Judy North. Born in 1937 in Los Angeles. Studied at Otis Art Institute, Los Angeles, 1955–58; California School of Fine Arts (now San Francisco Art Institute), 1958–59. Teaching experience includes Bennington College, Vermont, 1966–69. North's first one-person exhibition took place at Usdan Art Gallery, Bennington College, Vermont, 1969; subsequent solo exhibitions include Quay Gallery, San Francisco, 1976; Purdue University, Lafayette, Indiana, 1979; Mississippi University for Women, Columbus, 1982; Fuller-Goldeen Gallery, San Francisco, 1984. Currently resides in San Geronimo, California.

Georgia O'Keeffe. Born in 1887 near Sun Prairie, Wisconsin. Studied at School of The Art Institute of Chicago, 1905–6; Art Students League, New York, 1907–8; Columbia University, New York, 1914–16. Teaching experience includes University of Virginia, Charlottesville, 1913–16 (summers); West Texas State Normal College, Canyon, 1916–18. O'Keeffe's first one-person exhibition took place at 291, New York, 1917; subsequent solo exhibitions include Intimate Gallery, New York, 1926, 1927, 1928, 1929; The Art Institute of Chicago, 1943 (cat.); Whitney Museum of American Art, New York, 1970 (circulated; cat.). Currently resides in Abiquiu, New Mexico.

Nathan Oliveira. Born in 1928 in Oakland. Studied at California College of Arts and Crafts, Oakland, 1947–52, B.F.A. 1951, M.F.A. 1952; Mills College, Oakland, 1950. Teaching experience includes Stanford University, California, 1964–present. Oliveira's first one-person exhibition took place at Eric Locke Gallery, San Francisco, 1957; subsequent solo exhibitions include UCLA Art Galleries (now The Frederick S. Wight Art Gallery), University of California, Los Angeles, 1963 (cat.); San Francisco Museum of Art (now San Francisco Museum of Modern Art), 1969 (cat.), 1984 (circulated; cat.); The Oakland Museum, 1973 (cat.). Currently resides in Stanford, California.

Elizabeth Osborne. Born in 1936 in Philadelphia. Studied at Pennsylvania Academy of the Fine Arts, Philadelphia, 1954–58, Certificate 1958; University of Pennsylvania, Philadelphia, 1958–59. Teaching experience includes Pennsylvania Academy of the Fine Arts, Philadelphia, 1961–present. Osborne's first one-person exhibition took place at Perakis Gallery, Philadelphia, 1963 (also 1966); subsequent solo exhibitions include Peale Galleries, Pennsylvania Academy of the Fine Arts, Philadelphia, 1967; Marian Locks Gallery, Philadelphia, 1972, 1976, 1978; Fischbach Gallery, New York, 1980, 1982, 1984. Currently resides in Philadelphia.

David Park. Born in 1911 in Boston. Studied at Otis Art Institute, Los Angeles, 1928–29. Teaching experience included Winsor School, Boston, 1936–41; California School of Fine Arts (now San Francisco Art Institute), 1943–52; University of California, Berkeley, 1955–60. Park's first one-person exhibition took place at San Francisco Museum of Art (now San Francisco Museum of Modern Art), 1936 (also 1939, 1940); subsequent solo exhibitions included Staempfli Gallery, New York, 1959 (cat.), 1960, 1961 (cat.), 1963, 1966; University Art Gallery (now University Art Museum), University of California, Berkeley, 1964 (cat.); Maxwell Galleries, Ltd., San Francisco, 1970 (cat.), 1973 (cat.), 1975, 1976; Newport Harbor Art Museum, Newport Beach, California, 1977 (circulated; cat.). Died in 1960 in Berkeley, California.

David Parrish. Born in 1939 in Birmingham, Alabama. Studied at University of Alabama, Tuscaloosa, 1957–61, B.F.A. 1961. Parrish's first one-person exhibition took place at Brooks Memorial Art Gallery, Memphis, 1971; subsequent solo exhibitions include Galerie François Petit, Paris, 1973; Sidney Janis Gallery, New York, 1975; Huntsville Museum of Art, Alabama, 1977; Nancy Hoffman Gallery, New York, 1981. Currently resides in Huntsville, Alabama.

Philip Pearlstein. Born in 1924 in Pittsburgh. Studied at Carnegie Institute of Technology (now Carnegie-Mellon University), Pittsburgh, 1942–43, 1946–49, B.F.A. 1949; New York University, 1950–55, M.A. 1955. Teaching experience includes Pratt Institute, Brooklyn, 1959–63; Brooklyn College, 1963–present. Pearlstein's first one-person exhibition took place at Tanager Gallery, New York, 1955; subsequent solo exhibitions include Allan Frumkin Gallery, New York, 1961–64, 1966, 1967, 1969 (cat.), 1970, 1976 (cat.), 1977 (cat.), 1982 (cat.); Georgia Museum of Art, University of Georgia, Athens, 1970 (circulated; cat.); Madison Art Center, Wisconsin, 1978 (cat.); Milwaukee Art Museum, 1983 (circulated; cat.). Currently resides in New York.

Guy Pène du Bois. Born in 1884 in Brooklyn. Studied at New York School of Art, 1899–1905; Académie Colarossi, Paris, 1905–6; with Théophile Steinlen, Paris, 1905–6. Teaching experience included Art Students League, New York, 1920–21, 1930–32, 1935; Cooper Union School of Art, New York, 1939–(date unknown). Pène du Bois's first one-person exhibition took place at Whitney Studio Club, New York, 1918; subsequent solo exhibitions included Kraushaar Galleries, New York, 1922, 1924, 1925, 1927, 1930, 1932, 1935, 1936, 1938, 1942, 1943, 1946; Corcoran Gallery of Art, Washington, D.C., 1980 (circulated; cat.). Died in 1958 in Boston.

Joseph Piccillo. Born in 1941 in Buffalo. Studied at State University of New York, Buffalo, 1959–64, B.S. 1961, M.F.A. 1964. Teaching experience includes State University of New York, Buffalo, 1967–present. Piccillo's first one-person exhibition took place at Banfer Gallery, New York, 1966; subsequent solo exhibitions include Albright-Knox Art Gallery, Buffalo, 1969 (also 1981 [cat.]); Krasner Gallery, New York, 1971, 1972, 1974–78; Gallery Louise Oppenheim, Geneva, 1978, 1979; Monique Knowlton Gallery, New York, 1980, 1981, 1983, 1984; Betsy Rosenfield Gallery, Chicago, 1981, 1984. Currently resides in Buffalo.

Fairfield Porter. Born in 1907 in Winnetka, Illinois. Studied at Harvard University, Cambridge, Massachusetts, 1924–28, B.S. 1928; Art Students League, New York, 1928–30. Teaching experience included Amherst College, Massachusetts, 1969–70; School of Visual Arts, New York, 1974–75. Porter's first one-person exhibition took place at North Shore Art Center, Winnetka, Illinois, 1939; subsequent solo exhibitions included Tibor de Nagy Gallery, New York, 1951; Cleveland Museum of Art, 1966; Hirschl & Adler Modern, New York, 1972, 1974, 1976, 1979; Heckscher Museum, Huntington, New York, 1974 (cat.); Museum of Fine Arts, Boston, 1982 (circulated; cat.). Died in 1975 in Southampton, New York.

Stephen Posen. Born in 1939 in St. Louis. Studied at Washington University, St. Louis, 1958–62, B.F.A. 1962; Yale University, New Haven, Connecticut, 1962–64, M.F.A. 1964. Teaching experience includes Cooper Union School of Art, New York, 1973–present. Posen's first one-person exhibition took place at O. K. Harris Gallery, New York, 1969 (also 1970, 1971, 1974); subsequent solo exhibitions include Robert Miller Gallery, New York, 1978. Currently resides in New York.

Joseph Raffael. Born in 1933 in Brooklyn. Studied at Cooper Union School of Art, New York, 1951–54; Yale University, New Haven, Connecticut, 1954–56, B.F.A. 1956. Teaching experience includes University of California, Davis, 1966; School of Visual Arts, New York, 1967–69; California State University, Sacramento, 1969–74. Raffael's first one-person exhibition took place at the Stable Gallery, New York, 1965 (also 1966, 1968); subsequent solo exhibitions include Worth Rydar Gallery, University of California, Berkeley, 1969; Nancy Hoffman Gallery, New York, 1972–74, 1976, 1979, 1980, 1981, 1983; Quay Gallery, San Francisco, 1975; San Francisco Museum of Modern

Art, 1978 (circulated; cat.); John Berggruen Gallery, San Francisco, 1978, 1981, 1982. Currently resides in San Geronimo, California.

Richard Raiselis. Born in 1951 in Bridgeport, Connecticut. Studied at Yale University, New Haven, Connecticut, 1969–73, B.A. 1973; the Ibero-American University, Mexico City, 1970 (summer); Skowhegan School of Painting and Sculpture, Maine, 1972 (summer); Tyler School of Art, Temple University, Philadelphia, 1974–76, M.F.A. 1976. Teaching experience includes Tyler School of Art, Temple University, Philadelphia, 1979–83; University of Michigan, Ann Arbor, 1983–present. Currently resides in Ann Arbor, Michigan.

Mel Ramos. Born in 1935 in Sacramento, California. Studied at Sacramento City College, California, 1953–54; San Jose State College (now San Jose State University), California, 1954–55; Sacramento State College (now California State University, Sacramento), California, 1955–58, B.A. 1957, M.A., 1958. Teaching experience includes California State University, Hayward, 1966–present. Ramos's first one-person exhibition took place at Bianchini Gallery, New York, 1964 (also 1965); subsequent solo exhibitions include David Stuart Gallery, Los Angeles, 1965, 1967–69, 1974, 1976; San Francisco Museum of Art (now San Francisco Museum of Modern Art), 1967; Utah Museum of Fine Arts, University of Utah, Salt Lake City, 1972; Louis K. Meisel Gallery, New York, 1974, 1976, 1981; The Oakland Museum, 1977 (cat.); Rose Art Museum, Brandeis University, Waltham, Massachusetts, 1980 (cat.); Modernism, San Francisco, 1981. Currently resides in Oakland.

Bill Richards. Born in 1944 in Brooklyn. Studied at Pratt Institute, Brooklyn, 1962–66, B.F.A. 1966; University of Iowa, Iowa City, 1966–68, M.A. 1968; University of New Mexico, Albuquerque, 1968–70, M.F.A. 1970. Teaching experience includes School of Visual Arts, New York,

1977–79. Richards's first one-person exhibition took place at Irwin Tuttie Gallery, Dallas, Texas, 1973; subsequent solo exhibitions include Nancy Hoffman Gallery, New York, 1980, 1985; Allen R. Hite Art Institute, University of Louisville, Kentucky, 1983. Currently resides in New York.

Herman Rose. Born in 1909 in Brooklyn. Studied at National Academy School of Fine Arts, New York. Teaching experience includes Brooklyn College, 1949–51; Hofstra University, Hempstead, New York, 1959–69; New School for Social Research, New York, 1963–present. Rose's first one-person exhibition took place at Egan Gallery, New York, 1946; subsequent solo exhibitions include ACA Galleries, New York, 1952, 1955, 1956; Zabriskie Gallery, New York, 1967, 1969, 1972, 1974; Sid Deutsch Art Gallery, New York, 1981. Currently resides in New York.

Barnet Rubenstein. Born in 1923 in Boston. Studied at Massachusetts College of Art, Boston, 1946–47; School of the Museum of Fine Arts, Boston, 1947–52, Dipl. 1951, Certificate, 1952. Teaching experience includes School of the Museum of Fine Arts, Boston, 1967–present. Rubenstein's first one-person exhibition took place at Galerie de la Librairie Anglaise, Paris, 1959 (also 1961); subsequent solo exhibitions include Museum of Fine Arts, Boston, 1979 (cat.); The Alpha Gallery, Boston, 1980, 1983, 1985. Currently resides in Boston.

Marcea Rundquist. Born in 1946 in Wellsville, New York. Studied at Mount Holyoke College, South Hadley, Massachusetts, 1964–68, B.A. 1968; Washington University, St. Louis, 1973–77, B.F.A. 1975, M.F.A. 1977. Rundquist's first one-person exhibition took place at Roy Boyd Gallery, Chicago, 1980 (also 1981); subsequent solo exhibitions include Okun/Thomas Gallery, St. Louis, 1981, 1982; Carol Shapiro Gallery, St. Louis, 1982; Ivory/Kimpton Gallery, San Francisco, 1983. Currently resides in Northampton, Massachusetts.

Edward Ruscha. Born in 1937 in Omaha. Studied at Chouinard Art Institute, Los Angeles, 1956–60. Ruscha's first one-person exhibition took place at Ferus Gallery, Los Angeles, 1963 (also 1964, 1965); subsequent solo exhibitions include Alexander Iolas Gallery, New York, 1967, 1970; The Minneapolis Institute of Arts, 1972 (cat.); Leo Castelli Gallery, New York, 1973–75, 1978, 1980, 1981; The Arts Council of Great Britain, London, 1975 (circulated; cat.); Albright-Knox Art Gallery, Buffalo, 1976 (cat.); San Francisco Museum of Modern Art, 1982 (circulated; cat.). Currently resides in Hollywood, California.

John Salt. Born in 1937 in Birmingham, England. Studied at Birmingham College of Art, England, 1952–58, Natl. Dipl. in Design, 1957; Slade School of Fine Arts, London, 1958–60, Dipl. of Fine Arts, 1960; Maryland Institute College of Art, Baltimore, 1967–69, M.F.A. 1969. Salt's first one-person exhibition took place at Ikon Gallery, Birmingham, England, 1965 (also 1967); subsequent solo exhibitions include Lion Gallery, Stourbridge, England, 1966; Zabriskie Gallery, New York, 1969; Gertrude Kasle Gallery, Detroit, 1970; O. K. Harris Gallery, New York, 1970, 1973, 1981. Currently resides in Bucknell, England.

Paul Sarkisian. Born in 1928 in Chicago. Studied at School of The Art Institute of Chicago, 1945–48; Otis Art Institute, Los Angeles, 1953–54; Mexico City College, 1955–56. Teaching experience includes Pasadena Art Museum (now Norton Simon Museum), California, 1965–69. Sarkisian's first one-person exhibition took place at Nova Gallery, Boston, 1958; subsequent solo exhibitions include Corcoran Gallery of Art, Washington, D.C., 1969 (cat.); Contemporary Arts Museum, Houston, 1977; Nancy Hoffman Gallery, New York, 1978, 1980, 1982. Currently resides in Cerillos, New Mexico.

Julie Schneider. Born in 1944 in Seattle. Studied at University of Wisconsin, Madi-

son, 1962–68, 1970–76, B.S. 1972, M.F.A. 1976. Teaching experience includes Williams College, Williamstown, Massachusetts, 1982, 1984. Schneider's first one-person exhibition took place at American International College, Springfield, Massachusetts, 1980; subsequent solo exhibitions include Fairweather Hardin Gallery, Chicago, 1982; Arlington Art Center, Virginia, 1985. Currently resides in Arlington, Virginia.

Ben Schonzeit. Born in 1942 in Brooklyn. Studied at Cooper Union School of Art, New York, 1960–64, B.F.A. 1964. Schonzeit's first one-person exhibition took place at French & Co., New York, 1970; subsequent solo exhibitions include Galerie Miklo, Berlin, West Germany, 1971–73; Nancy Hoffman Gallery, New York, 1973, 1975, 1976, 1979, 1980–83; Galerie Degestlo, Hamburg, West Germany, 1971, 1975, 1976, 1978, 1979, 1981; Delaware Art Museum, Wilmington, 1982, 1984. Currently resides in New York.

Susan Shatter. Born in 1943 in New York. Studied at University of Wisconsin, Madison, 1960–61; Pratt Institute, Brooklyn, 1962–65, B.F.A. 1965; Skowhegan School of Painting and Sculpture, Maine, 1964; Boston University, 1970–72, M.F.A. 1972. Teaching experience includes University of Pennsylvania, Philadelphia, 1974–75, 1979, 1983–84; Bennington College, Vermont, 1979; School of Visual Arts, New York, 1979, 1983–84. Shatter's first one-person exhibition took place at Fischbach Gallery, New York, 1973 (also 1976, 1978, 1980, 1982); subsequent solo exhibitions include Harcus-Krakow Gallery, Boston, 1977, 1979, 1984; Mattingly Baker Gallery, Dallas, 1981. Currently resides in New York.

Laura Shechter. Born in 1944 in Brooklyn. Studied at Brooklyn College, 1961–65, B.A. 1965. Shechter's first one-person exhibition took place at Green Mountain Gallery, New York, 1971; subsequent solo exhibitions include Suffolk Museum, Stony

Brook, New York, 1971; Forum Gallery, New York, 1976, 1980, 1983; Capricorn Gallery, Bethesda, Maryland, 1977; Greenville County Museum of Art, South Carolina, 1982; Charles A. Wustum Museum of Fine Arts, Racine, Wisconsin, 1982. Currently resides in Brooklyn.

Charles Sheeler. Born in 1883 in Philadelphia. Studied at Pennsylvania School of Industrial Art, Philadelphia, 1900–1903; Pennsylvania Academy of the Fine Arts, 1903–6. Sheeler's first one-person exhibition took place at the Modern Gallery, New York, 1917; subsequent solo exhibitions included Downtown Gallery, New York, 1931, 1940, 1946, 1949, 1951, 1956, 1958, 1965, 1966; The Museum of Modern Art, New York, 1939 (cat.); Walker Art Center, Minneapolis, 1952 (cat.); The Frederick S. Wight Art Gallery, University of California, Los Angeles, 1954 (circulated; cat.); National Collection of Fine Arts (now National Museum of American Art), Smithsonian Institution, Washington, D.C., 1968 (circulated; cat.); Whitney Museum of American Art, New York, 1980 (cat.). Died in 1965 in Dobbs Ferry, New York.

Lorraine Shemesh. Born in 1949 in Jersey City. Studied at Boston University, 1967–71, B.F.A. 1971; Tyler School of Art, Temple University, Philadelphia, 1971–73, M.F.A. 1973; Tyler School of Art in Rome, 1971–72. Teaching experience includes Rhode Island School of Design, Providence, 1973–80; Amherst College, Massachusetts, 1980–81. Shemesh's first one-person exhibition took place at Woods-Gerry Gallery, Rhode Island School of Design, Providence, 1976; subsequent solo exhibitions include The Alpha Gallery, Boston, 1978; Allan Stone Gallery, New York, 1984, 1985. Currently resides in New York.

Aaron Shikler. Born in 1922 in Brooklyn. Studied at Barnes Foundation, Merion, Pennsylvania, 1941–43; Tyler School of Art, Temple University, Philadelphia, 1943–48, B.F.A., B.S.ed., M.F.A., 1948; American University, Shrivenham, En-

gland, 1945; Hans Hofmann School of Fine Arts, New York, 1949–51. Shikler's first one-person exhibition took place at Davis Galleries, New York, 1953 (also 1954, 1957, 1958, 1961, 1962, 1964, 1967, 1971); subsequent solo exhibitions include California Palace of the Legion of Honor, San Francisco, 1970; Davis and Langdale Co., New York, 1975, 1979, 1983. Currently resides in New York.

Everett Shinn. Born in 1876 in Woodstown, New Jersey. Studied at Spring Garden Institute, Philadelphia, 1888–90; Pennsylvania Academy of the Fine Arts, Philadelphia, 1893–97. Shinn's first one-person exhibition took place at Boussod, Valadon and Co., New York, 1899 (also 1900, 1901); subsequent solo exhibitions included M. Knoedler and Co., New York, 1903; Durand-Ruel, New York, 1904; James Graham and Sons, New York, 1945 (also 1952, 1958, 1965); The Henry Clay Frick Fine Arts Department, University of Pittsburgh, 1959 (cat.); New Jersey State Museum, Trenton, 1974 (circulated; cat.). Died in 1953 in New York.

Harriet Shorr. Born in 1939 in New York. Studied at Swarthmore College, Pennsylvania, 1956–60, B.A. 1960; Yale University, New Haven, Connecticut, 1961–63, B.F.A. 1963. Teaching experience includes Swarthmore College, Pennsylvania, 1963–74; State University of New York, Purchase, 1979–present. Shorr's first one-person exhibition took place at Gross-McCleaf Gallery, Philadelphia, 1970; subsequent solo exhibitions include Green Mountain Gallery, New York, 1972, 1973, 1975; Fischbach Gallery, New York, 1979, 1980, 1983, 1984; Ivory/Kimpton Gallery, San Francisco, 1984. Currently resides in New York.

John Sloan. Born in 1871 in Lock Haven, Pennsylvania. Studied at Pennsylvania Academy of the Fine Arts, Philadelphia, 1892–94. Teaching experience included Art Students League, New York, 1914–26, 1935–37. Sloan's first one-person exhibi-

tion took place at Whitney Studio Club, New York, 1916 (cat.); subsequent solo exhibitions included Kraushaar Galleries, New York, 1917, 1926, 1927, 1930, 1937 (cat.), 1939, 1943, 1948 (cat.), 1952, 1960, 1966; Addison Gallery of American Art, Phillips Academy, Andover, Massachusetts, 1938 (cat.); Whitney Museum of American Art, New York, 1936, 1952; National Gallery of Art, Washington, D.C., 1971 (circulated; cat.). Died in 1951 in Hanover, New Hampshire.

Mary Snowden. Born in 1940 in Johnstown, Pennsylvania. Studied at Brown University, Providence, 1958–62, B.A. 1962; University of California, Berkeley, 1962–64, M.A. 1964. Teaching experience includes California College of Arts and Crafts, Oakland, 1965–present. Snowden's first one-person exhibition took place at Quay Gallery, San Francisco, 1966 (also 1969, 1972); subsequent solo exhibitions include Berkeley Art Center, 1968, 1976; Braunstein Gallery, San Francisco, 1978, 1979, 1982. Currently resides in Oakland.

Diane Sophrin. Born in 1950 in New York. Studied at State University of New York, Binghamton, 1968–72, B.A. 1972; Jan van Eyck Academie, Maastricht, The Netherlands, 1973–74; School of the Museum of Fine Arts, Boston, 1978. Teaching experience includes State University of New York, Binghamton, 1974–76; Community College of Vermont, Montpelier, 1981–82. Sophrin's first one-person exhibition took place at Portland Public Library, Maine, 1977 (also 1980); subsequent solo exhibitions include Wood Art Gallery, Montpelier, Vermont, 1980, 1981; St. Michael's College, Winooski, Vermont, 1981; Southern Vermont College, Bennington, 1982. Currently resides in Rochester, New York.

Raphael Soyer. Born in 1899 in Borisoglebsk, Russia. Studied at Cooper Union School of Art, New York, 1914–17; National Academy School of Fine Arts, New York, 1918–22; Art Students League, New York, 1920, 1921, 1923, 1926 (winters). Teaching

experience includes Art Students League, New York, 1933–42; New School for Social Research, New York, 1957–62; National Academy School of Fine Arts, New York, 1965–67. Soyer's first one-person exhibition took place at Daniel Gallery, New York, 1929; subsequent solo exhibitions include Valentine Gallery, New York, 1933, 1935, 1938; Associated American Artists, New York, 1941, 1948, 1953; ACA Galleries, New York, 1960; Forum Gallery, New York, 1964, 1966; Whitney Museum of American Art, New York, 1967 (circulated; cat.); Hirshhorn Museum and Sculpture Garden, Smithsonian Institution, Washington, D.C., 1982 (circulated; cat.). Currently resides in New York.

Joseph Stella. Born in 1877 in Muro Lucano, Italy. Studied at Art Students League, New York, 1897; New York School of Art, 1898–1900. Stella's first one-person exhibition took place at Italian National Club, New York, 1913; subsequent solo exhibitions included Bourgeois Gallery, New York, 1920 (cat.); Société Anonyme, New York, 1923; Valentine Gallery, New York, 1926, 1928, 1931, 1935 (cat.); The Newark Museum, New Jersey, 1939 (cat.), 1978; Zabriskie Gallery, New York, 1958 (cat.), 1959 (cat.), 1960 (cat.), 1961 (cat.); The Museum of Modern Art, New York, 1960 (circulated; cat.); Whitney Museum of American Art, New York, 1963 (cat.); Hirshhorn Museum and Sculpture Garden, Smithsonian Institution, Washington, D.C., 1983 (circulated; cat.). Died in 1946 in Queens.

Sally Sturman. Born in 1953 in Chicago. Studied at University of Hartford, 1971; University of Michigan, Ann Arbor, 1971–73; École des Beaux-Arts, Paris, 1976; Rhode Island School of Design, Providence, 1973–76, B.F.A. 1976. Sturman's first one-person exhibition took place at Kathryn Markel Gallery, New York, 1982. Currently resides in New York.

Billy Sullivan. Born in 1946 in Brooklyn. Studied at School of Visual Arts, New York,

1968. Sullivan's first one-person exhibition took place at Contact Graphics, Houston, 1971; subsequent solo exhibitions include Kornblee Gallery, New York, 1978–82; Roger Ramsay Gallery, Chicago, 1983; Holly Solomon Gallery, New York, 1985. Currently resides in New York.

Altoon Sultan. Born in 1948 in Brooklyn. Studied at Brooklyn College, 1966–71, B.A. 1969, M.F.A. 1971; Skowhegan School of Painting and Sculpture, Maine, 1970. Sultan's first one-person exhibition took place at First Street Gallery, New York, 1971; subsequent solo exhibitions include University Art Gallery, University of South Dakota, Vermillion, 1975; Marlborough Gallery, New York, 1977 (cat.), 1979 (cat.), 1982 (cat.), 1984 (cat.). Currently resides in New York.

Sarah Supplee. Born in 1941 in Laurel, Maryland. Studied at Pennsylvania State University, State College, 1959–60; University of Maryland, College Park, 1960–61; American University, Washington, D.C., 1961–63, B.A. 1963; Art Students League, New York, 1964 (summer); University of Iowa, Iowa City, 1963–65, M.A. 1965. Supplee's first one-person exhibition took place at Swain School of Design, New Bedford, Massachusetts, 1970; subsequent solo exhibitions include Sunne Savage Gallery, Boston, 1978, 1980; O.K. Harris West, Scottsdale, Arizona, 1981; Hirschl & Adler Modern, New York, 1982 (cat.), 1984 (cat.). Currently resides in Lowell, Massachusetts.

Wayne Thiebaud. Born in 1920 in Mesa, Arizona. Studied at Long Beach City College, California, 1940–41; San Jose State College (now San Jose State University), California, 1949–50; Sacramento State College (now California State University, Sacramento), California, 1950–53, B.A. 1951, M.A. 1953. Teaching experience includes Sacramento City College, California, 1951–60; University of California, Davis, 1960–present. Thiebaud's first one-person exhibition took place at E. B. Crocker Art

Gallery (now Crocker Art Museum), Sacramento, California, 1950 (also 1951, 1952, 1957, 1958, 1966, 1970 [cat.], 1983); subsequent solo exhibitions include Allan Stone Gallery, New York, 1962–70, 1972, 1973, 1976, 1979, 1980, 1982; Stanford University Art Museum and Gallery, California, 1965 (circulated; cat.); Pasadena Art Museum (now Norton Simon Museum), California, 1968 (circulated; cat.); Whitney Museum of American Art, New York, 1971 (circulated; cat.); Phoenix Art Museum, 1976 (circulated; cat.); San Francisco Museum of Modern Art, 1985 (circulated; cat.). Currently resides in Sacramento, California.

James Torlakson. Born in 1951 in San Francisco. Studied at California College of Arts and Crafts, Oakland, 1969–73, B.F.A. 1973; San Francisco State University, 1973–74, M.F.A. 1974. Teaching experience includes California College of Arts and Crafts, Oakland, 1979–83; Skyline College, San Bruno, California, 1981–present. Torlakson's first one-person exhibition took place at Reisinger Galleries, San Francisco, 1972; subsequent solo exhibitions include John Berggruen Gallery, San Francisco, 1974, 1978, 1980, 1983; Nancy Hoffman Gallery, New York, 1975; Museum of Art, Carnegie Institute, Pittsburgh, 1982 (cat.). Currently resides in Pacifica, California.

Diane Townsend. Born in 1946 in Indianapolis. Studied at Indiana University, Bloomington, 1965–69, B.F.A. 1969; Queens College, New York, 1969–71, M.F.A. 1971. Teaching experience includes New York Institute of Technology, 1972–83. Townsend's first one-person exhibition took place at Whitney Museum Art Resources Center, New York, 1974; subsequent solo exhibitions include Prince Street Gallery, New York, 1976; Tatistcheff & Co., Inc., New York, 1984. Currently resides in New York.

James Valerio. Born in 1938 in Chicago. Studied at School of The Art Institute of Chicago, 1962–68, B.F.A. 1966, M.F.A.

1968. Teaching experience includes Rock Valley Junior College, Rockford, Illinois, 1968–70; University of California, Los Angeles, 1970–79; Cornell University, Ithaca, New York, 1979–82. Valerio's first one-person exhibition took place at Gerald John Hayes Gallery, Los Angeles, 1971; subsequent solo exhibitions include John Berggruen Gallery, San Francisco, 1977; Frumkin & Struve, Chicago, 1981, 1984; Allan Frumkin Gallery, New York, 1983 (cat.). Currently resides in Ithaca, New York.

Beth Van Hoesen. Born in 1926 in Boise, Idaho. Studied at Stanford University, California, 1944–48, B.A. 1948; California School of Fine Arts (now San Francisco Art Institute), San Francisco, 1946–47, 1951, 1953; École des Beaux-Arts de Fontaine-bleau, France, 1948; Académie Julian, Paris, 1948–50; Jean Lurcat, St.-Céré, France, 1955. Van Hoesen's first one-person exhibition took place at Lucien Labaudt Gallery, San Francisco, 1952; subsequent solo exhibitions include Stanford University Art Museum and Gallery, California, 1957, 1983; M. H. de Young Memorial Museum, San Francisco, 1959; Achenbach Foundation for Graphic Arts, California Palace of the Legion of Honor, San Francisco, 1961 (circulated; cat.), 1974 (cat.); Felix Landau Gallery, Los Angeles, 1966; Santa Barbara Museum of Art, California, 1974; The Oakland Museum, 1980 (cat.); John Berggruen Gallery, San Francisco, 1982 (cat.); de Saisset Museum, University of Santa Clara, California, 1983 (circulated; cat.). Currently resides in San Francisco.

Michael Webb. Born in 1947 in Big Springs, Texas. Studied at University of Texas, El Paso, 1965–70, B.A. 1970; Pratt Institute, Brooklyn, 1970–72, M.F.A. 1972. Teaching experience includes Drexel University, Philadelphia, 1974–present. Webb's first one-person exhibition took place at American Institute of Architects Gallery, Philadelphia, 1980 (also 1983). Currently resides in Bala-Cynwyd, Pennsylvania.

Idelle Weber. Born in 1932 in Chicago. Studied at University of California, Los Angeles, 1951–55, B.A. 1954, M.F.A. 1955. Weber's first one-person exhibition took place at Bertha Schaefer Gallery, New York, 1963; subsequent solo exhibitions include Hundred Acres Gallery, New York, 1973, 1975, 1977; Art Gallery, Chatham College, Pittsburgh, 1979; O. K. Harris Gallery, New York, 1979, 1982; Segal Contemporary Art, New York, 1984. Currently resides in New York.

James Weeks. Born in 1922 in Oakland. Studied at California School of Fine Arts (now San Francisco Art Institute), 1940–42; Hartwell School of Design, San Francisco, 1946–47. Teaching experience includes University of California, Los Angeles, 1967–70; Boston University, 1970–present. First one-person exhibition took place at Lucien Labaudt Gallery, San Francisco, 1951; subsequent solo exhibitions include California Palace of the Legion of Honor, San Francisco, 1953; Poindexter Gallery, New York, 1960, 1963, 1965, 1968, 1974; Felix Landau Gallery, Los Angeles, 1964, 1967, 1970; San Francisco Museum of Art (now San Francisco Museum of Modern Art), 1965 (cat.); Rose Art Museum, Brandeis University, Waltham, Massachusetts, 1978 (circulated; cat.). Currently resides in Bedford, Massachusetts.

James Weidle. Born in 1950 in St. Louis. Studied at Southern Illinois University, Carbondale, 1970–73, B.A. 1973; University of Pennsylvania, Philadelphia, 1977–80, M.F.A. 1980. Weidle's first one-person exhibition took place at Fischbach Gallery, New York, 1983. Currently resides in Portland, Maine.

Paul Weisenfeld. Born in 1942 in Los Angeles. Studied at Chouinard Institute, Los Angeles, 1954–59; University of California, Los Angeles, 1960–64, B.A. 1964; Kunstakademie, Munich, West Germany, 1964–66; Indiana University, Bloomington, 1966–68, M.F.A. 1968. Teaching experience includes State University of New

York, Buffalo, 1969–73. Weisenfeld's first one-person exhibition took place at Galerie Hartman, Munich, West Germany, 1969; subsequent solo exhibitions include Albright-Knox Art Gallery, Buffalo, 1973 (cat.); Robert Schoelkopf Gallery, New York, 1973, 1976, 1981; J. B. Speed Art Museum, Louisville, Kentucky, 1984 (cat.). Currently resides in Landshut, West Germany.

Neil Welliver. Born in 1929 in Millville, Pennsylvania. Studied at Philadelphia Museum College of Art, 1948–53, B.F.A. 1953; Yale University, New Haven, Connecticut, 1953–55, M.F.A. 1955. Teaching experience includes Cooper Union School of Art, New York, 1953–57; Yale University, New Haven, Connecticut, 1955–65; University of Pennsylvania, Philadelphia, 1966–78. Welliver's first one-person exhibition took place at Mirsky Gallery, Boston, 1960; subsequent solo exhibitions include Tibor de Nagy Gallery, New York, 1967–70; Fischbach Gallery, New York, 1974, 1979, 1980, 1981; The Currier Gallery of Art, Manchester, New Hampshire, 1982 (circulated; cat.); Marlborough Gallery, Inc., New York, 1983 (cat.). Currently resides in Lincolnville, Maine.

James Winn. Born in 1949 in Hannibal, Missouri. Studied at American Academy of Art, Chicago, 1967–69; Illinois State University, Normal, 1978–82, B.S. 1980, M.S. 1981, M.F.A. 1982. Teaching experience includes Bethel College, St. Paul, 1984. Winn's first one-person exhibition took place at Illinois Central College, East Peoria, 1971; subsequent solo exhibitions include Sangaman State University, Illinois, 1982; Frumkin & Struve, Chicago, 1983. Currently resides in Sycamore, Illinois.

Paul Wonner. Born in 1920 in Tucson, Arizona. Studied at California College of Arts and Crafts, Oakland, 1937–41, B.A. 1941; University of California, Berkeley, 1950–55, B.A. 1952, M.A. 1953, M.L.S. 1955. Teaching experience includes Otis Art In-

stitute, Los Angeles, 1965–66; University of California, Santa Barbara, 1968–71; University of California, Davis, 1975–76. Wonner's first one-person exhibition took place at M. H. de Young Memorial Museum, San Francisco, 1955; subsequent solo exhibitions include Felix Landau Gallery, Los Angeles, 1959, 1960, 1962–64, 1968, 1971; Poindexter Gallery, New York, 1962, 1964, 1971; The Santa Barbara Museum of Art, California, 1960; The Art Museum Galleries (now University Art Museum), California State University, Long Beach, 1975, 1981; San Francisco Museum of Modern Art, 1981 (circulated; cat.); Hirschl & Adler Modern, New York, 1983 (cat.). Currently resides in San Francisco.

Grant Wood. Born in 1891 near Anamosa, Iowa. Studied at Minneapolis School of Design and Handicraft and Normal Art, 1910–11 (summers); School of The Art Institute of Chicago, 1913–16; Académie Julian, Paris, 1923. Teaching experience included Stone City Colony and Art School, Iowa, 1932–34; State University of Iowa (now University of Iowa), Iowa City, 1934–42. Wood's first one-person exhibition took place at Killian's Department Store, Cedar Rapids, Iowa, 1919; subsequent solo exhibitions included Galerie Carmine, Paris, 1926; Lakeside Press Galleries, Chicago, 1935 (cat.); University of Kansas Museum of Art (now Spencer Museum of Art), University of Kansas, Lawrence, 1959 (cat.); Cedar Rapids Art Center (now Cedar Rapids Museum of Art), Iowa, 1972 (cat.), 1973 (cat.); Minneapolis Institute of Arts, 1983 (circulated; cat.). Died in 1972 in Iowa City.

Selected Bibliography

BOOKS

Amiet, Pierre. *Art of the Ancient World: A Handbook of Style and Form.* New York: Rizzoli, 1981.

Arnheim, Rudolf. *Art and Visual Perception.* Berkeley: University of California Press, 1954.

Arthur, John. *Realist Drawings and Watercolors: Contemporary American Works on Paper.* Boston: New York Graphic Society, 1980.

————. *Realists at Work.* New York: Watson-Guptill, 1983.

Ashton, Dore. *American Art since 1945.* New York: Oxford University Press, 1982.

Baigell, Matthew. *The American Scene: American Painting of the 1930's.* New York: Praeger, 1974.

Battcock, Gregory, ed. *Super Realism.* New York: Dutton, 1975.

Bernheimer, Richard. *The Nature of Representation.* New York: New York University Press, 1961.

Boswell, Peyton. *Modern American Painting.* New York: Dodd, Mead, 1939.

Breuil, Henri. *Four Hundred Centuries of Cave Art.* New York: Hacker, 1979.

Chase, Linda. *Hyperréalisme.* New York: Rizzoli, 1975.

Cummings, Paul. *American Drawings: The 20th Century.* New York: Viking Press, 1976.

Davidson, Abraham A. *Early American Modernist Painting, 1910–1935.* New York: Harper and Row, 1981.

Friedlaender, Walter. *David to Delacroix.* Cambridge, Mass.: Harvard University Press, 1966.

Gerdts, William H. *The Great American Nude.* New York: Praeger, 1974.

Glackens, Ira. *William Glackens and the Ashcan Group.* New York: Crown, 1957.

Gombrich, Ernst. *Art and Illusion.* London: Phaidon, 1972.

Hartt, Frederick. *Art: A History of Painting, Sculpture, and Architecture*. New York: Abrams, 1976.

Heller, Nancy, and Julia Williams. *The Regionalists*. New York: Watson-Guptill, 1976.

Hills, Patricia, and Roberta K. Tarbell. *The Figurative Tradition and the Whitney Museum of American Art/Paintings and Sculpture from the Permanent Collection*. Cranbury, N.J.: Associated University Presses, 1980.

Holt, Elizabeth, ed. *Documentary History of Art*. Garden City, N.Y.: Doubleday, 1981.

Honisch, Dieter, and Jens Christian Jensen, eds. *Amerikanische Kunst von 1945 bis Heute*. Cologne: DuMont, 1976.

Honour, Hugh, and John Fleming. *The Visual Arts: A History*. Englewood Cliffs, N.J.: Prentice-Hall, 1983.

Hughes, Robert. *The Shock of the New*. New York: Knopf, 1980.

Hunter, Sam. *American Art of the Twentieth Century*. New York: Abrams, 1973.

Janson, H. W. *History of Art*. New York: Abrams, 1977.

Kultermann, Udo. *New Realism*. Greenwich, Conn.: New York Graphic Society, 1972.

Leroi-Gourhan, André. *Treasures of Prehistoric Art*. New York: Abrams, 1967.

Lipman, Jean, and Richard Marshall. *Art about Art*. New York: Dutton in association with the Whitney Museum of American Art, 1978.

Lucie-Smith, Edward. *Art Now: From Abstract Expressionism to Super Realism*. New York: Morrow, 1977.

———. *Late Modern: The Visual Arts since 1945*. New York: Praeger, 1969.

———. *Super Realism*. New York: Phaidon, 1979.

Marshack, Alexander. *The Root of Civilization: The Cognitive Beginnings of Man's First Art, Symbols, and Notation*. New York: McGraw-Hill, 1972.

Mathey, François. *American Realism: A Pictorial Survey from the Early Eighteenth Century to the 1970's*. New York: Rizzoli, 1978.

Meisel, Louis K. *Photorealism*. New York: Abrams, 1980.

Nochlin, Linda. *Realism*. Baltimore: Penguin Books, 1971.

———. *Realism and Tradition in Art, 1848–1900: Sources and Documents*. Englewood Cliffs, N.J.: Prentice-Hall, 1966.

Panofsky, Erwin. *Meaning in the Visual Arts*. Garden City, N.Y.: Doubleday, 1955.

Politt, J. J. *The Art of Rome: Sources and Documents*. Englewood Cliffs, N.J.: Prentice-Hall, 1983.

Rose, Barbara. *Readings in American Art 1900–1975*. New York: Praeger, 1975.

Sager, Peter. *Neue Formen des Realismus*. Cologne: DuMont Schauberg, 1973.

Stebbins, Theodore E., Jr. *American Master Drawings and Watercolors*. New York: Harper and Row, 1976.

Strand, Mark. *The Art of the Real: Nine American Figurative Painters*. New York: Clarkson N. Potter, 1983.

Walker, John. *Art since Pop*. London: Thames and Hudson, c. 1975, 1978.

Wilmerding, John. *American Art*. New York: Penguin Books, 1976.

———, ed. *The Genius of American Painting*. New York: Morrow, 1973.

Young, Mahonri Sharp. *American Realists: Homer to Hopper*. New York: Galahad Books, 1981.

———. *The Eight: The Realist Revolt in American Painting*. New York: Watson-Guptill, 1973.

EXHIBITION CATALOGUES

Abstract Painting and Sculpture in America, 1927–1944. Pittsburgh: Carnegie Institute Museum of Art, 1983.

American Art Today: Still Life. Miami: Florida International University Art Museum, 1985.

American Impressionist and Realist Paintings and Drawings, from the Collection of Mr. and Mrs. Raymond J. Horowitz. New York: Metropolitan Museum of Art, 1973.

American Realism and the Industrial Age. Cleveland: Cleveland Museum of Art, 1980.

American Realists and Magic Realists. New York: Museum of Modern Art, 1943.

American Still Life Painting, 1945–1983. Houston: Contemporary Arts Museum, 1983.

Amerika: Traum und Depression 1920–40. Berlin: Akademie der Künste, 1980.

Berman, Greta, and Jeffrey Wechsler. *Realism and Realities: The Other Side of American Painting, 1940–1960*. New Brunswick, N.J.: Rutgers University Art Gallery, 1982.

Directions 2: Aspects of a New Realism. Milwaukee: Milwaukee Art Center, 1969.

Documenta 5. Kassel: Documenta, 1972.

Gamwell, Lynn. *West Coast Realism*. Laguna Beach, Calif.: Laguna Beach Museum of Art, 1983.

Goodyear, Frank H., Jr. *Contemporary American Realism since 1960*. Boston: New York Graphic Society, 1981.

————. *8 Contemporary American Realists*. Philadelphia: Pennsylvania Academy of the Fine Arts, 1977.

————. *Perspectives on Contemporary American Realism: Works of Art on Paper from the Collection of Jalane and Richard Davidson*. Philadelphia: Pennsylvania Academy of the Fine Arts, 1982.

Hoopes, Donalson F., and Nancy W. Moure. *American Narrative Painting*. Los Angeles: Los Angeles County Museum of Art, 1974.

Kelly, W. J., and Larry Day. *American Figure Drawing*. Bethlehem, Pa.: Lehigh University, 1976.

Monte, James K. *22 Realists*. New York: Whitney Museum of American Art, 1970.

New/Photo Realism. Hartford, Conn.: Wadsworth Atheneum, 1974.

Nygren, Edward J. *The Human Form/Contemporary American Figure Drawing and the Academic Tradition*. Washington, D.C.: Corcoran Gallery of Art, 1980.

Real, Really Real, Super Real/Directions in Contemporary American Realism. San Antonio: San Antonio Museum of Art, 1981.

Realism and Abstraction: Counterpoints in American Drawing, 1900–1940. New York: Hirschl & Adler Galleries, 1983.

Realism Now. Poughkeepsie, N.Y.: Vassar College Art Gallery, 1968.

Realism/Photorealism. Tulsa: Philbrook Art Center, 1980.

Les Réalismes 1919–1939. Paris: Centre Georges Pompidou, 1980.

Recent Painting U.S.A.: The Figure. New York: Museum of Modern Art, 1962.

Rose, Bernice. *Drawing Now*. New York: Museum of Modern Art, 1976.

Selz, Peter. *New Images of Man*. New York: Museum of Modern Art, c. 1959, 1960.

Sharp-Focus Realism. New York: Sidney Janis Gallery, 1972.

Triumph of Realism. Brooklyn: Brooklyn Museum, 1967.

Waldman, Diane. *Twentieth-Century American Drawing: Three Avant-Garde Generations*. New York: Solomon R. Guggenheim Museum, 1976.

Wechsler, Jeffrey. *Surrealism and American Art, 1931–1947*. New Brunswick, N.J.: Rutgers University Art Gallery, 1977.

ARTICLES

An (R) following an entry indicates a review.

Alloway, Lawrence. "Realism as a Problem." *Art-Rite*, Summer 1974, pp. 27–28, ill.

Baigell, Matthew. "Notes on Realistic Painting and Photography, c. 1900–10." *Arts Magazine*, November 1979, pp. 141–43, ill.

Baldwin, C. R. "Realism, the American Mainstream." *Réalités*, November 1973, pp. 42–51, ill.

Bell, Jane. "The Stuart M. Speiser Collection." *Arts Magazine*, December 1973, pp. 74–75, ill. R.

Chase, Linda. "Photo-Realism: Post-Modernist Illusionism." *Art International*, March–April 1976, pp. 14–27, ill.

Henry, Gerrit. "Painterly Realism and the Modern Landscape." *Art in America*, September 1981, pp. 112–119, ill.

————. "The Real Thing." *Art International*, Summer 1972, pp. 86–91, 144.

————. "A Realist Twin Bill." *Art News*, January 1973, pp. 26–28, ill. R.

Hughes, Robert. "An Omniverous and Literal Dependence." *Arts Magazine*, June 1974, pp. 24–29, ill.

Karp, Ivan. "Rent Is the Only Reality or, The Hotel Instead of the Hymn." *Arts Magazine*, December 1971–January 1972, pp. 47–51, ill.

Kurtz, Bruce. "Documenta 5: A Critical Preview." *Arts Magazine*, June 1972, pp. 31–43, ill.

Kuspit, Donald B. "What's Real in Realism?" *Art in America*, September 1981, pp. 84–94, ill. R.

Lucie-Smith, Edward. "The Neutral Style." *Art and Artists*, July 1975, pp. 6–15, ill.

Marandel, J. Patrice. "The Deductive Image: Notes on Some Figurative Painters." *Art International*, September 1971, pp. 58–61, ill.

Nemser, Cindy. "The Close Up Vision—Representational Art—Part II." *Arts Magazine*, May 1972, pp. 44–48, ill.

———. "Representational Painting in 1971: A New Synthesis." *Arts Magazine*, December 1971–January 1972, pp. 41–46, ill.

Nochlin, Linda. "The Realist Criminal and the Abstract Law." *Art in America*, September–October 1973, pp. 54–61, ill.

———. "The Realist Criminal and the Abstract Law, II." *Art in America*, November–December 1973, pp. 96–103, ill.

———. "Some Women Realists, Part I." *Arts Magazine*, February 1974, pp. 46–51, ill.

———. "Some Women Realists." *Arts Magazine*, May 1974, pp. 29–33, ill.

"Photographic Realism." *Art-Rite*, Spring 1975, pp. 14–15, ill.

Restany, Pierre. "Sharp Focus: la continuité réaliste d'une vision américaine." *Domus*, August 1973, pp. 9–13, ill.

Seitz, William C. "The Real and the Artificial: Painting of the New Environment." *Art in America*, November–December 1972, pp. 58–72, ill.

"Special Issue: Super Realism." *Arts Magazine*, February 1974.

Werner, A. "W.P.A. & Social Realism." *Art and Artists*, October 1975, pp. 24–31, ill.

Young, Mahonri Sharp. "American Realists of the 1930's." *Apollo*, March 1981, pp. 156–84, ill.

Photograph Credits

Most of the photography for this catalogue was done by Andrew Kent.

Robert C. Dawson: Plates 17, 34, 152; M. Lee Fatherree: Plates 6, 7, 11, 12, 16, 23, 27, 28, 33, 49, 51, 52, 53, 54, 60, 62, 63, 72, 73, 83, 84, 85, 89, 92, 93, 99, 108, 109, 111, 112, 114, 118, 121, 122, 123, 138, 147, 148, 149, 150, 156, 161, 163, 164, 165, 166, 167, 168, 171, 175, 183, 187, 194, 195, 199, 203, 206, 208, 209, 211, 212, 217, 219, 221, 222, 232.

Deutsches Archäologisches Institut, Rome: Fig. 3; French Government Tourist Office/Ben Blackwell: Fig. 1; The Louvre, Paris: Fig. 6; Museum of Modern Art, N.Y.: Fig. 7; Oriental Institute, University of Chicago: Fig. 2; Rijksmuseum, Amsterdam: Fig. 5; Staatliche Kunstsammlungen, Dresden: Fig. 4.

Board of Trustees

Staff

Henry T. Hopkins
 Director
T. William Melis
 Deputy Director
Kathleen Rydar
 Director of Development
Cecilia Franklin
 Controller
Graham W. J. Beal
 Chief Curator
Van Deren Coke
 Director,
 Department of Photography
Karen Tsujimoto
 Curator
Dorothy Vandersteel
 Associate Curator,
 Department of Photography

Suzanne Anderson
 Graphic Designer
Mark Ashworth
 Matting
Robert Barone
 Communications Assistant
David Bedell
 Preparator, Rental Gallery
Oni Berglund
 Collectors Forum Coordinator
Michael Berns
 Data Entry Operator
James Bernstein
 Codirector, Conservation
Claudia Beth Bismark
 Manager,
 Modern Art Council
Suzanne Bocanegra
 Bookshop Assistant
Margy Boyd
 Program Director,
 Art Tours and Travel
Bruce Brodie
 Conservation Technician

Beverly B. Buhnerkempe
 Senior Assistant Controller
Catherine Byrne
 Development Secretary
Gail Camhi
 Clerk/Typist,
 Conservation
Eugenie Candau
 Librarian
Hilda Cardenas
 Admissions
Patti Carroll
 Curatorial Assistant,
 Department of Photography
Neil Cockerline
 Conservation Intern
Lilly de Groot
 Admissions
Robert Dix
 Gallery Technician
Vera Anne Doherty
 Receptionist
Diana duPont
 Research Assistant II
Robert Dziedzic
 Bookshop Assistant
Inge-Lise Eckmann
 Codirector, Conservation
Debra Erviti
 Slide Librarian
Adele Feinstein
 Curatorial Secretary
Helene Fried
 Adjunct Curator/Planning Coordinator,
 Department of Architecture
 and Design
Tina Garfinkel
 Associate Registrar/Exhibitions
Nona R. Ghent
 Assistant to the Director
Greacian Goeke
 Public Relations Assistant
Donna Graves
 Curatorial Assistant

Sarah Grew
 Bookshop Assistant
Miriam Grunfeld
 Assistant Director of Education
Laurice Guerin
 Coordinator of Development and
 Membership Services
Heather Hendrickson
 Rights and Reproductions Coordinator
Christina Henrikson
 Corporate Consultant, Rental Gallery
Toby Kahn
 MuseumBooks, Manager
Claudia Kocmieroski
 Bookshop Assistant
Debra Lande
 MuseumBooks,
 Assistant Manager/Buyer
Deborah Lawn
 Public Relations Assistant
Susan Lefkowich
 Assistant Director of Development for
 Membership and Marketing
Sara Leith
 Research Assistant I
Robert Lieber
 Bookshop Assistant
Pauline Mohr
 Conservator
Sharon Moore
 Administrative Secretary,
 Conservation
Christine Mueller
 Mailroom and Supplies Coordinator
Garna Muller
 Associate Research/Collections Director

Anne Munroe
 Exhibitions and Publications Coordinator
Nancy O'Brien
 Assistant Graphic Designer II
Matrisha One Person
 Bookshop Assistant
Pamela Pack
 Assistant Registrar
Marian Parmenter
 Director, Rental Gallery
Lauren Parrill
 Receptionist, Rental Gallery
Lochiel Poutiatine
 Bookkeeper, Rental Gallery
Kristy Pruett
 Receptionist/Admissions
Richard Putz
 Gallery Technician
Suzanne Richards
 Executive Secretary
Kent Roberts
 Assistant Gallery Superintendent
Janice Robinson
 Assistant Controller I
Carol Rosset
 Associate Registrar/Permanent
 Collection
Jo Rowlings
 Public Relations Assistant
Susan Schneider
 Assistant Graphic Designer I
Michael Schwager
 Curatorial Assistant
J. William Shank
 Conservator
Myra Shapiro
 Volunteer Coordinator

Joseph Shield
 Gallery Attendant
Carol Singer
 Bookshop Assistant
Carol Stanton
 Bookshop Assistant
Laura Sueoka
 Research Assistant II
Sally Sutherland
 Assistant Director of Development,
 Special Programs
Beau Takahara
 Education Department Coordinator
Lydia Tanji
 Curatorial Secretary
Roy Tomlinson
 Gallery Technician
Karin Victoria
 Curatorial Secretary,
 Department of Photography
Andrea Voinot
 Bookshop Assistant
Ferd Von Schlafke
 Preparator
Lesley Walker
 Admissions
Julius Wasserstein
 Gallery Superintendent
Robert A. Whyte
 Director of Education
Jim Wright
 Conservator

Index

Page numbers are in roman type. Plate numbers of illustrations are in *italic* type. Figures are specifically so designated.